Agitating Images

Agitating Images

PHOTOGRAPHY AGAINST HISTORY IN INDIGENOUS SIBERIA

Craig Campbell

University of Minnesota Press
Minneapolis • London

FIRST PEOPLES
New Directions in Indigenous Studies

The University of Minnesota Press gratefully acknowledges financial assistance provided for the publication of this book from the Office of the Vice President for Research at the University of Texas at Austin.

Publication of this book was made possible, in part, with a grant from the Andrew W. Mellon Foundation.

Spot illustrations appear courtesy of Krasnoiarsk Krai Regional Museum.

Portions of the book were previously published as "History's Ornament: Photography and Cultural Engineering in Early Soviet Siberia," *Journal of Historical Sociology* (2013).

Published by the University of Minnesota Press
111 Third Avenue South, Suite 290
Minneapolis, MN 55401-2520
http://www.upress.umn.edu

Library of Congress Cataloging-in-Publication Data
Campbell, Craig.
 Agitating images : photography against history in indigenous Siberia / Craig Campbell.
(First peoples : new directions in indigenous studies)
 Includes bibliographical references and index.
 ISBN 978-0-8166-8106-8 (pb : alk. paper)
 ISBN 978-0-8166-8105-1 (hc : alk. paper)
1. Evenki (Asian people)—Cultural assimilation—Russia (Federation)—Siberia, Northwestern—History—20th century. 2. Evenki (Asian people)—Government relations—History—20th century. 3. Evenki (Asian people)—Government policy—Soviet Union. 4. Historiography and photography. I. Title.
 DK759.E83C36 2014
 323.1194'1—dc23

 2013050882

Printed in the United States of America on acid-free paper

The University of Minnesota is an equal-opportunity educator and employer.

20 19 18 17 16 15 14 10 9 8 7 6 5 4 3 2 1

Contents

Acknowledgments vii

Prologue ix

Introduction: In the Archives of the Cultural Base 1

The Years Are Like Centuries 9

Dangerous Communications 153

Conclusion: Ethics of Presence and the (De)generative Image 211

Notes 229

Bibliography 247

Index 261

Acknowledgments

This book, from start to finish, is a minor career; the research has gone in many directions and has been whittled down to its core articulations through countless conversations. To all those who listened to me and offered advice, I am deeply grateful. Unfortunately I've lost track of some who helped me in the earliest stages. So I begin with an apology as well as a declaration of general gratitude for myriad gifts of knowledge, friendship, forgiveness, understanding, tolerance, money, and love.

My children grew up while I researched this book—their acceptance of the strange pace of life for a scholar (being around too much, being away too much, and sometimes just half-being) has been essential to sustaining my project. Their mother, too, cared enough for these words and this work to lend her generous support, time, and editorial gaze in earlier stages. Thank you.

Agitating Images grew out of graduate work undertaken at the University of Alberta, where there are many people who deserve acknowledgment. Derek Sayer and Elena Siemens were my invaluable mentors and supporters: they trusted in me, and in turn I learned to trust myself. An important Wild Rose cohort of fellow travelers includes Yoke Sum Wong, Karen Engle, Mark Jackson, Kim Mair, Erin Stepney, Amy Swiffen, Dan Webb, and others.

David Anderson has been an important partner in much of my Siberian research. He has also been a steadfast role model for committed ethnography as well as an important friend and mentor.

My friend from Novosibirsk, Anatolii Ablazhey, helped in many ways and has been a steadfast supporter of my research. I must also thank A. Sirina, M. Batashev, N. Makarov, and N. Martynovich. Of course many more need to be acknowledged, and I apologize for not naming all of them here. Archivists and librarians, sociologists, archaeologists, and ethnographers from Tura,

Krasnoiarsk, Irkutsk, Ekaterinburg, Novosibirsk, Moscow, and St. Petersburg all helped this project at various stages.

Many friends in Tura need to be thanked, and already too many years have passed since I have seen them. Most especially I thank the Khutukogir family for extending their support and their homes to me on my visits.

In Austin, Texas, I have found an uncommon community to whom I am deeply indebted. Katie Stewart and John Hartigan have done so much to make space for me here. Writing sessions with Sofian Merabet, Ann Cvetkovich, Randy Lewis, Heather Hindman, and others associated with Public Feelings were tremendous.

Many institutions play a role in one's research, and they should not be left out, least of all because they make this practice possible. The Canadian Social Sciences and Humanities Research Council has been very generous toward me and has given me a great deal of financial support over the years. Others include the Canadian Circumpolar Institute and the Department of Sociology at the University of Alberta.

Prologue

What stands out most to us when we look at this hundred-year-old image? Is it the gaze of these men, women, and children staring at an ancient camera's lens? Although the look is arresting, I don't think this is the first thing the viewer will notice. I suggest our first level of engagement is to wonder what is going on, on the surface of the image. Not only are three people painted out (or in, depending on your opinion), but the effect of the touch-up produces an uncanny confusion of territory. While it promises to excerpt a photographic element from the plane of the image, it also threatens to decouple the indexicality secured by photography.

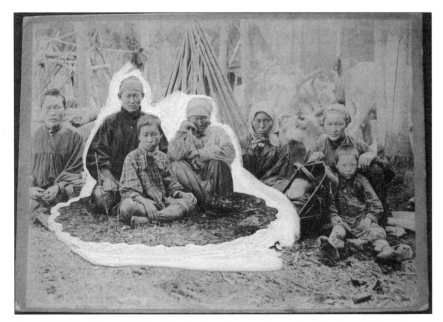

Figure 1. A falsified image? Neither the photographer nor the manipulator is noted. Courtesy Tura Regional Museum. I. M. Suslov collection.

"Maiskie Tungusy" was written in Cyrillic on the verso of a photographic print from which this image is reproduced. Aside from three other alpha-numerical classificatory markings connecting this photograph to specific institutional histories and archival ecologies, I've found nothing else written about the image. "Tungusy" is a pluralized ethnonym. It was used most commonly into the early twentieth century to describe a variety of indigenous peoples widely dispersed across North and Central Asia; this includes the Siberian Evenkis who are at the center of this study. The term *Maiskie* probably locates this group of Tungus in the Maia River basin, an area in central Siberia east of the Enisei and Lena Rivers.

The thickly painted white border draws three bodies out of the group of "Maiskie Tungus." It seems to float them on a separate plane. On first inspection one might imagine that the white border obscures the artificial insertion of three people into an already existing group. The erasure of certain elements (such as the baby's cradle to the right of the alteration) reveals on close inspection that underneath the white paint the picture is a cohesive whole. This is no composite image; rather it is a deliberate attempt to slice through one "real" to present another. This photograph draws attention to itself. The overt distortion and obfuscation of this image present rare evidence for techniques of visible manipulation—the trace of the *act* of falsification rather than its after-effect. While all photographs function as perversion to the empirical event, most are presented in their relationship to that-which-once-was as transparent reflection: unmodified replication, if not unmodulated reproduction.

The danger of the falsified photograph is not the real it hides or masks but the unmarked real it produces. Regardless, my interests in this photograph's modifications as well as other conspicuous adjustments—minor marks and modifications—are intended less as cyphers for a discourse on the nature of the real and more as enticement to dwell a little longer on the surface of the image. The title of this book—*Agitating Images*—gives away little beyond a promise to engage with the visual and the implication of some sort of trouble. But perhaps "trouble" is too negative a term; after all, *agitation* is a word that also implies a potentially more benign mixture of elements. In many ways *Agitating Images* is a project defined both by trouble and mixture:

a hopeful commingling of disparate parts or claims. The "trouble" I invoke is analyzed and historicized, but it is also a critical trouble that is expected and invited; in this latter sense I present agitation in the form of a montage of photographic images accompanied by histories, observations, and critiques. This trouble is coaxed and encouraged to settle, however awkwardly, like that gloomy space between night and day in the arctic winter where our certainty of the shape of things is least secure—where form is a little less sharply defined. Photographs and histories find themselves in a space half-formed, half-unformed. Their specific roles seeping out into the other, their interplay complicating a "coming into" something: shaping up or sedimenting and hardening.

"Agitation" [*agitatsiia*, in Russian] was the name given to a project of Communist activists who were working in the first decades of the twentieth century. They took their struggles to peasants in the fields just as they did to proletarian workers in factories. They also traveled to remote regions of the former Tsarist Empire to meet indigenous Siberian peoples. The agitators were community workers attempting to bring about class warfare in a place where there was little sense of conventional class differentiation and where Marxist class analysis could only be applied through highly selective and acrobatic rhetorical acts. Inevitably the models used by labor agitators came up short against the organic and ill-understood character of work in the reindeer camp, the trapper's tent, and annual clan gatherings. As was so often the case elsewhere, policy and methods designed for Europe were poorly suited to the everyday realities of colonial outposts. Reindeer herders in Siberia, after all, bore little resemblance to peasant farmers and even less to the urban proletariat. Revolutionary methodology, at least in the earliest days, was a relatively blunt tool of urgent politics and action.

Agitation itself has a history as a word describing the effort to raise a shared sense of discontent among a group—the agitator thus being a kind of agent of incipient change. Karl Marx often used the term to describe a broad range of activists committed to political transformation. As the pragmatics of revolution required a division of labor and clarification of jobs and their attendant responsibilities, the role of the agitator came to be codified in the context of Soviet revolutionary politics. Eugene Debs, an American union organizer,

wrote on the definition of an agitator in an 1890 English-language labor pamphlet: "The employer wants quiet, stagnation; wants to be let severely alone. The agitator won't have it so. At the bottom of the labor question there exists a wrong of incalculable enormity. The labor agitator seeks to unearth it— to lay it bare, *to expose it to the gaze of the world* and exterminate it."[1] What Debs described was an aesthetics of injustice; a regime of looking that would make visible the overlooked and unmarked in everyday life. The conditions of postrevolutionary Communism in Russia imagined a role even more bold and expansive for the agitator. The form of Communism developed under V. I. Lenin and the Bolshevik Party necessitated not only a revolution in rights and labor practices but also a revolution in everyday life. The reconstruction of economies and social relations was quite simply not enough: agitation needed to disturb established orders of being with a program that was more profoundly encompassing. The aesthetic regime of change was designed to reconstruct the palpable sense of ordinary life and possibility. In 1902, Lenin described in detail the agitator's grave assignment:

> [The agitator] will take as an illustration a fact that is most glaring
> and most widely known to his audience, say, the death of an unem-
> ployed worker's family from starvation, the growing impoverish-
> ment, etc., and, utilising this fact, known to all, will direct his efforts
> to presenting a *single idea* to the "masses", e.g., the senselessness of
> the contradiction between the increase of wealth and the increase of
> poverty; he will strive *to rouse* discontent and indignation among the
> masses against this crying injustice, leaving a more complete explana-
> tion of this contradiction to the propagandist.[2]

Without naming it thus, Lenin's focus was on the *everyday,* on the form of ordinary life as it was lived out by countless people struggling to make sense of the twentieth century's ebullient and terrifying upheavals. Agitation's necessary attention to the facts of everyday life, to the lived feeling of injustice, is possible by a hyper-attunement to ordinary experience and expression. In a visual register it was also just the look of it all and later a learned way of looking at the surface of the ordinary. The object of attention was the manner in

which ideology obscured the possibility of radical (revolutionary!) change. The division of labor between the agitator and the propagandist is critical in my own appropriation of the term. Agitation is an act of cultural critique, whereas propaganda—foreclosing on the possibility of discussion, disagreement, or negotiation—is dogma. Agitation cries out that something is not right, while propaganda proscribes the path to change. Agitation in the years following the 1917 October Revolution was marked by a militarization of culture and language in a rigid march of "progress."[3] Soviet society was at war with illiteracy. It was at war with "stagnation" and "backwardness." In central Siberia it was also at war with shamanism and other particularities of indigenous life deemed incompatible with Soviet modernity. Debs dramatically claimed: "Agitation is the order of nature. Nature abhors quiet as it does a vacuum."[4] Agitation in the context of early Soviet cultural interventions was an essential component in an obligatory process of cultural reconstruction, a process wherein ideas and practices were evaluated according to Communist principles. Those principles that failed to meet the ideal were disrupted, denigrated, and, where possible, liquidated or destroyed. There could be no vacuum for the state's sociology, for its totalizing interventions into everyday life.

Innokentii Mikhailovich Suslov, the man standing to the right in figure 2 with his arm raised in the air, was one of the primary agents of cultural change in the central Siberian territory of Evenkiia. He was born in Siberia but trained as an anthropologist and geographer in St. Petersburg. After the 1917 revolution (that toppled tsarist rule) and the subsequent civil war (that sorted out national power), Suslov traveled the Russian countryside on specially outfitted agitational trains. The goal of these caravans was to convince peasants and other rural peoples to support the revolutionary enterprise. Later he returned to central Siberia to supervise Communist "enlightenment" work among indigenous peoples. One of his most significant and enduring projects was orchestrating the construction and implementation of a system of remote outposts, called Culture Bases.

The agitation I have deployed in this work engages more than the specific historical connotation of the Communist Revolution. In an expanded sense it functions as a kind of historiographical ethos. Agitation serendipitously describes what I've come to see as a troubled (and troubling) relationship

Figure 2. Obvious traces of modification are visible in this image. Courtesy Tura Regional Museum. I. M. Suslov collection.

between photography and historiography. In this book I will argue that all photographs are actually agitating; even the most mundane and seemingly transparent images will be shown to have the capacity to agitate against or undo our meaning-making endeavors. Photographs are qualitatively different things than are words, sentences, essays, and monographs. They communicate in unique ways, and their appearance in proximity to exposition and argument is deeply problematic. The effect of photographs is also overlooked in scholarly writing with surprising frequency. To extend the militaristic tone from revolutionary Communism: photographs are *agents provocateurs*. They pose (or are posed) as media amenable to interpretation and the ascription of meaning, whereas in actuality they undermine meaning and interpretation by indexing the irreducible meaninglessness of the everyday.

Agitation as an ethos—as an orientation toward the writing of history— shares in the spirit of innervation invoked by the famous cultural critic Walter Benjamin in his exploration of aesthetics. There was ballistic tactility

in some of the emerging forms of art and visual exhibition described and critiqued by cultural critics in the 1920s and '30s. As Walter Benjamin saw it, the spectator did not *see* this art, "it *happened* to him."[5] The registers of shock or "shock effects" transcended and troubled the contemplative (and complacent) world of tradition and mind, binding it up with body effects and social reverberations. Benjamin's aesthetics of innervation—described through emerging theories of the psyche and motivated by revolutionary artists and thinkers—was a site or perhaps a utopian sociospatial reorganization. Innervation for Benjamin was a metaphorical suture used to demark mind–body transference: a two-way street, as Miriam Bratu Hansen describes it, which is "not only a conversion of mental, affective energy into somatic, motoric form, but also the possibility of reconverting, and recovering, split-off psychic energy through motoric stimulation."[6] This two-way street of innervation or agitation troubles the boundary between the mind and the body. Susan Buck-Morss wrote that "'innervation' is Benjamin's term for a mimetic reception of the external world, one that is empowering, in contrast to a defensive mimetic adaptation that protects at the price of paralyzing the organism, robbing it of its capacity of imagination, and therefore of active response."[7] Benjamin's mimetic faculty, which blows apart conventions of verisimilitude, looks to semblance, interplay, and affinity through touch and tactility . . . through bodily engagements with the world: "Revolutions are innervations of the collective" wrote Benjamin.[8] The photo-fragments in my book are a little army of agitators, set to radically challenge archives of "non-sensuous correspondences."[9] The tactility of seeing is thus tied to the revolutionary potential of the images vis-à-vis the historical claims set beside them.

Another resonance for this project of agitation is the trouble invoked by Judith Butler in her work on gender and performance. In a widely quoted passage from the preface to the second edition of *Gender Trouble,* Butler writes on the inevitability of trouble and the necessity of making it as well as being in it.[10] Making trouble and being in trouble for Butler torments the "subtle ruse of power" that would deny ground for difference. This "subtle ruse of power" concerning behavior and gender is reproduced through historical writing, not concerning gender alone but concerning the *everyday* as well. The irreducible fact of a life lived—an affective order (and ordering) of the

world—refuses the undifferentiated otherness of the past generated by so much historical writing. Agitating photography, like troubling gender, turns on a recognition of indeterminacy. This "subtle ruse of power" is closure or stagnation. It is the denial of a space from which to speak opposition, what Jacques Rancière calls for in his work on dissensus and emancipation.[11]

In a fashion I see Butler's notion of trouble resonant also with Walter Benjamin's writing on history as an effort "to seize hold of a memory as it flashes up a moment of danger." [12] This is a danger that, according to Benjamin, "affects both the content of the tradition and its receivers."[13] While deciding on which histories matter may be the task of articulating the past historically—producing a consensual framing of reality—I'll show how photographs "flash up" dangerously as they position themselves not against historical claims but against everyday consensus. Accepting the inevitability of trouble enriches history; engineering agitation empowers the spectator-reader to more boldly push against the thousand little closures native to writing about the past.

Figure 3 is a manipulated image presented as an obscured photographic trace designed to mark an absence. It occupies a space of provisional externality in this book by pointing to a Web page I have called the archival degenerator. The degenerator is an archival game that can exist only as a digital supplement to a print publication. The manipulated and obscured photograph, a collage of sorts, is placed to amplify and complicate the absence of the intervention. It points outward from the book to the game, which in turn indexes archives and histories through its chaotic mechanism. My archival degenerator is an experiment in surrealist archival science. It is a degenerate's catalogue that presents an engaged randomization of the entire collection of photographs from the Endangered Archives Programme originating in the Krasnoiarsk Krai Regional Museum. The point of the archival degenerator is to bring multiple images together, to allow them to rub up against one another, to produce unexpected encounters and to engineer serendipity. What will become of this? Who knows? The point of this exercise is that the categories of the archive are arbitrary, just as the categories I generate are arbitrary. But the poetry of degenerated archival orders suggests different readings and possibilities. The degenerate's catalogue throws together two random images each time you activate the engine.

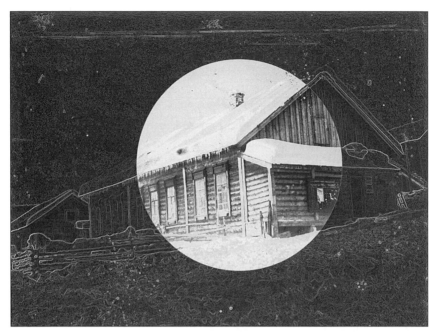

Figure 3. A manipulated image. Original image courtesy Krasnoiarsk Krai Regional Museum.

Like anything corrupt, the archival degenerator upsets rules and codes. It undermines the fictions of closure and comprehensibility. It refuses the archive and its logics of order and practice. It agitates history and power and draws attention to the implicit and unspoken rules governing access and expression. The juxtapositions created in the degenerate's catalogue are ephemeral and in some ways dilettantish. They are not easily instrumentalized and are best seen as a tool to generate novel associations. As Ted Bishop writes in *Riding with Rilke*, the heart of archival work is "the discovery of surprising connections between disparate artifacts."[14] Most of the surprising connections I've made while playing with the degenerate's catalogue are actually disconnections and incredulities: "Where are the signs of trauma after the brutal small pox epidemic?" "What does this pile of reindeer carcasses have to do with Bolshevik party politics?" or even more mundane observations:

"What kind of tea are they brewing?"

"Did that man ever travel to Moscow?"
"What a beautiful coat!"
"They look cold."
"I'm hungry for fish."

Being in the archive presents a situated encounter with the structuration of history itself. While doing research for this book, I often found myself in the dull repositories of state institutions and regional museums. I felt like a disciplinary interloper, an ethnographer lost in foreign parts—immersed in a vast ocean of documents all connected to one another in myriad and incalculable ways. Such scope and intricacy seem to make a project of relational historiography laughably parochial. The incalculable immensity of the ephemeral haunts historical representation. What was left behind disturbs me to this day: unread documents, partially read documents, hot trails grown cold, unmapped networks, and most significantly the immensity of it all; all potentially meaningful, all superficially useless. Each document points to intimate labors, inscriptions, and extensive bureaucratic systems; each one moves through ages of revolutionary excitement, repressions, banal organizations, reorganizations, and re-reorganizations. Each document conveys the class marks and carefully inscribed histories of its movements from one place to another. From their fragmentations through re-formations and re-fragmentations they bear the indexical marks back to the ledgers of previous researchers. These are archival threads that have no place in this work, but that I am loath to cut out; their collective absence is too obvious and too frequently unspoken. Perhaps we are in a moment whereby grand schematizations and constructions of historical events are looked upon with a modicum of suspicion: now more than ever there is a desire to know the past as a collection of sensuous instances. Or perhaps not. The discursive realities of an archive structure our interpretation of it. But the affective orders of the archival researchers' *observation of*—and more importantly *contact with*—history must not be written away under the pragmatic efficiencies of reductive categories. Certainly, it is discourse. But it is more, too.

A photograph, in any event, cuts across historical narratives referring to a single moment but anticipating an indeterminate possibility. Remember the archive is not just about the past; it is about the future, or rather, it anticipates

a future audience. The photograph (like the archive ... as an archive) is a future-oriented object, for it is always establishing connections beyond itself and being reinterpreted in each photo-encounter. It is remarkable how easily a photograph can eviscerate historical narrative. Like a coroner's scalpel, it cuts into these partial pasts with its precision and sensuous particularity; it makes me think of Brion Gysin and William Burroughs with their cut-ups. Those two sought to find hidden pulses and forgotten rhythms through their poetry, prose, and art. Their cutups also point back further to the Romanian Dadaist Tristan Tzara, whose nihilism lit up generations of artists. His lusty inchoate protest rang out against "greasy objectivity, and harmony, the science that finds everything in order." It was, as others would call it, an innervation with a profound ballistic tactility.

"To Expose It to the Gaze of the World"

While *Agitating Images* is an experiment in form and a serious yet playful engagement with design, it is also a commitment to critical cultural history. I've written this book in two parts. The first part, "The Years Are Like Centuries," is a historical examination of the encounter between indigenous peoples in central Siberia, especially Evenkis, and the newly minted Bolshevik-led Communist government. The second part of this book, "Dangerous Communications," positions this history in conversation with ideas about photography and archives. As a whole the work ranges across the murky territorial boundaries between indigenous studies, cultural anthropology, cultural theory, history, and sociology.

The 1920s and '30s marked a colossal and explosive shift of everyday life across all of Russia, including its subordinate lands in northern Asia. Through the examination of an event—the production and performance of Communism in central Siberia, one of the frontiers for Russia's mass utopia—I show how the ruling Bolshevik party, faced with an enormous inland territory and what was perceived as a culturally anterior population, developed a unique technology to facilitate the shaping and manipulation of the indigenous cultural everyday. This technology was called the *Kul'tbaza*, or Culture Base. In particular this book focuses on the Tungus Culture Base, a prototype that

functioned as a model for Soviet intervention across the Siberian North. The Tungus Culture Base also laid the foundations for an Evenki "city in the forest": Tura, the capital of an autonomous ethnic homeland for a fledgling Evenki nation.

Rather than illustrate my history of Soviet programs of culture change with archival photographs, I present archival photographs as an anti-illustration, an intrusion into the historiographical calm of the text. In the first part of this book, untitled and uncaptioned photographic images actively agitate against the written history. They undermine it by offering paths of critique and challenge that might otherwise be marginalized and ignored. Following Lenin's rhetoric, these image agitators strive to rouse discontent, even indignation. It is perversely a struggle with the history I am writing—an invited and necessary perversion. Through states of agitation and historical apprehension, I stake a claim for a modality of publishing that delivers authoritative and expository claims alongside the means to engage with the limits of authorship and expertise—something that works to undo the sedimentation of historical reality.

The second part of this work, "Dangerous Communications," is embellished in a more or less conventional manner with archival photographs that I have collected while doing research in Siberia. This part actually reconfigures its subject through an engagement with expeditionary photographs from Siberian archives. These photographs are meant to accompany and extend the textual arguments, but they are not, for the most part, discussed in the text as examples. Unlike the photographs presented in the prologue, they are not illustrations with captions but are instead historically complicit and collusive. They offer new possibilities and openings rather than simple affirmations and closures. The images in this section are thus agitating in a passive sense and in the way that they redistribute the production of historical knowledge across an ambivalent register of ordinary life.

Introduction

In the Archives of the Cultural Base

> The idea that culture is something to be produced, invented, constructed, or reconstructed underlined so much of the USSR's social vision . . . its stunning reach was perhaps nowhere more strikingly seen than in the ways it transformed the lives of the peoples living along its furthest borders.
>
> —Bruce Grant, *In the Soviet House of Culture*

In his book *In the Soviet House of Culture,* anthropologist Bruce Grant presents one of the key narratives that initially piqued my interest in exploring Siberia and studying the histories of indigenous Siberians—histories which have offered up both similarities and disjunctures to my earlier readings into aboriginal-state relations and twentieth-century colonialism in the Canadian North. His reference to something called the "House of Culture" offered a deliciously unfamiliar and enticing analogy for what appeared to be a qualitatively different form of colonial relationship. Whereas Grant wrote about the Nivkhi of Sakhalin Island, my introduction to Siberian history and ethnography began in 1995 with an Evenki family in the far northern village of Oleneok, Republic of Sakha (Yakutiia). Since that time I have pursued studies in the culture and history of Evenki-speaking peoples of central Siberia with a particular focus on those living in a territory known as Evenkiia. Most recently I have undertaken research into the striking cultural transformations that took place in the Soviet Union after the 1917 Communist Revolution.

The convolutions of power, articulated through centers and peripheries, are at the heart of nearly every study of Siberia. As Bruce Grant notes, the engineered cultural transformations happened to people living on the *furthest borders* of the Soviet Union. From Moscow to the outermost settlements along the Pacific Ocean is a distance of over six thousand kilometers. My own paths, traced through the Russian Federation beginning in the mid-1990s, were

primarily located in the Evenki Autonomous District (Evenkiia, EAO), a region that is at the geographical center of Russia. Ironically this geographical center also represents a cultural and political "fringe." Thousands of kilometers from the rail and highway systems to the south, Evenkiia is connected to the rest of the country by shipping routes that rely on frozen winter ice roads, limited seasonal river travel, and air transport; even with present-day transportation technology, getting in and out of that area from urban centers in the South takes significant time and effort. At the beginning of the twentieth century Evenkiia was known as the Turukhansk North, and it was very much the edge of the empire, although located in the very center of it. Empire's edge in this case refers not to distance from the center as it is measured in kilometers or versts, but rather to a metric of access and to a fertility of imagination born of ignorance. Siberia, for most Russians, was also very much on the periphery of the imagination. It was (and continues to be for many) alternately a site of struggle and privation as well as a site of purity, proximity to nature, and authenticity. It is in this center-on-the-edge that I developed my own secular pilgrimage to houses of culture and historical epicenters in central Siberia.

Whereas Bruce Grant takes the House of Culture *[dom kultura]* as his central metaphor for Soviet cultural transformation, my project is an attempt to look through the genealogy of the House of Culture to its predecessor, the Culture Base *[kul'tbaza]*.[1] For me, the Culture Base carries the same hint of estrangement and "otherness" as did the House of Culture when I first encountered it. It is a nomenclature that begins with a defamiliarization; an untranslatable word that signals difference and refuses easy containment and understanding. There is no parallel to either the Culture Base or the House of Culture in the Canadian aboriginal experience of colonialism, though missions, forts, trading posts, mission schools, and residential schools were all (similarly) locations of cultural encounter, subjugation, and (often) forced assimilation. The Soviet Culture Base, however, was built on a very different paradigm. While it was indeed built to drive the process of cultural transformation, it was designed *not* to obliterate cultural difference; it was designed to discipline it. As a technology of discipline, the Culture Base was the first concrete effort on the part of the soviets to bring socialist enlightenment to the farthest reaches of the taiga.

In my writings here, I use the first Culture Base, located in the Turukhansk North and constructed at the end of the 1920s, to anchor the historical and theoretically peripatetic explorations of historiography and photography. This Culture Base became known as the administrative town of Tura, and it is to this place that I traveled with my family in 1998, and where I encountered photographic archives housed in a small regional museum. From Tura I made many other trips and investigations: walking through the taiga, exploring rivers by motorboat, trekking on reindeer saddle and sleigh, driving winter roads on great Soviet trucks, and flying by helicopter to locations around the Ilimpii taiga in Evenkiia. *Agitating Images,* however, is built principally on archival research in Moscow, St. Petersburg, Ekaterinburg, Novosibirsk, Irkutsk, and Krasnoiarsk. A great deal of it emerged out of my involvement with the Endangered Archives Programme 016, an initiative funded by the British Library to digitize and preserve glass-plate negatives from provincial archives in Siberia.

At the beginning of the twenty-first century, the word *Siberia* continues to conjure up images of a distant, brutal, and cold land. A hundred years ago, Marie Antoinette Czaplicka (a Polish anthropologist and a lecturer at Oxford University around 1916) wrote that when she was a child *Siberia* meant one thing: "dire peril to the bodies, sore torture for the souls, of the bravest, cleverest, and most independently minded of our people."[2] This was a place on the margins of "civilization," where the light of European science and reason rarely fell; it was replete with places of dark shamanic rituals where "Stone Age" nomads wandered the icy tundra ceaselessly along paths as old as time. This was a land for the destitute exiles, for criminal intellectuals and other deviants: a prison with no walls. Evenki historian V. N. Uvachan wrote that before "the October Revolution, the Turukhansk territory was a forlorn land of white silence and great sorrow. It was called 'the wretched Turukhansk' and the 'the prison without bars.'"[3] It is this vast mythologized land that Communist agitators, instructors, and administrators set out to permanently transform in 1917.

Siberia continues to be a mythologized and exoticized land, defined largely by its remoteness, a seemingly indelible history of challenge, and a brutally cold environment. While it is no longer so associated with political exile (though the infamous gulags continue to feature prominently in histories and

mythologies about Siberia), it certainly can still be seen as a site of challenge for southerners and urbanites, due in large part to a famously brutal climate and harsh living conditions defined by little access to consumer goods and "civilized" amenities. In the post-Soviet era this general perception is perpetuated by people living in towns and cities that are more populated and well connected through networks of transport and travel. It is difficult to consider Tura, the site of the first Culture Base, among those less accessible places, as it is today a robust municipal center serviced with daily interregional flights.

In the years following the collapse of the Soviet Union, remotely located Evenki villages in central Siberia had become increasingly cut off from regional and provincial centers. This was due in part to dysfunctional systems of transport rendered fragile and precarious after the withdrawal of state subsidies. These were systems built over fifty years through programs of sovietization, development, and industrialization by the USSR. The remnants of Soviet high modernism in the Siberian North are seen not only in the decaying ruins of abandoned machinery but in the distribution and arrangement of villages. Traditional economies and systems of mobility, cast as "backwards" and inefficient, were reconstructed and replaced with heavily bureaucratized and centralized economies. After Communism, the atrophied functions of a paternalist state came to mark much of the North as a geography of abandonment and neglect.

As I have explored in earlier research, the projects of socialist reconstruction that took place in the twentieth century did a great deal to alter, damage, and displace traditional Evenki economies and forms of mobility. This left in the wake of Communism a critical isolation of demobilized and "ghettoized" Evenkis.[4] Many Evenkis were unable to access the means that would allow them to leave remote rural villages, whether it was aircraft, trucks driving on winter roads, or even reindeer. Furthermore, an acute housing crisis throughout the Russian Federation meant that even if they could access networks of mobility they would have no place to live (and quite possibly no capacity to earn money). Thus, through an array of local and national impediments many Evenkis and other indigenous minorities have found themselves stuck in remote villages.

My investigation of the Culture Base documents a critical moment of

change in a persistently uneasy relationship between the central government and indigenous minorities on the periphery of power. Producing a cultural history of this Culture Base requires a *composite staging*—that is, a production of boundaries and territorializations around a theme—of sovietization in central Siberia. The indigenous peoples of Evenkiia were not the only ones who were affected by the process of sovietization. Across the Siberian North, over forty indigenous nations representing hundreds of thousands of individuals were drawn into Soviet modernity. *Agitating Images* explores these programs of sovietization, which sought to disassemble and remake the complex of social and ecological relations that made up the pre-Soviet landscape of the North. The photographs set in accompaniment to this history, and the terms and frameworks used to tell it, present a convulsive and unstable image of a Siberian every day on the verge and in the midst of disorienting and violent transfiguration.

The research for this project was not solely focused on textual and archival research into the original sites of socialist construction in Evenkiia; it also presents an unequivocal engagement with the sensuous materiality of photographic documents. This approach deviates from most scholarly investigations of Russian, Soviet, and Siberian history, which until recently have paid little attention to visual culture.[5] My project aims to dwell on the surface of one particular Soviet development project and seeks to haunt its specific history of the Tura Culture Base with the visual residue of the era. As will be established in this book, the events following the realization of Soviet power indicate that the projects of social engineering/sovietization can be regarded—along with architecture, film, visual and performing arts, and literature—as an aesthetic as much as an economic venture. Utopian visions and their imaginary were wrapped up in the pragmatics of revolution and socialist construction.

The images that I exhibit depicting Evenkiia do not simply produce a story of strangers who arrived with missionary zeal, transforming and obliterating what they saw as objectionable and deviant. The story of Evenkiia is also a story of a carefully fostered and emerging intelligentsia, of socialist paternalism. It is a story of Evenkis going to war in Europe, to labor camps on the Kolyma, to schools and colleges in Krasnoiarsk and Sverdlovsk, and

to resorts on the Black Sea. Evenkiia's histories rub against the stereotypes of Siberian deprivation, cultural isolation, and backwardness. The array of images presented are shot through with and complicated by a profusion of temporal disjunctures, including not only the utopian dreamworlds of Soviet Communism shared by many indigenous peoples, but also the various nostalgias for socialism and communal life that have proliferated in the aftermath of that grand experiment.

Agitating Images examines this era when the construction of Soviet landscapes began, and it seeks to bring into the account the lives of peoples affected by those structures. While the rest of Russia was undergoing radical and bloody transformations, life on the land for most hunters and herders in Evenkiia was not so confrontational. After the privations immediately following the revolution, when commodities were more scarce than usual, a kind of stability occurred; there were more regular supplies of food, fuel, and hunting necessities and more direct access to medical aid. Education began in earnest and Evenkis were welcomed as sympathetic Communists. The rate of exchange for the promises of socialism seemed to many quite reasonable. One early group of indigenous students, taken on a tour of Moscow in the 1930s, wrote:

> We, excursionists and pupils from the schools in the Evenki National Area, have visited the museum home and the places where Lenin—the founder of the Soviet state and the leader of the world proletariat— was fond of relaxing.
>
> Today we are returning to the North, to the land of "eternal snow and eternal suffering" as pre-revolutionary writers called it. But they spoke of times long past.
>
> We, the children of Evenkis, live a happy and joyful life. We enjoy broad opportunities to become engineers, teachers, flyers, etc.
>
> All that was given to us by the Communist Party founded by Lenin.
>
> Dear Lenin: we hold your memory sacred, and we shall study and work much better so as to be worthy Leninists.[6]

This frozen discourse of state salute is distasteful to many for its willful ignorance of past violence and coercion. Nonetheless it is critical to recognize the investment many indigenous peoples had in the project, including their socialist feelings and commitments to a redistribution of the possible. Immediately following the 1917 revolution, through the civil war, and into the Stalin years, the period of socialist construction was undertaken as a multiethnic and comprehensively utopian project. In this period, ethnic groups were supported and encouraged to articulate their status as independent nations. Russian culture itself was often denigrated because it was perceived to be chauvinistic and associated with tsarist imperialism, colonialism, and exploitation. All this would quickly change as the dreams of prosperity and autonomy were compromised by totalitarian brutality; but for a moment, at least, it was a convincing possible world.

The Years Are Like Centuries

The old Evenki calendar and a laser device are depicted side by side
in this photo-panorama. Ages have passed between the birth of the
one and the other, but actually only half a century separates them in
the history of the peoples of the Soviet North.

—Uvachan, *The Peoples of the North and Their Road to Socialism*

The litany of place names and territorial monikers in this book will probably
be daunting for those not familiar with Siberian history and geography. To
simplify the task of reading this work, I will set the scene with the help of
a few maps. These maps are meant to orient the reader within the book's
dense geographies—produced through descriptions and depictions as much
as through the reader's own experience and expectations. The first and most
general term I use here is *central Siberia*. Central Siberia is a loosely defined
zone surrounding the geographical center of the Russian Federation.[1] It is
also roughly coterminous with the Central Siberian Plateau (fig. 4), a vast
geologically defined region of 1.5 million square kilometers. The geopoliti-
cal place located in central Siberia that most concerns this little history is
Evenkiia.

Figure 5 is a hand-drawn chart from the early 1930s depicting the specific
location of the Tungus Culture Base.[2] It bears the title "Sketch of a map of
the Evenki National District" and seems to be principally concerned with
depicting the first stages of socialist organization: nomadic soviets, native re-
gional executive committees, trading concerns, and reindeer-caravan routes.
Figure 6 is a map of the Evenki National District from the late 1930s.[3] I've
included it here to show how the sketched map described above became for-
malized. Under the direction of the Krasnoiarsk Department of Land and
Water Use, following multiple expeditions, this comprehensive map featuring
detailed information about the territory was produced. I have also included a

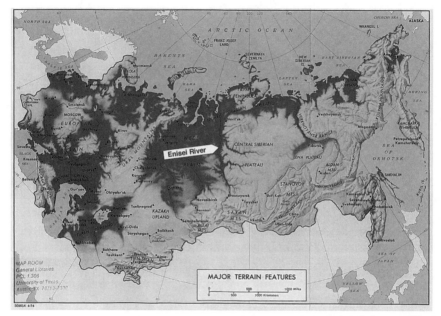

Figure 4. A Soviet-era map showing the major terrain features of the USSR. My marker points to the Enisei River.

map (fig. 7) showing the situation of Evenkiia within the Russian Federation at the time of this writing. Finally, figure 8 is a plan of Tura, the "Tungus City in the Forest." It is an outtake from my short video, *Along the Kochechum*. This map is included to begin the work of grounding the views through photographic particularity. In this composite image, a shot of a motorboat in the Kochechum River is superimposed over the map of the settlement.

Territorial nomenclature has changed a great deal in the past hundred years, although the actual boundaries marking one place off from another have not changed significantly for the most part. Territorial units separating *gubernias*, *krais*, *oblasts*, and *okrugs* produce a confusing history of the North. Regardless of shifts and changes, boundary effects have been tenacious technologies of permanence: maps of the mind and of practice and habit are eclipsed by maps of power and authority that have the capacity to repartition patterns of mobility.

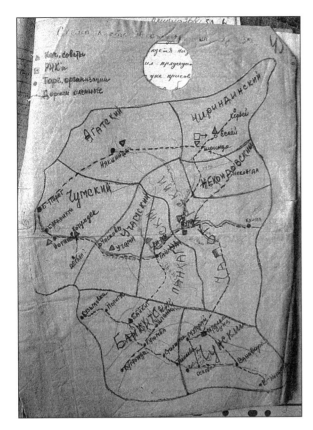

Figure 5. An early hand-drawn map on cloth. It depicts the regions of what was then the Evenki National Okrug. Significant marks include sites of "Nomadic Soviets," "Trading Organizations," "Revolutionary Executive Committees," and "Reindeer Routes."

The maps presented here are meant to demonstrate as well as illustrate. They help to document the imposition of administrative boundaries that have cut families apart and brought others together, boundaries that have reconfigured spaces of mobility and patterns of communication—all problems that I'll explore in this book. What the maps are meant to demonstrate is somewhat more elusive: the demonstrative effect of the maps ties in to a larger project that would make this history nervous. They light up its closures with questions and contestations. This is a nervous history because I know of no other way to do it. It is—following Walter Benjamin's refusal of surrealism's dream fetish—a constellation of awakening.[4] By which I mean an

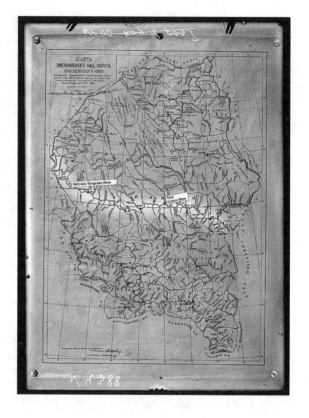

Figure 6. A photographic reproduction of a map of the Evenki National Okrug from the 1930s. I have highlighted the Nizhnaia Tunguska River here and indicated the location of the Tura Culture Base, which by the 1930s had become simply the Tura Settlement.

attunement to emergent historical consciousness, or historical consciousness as necessarily emergent. Maps (and photographs) as realist technologies mask as much as they reveal. Posing as documents, they are as productive of mythologies as they are of historical truths. Dragging them into the historical space of critique renders them available to a constellation of awakening, undermining the fantasies of authoritative representation that are so important to conventional historiography. The maps and images that I show, just as the words I write, are cautiously positioned within the "space of history."

This little history knows it is a nervous system, built on closures and capitulations. It is engineered as an invitation to its own interiority. It is made to be a nervous system in the way that Michael Taussig means when he

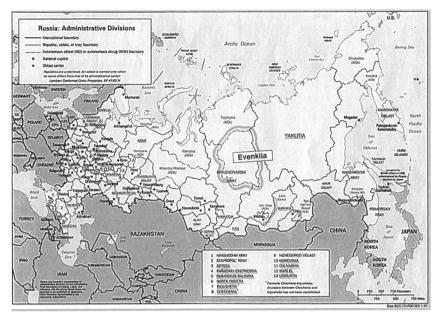

Figure 7. A map of the post–Soviet Russian Federation. Evenkiia's location in the Krasnoiarsk Krai is indicated here.

writes that "even while it inspires confidence in the physical centerfold of our worldly existence . . . and as such bespeaks *control, hierarchy,* and *intelligence*—it is also . . . somewhat unsettling to be centered on something so fragile, so determinedly other, so nervous."[5] The incongruity of history and critique without an authorial voice may be an illusion; what if history and critique are only possible in the wake of authority's unmasking? Nervousness here becomes a cultivated practice; agitation without the arrogance of certitude.

The principal interventions here, those that are meant to show up the system's "nerves," are photographs. Or rather, they are photographic fragments; close-ups. They are cut and processed, but they retain their elemental character of photographic-ness. This is the photo-element: that undeniable umbilicus to reality, to *that which once was,* as Roland Barthes once put it. The photographs are connected to this nervous history by proximity and touch. In another instantiation, they might be deployed in their entirety and used

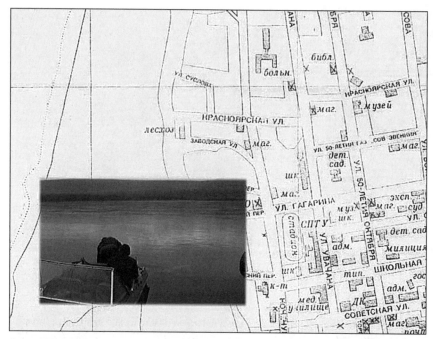

Figure 8. Outtake from my video *Along the Kochechum.* This scene shows a juxtaposition of a map of the Tura Settlement with a scene of two men in a motorboat on the Kochechum River.

to illustrate my ideas: "This is a shaman," "This is his drum," "Here is his grave": self-contained systems of re-signification. What do these fragments do? Maybe that is less important than what I want them to do. I want them to suggest intimacies otherwise effaced by my little history. I want them to draw you in to an encounter that once was, as well as to the conditionality of this work. I want them to counterintuitively liven up the page as a constellation of awakening; an illumination of the project's own impossibility.

The "close-up" in film theory is typically understood as a device that renders a partial object from the larger scene. Following the Hungarian film critic Béla Balázs, Gilles Deleuze writes, "the close-up does *not* tear away its object from a set of which it would form part . . . but on the contrary, *it abstracts it from all spatiotemporal coordinates,* that is to say it raises it to the

state of Entity."[6] My fragments work in
this logic but they also refuse it to some
degree. Their occasionally bewildering
abstraction undermines their capacity
to be read as entities. This is not ambi-
guity, but indeterminacy. Almost all of
the fragments include a complexity of
objects; furthermore they are framed
in such an awkward manner as to insist
on their foundational formlessness. The
fragments are not always about some-
thing other than an indeterminate refer-
ence, an obtuse and affective pastness of
mediation, of human-machine–human
encounter produced in the photographic
moment. If the logic of the close-up is to
decontextualize "by depriving the image
of spatial coordinates,"[7] the logic of these
photographic fragments is to deprive the
history of ideological coordinates.

 There is no easy connection: this is a
link built on trust. The kind of trust that
builds the authority of photography (*I saw this*), ethnography (*I was there*),
and criticism (*I read this*). The photographic fragment does not obliterate the
structure of authority; rather, it agitates the structure. Like the close-up—
Deleuze's "affection-image"—the fragment "has a face as receptive immo-
bile surface, receptive plate of inscription, impassive suspense: it is a *reflecting
and reflected unity*."[8] The faciality of the photographic fragment is a surface
that belies unknowable depth and unmade connections: a "reflecting and re-
flected unity." To carry on with the metaphor of the nervous system, the
face is also of this bodily unity but it deflects attention from a greater system.
The face in this logic is the public secret: the front, the façade, and the robe
of power. The nervous system is still there in its receptivity and its anxiety.
The photographic fragment turns out to be no fragment at all, at least no less

than the photograph it was taken from. In so obviously fragmenting the photographic image, the structure of reality's violent rendition is implicated. The reality of photography's violent rendition is drawn into a poetics of implication that passes through the photographer, the archive, the reader/spectator, and the photographic subject. Competing narratives, alternatives, and possibilities agitate the structure of historical authority and closure. It is a nervous history.

An Evenki System of Paths

No sweeping geographical or historical label, such as the "Russian Empire" or the "Soviet Union," can provide easy generalizations about the central Siberian North prior to the arrival of rifles, flour, tea, beads, and other trade goods in the sixteenth century.[9] There were people, generally organized into families and extended clans, speaking a variety of languages and dialects and occupying themselves in many different activities. Ancestors of the Evenki, Sakha (Yakut), Dolgan, Yukhagir, Ket, and other peoples intermarried, avoided one another, fought, and traded. For the purposes of this work, it is more or less adequate to note that for hundreds of years prior to the arrival of the Russians, there were predominantly Evenki-speaking peoples living in the territory that is now known as Evenkiia, in central Siberia. If the cultural scene in sixteenth-century central Siberia is poorly detailed in historical records, knowledge about Evenki culture, as late as the end of the nineteenth century, is not much more developed. Soviet ethnographer Glafira M. Vasilevich once commented that the social and political organization of Evenkis in central Siberia, in the late imperial era, was poorly understood.[10]

At the end of the nineteenth century and the beginning of the twentieth century, Evenkis were called Tungus by those who didn't share their tongue. The designation *Tungus* was used by Russians to describe a number of different indigenous Siberian peoples speaking a group of languages defined by linguists as Tungus-Manchu or Tungusic. Evenkis, Evens, Orochis, Nanai, Udege, and others were grouped together under the 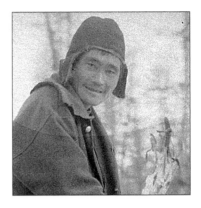 generic moniker of Tungusik (language-speaking) peoples.[11] The Evenki-speaking peoples had homelands throughout central and eastern Siberia as well as the Russian Far East. Along with others labeled Tungus, the Evenkis are most well known for their nomadic mode of life and their spiritual culture: they are almost invariably represented as pastoral reindeer herders and shamans.[12] While reindeer and shamans are key in the enduring symbolic worlds of Evenkis, in the twenty-first century many individuals have little regular or even direct experience with either. Nonetheless, Evenkis and the Evenki language persist today; individuals are embedded in cultural continuities, actively identify as Evenkis, and participate in the ongoing reproduction of their cultural heritage.

Evenkis have never been "simply" hunters and herders (or shamans, for that matter). This configuration privileges the economic as an object of analysis and representation, reproducing a now-tired cliché. However, it has been an effective, if reductive, shorthand for stating that the principal fashion by which they made their way in the world was through hunting, fishing, and herding. Prior to industrialization, reindeer played a pivotal role in nearly all spheres of everyday life. Reindeer were also central in northern development; they were co-opted into the Soviet effort to build socialism in the North. But reindeer are not everything to Evenkis. An understanding of cultural identity is complicated by the instability of economic taxonomies that are at best poor records of past lives: hunting, herding, trapping, fishing, gathering plants and medicines, scrounging, foraging, trading, borrowing, lending, crafting,

divining, transporting, reproducing. The economies were and are complex, and it is a disservice as well as a misrepresentation to refer to Evenkis simply as hunters of the North, reindeer herders, or shamans. Today dance troupes tour Russia and beyond, performing at festivals around the world. Authors are writing articles and books; children study Evenki in schools with new materials produced by teachers engaged in the development of pedagogical theory.

In twentieth-century anthropological discourse, the Evenki "way of life" and economy have been canonized as hunting and gathering [*oxota i sobiratel'stvo*]. These terms are at least capacious enough to include what is often thought of as women's work, such as plant and berry gathering—though gendered patterns of labor have not always been so clearly marked by Evenkis, or at least

they were flexible enough to warrant a caveat about generalizations of gendered labor practices.[13] Hunting and gathering also is suggestive of an economy in which mobility was central in a relational ecology. Russian ethnographer Sergei Mikhailovich Shirokogoroff wrote the following characterization of Tungus mobility in the early twentieth century:

> In accordance with the acquired knowledge of the primary milieu the
> Tungus have worked out their system of migrations, also imposed
> by their chief industry of hunting and reindeer breeding. . . . We have
> seen that the Tungus have created a system of communications, the
> paths. Indeed, in the eyes of the people accustomed to the railways and
> artificially erected high-roads with bridges [and] dams, the system of

Tungus paths would not seem to be a technical achievement, a cultural adaptation. However, it is not so when one looks more closely at the phenomenon.[14]

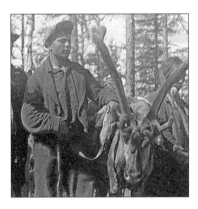

In this passage, Shirokogoroff highlights the cultural genius of the Tungus system of paths. The appreciation of such cultural logics was an emerging ethnographic discourse in the early twentieth century that persists as one of the foundations of social cultural anthropology a century later. The Evenkis of central Siberia were no less than masters of living in the boreal subarctic forests. The nomadic life sustained and reproduced ancient social relations. Through careful acts of dwelling and traveling through known places in the landscape, the Evenkis created and participated in a meaningful world around them. Hunting reindeer and moose, trapping sable and squirrel, picking berries, gathering medicinal plants, and setting fish weirs were all activities governed by the seasonal round and enacted through interpersonal, interfamily, interclan, and intercultural relations.[15]

Had photography existed so many years ago, we might have had more sensuous documents to remind us that the Evenkis were more than hunters and as such not reducible to economic categories. Such complexity can also be read through ethnographies and storytelling, which constitute a unique counterpoint to more generalizing historiographies and a flattening historical gaze. The sensuous details of photography remind us how inadequate these terms are: to label a man a hunter and to look at a picture of a hunter produce dramatically different results. Whereas the former may conjure up a wide and personal array of images (from Robin Hood to Leatherstockings to Dersu Uzala), the other rails against that classification, pointing in myriad directions: "Is that a pipe in his hand?" "Where did it come from?" "What kind of tobacco did he use?" "Where did he get the tobacco?" And so on.

There is a critical difference here between the search for hidden categories that is produced by close textual and ethnographic readings and the implicit

resistance of photographs to the taxono-
mies we "discover." Peter Burke describes
the task of the historian vis-à-vis photog-
raphy in his work *Eyewitnessing:*

> The historian needs to read between
> the lines, noting the small but signif-
> icant details—including significant
> absences—and using them as clues
> to information which the image-
> makers did not know they knew, or
> to assumptions they were not aware
> of holding.[16]

This methodology of image-led histori-
cal investigation implicates and activates
the photographic image through robust
scrutiny and careful reasoning. Following
this methodology, however, may further
reinforce a historiographical tendency to
foreclosure that ignores the significant
agency of photographs. Or, as Dale Pes-

men writes in her examination of the Russian concept of "soul": "Perhaps . . .
surfaces are better than we think."[17] In one interpretation of the work of
literary critic and philosopher Mikhail Bakhtin, Caryl Emerson notes that

> Bakhtin implies that we cripple ourselves unnecessarily by seeking
> truth in a hypothetical, static state of Being. It is precisely the absence
> of such preexistent order or cosmogony that obligates us to attend
> so carefully to particulars in their immediate, responsive network of
> relations; it is this absence of Platonic essences that legitimizes the
> work we put in to achieve harmony amid the plenitude (often unde-
> servedly called chaos) of the sublunary world.[18]

Photography's role as mirror to a visu-
ally plentiful "sublunary world" similarly
obligates us to position our gaze within
relational networks. In this way I read
surface as both the sensuous superficiality
of the visible and the semiotic plenitude
of signification flowing from a document
that demands our simultaneous attention
to the there-then and the here-now.

Such an agency is explored elsewhere
in my project. It is also addressed power-
fully in much of the recent anthropologi-
cal work on photography[19] that refuses to
allow photographs to settle into materi-
alistic particularity: "orality penetrates all
levels of historical relations with photo-
graphs, not simply in terms of verbal-
izing content, but of the way the visual
imprints itself, is absorbed and is played
back orally . . ."[20] Photography has not
only changed the way that the past and
the Other can be represented through

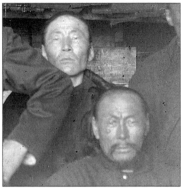

more sensuous and accurate representations; it provides the material for cate-
gorical rejection of conventional pronouncements, closures, statements, and
authorities. Historiography fails when the photograph is mistakenly reduced
to a more or less static historical resource and seen, much like archives, as a di-
rect record of the past, bearing witness to and simplistically representing past
ways of knowing and being. As I argue here, photographs present an irre-
solvable ambiguity that ought to force writers of history to navigate between
everyday lives and the necessary closures we develop to talk about them. The
point is not writing away this ambiguity but, as Michael Taussig suggests, al-
lowing "oneself to be brought face-to-face and remain within the ambigu-
ity, grasping it whole, so to speak."[21] Being brought "face-to-face" is a phrase

that doesn't simply play on photography's own troubling mimesis that draws spectator and subject together in an uncanny exchange of gazes. It can also gesture toward proximity and the communication of bodies across space (if not only time).

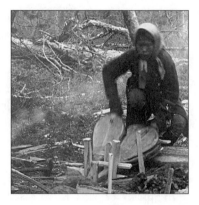

While Evenki peoples lived on the margin of the Russian Empire, it is essential to remember that they lived at the center of their own social worlds. The people living in the inland territories of the central Siberian North at the beginning of the twentieth century were mostly Evenki, Yakuts (or Sakha), and mixed Evenki-Sakha. The Evenkis living here were typically referred to as Tungus until the middle of the twentieth century. They would have been included in the Turyzh clan of Tungus in the nineteenth and early twentieth centuries. Prior to this, they were generally included in various different, if poorly documented and understood (by foreigners), clan affiliations. At the turn of the nineteenth century, Ilimpii Evenkis had their own administrative unit, known as a *volost*. The volost was often simply renamed "raion" in the Soviet era, with no territorial alteration. In 1824, the Ilimpii administrative "clan" was composed of ten actual Evenki clans (Gurgugir, Eldogir, Kombagir, Oegir, Udygir, Khirogir, Khukochar, Khutokogir, Emidak, and Ialogir). The relationship of the administrative clans imposed by the tsarist system of tribute and more indigenous forms of governance is another area that is poorly documented. Likely they existed as overlapping and interacting formations of power.

Evenkis traditionally lived and hunted in relatively small family groups, and their larger clan affiliations helped to mediate their relationship with representatives of European power. This is a point articulated in the work of the ethnographer Lydia Dobrova-Iadrintseva, who wrote one of the first Soviet ethnographies of the Turukhansk region.[22] According to anthropologist Nikolai Ssorin-Chaikov, Dobrova-Iadrintseva "argued that the Russian indigenous administrative practices and fur trade were crucial to the survival of state-

less, kin-based communal structures; she analyzed larger systems of inequalities, tax-collecting "districts," and administrative "clans" constructed by the Russian state."[23]

Irrespective of my own critiques of historical and cultural representation, it is undeniable that nomadic mobility has been one of the defining characteristics of everyday life for indigenous peoples in Siberia. For Evenkis, reindeer hold a central symbolic place. Indeed, across the Siberian North reindeer are iconic. There are immeasurable numbers of wild reindeer in Siberia. Some migrate great distances; others are nonmigratory and dwell in local forests, hills, and mountainous areas. In addition to these wild reindeer, many indigenous Siberians have raised domesticated reindeer. While some, like the Chukchi or Khanty, raise large herds of reindeer, most Evenkis have kept domestic reindeer principally as a form of transport rather than as food. Evenki reindeer herds traditionally consisted of far fewer reindeer than they would have if they were being raised for meat. Reindeer mobility has enabled hunting for meat- and fur-bearing animals, trading, and visiting friends and family or sites of worship.

The utility of reindeer was apparent to newcomers to the region; to the Russians, the interior regions of the Turukhansk North, the lands beyond the rivers, were vast and impenetrable. Horses and other pack animals were poorly adapted and singularly useless in the face of radical extremes of temperature and climate, challenging terrain, and unfamiliar plants for fodder. The Enisei River provided a major navigable route for European traders and the Podkamennaia Tunguska and Nizhnaia Tunguska Rivers offered some transport opportunities for shallow-bottomed boats. This left an interior of forests, bogs, lakes, and small rivers only rarely visited by nonindigenous peoples. American anthropologist Henry Usher Hall describes the Turukhansk District in the early 1900s as a network of waterways and highways:

On the banks of the river one does
not speak of being in the tundra.
This is a highway which connects
the settler or transient voyager with
a living world; to the nomad of the
tundra, it is only a place to which
one comes with nets to get supplies
for the winter larder or to pay in
labor some part of the debt which
the trader will never wholly write
off. . . . When the time to strike his
tent comes he does not say, it is true,
"I am going home," but "I am going
to the tundra," which is, in effect,
the same thing. Then he packs his
tent and so much of his catch as the
traders have left him, and his scanty
household goods, upon two or three
or half a dozen sledges, and, since
snow has not yet fallen or at any rate
is not yet deep, harnesses four or
five reindeer to a sledge, instead of

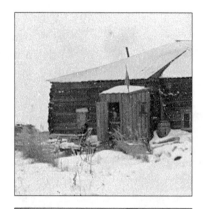

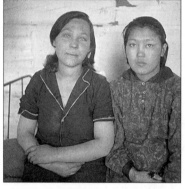

the winter team of two, and is whisked off over the low hills to the
wide spaces where he can call his soul and his time his own.[24]

When Russians wanted to travel through the taiga in the central Siberian
North, they typically hired Evenki guides and their reindeer. Reindeer are
the most efficient and effective means of traveling across great areas of for-
est, bog, and tundra, and many Evenkis worked in the burgeoning transport
industry as freight drivers, postal carriers, chauffeurs, and guides until they
were displaced by motorboats, snow machines, massive all-terrain vehicles,
biplanes, and helicopters. First they moved missionaries and the occasional
explorer; then, in the Soviet era, they helped move everything from the mail
to scientists and their exploratory equipment.

Reindeer ownership is typically iden-
tified as one of the key elements in an
Evenki economy and was understood
by Soviet analysts as the principal source
of wealth that differentiated between
impoverished and wealthy Evenkis—a
point that had great relevance as the
Communists invented, accelerated, and
provoked rural class war in the 1930s. In-
deed, according to the class hierarchies
imposed through Marxist rationale, those

who were mobile controlled the means of production, reindeer, and hence
became wealthy through accumulation and—and this is where it is most
contentious—exploitation.[25] Because not all Evenkis owned reindeer, they
were not all equally mobile, and this was one basis for class differentiation.
Though I treat this issue with some more detail elsewhere, it is important to
note that the outcome of this rationale ranged from exile or imprisonment to
confiscation of reindeer and general socioeconomic marginalization.

On the other end of the spectrum of class affiliation were the most im-
poverished Evenkis: reindeer-less Evenkis [bezolennyie]. These Evenkis were
"sedentarized" and appear to have lived year-round near lakes where they
could fish.[26] Soviet ethnographer B. O. Dolgikh described the "Olenek Tun-
gus" as a group of Evenkis living on the eastern border of central Siberia who
kept precariously few reindeer. According to Dolgikh, the Olenek Tungus
were primarily interested in "hunting wild deer, especially in areas where
the herds of wild deer crossed the Olenek River. An unlucky autumn hunt
for wild deer had the onerous result that the whole population went hun-
gry."[27] In fact, a good portion of those Evenki living in the Ilimpii area of
the Turukhansk North (Surinda, Ekonda, and Viliui Rivers area) were largely
semisedentary, living year-round [postoyannyi] or at least through the winter
in semipermanent wooden and bark lodges [balagani] and living primarily
off of the fish they caught in the lakes. In this way, food security and general
prosperity was most often linked to reindeer ownership.

While Communists saw the distinction between reindeer herders and

these sedentary or semisedentary Evenki as a class distinction, it is worth considering that the semisedentary lifestyle may have been a choice rather than one imposed by social inequalities. According to Soviet anthropologist Tugolukov, in 1822 when missionary Ioann Petelin traveled to the source of the Viliui River from Yakutiia, he encountered Tungus at Lake Surinde, whom he described as being "honest, poor in clothing, but content and happy with their situation."[28] Compared to this characterization, accounts from the early Soviet period are much more critical of Evenki impoverishment. This is due partly to a necessity or proclivity to read exploitation and class differentiation in all cultural situations. But it also was no doubt a result of seeing the effects of starvation that followed a succession of poor hunting seasons and smallpox epidemics in the early twentieth century. Explorer Fridtjof Nansen, who recounts a story of a smallpox epidemic from his travels in 1913, offers one earlier account of the epidemic:

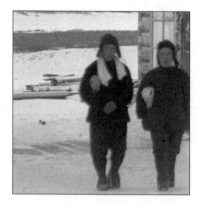

> With contributions from the Siberian members of the Duma the Red Cross Society sent out an expedition from Krasnoyarsk, but too late in the spring, when the snow had already begun to melt. They got past Turukhansk, but could not penetrate any farther into the tundra on account of the state of the ground. They went far enough to find tents where all was still; the occupants lay dead within, five or six of them, and outside lay the dead reindeer . . . In some tents they found people still alive, but in a terrible state, without fire and nearly starved to death, covered with sores that were not yet healed. How many such tragedies the great tundra conceals![29]

The invisibility of central Siberia's inland territories was a powerful belief and mythology for outsiders and one that would come to define new scopic

regimes under the Soviet flag. Subject to rule by tsarist Russia since the 1600s, there was clear expectation of paternalist concern for the well-being of the "natives." The barely (and rarely) visible horrors of sickness and starvation in "the great tundra," when they were reported, were attestations to the failure of the Tsarist Empire. Illnesses as well as a general state of deprivation were also taken as evidence of the inherent instability of nomadic economies, which, as we will see, had become indelibly tied to narratives of cultural evolution.

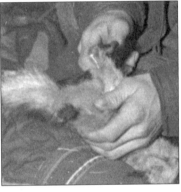

Tsarist Rule

Russians and representatives of the Russian Empire arrived in central Siberia, west of the Enisei River, in the seventeenth century. Their first base in the area was Fort Mangazeia. It began as a small fortified structure that marked the beginning of Russian imperial colonialism for the indigenous peoples living around the Enisei River. It was not, however, the first edifice. Traders had established stores years before the official arrival of the tsar's men. For the nomadic peoples of the Siberian North, colonialism under the Russian imperial eagle meant subjugation to a host of official and unofficial roles and rules. To ensure complicity with new orders of power, military forts and bases were built on navigable river ways. Indigenous peoples were obliged to pay tribute to the tsar in the form of valuable animal pelts, and they were categorized as tribute payers [*iasachniki*]. By the nineteenth century, Siberia had become an indivisible part of Russia. It was not "merely" a colony but rather a feature of the imperial body itself. As geographer Mark Bassin describes it,

Although Siberia was seen by many European Russians as a foreign Asiatic colony, it was at the same time somewhat more than this. The simple circumstance of territorial contiguity with the metropolis—a geographical arrangement shared by no other European empire— together with Siberia's large and long-established Russian population made it possible to see the territories beyond the Urals as a continuation or extension of the zone of Russian culture and society.[30]

In the process of annexing the Siberian lands, the northern peoples too were annexed—as though they were a simple extension of coveted natural resources or a byproduct of expansion. While Siberia itself had become an integral part of Russia, the indigenous peoples living there had a more difficult fit; they were now aliens and foreigners to the newly claimed Russian soil. As colonial subjects, their responsibilities were enshrined in a system of tributary payments called *iasak*. The *iasak* system would become one of the primary points of socialist agitation against the tsarist system in the North. It is well documented that tribute payers received little protection from the tsarist regime and that they were often victims of corrupt merchants and officials.[31] Indeed it seems that this exploitation was a structural phenomenon, resulting from the vagaries of remote rule and the challenges of enforcement. Tsar Peter I ("Peter the Great") undertook administrative reforms in the early 1700s and made efforts to control the lawless exploitation of the natives, but these appear to have been generally unenforced and possibly unenforceable. Although the Siberian Governorship [*Sibirskaia*

Gubernia] was created in the seventeenth century, it was not until the nineteenth century that significant changes would be effected.[32]

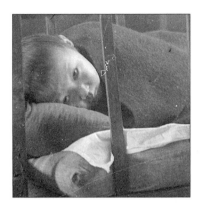

Although tsarist Russia was an undeniably colonial empire, the nature of its colonialism was different than that of most other colonial powers.[33] With the exception of Alaska, the colonial landscape was divided only by distance and not by bodies of water. As writer and critic Andrei Siniavskii writes, Russia "assimilated neighboring lands, which were not considered colonies at all, but an integral part of the state, of a single indivisible Russia."[34] The expansive, contiguously linked empire was inherited by the new postrevolutionary government. In Russell Snow's study of Bolshevism in Siberia, he notes that the "Tsarist government in Siberia was a huge administrative complex, employing thousands of people."[35] By the time of the 1917 revolution, Siberia was understood to be part of Russia and was included by default in the Russian Soviet Federative Socialist Republic (RSFSR).

The Bolsheviks had their own complicated relationship with colonization, but for the most part "colonization" was associated with European, bourgeois, capitalist imperialism. According to the Bolshevik model that emerged, Russia, and later the Soviet Union, would empower its ethnic (national) minorities and put an end to imperial rule in the North. This was largely possible because Siberia and the Russian Far East had been incorporated as a part of Russia in both practice and imagination.

The process of annexing the central Siberian North and the area that would become Evenkiia began in the seventeenth century. The historian Bakhrushin wrote, "by the petition of traders and industrialists, the Samson Novatskov cartel expedition was outfitted in 1629 for the pacification of the Tungus of the Lower Tunguska River."[36] The *iasak* men moved quickly and B. O. Dolgikh writes that by the mid-1600s, Tungus from the Olenek region (hundreds of kilometers to the east) were paying *iasak* at Lake Essei.[37]

While no navigable rivers serve it, Lake Essei became an important settlement linking the Enisei River to the Lena. The largely river-bound invaders made few incursions into the interior, known as the Ilimpii Tundra. The Ilimpii area became historically important to the Communists, as it was part of a region that existed outside established corridors of travel and transportation. It was also remote, inaccessible, and largely unknown.

According to anthropologist V. V. Karlov, at the end of the seventeenth and beginning of the eighteenth centuries, trade relations seriously altered the economy of the Evenki population of Siberia.[38] Karlov goes on to note that by the end of the eighteenth century, the Evenkis' trade with Russian peasants in the South had increased and had become an essential component of their economy and cultural tradition.[39] Karlov also marks out the Ilimpii Tundra as one of the most independent or "pure" locations in Siberia: in the deep interior (from the middle of the Nizhnaia Tunguska and north), the Evenki economy was more independent from trade than it was with Evenkis in the South.

The Russians, with the significant exception of traders and missionaries, were rarely active in the inland regions of the central Siberian North. The Ilimpii Tundra, like some areas of the Russian Far North and Far East, was noted for its remoteness.[40] Administrators seemed most content to survey the nomadic and wandering "aliens" through tribute ledgers rather than through significant or sustained contact. In many ways, the territorialization created by a concert of pre-tsarist clans and Russian-imposed clan structure served to solidify actual social relations within the Evenki speaking groups. According to nineteenth-century reforms, elders or "princelings" represented indigenous clans. These positions were appointed (or at least approved) by the local governor. The clan elders were responsible for the collection of *iasak* from their people and for submitting the tribute to the tsar. In the eighteenth century, according to anthropologist Demitri Shimkin, "much of the

old leadership was assimilated into the
tsarist bureaucracy . . . Kin based units
became, to a considerable extent, ad-
ministrative, territorial units."[41] In the
Turukhansk North, the tribute was paid
at annual "festivals" in Mangazeia or
Monastyrskoe, and elsewhere (such as
Turukhansk, a town on the left bank of
the Enisei River). In addition to the trade
fairs, there were clan and family meetings
or gatherings called *suglani*. These were
meetings that occurred on an annual
or semiannual basis. While *suglani*, as a
form of political organization, preceded
the era of tsarist tributary relations, they
were also transformed through the new
conditions of subordination under the
tsars. The institution of the Suglan was
appropriated and refashioned in the So-
viet era as a symbol of local autonomy.
This continuity, however pragmatic, was
also susceptible to ideological critique

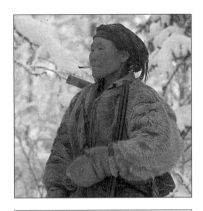

and would later be criticized for simply replicating patriarchal and bourgeois
inequalities, when the Communists organized clan soviets. In spite of the
discouragement by Communist organizers, many of the same elders who
were the princelings prior to the Soviet era were elected to chair the soviets
in a new era of socialism.[42]

Some of the earliest significant ethnographic research on the northern
part of Evenkiia (aka the Ilimpii Tundra) was produced by A. F. Middendorf
between 1843 and 1844. Middendorf was sympathetic to the indigenous Si-
berians,[43] although it seems that the ethnographic observations in his work
were sometimes only incidental to a broad research and survey program,
which included the study of permafrost, botany, and zoology.[44] His work was
undertaken within something that has come to be called a *salvage paradigm*,

an ethnological fascination with rapidly passing cultural practices, made all the more acute for the perceived urgency tied to the apparently inevitable disappearance of symbolic and material culture. In the pre-Soviet proceedings from the meetings of the Russian Committee for the Study of Central and East Asia (1905), it is argued that some indigenous peoples in Siberia (the Ostiak, for example) "will completely cease to exist for scholarship" and that "scholars had only been able to conduct some linguistic research but had not yet had time to study the Ostiaks from the ethnographic point of view."[45] The outcome of this was a great focus on the collection of ethnographic data and cultural artifacts. M. G. Turov notes that Middendorf recorded data on the hunt of wild reindeer, tundra reindeer husbandry, and systems of mobility.[46] Middendorf's book *Travels in the North and East of Sibe-*

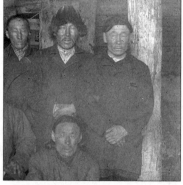

ria was published in German in 1845 and in Russian in 1860. This is critical because anthropological inquiry driven by a desire to salvage disappearing cultural knowledge and material culture would later be critiqued as apolitical and bourgeois.[47]

In the nineteenth century, the tsarist administration split Siberia into two "general-governorships": East Siberia and West Siberia. These general-governorships were then "divided into gubernii," or provinces.[48] Important reforms were undertaken in 1822 after many years of corruption and excessive exploitation, and amid growing criticism. Around the time of these liberalizing reforms led by the tsar's advisor, Count Mikhail Speransky, Krasnoiarsk became the capital of the Enisei Gubernia, a position of governance it maintains to this day. The boundaries of the Enisei Gubernia are roughly co-

terminous with those of the Krasnoiarsk
Krai today. The Turukhansk District was
a division of the Enisei Gubernia, with
Turukhansk as its capital. Beyond these
larger territorial divisions, several other
layers of administrative responsibility
were assigned. In their article "A history
of Russian administrative boundaries
(XVIII–XX centuries)," Merzliakova and
Karimov write:

There were several types of special division besides administrative
gubernia and *uezd*. Since 1864 the country was divided into court dis-
tricts. A group of *gubernia* was a subject of one district court. There
was diocese division set by the Orthodox Church. There existed
also military districts subordinated to Governor general, and some
other types. Special court, military and other units usually included
several *gubernia* or even did not correspond to the framework of
administrative division. This was a form of "division of powers" in
geographical space.[49]

Shifting territorial organization and administrative regimes must have ap-
peared chaotic to those on the ground, affected by the changes but insulated
from their obscure appearance.

At the beginning of the twentieth century, what is sometimes called the
Enisei North was known as the Turukhansk Krai. This is a territory that in-
cludes the remote areas of tundra and taiga referred to in this work. The Krai
was governed by the administrative center called Turukhansk. The village of
Turukhansk was founded in 1609. It came to be recognized as an important
settlement and waypoint for marine traffic. There was a key Orthodox mis-
sion there that operated as a hub for much of the Church's missionary work
prior to the revolution. The Enisei River (like all the Siberian rivers flowing
north to the Arctic Ocean) was a critical route for travel and transportation—
especially before the construction of the Trans-Siberian railway. In many

respects such corridors of travel defined the appearance of Siberia to its rulers. When the railway connecting Krasnoiarsk with European Russia was completed at the end of the nineteenth century, the importance of the river capitals diminished and southern cities serviced by the railway rose in importance as commercial and administrative centers.[50] In that era, the seat of power moved from Turukhansk south to Eniseisk, and then eventually to Krasnoiarsk. Eniseisk began as a fort in the early 1600s and was the most important administrative and commercial center along the Enisei until the construction of the railway. By the end of the tsarist regime, Krasnoiarsk eclipsed the Enisei River settlements in importance.

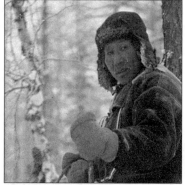

Soviet and Western historiographers have emphasized a chaotic and lawless era under tsarist rule. While the state promised protection to the indigenous tribute payers [*iasachniki*], there was little recourse for Evenkis and others who were exploited and abused by various traders, administrators, and officials. The rampant exploitation of the indigenous peoples became an important point upon which the Bolsheviks would claim liberation of Siberia from the oppressive tsarist regime of tribute payment. The system of *iasak* was an obviously unjust exchange with relatively little protection offered. Soviet historians searching for a baseline of oppression and exploitation also forcefully articulated this point.[51]

At the beginning of the twentieth century, Turukhansk was the most significant settlement in the area. It was the site of large trade fairs, and it boasted a monastery. It is also infamous as a site for exile in both the tsarist and Soviet regimes (Stalin being the most famous exile to be imprisoned

there). Turukhansk is located at the junc-
tion of the Enisei and Nizhnaia Tun-
guska Rivers. The 1897 census reported
two hundred people living there, but
the population in the area seems to have
fluctuated significantly.[52] Sometimes
Turukhansk is known as New Manga-
zeia, so called because of resettlements
there after Mangazeia, a settlement on
the Taz River (west of the Enisei) that
was destroyed by fire. Mangazeia was the
center of the Uyezd (a major territorial
division in seventeenth-century Russia).
Around 1670, Turukhansk (New Manga-
zeia) became the new capital of the Eni-
seisk Uyezd. In 1909, the administrative
center was moved across and up the Eni-
sei River to the settlement of Monastyr-
skoe, which was located on the mouth of
the Lower Tunguska River.[53] Monastyr-
skoe came to be called New Turukhansk,
and eventually, just Turukhansk.[54]

For most Russian administrators any place beyond navigable rivers was
considered excessively remote. These places were only visited by adventur-
ers, scientists, priests, and traders. One missionary who made regular and ex-
tensive trips inland was Father M. I. Suslov, but he was not alone. Throughout
the North there were dozens of Orthodox priests serving remote indigenous
groups. Some of the earliest non-Russian ethnographers, Czaplicka and Hall,
made an expedition to Siberia around the time of the revolution. Unlike the
priests, their mission was driven by anthropological curiosity. In 1914, they
traveled to "find 'the most primitive and comparatively the purest type of
race' of Siberian native, 'the Tungus.'"[55] Czaplicka meant by this claim those
with the least sustained contact with European ways, techniques, and com-
modities. The scientific gaze of anthropologists and geographers combined

with the moral scrutiny of the Church, however, was always relatively limited. It wasn't until the Communists came to power that Europeans began to invest seriously in transforming the social landscape in the places beyond the navigable rivers. Even then, the cost and challenge of traveling through the central Siberian taiga was crippled by marginal state interest and commitment. It would take the promise of natural wealth and the capacity of aerial transport before the Soviet Union would truly begin its industrial revolution in the North.

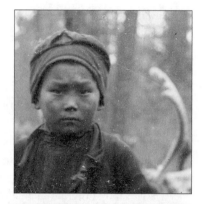

Looking at a map of the region, it is evident that there are large areas that were so "deep" in the taiga that the gaze of both Russian and Soviet regimes fell far shorter than elsewhere in Siberia. Indeed, "lost tribes" in Siberia is something of a trope in Russian cultural narratives of both Soviet and post-Soviet eras.

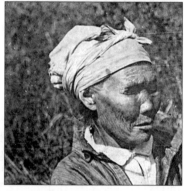

Where explorers and traders failed to enter the taiga, they succeeded in drawing the Evenkis out, through trade fairs and trading posts. At the beginning of the twentieth century "there were already established trading posts and permanent factories . . . on the Nizhanaia Tunguska basin: Tura, Vivi, Agata, Kosoi Porog (Bolshoi Porog), and in the middle Yessei."[56] These were not perennial outposts but permanent trading posts with live-in merchants.

The Orthodox mission in Turukhansk (Monastyrskoe) oversaw a number of small churches in the Ilimpii Tundra, notably on Lake Essei and on Lake Chirinda. Traders also built remote trading posts along the rivers. These were not year-round or permanent posts but small wintering huts that were probably poorly furnished and outfitted. There was one near the mouth of the Kochechum, along the Nizhnaia Tunguska River. This fort has been commented

on by a number of historians and appears to have been owned by a *tungusnik*—a merchant specializing in trading with (and by implication exploiting) "Tungus" trappers. Russians also relied on *batraki*, who were typically native reindeer herders. One scientific expedition passed through this area between 1873 and 1875. This was Polish exile A. Chekanovski's expedition, along the Nizhnaia Tunguska River to Olenek and on to the Lena River. 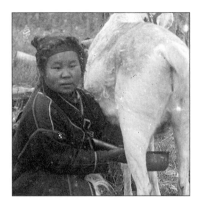 This was a route that the grandson of missionary M. I. Suslov would map out in the 1930s. The expedition was well funded by the Geological Society as it explored an unknown river system.[57]

In addition to the tribute collectors, Orthodox missionaries, who brought their messianic ideologies of qualified submission and salvation, worked their way into the North. Their missionary efforts were uneven and ultimately rarely accepted or even understood in full. Instead, ethnographic and historical records suggest that many Evenkis practiced a spiritual syncretism that combined Orthodox Christianity with nonorganized religious practices including shamanism and other forms of spiritual mediation. The Christianity of the Evenki therefore included elements of earlier religious practices, or conversely their spiritual worlds accommodated and incorporated Christian elements. Such accommodation is explored by Anatolii Ablazhei in his historical sociological work on missionaries of the Tobolsk region of western Siberia: "The adoption of Christianity could take the form of simply incorporating individual Christian elements as additions to the existing structures of traditional consciousness, while rethinking and reinterpreting the new elements as appropriate."[58] The spiritual terrain, as one would expect from a group of nonliterate people who had infrequent and unsustained contact with a single religious canon, was not a unified religious experience but rather complex, fragmented, situational, and unique. Much like their shamanic and animistic beliefs, there was a great deal of variation and a tendency to respect the beliefs of others.

The monastery, located at the confluence of the Nizhnaia Tunguska and Enisei Rivers was an important site of commercial and spiritual pilgrimage. Aside from the annual Turukhansk trade fair, there are also many stories of Evenkis traveling to Turukhansk to visit the monastery. Orthodox missionaries based their ministries out of the Troitsky Monastery and traveled broadly through the taiga east of the Enisei River. One of the 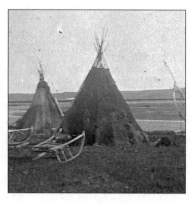 central figures in the Enisei Missionary Society in the late nineteenth century was Father Mikhail Ivanovich Suslov.[59] Suslov was the patriarch of a family whose history is tied to the history of the indigenous peoples of the Turukhansk North. M. I. Suslov had an extensive ministry throughout the Turukhansk taiga and tundra that serviced distant parishes like those at Essei and Chirinda.

Father M. I. Suslov had come to the central Siberian North as an Orthodox missionary, and by the end of the nineteenth century he had become "a central figure in the Enisei Missionary Society . . . [He] devoted his entire life to serving one of the most remote corners of imperial Russia and did so with a great sensitivity to local language and custom."[60] His grandson, Innokentii Mikhailovich Suslov, would become a critical figure in the Soviet projects of culture change.

Toward the End of the Tsarist Empire

The administration of Siberia was reorganized under Siberian Governorship in 1708 and new boundaries were drawn in 1719 (creating five provinces), but it was not until the second decade of the nineteenth century that administrative reforms brought regularity and stability to the Russian Empire in Siberia.[61] The most significant changes in Siberian governance occurred under the reign of Peter I. For many years the tsar had been planning a reorganization and restructuring of the rule of Siberia, which until then had been haphazard

and ill defined. In 1819, Peter I appointed
M. M. Speransky governor general of Si-
beria with the special task of surveying the
territory and recommending a plan to re-
structure governance. For the indigenous
peoples, the most critical outcome of this
was in Speransky's 1822 "statute for the ad-
ministration of the indigenes":

Five major principles of the Statute
were: 1) divide the natives into the
three categories of settled natives [*osedlyye*], nomads [*kochevyye*], and
vagrants [*brodyachiye*]; 2) for the nomads and the vagrants, the admin-
istration should be based on their old customs, but these had to be
better defined and organized; 3) the police functions of local authorities
should be of only a general supervisory nature, the internal autonomy
of tribes should be left untouched; 4) freedom of trade and industry
should be protected; 5) taxes and tribute should be made proportional
to the abilities of each tribe and be imposed at regular intervals.[62]

Significantly the categories of settled, nomadic, and vagrant (or wandering)
demark forms of mobility. Their classification was of concern to an adminis-
trative or bureaucratic gaze that sought to enumerate and follow potentially
volatile subjects. In her study of place names and colonial histories in Singa-
pore, Yoke Sum Wong notes that "mobility, as much as it is about movement,
can also embrace stillness, the constant, and the organized."[63] The thrust of her
project is a situated apprehension of landscapes and mobile bodies. The place
where mobility happens, she shows, is tremendously important in understand-
ing how colonial power meets and interfaces with the agency of the local and
the everyday. Mobility is a theme that runs through this history of sovietization
in central Siberia. It is a critical idiom that helps to define everyday life in the
Turukhansk North for both the indigenous peoples and the newcomers.

While the "statute for the administration of the indigenes" committed the
classificatory schema to policy in 1822, it would continue to be used to define

indigenous Siberians into the Soviet era and would become imbricated in emerging discourses of progress and cultural evolution. Nomadic ways of traveling and living on the land were institutionally categorized as unequivocally other to civilized and, eventually, socialist ways of being. The modern view of nomadic mobility as fundamentally different, irrational, and anachronistic was one of the ideological foundations that would ultimately lead to the widespread "sedentarization" programs in the Soviet era. Drawing "nomads" and "vagrants" to a settled mode of living was a constitutive element of Speransky's statute.[64] If sedentarization began with Speransky, it did not end until over a hundred years later when reindeer economies were fully industrialized and sedentarization was fully realized. In addition to the taxonomic system of mobility/economy imposed

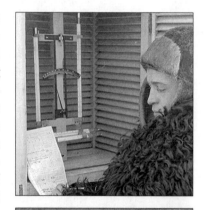
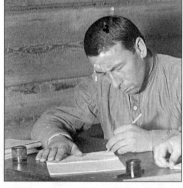

by the tsarist regime, the 1822 Statute of Alien Administration instituted a new order of tributary relations with something called the "administrative clan." These clans would later form the basis of clan and nomadic soviets.

Despite Speransky's reforms, little is said to have changed to improve the lot of indigenous Siberians. One Soviet historian claims that injustice flourished until the October Revolution:

> The administrative system in the North of Yenisei Gubernia is shocking. The lives of the native people have been put into the hands of a band of criminals consisting of the local Turukhansk administration and dealers, united by their common interest in exploiting the native population, who act under the guise of law and authority because the

territory is so secluded and remote. The local administration and dealers hold sway over the soul and body of the native . . .[65]

The turmoil of revolutionary and post-revolutionary Russia had effects that filtered out into the taiga of the Turukhansk North. Indigenous minorities were navigating a quickly changing sociopolitical landscape in the second decade of the twentieth century. Cultural mediators and newcomers shifted in both name and practice; socialist missionaries replaced Orthodox missionaries. The presence and duration of the newcomers intensified, as did their interventions into the character of everyday life.

Evenki New Life: Foundations of Soviet Modernity and Socialist Culture Shaping

To explore the history of Soviet power in central Siberia, I tie in the biography of Innokentii Mikhailovich Suslov, the grandson of missionary M. I. Suslov, who had served the remote taiga and tundra of the Turukhansk North. Innokentii Mikhailovich was a critical figure in the history of sovietization of central Siberia. I will return regularly to his story as I work through some of the relevant contextual histories that bear upon the sovietization projects of the late 1920s. Innokentii Mikhailovich Suslov was born in Turukhansk in 1893. He grew up in a family attuned both to the missionary history of the Orthodox Church and the local nuances of belief, history, and language. He himself, however, entered a program in geography and ethnography at St. Petersburg University in 1912 after schooling in Eniseisk. At this time he began his studies under the famous Russian ethnographers Shternberg, Petri, and Shirokogoroff.

The history of the Communist Revolution in Russia is typically recounted in terms of increasing protest and agonizing civil discord that eventually led

to the October Revolution in 1917, when
the Russian Provisional Government was
overthrown by Bolshevik-led revolution-
aries. Petrograd (known as St. Peters-
burg, Petrograd, Leningrad, and now
St. Petersburg again) became the center
for Soviet revolutionary power: an actu-
alized utopian dream of emancipation.
The decade leading up to this final coup
d'état was characterized by generalized
social turmoil and upheaval. Not only
was Russia dealing with growing civil
discontent but it was also embroiled in
the First World War, which began to cost
Russian lives as early as 1914 and which
helped to foment an overwhelming pop-
ular disenchantment with the ruling ar-
istocracy. Idealists, revolutionaries, and
others gathered in centers like Moscow
and St. Petersburg but also in distant
corners of the Tsarist Empire. They set
about on a host of revolutionary and

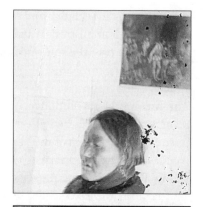

emancipatory projects that ultimately resulted in the destruction of the Tsar-
ist Empire and its replacement by a Communist one.

Despite over a decade of civil unrest and struggle, people in Russia carried
out the mundane tasks of living. Even revolutionaries (at least those who
where not exiled to places like Turukhansk or Sakhalin Island) visited loved
ones, met for tea with friends, and read books. Foreigners continued with
their own business enterprises in Siberia as well. Czaplicka and Hall, for ex-
ample, undertook their ethnographic expedition in 1914. I. M. Suslov left his
family in Siberia and began studies in geography during this period of time.
The key cultural centers in the Russian empire were St. Petersburg and Mos-
cow. Their universities and technical institutes drew students not only from
European Russia but from Siberia as well. In this respect they were not un-

like other imperial centers of power that benefited from the flows of wealth and knowledge carried on the tide of colonial exploitation. In 1912, Suslov entered the department of natural sciences (specializing in geography and ethnography) at the University of St. Petersburg. He writes that he maintained a strong interest in the Far North and the unknown lands within Russia. He actively studied the geography and the peoples of the Turukhansk territory, working under the direct supervision of the anthropologist Lev Ia. Shternberg. Suslov undertook his studies at a time of great upheaval and change. In 1905, there was a massive uprising and revolution that resulted in some concessions to reform but ultimately to a reinforcement of the autocratic rule of the tsar. While internal political change was a major concern in Russia, the outbreak of the First World War shifted the landscape

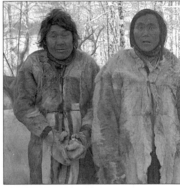

even more significantly. By 1915, Suslov's studies were cut short with the mobilization of students to participate in Russia's war against Austria-Hungary and Germany. Suslov was stationed in the southern Urals until 1918, when he volunteered with the Red Army, which was formed by the Bolsheviks after the successes of the 1917 revolution. From the earliest days of the revolution local level struggles lit up across the Russian empire. In the years following the October Revolution, a civil war was fought as various factions struggled for supremacy. Ending participation in the European war, the Communists focused on fighting a civil war against anti-Communist "white" forces and consolidating their power. Battles with the white armies flared up across Russia and Siberia in a civil war that lasted until 1923, when the last anti-Communist resistance was extinguished.

As the Communists (led by the Bol-
shevik faction) solidified power, they
began to expend more energy on build-
ing social and economic foundations
for Communism. In 1921, Suslov was as-
signed to cultural-enlightenment work,
an ongoing project to disseminate Com-
munist ideas and generate support in
rural areas. Cultural enlightenment of-
fered a powerful foundation for political
socialization, both of which operated
within a broader paradigm of social trans-
formation; Soviet cultural enlightenment
is better understood as an inheritance of
prerevolutionary Russian thought than
a radical historical rupture.[66] The conti-
nuity of cultural-enlightenment projects
offered a legacy of methods in public edu-
cation and activism from which agitators
and revolutionaries in Siberia could bor-
row and build. The language of enlight-
enment had a broader meaning than that
applied to drawing backward Russian peasants, ethnic nationalities in Central
Asia, and "primitive" northern tribes into the modern world.

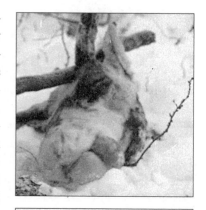

Communist cultural-enlightenment work had its roots in established tech-
niques of agitation [*agitatsiia*] and propaganda. Leading among the aspects of
cultural-enlightenment work were the "liquidation of illiteracy" campaigns,
which were seen by many (among them V. I. Lenin) to be the most critical
step in the war on backwardness. "While we have in our country a phenome-
non such as illiteracy it is difficult for us to speak of political education . . . An
illiterate person stands outside politics; he has first to be taught the alphabet.
Without this there can be no politics, without this there is only rumour, scan-
dal, gossip and prejudice, but no politics."[67] Among the non-Russians, the
project required not only the eradication of illiteracy but in many cases the

creation of dictionaries and the construc-
tion of a written language itself. Illiteracy
and cultural backwardness were seen as
serious impediments to full inclusion in
the shared experience of Soviet culture.
The liquidation of illiteracy was a critical
platform:

> In the countryside, cottage reading
> rooms were established as centres
> for literacy teaching and simultane-
> ously for establishing Communist Party influence . . . However, the
> cultural-enlightenment network in the countryside was much weaker
> than it was in towns.[68]

Although there isn't enough room to fully consider the history of Soviet en-
lightenment projects in this book, the notion of cultural enlightenment is
crucial to understand, especially in the logic that underpinned the technolo-
gies of cultural transformation. Education and the rhetoric of enlightenment
were bound together in the Soviet North. The Culture Bases developed in the
1920s and '30s were sometimes called cultural-enlightenment bases. A Soviet
decree on literacy in 1919 defined cultural enlightenment as the project of giv-
ing all citizens the opportunity to "participate consciously in the political life
of the country."[69] In her study of revolutionary cultural-enlightenment proj-
ects among rural peoples of Russia, Sarah Badcock notes that a remarkable

> feature of cultural enlightenment work was the way in which the
> wholesome messages it wished to convey were sweetened with music
> and simple joys. Singing, theater, public spectacles, and funfairs were
> all regarded as important vehicles for the enlightenment process.[70]

Nomadic reindeer herders, like the exploited industrial laborers and illiter-
ate peasants that took pride of place in the revolutionary imagination and
struggle, were often seen as philistines capable of dragging the Communist

project down, or at least stalling it, with
their anachronistic beliefs and practices.
After his service on the front, I. M.
Suslov joined one of the more interest-
ing experiments in socialist agitation
and cultural enlightenment. In 1919, he
began to work on the specially outfitted
agitation trains [*agitpoezd*] that were sent
along the rail system to bring revolution-
ary views and engage in consciousness-
building in rural areas. This mobile out-

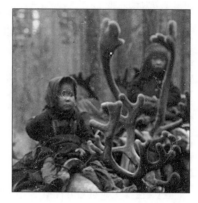

fit was created not only to foster support for the Communist project at the
time of civil war, but also to launch some of the culture-shaping projects that
began with the war on backwardness in rural Russia, Central Asia, and Sibe-
ria. As soon as the rail lines were secured by Communist revolutionaries, agi-
tational trains were sent out to propagandize the peasants and former colo-
nial subjects. The "agit-trains" were part of broader agitational-propaganda
enterprises that were organized through various institutions but came pri-
marily under the jurisdiction of *Narkompros*, the Peoples' Commissariat of
Enlightenment—a bureaucracy tasked with public education. Art historian
Annie Gérin notes that propaganda was a technology of socialization that
"became instrumental in creating common vocabularies, thus paving the way
toward a shared culture."[71] The shared cultural experience of national mi-
norities, which made them distinct from Russian and more broadly European
cultural practices, also threatened to derail their full participation in the new
Soviet community.

The structure of the mechanism for agitation, education, and propaganda,
according to Richard Taylor, "eventually combined a network of stationary
agitpunkty, placed at strategic points, with a number of travelling agitational
trains. The trains were to act as the vanguard of revolutionary agitation,
while the *agitpunkty* concentrated on propaganda saturation of the popula-
tion."[72] The *agitpunkty* ("agit-stations") and *agitpoezdy* (agit-trains) were not
the only tools for mass agitation. Taylor also remarks on the *politdoma* (po-

litical houses), "stationary centres for in-depth propaganda saturation of the local population."[73] These combined projects show the importance of propaganda for the Bolsheviks:

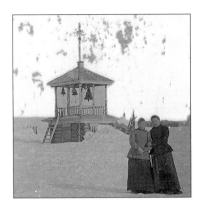

> The use of agit-trains represented an enormous investment by the Bolshe-viks in the value of propaganda. In all, five trains and one river steamer saw service. Each of the trains consisted of between sixteen and eighteen carriages and was staffed by a total of about 75–80 technicians, between fifteen and eighteen political instructors and a Red Army unit for defense. They each had a cinema, a radio station and a printing press. The exterior walls were brightly painted, initially with allegorical scenes, such as a dragon threatening to devour the Revolution and being challenged by the Red Army in the guise of St George, but later in more soberly realistic fashion.[74]

Innokentii Mikhailovich Suslov's autobiographical sketch [*kharakteristika*][75] does not reveal where he traveled when he worked aboard the agit-trains. He did write, however, of the importance of the instructional/agitational choir. He worked as deputy head of one *agitpoezd* as well as director of its chorus until 1922, when the project was liquidated. Suslov notes that his "Revolutionary Oratoria"—a history of revolutionary action set to music—was written during his travels with the agit-train:

> using a choir with accompanying orchestra it was performed in Siberia around two hundred times. In addition to this I wrote national melodies of the Kirgiz, Tatars, Teleuts (Kuznetskikh), Iakuts, and Tungus, and others. I reworked and popularized these as choral music which was performed as a cycle of ethnographic[76] concerts in Omsk in 1922.[77]

Suslov's cycle of "ethnographic con-
certs" is interesting not only as an ele-
ment in a larger program of cultural
transformation and civil war but also as a
project that suggests a radically different
notion of ethnography than that which
developed in the later half of the twen-
tieth century. Rather than operating as a
detached observer, Suslov and other rad-
ical ethnographers used their specialist
knowledge to engineer cultural change.

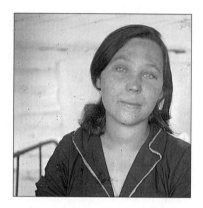

However, given Suslov's training and interests, the "ethnographic concerts"
reveal a unique sensibility that tied the production of the knowledge through
ethnographic research to the Marxist projects of cultural transformation.

In addition to his cultural-enlightenment work, in 1920 Suslov became a
member of *Sibnats,* the Siberian division of the Peoples' Commissariat for
the Affairs of the Nationalities [*Narkomnats*]. Narkomnats was the office
concerned with non-Russian ethnicities in Soviet Russia. This organization
was operated primarily by trained ethnographers or those sympathetic to
an ethnographically informed approach to revolution and culture change.
According to historian Francine Hirsch, the official role of Narkomnats was
to "win non-Russians over to the side of the revolution."[78] The broad goal of
Narkomnats was as a mediator between the Soviet state and non-Russians. In
his role with Sibnats, Suslov participated in the initiative to organize the first
all-Siberian meeting of natives, which took place in Omsk on March 20, 1921.
This meeting brought together the first wave of indigenous representatives
and burgeoning cultural elite under the direction of Communist administra-
tors and activists.

In the first days following the October Revolution, the Communist Party
concerned itself with building and consolidating power throughout the vast
Russian Empire. The transitional government of the nascent Soviet state faced
the challenge of convincing diverse national populations and ethnic groups
(many of which had no sense of ethnic nationalism) that they were not only a le-
gitimate force, but an inevitable one. To organized and politically savvy nations

and ethnic groups, they offered—at least nominally—national autonomy, so long as it was apprehended within the parameters outlined by Bolshevik Communism. The development of national regions "was a standard element of the 'Leninist nationality policy,' which assumed that the Soviet federation consisted of ethnic groups, that all ethnic groups were entitled to their own duly demarcated territories, that all national territories should have political and cultural autonomy, and that the vigorous development of such autonomy was the only precondition for future unity."[79] While indigenous representatives were fostered, trained, and encouraged to play greater and greater roles in government, this shift was not immediate. An element of this project was called *sovietization,* which was a general paradigm for cultural overhaul. In Soviet phraseology it signified a shift in "mentality" (in addition to the attendant shift in practice).

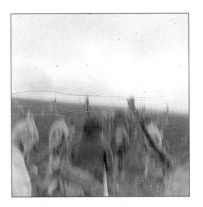

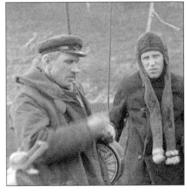

 The project of sovietization in Siberia involved thousands of villages and settlements throughout the central Siberian North. Although the Communist Party had inherited Siberia when it overthrew the tsarist governmental structures, there were other national groups on the edge of Soviet Russia that represented potentially unstable borders. The discourse on nationalism and nationality policies was directed toward the burgeoning Soviet republics. Within the Russian Federation itself the various ethnic groups (nations, peoples) were seen differently. The Siberian North (and Siberia in general) was seen as an integral part of Russia, whereas Central Asian states were less certain partners in socialism. Discourses on colonialism and imperialism tended to concern larger ethnic groups such as the Buriat, Tuvan, Chechens,

and so forth. The indigenous minorities of northern Siberia were generally excluded from the discourse of nationalism because they were understood to be outside of history[80] or, anachronistically, prior to history. They were seen to lack rationality, to be driven by petty and inexplicable concerns, and perhaps most importantly to be profoundly susceptible to cultural and environmental catastrophe. Ultimately, despite early work by

anthropologists, their lives were often seen as either untranslatable or unworthy of translation; at least until they set out on the path of socialism. As "sparsely numbered peoples" who posed little threat to Soviet power, they would receive attention through state subsidy, special consideration, and affirmative action.

Soviet historiography tended to view Siberian history as an array of fragmentary details needing to be arranged according to the Marxist-Leninist narrative of historical materialism, which claimed that history would progress through clear stages.[81] Soviet historical materialism was economically deterministic; for many years, Soviet historians were governed by fairly rigid ideological orthodoxies. Since the end of the Soviet era, if not earlier, historians in both Russia and the West have focused their attention more on a reflexive historiography that has considered the past in Siberia as more than decorative superstructure to larger economic struggles. Such a reflexive historiography has included, among other things, the social construction of Siberia and Siberians within discursive frameworks. This work has depicted Siberian history as an indeterminate field of diverse cultural activity. History in the later sense was divorced from the Marxist-Leninist mythology of progress that had given form to Soviet historical materialism. Yuri Slezkine, for example, presents the history of Europe and Siberia as a series of transformations in the way that indigenous peoples were represented by the invading, colonial, and dominant powers based in European Russia.[82] This series of transformations is characterized as beginning with a perception of indigenous peoples of Siberia and

their relationship to the state, essentially categorizing them as "other" (other than Russian, other than citizen, and usually other than Christian) and ultimately subaltern to the Russian cultural majority. In this sense, a generalizable cultural imperialism intensified over the centuries of "contact," the height of which was a long period of forced assimilation and overt culture change that began with the Communist Revolution.[83]

Revolution in the Turukhansk North

Soviet Siberia's narrative of struggle and revolution emerges from the dramatic years of dedicated agitation and enlightenment projects as well as the broad reconfiguration of cultural and economic practices. Immediately following the 1917 revolution, power in the Turukhansk North was seized, thanks in part to the concentration of exiles and prisoners stationed there. It wasn't until the summer of 1918, however, that the Communists won Krasnoiarsk, which is far to the south. The amalgamated effects of the "Imperialist War" (1914–1918), the 1917 October Revolution, and the civil war that followed resulted in shortages of food and supplies throughout the North: "the economy in the North was completely ruined. Coercion and extortion were practiced on an unprecedented level. The tribute paid by non-Russians was doubled. All principal branches of the economy—reindeer breeding, trapping, and fishing—were spoiled."[84] A situation of exploitation was exacerbated by the engrossing struggles. The vulnerability of the indigenous peoples of the central Siberian territories during the period of the October Revolution and the civil war was due in part to the importance of trade goods to their everyday lives as well as the failure of these to circulate into the more remote regions of central Siberia.[85] Between the time of the October Revolution in 1917 and the construction of the first cultural base in 1927, the socialist interventions in the taiga were limited. They succeeded primarily in delivering emergency

assistance and failed primarily in institu-
tional development. The actions were
aimed at aid and ending the crises of sick-
ness and starvation. The vulnerability of
the "natives" to sickness and starvation
was taken to be a fundamental condition
of their backwardness, not simply an ef-
fect of Russian imperialism or the desta-
bilization caused by war and revolution.

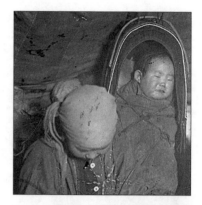

> During the prolonged period of the
> imperialist and civil wars the situ-
> ation of the population of Siberia
> deteriorated catastrophically. The
> curtailment of trade communica-
> tions with the southern regions,
> the sharp drop in production and
> reindeer-herding . . . completely
> ravaged the inhabitants. More than
> 60% of the hunters were left in 1924
> without firearms . . .[86]

The immediate need for aid and assistance bolstered the moral authority of
the Communists. What was a situational series of hardships and tragedies
linked to epidemics, epizootics, exploitation, and so forth, came to be seen as
an endemic vulnerability. The limited response (or the lag in development)
was a function, in part, of organizational challenges, the cost of sending
expeditions to the remote tundra, and more pressing crises in other parts of
the former Russian Empire. The cure and prescription, of course, was So-
viet modernity: state-sponsored cultural shaping and grooming. In his book
Seeing Like a State, James C. Scott describes high modernism as a faith-based
techno-bureaucratic form that drew legitimacy from science: high modern-
ism "was accordingly, uncritical, unskeptical, and thus unscientifically op-
timistic about the possibilities for the comprehensive planning of human

settlement and production."[87] The great
irony is that the arrogance of that era's
rhetoric was presented precisely as scien-
tific, though it is seen clearly now as quite
remarkably unscientific optimism.

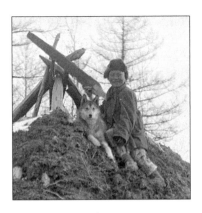

Immediately after the seizure of power
in 1917, socialists in Siberia began to or-
ganize workers, soldiers, and peasants.[88]
The primary unit of organization was
the *soviet*.[89] Bolshevik revolutionaries or-
ganized the Central Siberian Bureau in
Krasnoiarsk, sanctioned by the Bolshevik Party in Petrograd. Naumov writes
that in October 1917 there "was a total of around 10,000 Bolsheviks (out of
350,000 party members) in Siberia."[90] The Siberian Bolsheviks helped estab-
lish networks of laborers, cooperatives, and soviets and generally worked to
ensure the stability of Communist rule while the Red Army fought against
residual forces supporting the tsar or simply opposing the Communists' bid
for hegemony.

While struggle for power continued into 1922 and beyond, Soviet power in
the central Siberian North was consolidated in 1920, when the revolutionary
committee sent a telegram to Lenin stating the success of the Turukhansk
territorial congress. "Generally speaking, the Bolsheviks seized power in a
peaceful way."[91] In 1918, early plans to sovietize Siberia were drafted and ap-
proved by local revolutionary committees. This initial sense of sovietization
was principally concerned with the election of soviets across Siberia in a bid
to establish stability and a face of government rule. Later sovietization would
take on a more comprehensive tone of economic engineering, overt culture
shaping, and the remaking of everyday life. The establishment of soviets was
only the most preliminary move. Ultimately sovietization meant the imple-
mentation of Soviet culture; not only was every national group represented
through the hierarchies of soviets but every nation conformed to the general
and increasingly specific forms of Soviet culture.

If the first wave of sovietization was geared toward the generation of
stability and the articulation of Soviet power, cultural change was an implicit

component of second-wave sovietiza-
tion. It is also something that for many
years was largely overlooked. Stephen P.
Dunn and Ethel Dunn noted a kind of
blind spot for the period of the 1920s and
'30s in Siberia:

> Since this was the period when
> culture change was proceeding most
> rapidly and sometimes violently,
> concrete data on the techniques of
> culture change are also lacking or
> are present only in schematic form.
> The investigation of the history of
> directed culture change which must
> be carried out largely from non-
> ethnographic sources and probably
> on the spot is an item for the future
> agenda.[92]

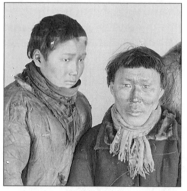

In the Siberian taiga, sovietization began
with the reconstruction of regional poli-
tics. Turukhansk, Eniseisk, Krasnoiarsk, and other centers of Russian power
had been turned over relatively quickly to the rule of revolutionary com-
mittees and representatives of Soviet power. In the taiga Russian power was
already diffuse and the Communists had to contend with imbrications of
indigenous forms of governance that were more or less synchronized with
orders formed under tsarist rule. They saw their first step as a revolutionary
one: to break the rule of the "princelings" and implement a new structure
of governance and representation. The so-called "princelings" were a local
level of hierarchy that had developed under the tributary system of imperial
Russia. They were to be replaced by representative governance in the form
of clan soviets [*rodovoi sovety*],[93] and they were the most basic form of rep-
resentation. Each clan soviet sent representatives to the local native execu-

tive committee [*TuzRIK*]: it was the job of the clan soviet to explain and clarify directives and instructions from the central government, undertake measures to improve the economic and cultural level of the clan, deliver health care, ensure compliance to the rules of trade and exchange, assist in the different forms of cooperatives and native sections of the economy, observe the health condition of reindeer herds, and so forth.[94]

In a rather mundane ledger of soviet-era trade, it is reported that in 1922 the "kulak" Iakunia Gaiul'skii sold one pound of gunpowder for forty squirrel hides and one pound of tobacco for twenty squirrel hides. Uvachan chides that "just like before the revolution, poor Evenkis were doubly oppressed."[95] The representation of the pre-Soviet era as a time of unbridled oppression was an important historical trope for Soviet historians. Such

details worked metonymically to represent an entire era as singularly brutal and corrupt and to justify and write the script for the project of socialist emancipation. Uvachan's note of the persistence of capitalist exploitation into the revolutionary and civil war era serves to illustrate the challenge of sovietizing remote areas of the Siberian North, where surveillance of everyday social and economic transactions was murky at best. Furthermore, this point works to dramatize a narrative of monumental achievement whereby the heroic efforts and sacrifices of the Bolshevik activists are challenged not only by backwardness and remoteness but also by the agency of oppressive and greedy merchants. It was a story of their effort to bring the order and light of socialist modernity into the darkest and most primitive corners of Siberia.

With a widespread and remarkably well-established network of support,

Soviet planners were able to call on sup-
porters from even the most obscure parts
of the former Russian Empire. Not only
was the aim to root out dissent and capi-
talist exploiters but also to inject sorely
needed cash into the struggling Soviet
economy. Party leaders left no doubt in the
minds of Siberian Communists that the
North mattered, at least in rhetoric. The
North represented both untold wealth and
unpoliced borders. The leader of the Bol-

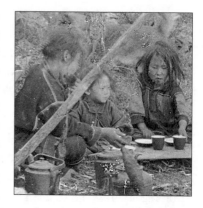

shevik Party, V. I. Lenin, is often cited by Soviet historians for acknowledging
or remarking upon the limitless potential wealth[96] that could be derived from
Siberia. Whereas many in Europe apparently thought of Siberia as a barren
wasteland, some, including Lenin, saw otherwise. Many Communist revolu-
tionaries from the tsarist era, including Lenin, had spent months and years of
their lives as exiles in Siberia. In a 1918 paper titled "The immediate tasks of the
Soviet Government," Lenin wrote that the development of Russia's natural
resources "by methods of modern technology will provide the basis for the
unprecedented progress of the productive forces."[97]

The industrial development of Russian natural wealth is an important
founding narrative of the Soviet North and Communist Siberia. In the South
along the Trans-Siberian railway, the dual aim was to extricate anti-Communist
elements and to secure the transport network along the world's longest border,
whereas in the North, Communists had the luxury of a singular (if singularly
challenging) goal of "organizing" the natives [*tuzemtsev*]. The implication of
organization was to work with indigenous individuals and groups sympa-
thetic to the revolution in order to establish local cadres of Communists. This
was a kind of internal colonialism. Based on the model of Soviet colonization
[*kolonizatsiia*], natives would become the most valuable and effective coloniz-
ers, or partners in their own colonization.[98] The perversity of this mentality
was a result of socialist messianism that developed a blind spot for its inher-
ent rhetorical contradictions. On the one hand, the Communists vociferously
denounced the imperialist colonialism of Western Europe; on the other,

they redeployed colonial techniques to
their own ends, ignoring the obvious fact
that colonialism and national autonomy
were conceptually antithetical. Francine
Hirsch outlines the philosophical gym-
nastics necessary to effect this:

> "*Kolonizatsiia* as we understand it now
> within the borders of the USSR" is not
> the "robbery of parts of the Union,
> of former colonies, by the RSFSR,
> the former metropole"; nor is it the
> "movement of Great Russian peasants
> to the Siberian or other expanses" to
> satisfy their land hunger. Soviet *kolo-
> nizatsiia,* they explained, "flows from
> the needs" of colonized regions.[99]

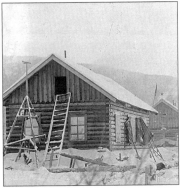

As a term, *kolonizatsiia* did not last very
long. Perhaps it was too honest a dis-
play of the actual relations of power, or
maybe it did not reflect the anticipation
of "true" national autonomies under socialism. As a nonofficial description
of indigenous-state relations, however, colonialism effectively describes the
situation in Siberia all the way up to the present day. As Alexander Pika wrote
in his introduction to the edited volume *Neotraditionalism in the Russian North,*
"in certain respects, the former policy of 'state paternalism' continues, with
funds being distributed randomly and meagerly. Central state organs have
been exercising limited administrative (rather than juridical) control over the
situation in the North, both in order to rein in particularly odious forms of
exploitation of small peoples and to ameliorate what they can."[100]

 At the time of the revolution and during the civil war, indigenous mi-
nority groups, for the most part, did not present a threat to the new regime.
Other non-Russian nationalities were a separate matter: Tuvans, Buriat, and

Yakut (Sakha), for instance, were seen
as numerous enough, with enough of a
consolidation of people and a national-
ist consciousness that they could pose a
threat if they were not rapidly incorpo-
rated into the project through entice-
ment and coercion. Those ethnic groups
in Central Asia and along the European
border of Russia constituted yet another
layer of threat. The indigenous minori-
ties were generally seen as primitive and

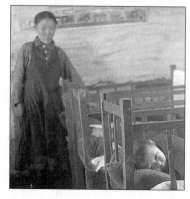

insignificant in their capacity to actively disrupt anything more than local-
level organization. While for many Russians the indigenous peoples were
unforgivably (or embarrassingly) backward, others tied to them a mythology
of purity and authenticity. Their economies and cultural practices were con-
sidered to be anachronistic: out of time in the world or stalled in the heady
march forward. This is a thesis well developed by Yuri Slezkine, who makes
significant note of the complexity in the representation of native minorities:
they were considered by Soviet ethnographers to be "primitive Commu-
nists." Lev Shternberg and Vladimir Bogoraz's school of evolutionist anthro-
pology supported the idea of primitive Communism, and it was legitimized
by Marx and Engels's interest in the work of American anthropologist L. H.
Morgan.[101] Indeed, Engels had commented positively on the work Shtern-
berg had done with the Nivkhi on Sakhalin Island in the Russian Far East. In
this regard, they were held in high esteem. The two images of indigenous
peoples—proto-Communists and backward laggards—fed a spectrum of
thoughts and approaches to governance. The dominant paradigm in Soviet
thought at least could support a trope similar to the *noble savage* of Western
Europe, though it was hardly beholden to this fantasy. Yuri Slezkine writes at
length about this in *Arctic Mirrors*:

> In the Bolshevik scheme of things, the other side of outright
> savagery was primitive communism, which meant that the out-
> right savages could be expected to become excellent students

of scientific communism and eventually "the propagandists of the ideas of sovietization and communism . . ."[102]

Debates in Moscow and Petrograd (St. Petersburg/Leningrad) consumed the attention of ethnographers and others concerned with the revolution in the North. It was one thing to say that the "natives" were primitive Communists; it was another thing to have actually spent time living with them:

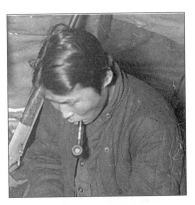

> The Soviet Union was outwardly born as a post-imperial form of power, a civic multinational state that aimed to modernize the societies it ruled and to transcend national divisions in the name of class solidarity. 103

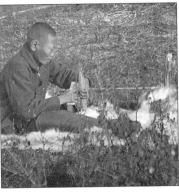

Nationhood here can be seen as a cultural form with associated aesthetic expectations. When they were not corrupt and shiftless, they were perceived as credulous victims of exploitation. But regardless of how native minorities were perceived, there was no debate about the need to hurry them along toward the future.

Saved from Industrial Capitalism: Early Organization

After 1920, the provisional government was replaced with a regional executive committee [*Raiispolkom*]. Once the Turukhansk Revolutionary Committee [*Revkom*] was formed, it set about the task of figuring out how to control its new territory. Inspectors were sent to travel the region and report back to

the local revolutionary committee. Ac-
cording to one report from the late 1930s,
titled "Description of the Ilimpii region
of the Evenki National district of Kras-
noiarsk Territory," there were eight clan
soviets formed in the Ilimpii taiga in 1924,
which were part of a much larger territo-
rial unit subordinate to the Turukhansk
Raiispolkom.[104]

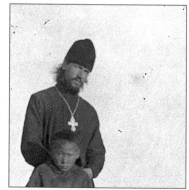

Work among the natives in the Yeni-
sei North was aided with four inspectors. Their job was to organize
clan soviets and lead meetings of these soviets, collect observations
on the economic conditions of the Native economy. The [territorial
executive committee] hired inspectors based on their preparedness,
familiarity with ethnography, the material and spiritual culture of
northern peoples, as well as state laws of the RSFSR.[105]

The work of the inspectors was challenging because many of their subjects
were nomadic hunters and herders who were perennially traveling through
their clan territories and who were rarely easy to locate. Administrative
centers like Turukhansk were responsible for enormous territories sparsely
populated with highly mobile hunters and herders. Recommendations in 1919
included the construction of a "Tunguskaia Lavka," a Tungus store in the
Ilimpii Tundra; a call to create auxiliary trading posts in a number of places
around the Turukhansk Krai; and medical and veterinary assistance. These
measures would help to solidify support for the Bolsheviks and aid in fighting
agitation against the implementation of socialist policies. One report notes
that "if these measures are not followed the natives will quickly die off and
this government will lose untold wealth . . . the Union should send out an
expedition to investigate the life of the natives in every respect."[106] The as-
surance of the revolution's success and the form any new government might
take were very much emergent and disputed problems in these early days.

In the earliest years following the rev-
olution, there were some efforts made
to support impoverished and starving
northerners. One Soviet historian, P. N.
Ivanov, notes the distribution of tons of
grain or bread to starving natives in the
early 1920s.[107] He goes on to state that
thanks to the generosity of the Party,
starvation was eliminated in the North
by 1923. Supplying remote settlements
throughout Siberia was a huge task that

was entirely reliant on the preestablished riverine networks. These efforts
required a very rapid seizure and control of the transportation networks. A
regularization of aid began to be established in 1925 with the construction
of *khlebopasny* stores (distribution points for emergency supplies of grain).
In 1925 and 1926 there was a major Red Cross[108] mission to the Ilimpii Tun-
dra (and more generally to the central Siberian North). Curiously the Red
Cross's project was criticized by one Soviet agent for failing to recognize the
"degeneration" of the natives. I. M. Suslov was critical of the fact that nearly
a decade after the October Revolution, natives in the Russian Federation were
still intermarrying, practicing shamanism, suffering from sickness and hun-
ger, and generally living outside the pale of Soviet modernity.[109]

This suggests a concern not only with the control of indigenous social or-
ganization but also with the subjugation of indigenous bodies. Ultimately,
though, it was not until the 1950s and '60s that the transformation of everyday
life in the taiga, according to Soviet sensibilities, would be effected through
"mass management."[110] Suslov's statement is reminiscent of early twentieth-
century eugenicists, and it implies a biopolitics of reproduction that had a
degree of currency with some Soviet ethnographers.[111] The historian Chris-
tina Kiaer's work on socialist eugenics acknowledges the interpenetration of
social and biological categories. In her essay "Delivered from Capitalism,"
Kiaer notes that Anatolii Lunacharski (the Bolshevik revolutionary and first
Commissar of Enlightenment, *Narkompros*)

wrote a film script celebrating the Lamarckian idea that eugenics could make people into "captains of the future" rather than "slaves of the past." In this example of a totalizing Bolshevik vision, the transition to the socialist future would be accomplished by the destruction of all the unacceptable elements that humanity had inherited from the capitalist past.[112]

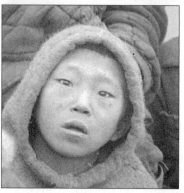

These aesthetics of transformation and construction appear as an unbridled optimism but need to be recognized as a species of rhetoric. Regardless of the degree to which the rhetoric matched reality, there were consequences for the entrenched belief that regressive legacies and states of "backwardness" were both learned and genetically inherited.

The gathering of information about the natives was identified as an essential step in the implementation of Communism. The goal of socialist construction in Siberia began with reconnaissance: a rapid study and evaluation of the territory. The Ilimpii area—the lands between the Enisei and the Oleneok, north of the Nizhnaia Tunguska River—was recognized as one of the least known regions in Siberia. In the first years following the revolution, inspector Elizar Sergeevich Savel'ev was appointed to report on the "Ilimpii Tundra," the land east of the Enisei River.[113] V. N. Uvachan writes that Savel'ev traveled from Turukhansk to the Ilimpii tundra in October 1923, returning to Turukhansk in March of 1924, living 168 days in the tundra and covering an area of 3.5 thousand kilometers. During this time he organized four clan soviets in the Ilimpii territory: Chirinda, Chapogir (Miroshkol), and Pankagir (Liutokil).[114] Inspectors continued to travel to these remote territories

and file reports to feed a growing bu-
reaucratic structure of governance; plans
were drafted for the supply of grain-
rationing stores and the employment of
touring physicians and veterinarians, as
well as the ongoing organization of na-
tives into clan Soviets.

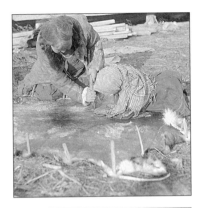

The Evenki response to the new po-
litical situation is difficult to gauge be-
cause the only published records of their
"voices" are through the reports of no-
madic soviets or officially sanctioned
denunciations and accusations. On the
one hand, the Communists were im-
plementing new programs of aid and
leveled promises of an enfranchisement
that must have sounded appealing (if
somewhat implausible). The imperial sys-
tem of "princelings" implemented under
tsarist rule—which was the state of af-
fairs for many generations—was initially
adapted to the new organizational sys-

tems imposed by the Communists. Wealthy and respected reindeer herders
simply became the representatives on the regional executive committees. But
it is doubtful that they became the target of anti-exploiter (anti-kulak) cam-
paigns until the 1930s. The initial focus seemed to be on *tungusniki*—a deroga-
tory term used to describe the merchants and traders who capitalized on the
exploitation of indigenous peoples—as well as on other foreign traders and
exploiters who made a career out of poor dealings with the local Evenkis.

The Communist Revolution seems to have affected the central Siberian
North mostly in aftershock. In my readings there are no accounts of vio-
lent upheaval or overthrow in the taiga. The main reports come from the
inspector Savel'ev and are also corroborated in Yuri Slezkine's book, where
it is noted that widespread suffering in the North occurred due to a shortage

of essential food and supplies (such as flower, salt, sugar, rifle shot, and so forth). It is also reported that throughout the Turukhansk North an epizootic of Siberian sores [*sibirskaia iazva*] killed many reindeer. Uvachan notes this as having occurred between 1921 and 1923.[115] The importance of reindeer as transportation and as a supplemental or emergency food supply should indicate how such an epizootic could compound the Evenkis' precarious situation.

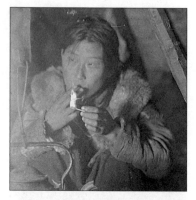

The goal of socialist development was to create a sympathetic and self-governing nation that would clearly submit to and participate in the Communist project. There was no generalizable block of resistance to this effort, and some Evenki peoples were quick to comply with (and benefit from) plans for a new life under Soviet rule. In the central Siberian North, at least, there was no invasion by military

force, and for the most part there was no overt or large-scale violence leveled against the Evenkis by the state. The hegemony of Soviet rule replaced the hegemonic power of tsarist/Orthodox rule. It has been noted elsewhere that "ordinary people . . . did not simply experience Soviet rule but to varying degrees implemented it, sometimes against their wishes, sometimes in their acts of soldiering and revenge."[116] This is a point echoed and articulated throughout the literature.[117]

In the first years following the revolution Evenki participation in the new socialist articulations of power was inevitable, and it wasn't long before impoverished Evenkis were coaxed by Bolsheviks into transforming their poverty into class-based victimhood. Where local struggles came to be articulated in terms of new Soviet laws and rhetorical forms, the applica-

tion of class differentiation was crucial,
but knowledge of the structure of class
differentiations was largely unexpressed
and only quasi-established until the Polar
Census of 1926–1927.[118] In *The Social Life
of the State in Subarctic Siberia,* Nikolai
Ssorin-Chaikov notes how the state "in-
corporated a Marxist reading of inequali-
ties both into their vision of the larger
Siberian political economy and that of
small-scale networks and communi-

ties."[119] He cites a 1921 report from the head of the Krasnoiarsk Museum,
reporting that the Tungus living along the Podkamennaia River "are shy and
distrustful, and they hide, among other things, the fact that they have pre-
served the institution of the clan princes, because they are afraid they could
be punished for maintaining it."[120] Clearly some Evenkis were avoiding the
Bolsheviks. Others, however, were co-opted, at least to some degree, into the
Soviet project. The class purity of what were perceived to be impoverished
Evenkis would give them access to power within the new Soviet structures of
rule. But Marxist-derived social classes could not be easily applied, especially
where social relations were built on alien notions of reciprocity and kinship.

As socialist ideologies began to take root among some Evenkis who were
co-opted into the project of socialist colonialism, it became easier to instigate
antagonisms as they were defined in the socialist imaginary. Whether these
were true class antagonisms, or local disputes rearticulated in Communist idi-
oms, is difficult to determine. Testimonies against exploitation by shamans,
for example, may be read either as coaxed by Communist agitators, as ex-
pressions of local disputes transcoded into Soviet legal and moral laws, or as
genuine statements by Communist converts—or a mix of all of the above.
One such testimonial, dated 1935, recounts the tragic story of a child fallen ill
in a small community named Vivi. The accuser charges that his wife and the
force of custom pushed him to submit his ill son to the shaman for healing.
The shaman, according to this man, was a fraud. He tried to heal the child
and failed, leading to the death of the child.[121] Had Russian medicine been

available, presumably the child would
not have died. This story became apoc-
ryphal as a testimony to the development
of class-consciousness and, ultimately,
class-antagonism.

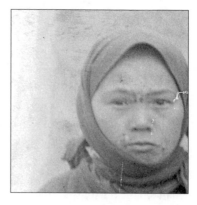

When considering early Soviet politi-
cal organization, it is vital to understand
that it was a volatile era when organi-
zations and affiliations changed rapidly.
There was competition between various
bureaus, divisions, and agencies as new
social taxonomies were developed to reconcile Communist ideals with the
pragmatics of everyday governance.[122] The role of the Communist Party vis-
à-vis the apparatus of the Soviet state was in continual flux. In historical re-
search this is precarious because the formal organization of documents is frag-
mented by a plethora of archives representing institutes, museums, and other
organizations. During the earliest stages of postrevolutionary disarray, initia-
tives to create worker and trade cooperatives were not solely driven by the
burgeoning Soviet state but by various different organizations and sometimes
even from within the indigenous communities themselves. Organization was
haphazard and highly localized. In other words, while it is useful to talk about
the Communist Party, there were many different groups active at the time.

When the Communists first began to work in the Turukhansk North they
were not faced with outright violence. As their work progressed, there was
certainly resistance to the attempts to reconfigure power according to Soviet
ideals. They were met "with more or less reactionary survivals [*perezhitkami*]
of the partriarchal-clan structure, for instance (Kalym, patriarchal slavery,
etc.) as well as kulaks, former princelings, and shamans."[123] Greater and more
sustained interventions were called for that would allow for the "liberation of
the clan soviets from the impact of kulak shamans and general improvement
of Soviet work in places."[124] The Culture Base was chosen as the tool for im-
plementing class war; not only would it allow for a steady demonstrational
environment for Soviet modernity but it presented a sustained intervention
that would allow for the efficacious isolation of exploitative elements.[125]

Part of the altruistic justification for sovietization was the emancipation of the "natives," firstly from tsarist survivals (corrupt and self-serving officials, priests, and traders) and secondly from themselves (shamans and wealthy reindeer herders). For most Communists there was no need for justification of the project, and its inevitability was self-evident; in this logic the instructors, agitators, and functionaries [*chinovniki*] were merely

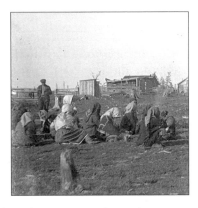

handmaidens in the natural will of social evolution (or at least they were playing along as an adaptive strategy to meet the desperate political volatility of the era). The battle took place on several fronts: one was the education of the native masses, and the other was the eradication of the exploiter classes.

The exploiters of the "Tungus" natives actually had their own name—*tungusniki*—and there is frequent use of this term in the archival and historical literature. A photograph by N. V. Sushilin produced during the 1926–1927 Polar Census actually labels the subject of the photograph "Tungusnik-Angarets M. I. Sizykh with his family."[126] As such it can be seen as a categorical marker of identity, and one that had the dangerous possibility of exposing its recipient to the punitive force of the state and subjecting them to various forms of repression. For the most part it is used to describe non-Tungus exploiters or, in a less charitable vein, anyone who traded with Tungus. One administrative report describes a Russian hunter as a "former" *tungusnik*, suggesting professional transformation was possible but that it was not easy to evade the blemishes of being a socialist reprobate.[127] Documents like this recall a time when identity was openly and irrefutably tied to power. Success in early Soviet Russia was heavily bound up in the politics of identity and class purity. Thus a former *tungusnik*, if not outright persecuted, could expect little advancement or possibility of aid within the regime. The identity markers were enforced by the ubiquitous *kharakteristiki*. They were considered Kulaks and were later lumped in with the economic opportunists that were tolerated under Lenin's New Economic Policy (1921–1928) and persecuted under Stalin's

first Five-Year Plan (1928–1932).[128] One
census enumerator offers an account of
a *tungusnik* who operated on the Lower
Tunguska River in the 1920s. When the
Evenkis came to trade, he would invite
them to drink for several days before be-
ginning the transaction.

> Here is how the Tungusnik merchant
> counted: Right before the eyes of
> the Tungus, he shows the fox-pelts
> and says: "One, two, three, three,
> two, three, four, five, one, two, three,
> four, four. In all that amounts to five
> pelts."[129]

This kind of account (of which there are
many) became an important narrative in
the socialist liberation of the indigenous
"toilers of the North." In 1920, the Sibe-
rian Revolutionary Committee annulled
all debts for hunters, trappers, and fish-
ers. Further measures against the exploitation of natives and against exploit-
ative elements were taken: on the fifth of May, 1923, the Enisei executive
committee [*Gubispolkom*] enacted a compulsory decree on the measures to
protect northern natives of the Enisei area against market exploitation by
private traders.[130]

The master narratives of progress and modernity central to the Soviet
worldview were tantalizingly relevant in the central Siberian North. "The
peoples of the North had no time to pass through the stage of industrial
capitalism; the Great October Revolution saved them from it."[131] Cultural
and economic development of the North was becoming a priority, and the
historical determinism which framed northern development was formulated
and codified "in a theoretical package known as the non-capitalist path of

development [*nekapitalisticheskii put' raz-vitiia*]."[132] The ethnographer David Anderson outlines this in greater detail, especially in context of the Taimyr area in the Far North. In this work he shows the genealogies of the ideas that underwrote Soviet development. Crucial to this ideology, and as noted above, was the special evolutionary position occupied by the indigenous Siberians.

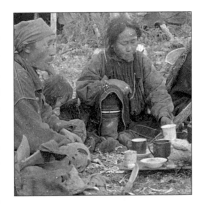

The first steps to bringing socialism to remote areas in the North was the establishment of cooperatives and simple production units called "PPOs", as well as a variety of councils: native soviets, clan soviets, village soviets, and nomadic soviets. V. I. Iurtaeva notes that one of the first priorities for the new revolutionary committees [*revkom*] was ensuring regular provisions to remote northern settlements.[133] Cooperatives performed this important task and quickly became

entrenched as important social and economic organizations in the Siberian North. The challenges faced by the Bolshevik government when it considered revolution in the Arctic were formidable. As I have noted elsewhere, the North presented such a boundless territory that victorious skirmishes against tsarist forces did not necessarily translate into the actual control of territory. Without established networks of transportation, the Bolsheviks were unable to replicate techniques of agitation they used in other parts of the Russian Federation.

Moscow left the administration of Siberia to local soviets, Party cells, and executive committees, but these units were most often tiny and primitive. As a result, actual responsibility for the region

fell to the Siberian Revolutionary Committee (Sibrevkom); the Siberian Bureau of the Party Central Committee; and the regional executive committee of the Urals, based in Sverdlovsk (currently Yekaterinburg).[134]

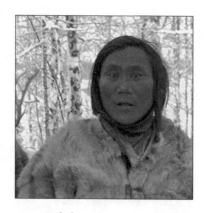

The actual work of "primitive" cells, soviets, and committees began with an accounting of northern lands, peoples, and state assets. Inspectors were sent out to surveil deep into more or less uncharted territories. In February of 1921, N. E. Arkad'in (an Evenki man appointed to head the Turukhansk Department of Native Affairs) made an expedition to the Ilimpii tundra.[135] In his report, he noted the difficult economic situation of the indigenous population. At a meeting of the regional executive committee it was decided to send rapid aid of food and equipment, entrusting Arkad'in to prepare a reindeer caravan to deliver products to the "starving natives." This action marked the earliest concrete steps of the organs of Soviet power to bring planned and regular interventions to the people of the east of the Enisei River.[136] Furthermore, the executive committee established a project of inquiry titled "The situation of nomadic soviets of the Turukhansk Krai." The project assigned northern inspectors to report on the soviets representing nomadic peoples and to aid in their functioning and organization.[137]

After 1922, the Turukhansk Krai was divided into four enormous inspectorates. The inspectorate that would eventually be the site of the Tungus Culture Base and capital of Evenkiia was called Ilimpii. E. S. Savel'ev was appointed inspector of the Ilimpii Tundra and maintained the role of "instructor" for the Turukhansk revolutionary executive committee until 1926.[138] In 1922 the Turukhansk Regional Executive Committee also established a department of native affairs, the head of which was an Evenki man, Nikolai Egorovich Arkad'in.[139] Beyond this appointment Arkad'in's role in the history of sovietization is unclear. The inspector Savel'ev, on the other hand,

produced several important reports on
conditions in the tundra regions east of
the Enisei River. Soviet ethnographer
V. A. Tugolukov writes about Savel'ev's
reports on the Ilimpii tundra:

Ice fishing on lake Murukte was done
by representatives of the Turyzh
clan. The inspector wrote that in
their unenlightened darkness, they
believed in all devils and shamans.
 Savel'ev explained that in the hunger of 1921 Ilimpii Evenkis
slaughtered over two thousand domestic reindeer for meat, the result
of which was that many were left without reindeer. In 1923 this was
the situation for 15% of the households.
 In the region of Ekonda lake between 1919–23, 26 people-or five
chums [households]-died from starvation.
 Savel'ev led a general meeting in Chirinda of the Ilimpii clans and
succeeded in organizing a communal herd of 500 reindeer "for the aid
of impoverished Tungus." A significant part of this herd (300 head)
was driven to Ekonda lake and redistributed on loan to Evenkis.[140]

While Tugolukov reports that five households from the Ekonda region per-
ished in a famine of 1919–1923, the earlier Soviet historian V. N. Uvachan as-
cribes hardships and suffering primarily to the pre-Soviet era. Presumably he
was selectively recounting events in what amounts to a panegyric to Soviet
socialism. Uvachan's blind spot, however, was a fairly common type of omis-
sion. He reports on one hunter's letter to the local Evenki-language news-
paper, *Evenki New Life:* "Those were hard times [before the revolution]. Evenks
were dying out. One spring 30 families perished near Lake Ekonda . . ."[141] He
may have just as easily described the epidemics and hungers that followed
the revolution. This selective historiography helps to develop a baseline for
saluting the arrival of Soviet modernity in the taiga. When Uvachan did ac-
knowledge suffering in the Soviet era, it was seen as a strictly transitional

phenomenon—a result of the incom-
plete implementation of socialism or of
active resistance from countercultural
and counterrevolutionary elements. In
other words, where hardship was man-
ifest in the early Soviet era, it could be
explained as a byproduct of backward-
ness that both anticipated and justified
industrial modernization and cultural
sovietization. Either way, suffering was
understood as an effect of capitalism, co-
lonialism, and imperialism as well as cul-
tural backwardness. Where it persisted,
if it was officially recognized at all, it
was seen to be symptomatic of residual
effects of imperialism, intentional sabo-
tage, oversight, or a lack of prioritization
in the unfinished project of sovietization.

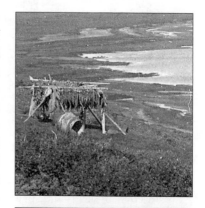

 If the work of the inspectors and in-
structors was a preliminary incursion of
Soviet ideas and observation in the cen-
tral Siberian taiga, the work of the agita-
tors represented a second wave of activism. When Soviet agents (instructors,
agitators, educators, and inspectors) began to arrive in the central Siberian
North, they brought with them an established and growing set of concep-
tual tools meant to facilitate the transformation of taiga nomads. The tech-
niques for agitating among the natives were publicized through educational
bulletins, newsletters, and journals. Agitators and educators shared their
experiences and approaches in cultural-enlightenment work.[142] Many of
these techniques were borrowed from Orthodox Christian missionization.
Indeed, the parallels are striking. Yuri Slezkine notes the similarities in terms
of hygiene and campaigns against dirt in the 1930s, which "advocated the
old missionary method . . . : convert women first, for it is women who are
the homemakers, the housekeepers, and the educators."[143] Alexia Bloch's[144]

study of residential schools in Soviet Si-
beria provides another example from the
1930s and beyond. The rhetoric of the
early techniques of culture change were
also less differentiated than the state plan-
ners would have liked:

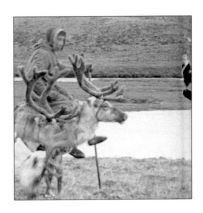

> In the civil war years, some Bol-
> sheviks had used an old-fashioned
> civilizing-mission rhetoric to justify
> Soviet economic policy. In a 1920
> speech, Grigorii Zinoviev had declared that the Soviet regime takes
> "these products which are necessary for us, not as former exploiters,
> but as older brothers bearing the torch of civilization."[145]

There was, in actuality—and to no surprise—a great deal of "bleed" from
one regime to the next, from overt techniques of missionization to language
itself.

Agitators, inspectors, and instructors were part of the infrastructure of
sovietization. The instructors mentioned above seem to be Party agents con-
tracted to help and monitor the various native soviets. It is not clear how, or
indeed if, they differed from "agitators," of whom I have seen no records.
Agitators had the job of instilling class-consciousness in "ignorant" peasants
and workers. In the *Encyclopedia of Soviet Life,* Iliya Zemtsov writes that "the
underlying task of the agitators is to extol Communist principles and ideas,
to glorify the Soviet way of life, to exhort people to live up to the proclaimed
standards of Communist morality, and to propagate the view that the Com-
munist way of life is right beyond any doubt, as well as to discredit capitalist
mores and values."[146] Class-consciousness followed the Bolshevik Party's in-
terpretation of Marxist class formation, which was adopted as the officially
recognized system of social classification in the Soviet Union.[147] Fitting
Marxist economic classes to the Russian scene was not always easy. Fitting it
to the scene in Siberia required even greater feats of creativity, obfuscation,
and intentional ignorance. The Bolshevik focus on class war—essentially a

war against exploitation and inequality—
was brought to the taiga and articulated
initially as a war against capitalists and
exploiters. The success of the revolution
was celebrated as the end of the tsarist
system of tribute payments [*iasak*] and
the implementation of socialist aid proj-
ects. Their express aim was not primarily
as the cultural upbringing of the natives,
but as the deliverance of the natives from
abject poverty and exploitation.

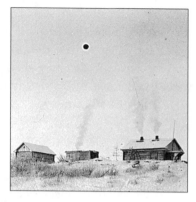

Bolshevik revolutionaries articulated the radical re-visioning of social
relations as a commitment to liquidate tradition (in both Russian and non-
Russian society) and replace it with a comprehensive Communist modernity.
The process for attaining this new civilization is described by historian Daniel
Peris in terms of a wide-ranging Bolshevik agenda that concerned "not only
political and economic relations but also culture, education, women, family
relations, and language."[148] In Peris's words, the transformation of Holy Rus-
sia into an atheistic Soviet Russia was at the heart of the project.

The idea of backwardness was central in the efforts to construct the So-
viet Union. To the most radical Bolsheviks, backwardness was more than a
small hurdle—it was an abhorrent state of being that threatened the project
and affronted the spirit of the revolution. Indeed, backwardness was an offense
that could be overcome only through a total program of modernization; an
offensive against backwardness and vestiges of archaic cultural practices. Sheila
Fitzpatrick writes that backwardness "stood for everything that belonged to old
Russia and needed to be changed in the name of progress and culture. Religion,
a form of superstition, was backward. Peasant farming was backward. Small-
scale private trade was backward, not to mention petty-bourgeois . . ."[149] In the
Siberian scene this was reformulated with backward religion being shamanism,
backward social relations being the perceived patriarchy of indigenous societ-
ies, and backward economic practices being reindeer herding and hunting in
the context of trading posts and predatory merchants.

First Wave of Sovietization

In a short biographical report held in the archives of the Evenki Autonomous District, I. M. Suslov states that he created the first clan soviet among the Tungus at the Chune River in 1926.[150] This was only the beginning of his involvement in a project that would bring socialism to the North. Suslov's efforts to establish Soviet forms of organization among indigenous peoples was a kind of ethnographic bureaucratism.

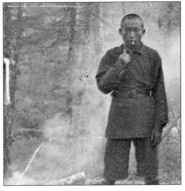

The Communist Party considered it necessary to involve the natives in the Soviet system, but as there were no industrial workers or proletariat, and no class consciousness or revolutionary feelings among them, a great deal of Marxist theorising and practical experimentation was required in order to decide upon the appropriate form for native soviets by "adapting them to pre-capitalist conditions." This indeed became the principal theme of Soviet ethnographic studies of Siberia in the 1930s.[151]

Only a year before Suslov helped to establish the Tungus Clan Soviet on the Chune River, the Siberian Region (Sibirskii Krai) was named and the Siberian Revolutionary Committee [Sibrevkom] was replaced by the more permanent Siberian Regional Executive Committee [Sibkraiispolkom].[152] The dizzying array of organizational and institutional structures that were assembled and disassembled in the first decades of the Soviet era were no doubt bizarre to remotely located indigenous peoples unfamiliar with the everyday life of Russian bureaucratic worlds. Regional instructors, however, made the most

of this by focusing on the development of local-level representation in the form of soviets, suggesting that the turmoil was temporary and that the intent was to work toward stability in the supply of goods and services as well as greater degrees of autonomy. The election of soviets was seen as the first step in restructuring native social organization; though in many ways it essentially reestablished pre-Soviet representative organizations. After ousting the *tungusniki*, the first order of business for the socialist newcomers was establishing a cadre of natives who could represent their brethren to the new political order and who could begin to help with the cultural internalization of Soviet principles. As I have noted elsewhere, this was articulated within the rhetoric of (r) evolutionary progress:

> Leninist Nationality politics offered an opportunity for pre-capitalist peoples to progress to Socialism without passing through the capitalist stage.[153]

The "opportunity" for these precapitalist peoples presented by the incipient state was sometimes called *korenizatsiia*.[154] Literally "nativization," *korenizatsiia* was a policy of "making use of people native to an area in leading posts etc.,"[155] as well as a way of generating broader support for Soviet Communism in a multi-ethnic environment. As Lewis H. Siegelbaum describes it, "korenizatsiia represented a victory . . . for the national communists who had been urging the party to make itself and the new political order more comprehensible, accessible and therefore legitimate in the eyes of the non-Russian

peoples."[156] The importance of creating
and fostering a cadre of native leaders is
clearly documented in the photographic
record as well. A rupture is visible be-
tween scopic regimes of the tsarist era
and the early Soviet era. Photographs
of indigenous peoples in the tsarist era
rarely document the name of their sub-
jects. Evidently the primary interest was
native typologies, not native biographies.
This was a practice that reconfirmed their

place out of time (they were not historical actors, but bystanders). In the first
years of the Soviet era, we begin to see photographers actively naming their
subjects. This is especially the case when they were members of indigenous
intelligentsia, men and women who had entered the flow of history as actors.
They were represented as the architects of the national project.

Social organization of the Evenkis of the central Siberian North at the
time of the revolution in 1917 had been integrated into larger systems and net-
works of exchange and encounter for centuries. While the nomadic hunters
and herders were familiar with some aspects of Russian culture and rule, they
were very much on the outside of it. Their invitation to participate in the new
order was truly revolutionary.

All clan soviets of a given district were to send their representatives
to the district native congress, which was to elect the District Na-
tive Executive Committee (*Tuzemnyi Raionnyi Ispolnitel'nyi Komitet,*
abbreviated TUZRIK).[157]

One report from 1926, "On the question of the organization of native vil-
lage or clan and regional soviets,"[158] describes the scene: there were three
clan soviets operating on the right bank of the Enisei River in the Ilimpii
Tundra. The three clan soviets in this area were called the Ilimpii, Panka-
gir, and Chapogir. The Ilimpii clan soviet consisted of nearly 1,500 "souls";

they traveled nomadically in the Lower
Tunguska basin, around Lake Chirinda,
Lake Murukta, and others. The center
for them according to the report was
either Chirinda or Tura. The Pankagirs
and Chapogirs each consisted of over
two hundred individuals. The former
gravitated toward Lake Vivi, while the
latter considered Tura their center. This
snapshot attempts to locate and enumer-
ate, and it is a relatively straightforward
example of the Soviet gaze: an instru-
mental and pragmatic accounting of
life in the margins of state power. It also
captures some of the anxiety felt by So-
viet administrators. They struggled with
few resources to maintain observational
clarity over an enormous territory. In the
mid-1920s, Suslov complained in reports
to the Enisei Governorship of "chaos in
the Tundra."[159] He was referring to the
difficult task of monitoring the move-

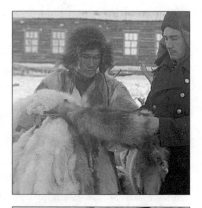

ments of multiple nomadic groups who refused to fit neatly into Soviet ru-
brics and taxonomies that sought to delimit ethnicity and national territories.

According to Yuri Slezkine, clan soviets were the favored model for native
self-government, but alternatives and variations existed,[160] particularly in the
early years. For example, archival documents refer almost interchangeably to
"nomadic soviets" and "native soviets," though there is some evidence that
nomadic soviets replaced clan soviets. By 1939, before major programs of vil-
lage consolidation and forced sedentarization, there were nine nomadic sovi-
ets in the Ilimpii region of the Evenki National District.[161] Certainly the very
notion of a clan soviet was at odds with models of sovietization that granted
privilege to economic taxonomies rather than kinship ones. A clan soviet
went against the very principles of progressive thought and was in danger of

supporting ways of being and organizing socially that were deemed backward and threatening to Communism. Clans and extended families were to expire under Communism. Such networks were read instrumentally and the parental role of obligation and expectation was in part usurped by the state. Leon Trotsky writes in *The Revolution Betrayed:*

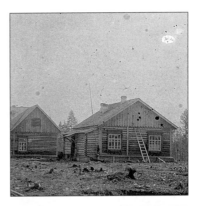

> The revolution made a heroic effort to destroy the so-called "family hearth"—that archaic, stuffy and stagnant institution in which the woman of the toiling classes performs galley labor from childhood to death. The place of the family as a shut-in petty enterprise was to be occupied, according to the plans, by a finished system of social care and accommodation: maternity houses, creches, kindergartens,

> schools, social dining rooms, social laundries, first-aid stations, hospitals, sanatoria, athletic organizations, moving-picture theaters, etc. The complete absorption of the housekeeping functions of the family by institutions of the socialist society, uniting all generations in solidarity and mutual aid, was to bring to woman, and thereby to the loving couple, a real liberation from the thousand-year-old fetters.[162]

The ideal kinship structure ultimately was modeled not on the Russian nuclear family but on modern love (which in itself was an invention of a European philosophical tradition).

Clan soviets were typically subordinated to any local Russian soviets and

were almost always under the direction of Russian "instructors." The native and no-madic soviets were local-level elected organizations that were the lowest in a chain of soviets leading up to the All-Union Soviet in Moscow. Among the Evenkis and other indigenous peoples, this marked the beginning of the expectation that they would have representation. It also was a point of new divisions that would overlay existing forms of social organization: prin-

cipally, this was between party members and non-party members. Unlike other places in the former Russian Empire, there was an additional register, because governance of indigenous peoples was initially controlled through a number of special statutes and provisions. The most important of these was the provisional statute. Slezkine notes that this provisional statute was supposed to reintroduce some order to "native administration" but that it was frustrated and blocked by indifference and antipathy to the project:

> Most local Russians opposed or ignored native self-government, and district executive committees refused to spend their limited resources on clan soviets.[163]

The effects of this were lessened by the direct access to and supervision by the Committee of the North. While many provincial and rural Communists may have seen little to be gained from intervening in the most remote areas of the taiga, there were others who saw the sovietization of the North as important, if not essential. One organization, noting the work of ethnographer Vladimir Bogoraz, claimed that "native peoples who 'know the flora and fauna' and the precious metals and minerals of a region were 'best suited' to 'exploiting that region's natural riches.' [Furthermore, they] suggested that natives and outsiders work together to further the 'economic and cultural development' of the Union's 'outlying territories.'"[164] Imagining what was

essentially an extension of tsarist impe-
rialism and colonialism as a partnership
was a critical, latent, and effectively resid-
ual ideological artifact that underwrote
most of the projects undertaken in the
name of sovietization.

Nationality Policies

Through the 1920s and '30s, sovietization
was the core project of the Communist

Party across Russia and the Central Asian republics. Peoples throughout the
former Tsarist Empire shared the experience of sovietization with variable
degrees of participation and co-optation. In this era the Communist Party
developed the specific techniques of rule whereby state planners created and
fostered socialist-consciousness based on ethnic nationalism. Yuri Slezkine
writes that

> the founders of the Soviet state believed that the way to unity lay
> through diversity and that by promoting ethnic particularism (within
> certain limits and to much acclaim from the presumed beneficia-
> ries), they were bringing about socialist internationalism and Soviet
> modernity.[165]

In response to the variegated character of the Russian empire, the Commu-
nist Party fostered the development of nationality policies that were an im-
portant part of revolutionary agitation even prior to 1917. That focus, how-
ever, was primarily directed toward the large ethnic groups, many of whom
had a sense of modern ethnic nationalism (from Ukrainians in Europe to
Kirghiz in Siberia). This would have important ramifications for the smaller
and less nationally conscious ethnic groups, such as the indigenous minori-
ties in northern Siberia. The development of nationality policies concerning
the northern minority peoples under Soviet rule has been a major focus of

anthropological and historical study by
Western scholars.

For ideological reasons many Marx-
ists were vehemently opposed to
the very idea of acknowledging
ethnic identities through a federal
state structure. . . . This ideological
principle existed at different strengths
throughout the Soviet era. Simultane-
ously, Marxist theory saw the emer-
gence of nations as a logical stage in the evolution of the dialectical
historical materialism and could hence be fitted into a Marxist frame-
work. As such, orthodox Marxists considered it a part of the necessary
development of pre-capitalist societies en route to Socialism.[166]

Even before the revolutionary uprisings of 1917, the Russian Communist
Party had developed a powerful set of ideas around national autonomies and
centralized authority. The group that was established to work out the details
of this was the Peoples' Commissariat for the Affairs of the Nationalities,
known as "Narkomnats." Narkomnats worked under the assumption that
Communism would not be achieved overnight and that interim measures
would be needed to achieve their goals. Pragmatically this allowed for the
development of a theory of federalism, where roughly autonomous groups,
through national self-determination, joined together in a union of nations.
 There was a great deal of concern in the ruling Communist Party over the
relationship between the new Russian Republic (RSFSR)[167] and the emerging
Soviet republics on its border. The new state was under internal and external
assault and did not begin to develop a sense of security until the end of the
civil war. Because of these other priorities, national construction and social-
ist development in the North among indigenous minorities was haphazard,
uneven, and somewhat arbitrary. Iurtaeva and others note that socialist con-
struction among the northern natives began immediately after the 1917 revo-
lution by both central and local party organizations.[168] However, it was not

until the Polar Department was created in 1922 that a coordinated plan began to emerge which was specifically tailored to the indigenous peoples of the North.

Two years later, the Committee for the Assistance to the Peoples of the Northern Borderlands (Committee of the North) was established. "Everyone agreed that to ensure correct progress through education, every ethnic group needed its own intelligentsia, and that meant that some [groups] had to be trained faster and more thoroughly than others."[169] The intelligentsia was meant to operate as a form of internal colonization. Thus a cadre of natives would become "active participants in the Soviet project, who were 'doing the colonizing' of their regions and were not 'being colonized.'"[170] The models for implication and assimilation were being developed around the Russian Federation with other national-

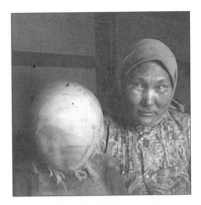

ities as well as with Russia's own peasants. Exploring the work to draw the Russian peasantry into the Soviet project, Orlando Figes has focused on the role of language and rhetoric.[171] The goal in the Russian countryside was the same as it was in the Siberian North: "The dissemination of the Revolution's rhetoric to the countryside—the development of a national discourse of civic rights and duties—[in order to] create the new political nation dreamed of by the leaders of democracy."[172]

Early Soviet activists were concerned with cultivating a nonimperialist and noncolonialist approach to their sovietization efforts. As Hirsch has outlined, sovietization was not to be colonialism (though it was certainly perceived as such abroad). Colonialism and imperialism, after all, had been forcefully criticized in Marxist-Leninist doctrine. Lenin himself understood colonialism

to be necessarily linked to imperialism, which itself was only conceptualized in relation to capitalism:

"If the victorious revolutionary prole-tariat conducts systematic propaganda among them, and the Soviet govern-ments come to their aid with all the means at their disposal—in that event it will be mistaken to assume that the backward peoples must inevitably go through the capitalist stage of devel-opment. Not only should we create independent contingents of fighters and party organisations in the colo-nies and the backward countries, not only at once launch propaganda for the organisation of peasants' soviets and strive to adapt them to the pre-capitalist conditions, but the Com-munist International should advance the proposition, with the appropriate theoretical grounding, that with the aid of the proletariat of the ad-vanced countries, backward countries can go over to the Soviet system and, through certain stages of development, to communism, without having to pass through the capitalist stage."[173]

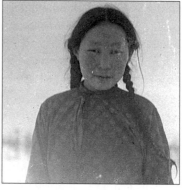

The meeting transcriptions, acts, reports, and other fragments of bureau-cratic habit and ritual that I have studied also document an era of language shift. The ideas of rights and duties along with civic participation and inclu-sion were part of a larger shift in language itself. The rise of a new revolution-ary lexicon was another example of everyday acts of implication that drew people into a mindfulness of change and state hegemony—a kind of socialist worlding project. "Tungus" was used interchangeably with "Evenki" for many

years; it persists today as well, though it has a strong derogatory overtone. When the Culture Base was first established, it was alternately known as the Tungus Culture Base and the Tura Culture Base. With the official recognition of ethnically determined names (ethnonyms), "Tungus" was eventually dropped. In archival documents from the early Soviet era, the term *inorodtsev* (alien) was often used to describe indigenous peoples. In other 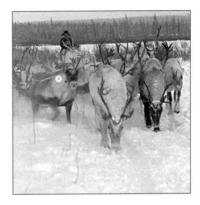 cases, the term *tuzemtsev* (native) was used. As indigenous peoples entered the family of Soviet multiculturalism, these were dropped in favor of specific ethnonyms or new terms purified by Soviet statistical science, such as the term "numerically small peoples." In some archival reports, evidence of this shift in policy is evident from corrections and marginalia. In one case an entire report had been redacted, an onerous task for the editor: scratching out the imperialist residue inherent in the language itself. Thus *inorodtsev* is there/not there on the same page as *tuzemtsev*. Evenkis are briefly caught in an act of erasure by fiat, their identity announced, recanted, and revealed: aliens, not-aliens, and natives. Inherited words became evidence of dangerous presocialist ideological survivals. Another example is *dusha* (soul), which was used in reference to individuals counted in a census. This word carried a clearly Christian heritage. It was not completely expelled from written lexica until the 1930s, when the antireligious campaigns were most broadly applied and Christianity was surgically removed from governmentalism. By the 1930s, the residue was gone and everyone knew the sanctioned and requisite lexicon as the word *soul* receded from bureaucratic registers.

Cultural Enlightenment and Revolutionary Evolutionism

While there was little tolerance for "backwardness" and tradition in the early years of the revolution and civil war, it was not until the inauguration of Stalin's first Five-Year Plan in 1928 that the state fully committed to a mobilization

against nonprogressive cultural elements (among other things). Sheila Fitzpatrick refers to this as a "second declassing"—a second thrust to liquidate class difference.[174] As I have shown, prior to this time there was little capacity to enact any serious programs of cultural change, including the effort necessary to undertake a program of "declassing." The war against tradition, however, appears to have been geared more toward stamp-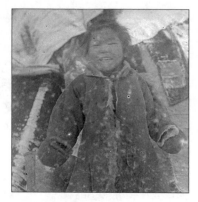 ing out what were considered to be the most deplorable cultural elements of backward societies. This war in many ways was a battle developed around the cultural practices of peasants across Russia as well as Buddhists and Muslims in Central Asia. According to agitators working in rural areas, the 1917 revolution was endangered by the "The 'darkness' of the peasants."[175] The enduring darkness and backwardness, over a decade later, was now seen to be an impediment that could stall the rush of socialist development. Targeted "elements" included vendettas, murder, abduction of women, forced marriages, and the buying and selling of women. From the earliest stages following the revolution, the Communist Party stated that it would "help 'the toiling masses to liberate their minds from religious prejudices,' by 'organizing on a wide scale scientific-educational and antireligious propaganda.'"[176] By the mid-1920s, this had become entwined in a growing and diverse bureaucracy that monitored and maintained the full industrialization of society.

The decrees, laws, and provisions that were initially developed for expediting the war on tradition did not have as much relevance among the nomadic herders and hunters of the North. Nonetheless, as with other policies, they were adapted to fit. Priests, imams, and lamas were identified as anti-Soviet agitators in other regions. In the North, shamans were fairly easily slotted into this category. A typical account follows:

Shamans persuaded their fellow countrymen not to send their children to school, [they] frightened with all kinds of horrors those

who turned for medical assistance
to hospitals, [they] threatened with
the revenge of the spirits those who
followed the advice of veterinarians,
visited the community centre, or
went to the cinema. During rituals
shamans often did direct anti-Soviet
agitation work . . . spoke viciously
and heatedly against schools, made
use of the religious superstition of
the backward and illiterate popula-
tion, [told people not to send] their
children to boarding schools.[177]

Unlike Orthodox Christianity, there was
no centralized and bureaucratized hier-
archy of power to target. Shamans were
often virtually indistinguishable from
other Evenkis (at least to the Russians).
Indeed, the categorization of shamans
according to their work[178] required a
much greater degree of scrutiny—one
that was ultimately provided by I. M. Suslov with his work *Shamanism and
the Struggle against It*. Their capacity to disrupt the work of "socialist enlight-
enment" was seen as a potential threat. The real persecution of people iden-
tified as shamans and kulaks came once an indigenous cadre had been devel-
oped. These individuals had more or less accepted the ideals of socialism,
including the narratives of Soviet messianism and the implicit call for class
war as a tool in cultural revolution. It is in such spaces that local political
struggles could be played out, using the ideological framework of Marxism-
Leninism to selectively (and often cynically) persecute individuals. Both Bal-
zer[179] and Boulgakova make reference to this in the context of other areas in
Siberia: Boulgakova writes that it was the first wave of students indoctrinated
in socialist ideals, including atheism, who led the persecution of shamans:

"Vladimir G. Bogoraz confirmed that the representatives of the indigenous people acted not only as executors of the repressions, but also as initiators of the fight against shamanism."[180]

Classificatory schemes thus identified shamans and other exploiters as well as a broad category of toiling arctic masses.

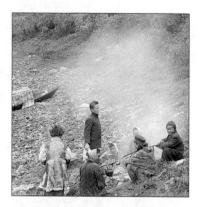

For the Bolsheviks, it was imperative that Russian society be "reclassed" forthwith. If the class identity of individuals was not known, how was it possible for the revolution to recognize its friends and enemies? [181]

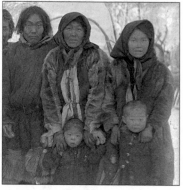

The class analysis of the indigenous Siberians grew out of the approach developed for Russia's "rural laborers": "a tripartite classification according to which peasants were either 'poor peasants' [bedniaki], 'middle peasants' [seredniaki], or 'kulaks,' the last being regarded as exploiters and proto-capitalists."[182] The reports from the early inspectors made explicit use of this language, applied haphazardly atop the typologies of the Speransky reforms noted earlier, that divided the "natives" into settled [osedlyi], nomadic [kochevniki], and wandering [brodiachi].

The mobility-oriented classification system reveals as much about Russian biases as it does about everyday life in the taiga in the first decades of the twentieth century. The three categories of mobility (wandering, nomadic, and settled) were seen as stages in cultural evolution and were thus tied to the state-sponsored evolutionism necessary for full participation in the Soviet project. A parallel schema, which was perhaps less confined to anachronisms implicit in the evolutionism, read a kind of primitive class structure

into these categories. The emphasis on
settlement or sedentarization attendant
to the construction of Communism was
not simply a move to administrative ef-
ficiency and economic productivity, but
was also expressed as an implicit sign of
cultural progress and of class liquidation.
Industrial modernity was ruthlessly sed-
entary, and its proponents saw nomadic
forms of mobility as an economic sur-
vival from bygone eras.[183] While many
Evenkis and other indigenous peoples
were opposed to radical reconstructions
of their ways of life, others, at least on
paper, welcomed the benefits promised
with sedentarization.[184]

The application of class typologies
was not without its problems. Fitzpatrick
notes that the Bolsheviks applied a flawed
class analysis to society; they turned it
into a political tool and "corrupted it as
a sociological category."[185] Extending this
implication of a corrupted category, Fitzpatrick argues that class was signifi-
cant in Soviet society as an official "classificatory system determining the
rights and obligations of different groups of citizens . . . [it] was an attribute
that defined one's relationship to the state."[186] Beyond the class-consciousness
and class conflict encouraged by itinerant instructors and agitators, there was
little that could be done in the taiga and tundra without a significant and en-
during Soviet presence. In other words, real instruction and agitation required
presence and duration. It also required a population that wasn't dying from
starvation and sickness.

I. M. Suslov's experience in the central Siberian North complicates this
picture of class ascriptions. As an ethnographer, he was interested in docu-
menting and explaining the economic, spiritual, and material culture of

Evenkis; yet as a socialist agitator and administrator, he was committed to a program of selective cultural change and manipulation. Suslov might well have been one of the academics that Yuri Slezkine had in mind when he described a movement of "populist ethnographers-turned-politicians [who] subscribed to the idea of progressive change brought from the outside."[187] To Suslov, culture was seen as a mutable set of practices that could 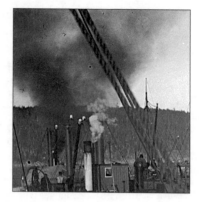 be adjusted and engineered, molded and shaped to fit the messianic ideals of Communism. For the ethnographers of the Committee of the North, the Evenkis (as with other nomadic peoples) were in need of a careful and guiding hand. It was not until 1924 that Suslov would play a genuinely transformative role of instructor and steward who could shepherd the Evenkis toward a prosperous, stable, and Communist future. This role was also espoused by Iulian Bromlei—one of the key ethnographers of the Brezhnev era—who recognized sovietization as an experiment conducted on a grand scale, not in a laboratory, but in the streets, fields, and forests of Russia.[188] Bromlei writes the following passage that makes explicit the important role and complicity of ethnographers in the program of cultural shaping:

> As is known, without ethnographic knowledge it is impossible to work out the correct outlook toward the economic-cultural legacies of peoples, to separate the content of progressive rational traditions from harmful anachronistic manifestations. For over fifty years, our government has used the recommendations of ethnographers in connection with economic reconstruction, culture, and lifeways, specifically, in planning new types of settlements and housing and the working out of new rituals to combat such harmful survivals of the past as the remnants of the inequality of women, polygamy, and religious customary traditions.[189]

One of the more remarkable examples of the ethnographically informed forced cultural change is that of I. M. Suslov's *Shamanism and the Struggle with It*. Published in various versions from a monograph to a serial publication in *Soviet North* (*Sovetskii Sever*, 1931) and the *Antireligious-ist* (*Antireligioznik*, 1932, titled: "Shamanism as an impediment to socialist construction"), Suslov calls for an elevated place for the battle against shamanism in the class war 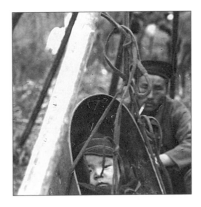 in the North. He notes that the shamanic ritual is the only spectacle in the vast taiga and that youth are particularly susceptible to its pageant.

"It is time to replace this "theatre" with real theatre, by creating a drama club of the natives and northerners . . . It is necessary to arrange collective listening to radio programs, games for the masses, lectures with slides, film screenings, question and answer sessions, and other options in the North for cultural entertainment."[190]

Regardless of the aims of cultural reconstruction, the need to secure food, medicine, and basic economic self-sufficiency would take precedence. There was a concern that the North and remote rural centers were being left behind in the rush to Communism. "The natives still depend on the elements, still starve after a bad season, and are still decimated by epidemics in the absence of medical help."[191] What was seen as a general failure to "raise the cultural level" of Russia's native peoples led to the development of the Committee of the North in 1924.

This was also an era of experimental utopianism in Russia and Siberia. The 1920s presented a unique moment in the development of the Soviet Union. As Stites wrote: "It is no exaggeration to say that almost the entire culture of the Revolution in the early years was 'utopian.' All the arts were suffused with technological fantasy and future speculation: Constructivist art,

experimental film, 'rationalist' architec-
ture, Biomechanics, machine music, En-
gineerism, and many other currents."[192]
The possibility of building a city where
there was none was as appealing as the
task of helping "primitive" peoples leap a
mountain of one hundred years, passing
through the capitalist stage and arriving
directly in state socialism. But what had
this to do with the deepest [gluboki] cor-
ners of Siberia? Was the Tungus cultural
base not also tied up in a utopian dream?
Crossing a mountain of one hundred
years in only five! What courage! But the
oppressive banality and massive weight
of the brutal environmental conditions,
multiplied by distance from civilization,
must have tempered such dreams. Per-
haps these utopianisms were most visible
in the transformative possibilities of jux-
taposing a "stone-aged" hunter next to a
radio apparatus. There are plenty of pic-

tures of Evenkis in camps with tents, dogs, and reindeer. Then there are also
a few, identifiably "propagandistic" photographs, staged with Evenkis in the
classroom, in the hospital, or the dormitory.

Improving the Natives: Committee of the North

In the taiga of the Turukhansk North, the Evenkis and Yakuts strove to main-
tain their traditional modes of life and travel quite apart from the drama of
the revolution and the Communists' fledgling steps toward sovietization. The
fracturing politics that embroiled those concerned with crafting government
and the advancement of state socialism and international Communism was
of little relevance to the lives of those living in tents traveling ancient migra-

tion routes through interior forests of the central Siberian North. The cumulative effects of revolution and civil war in addition to a smallpox epidemic and an epizootic of Siberian sores, however, generated a desperate situation. Attempts by regional governments and bureaucracies in the first years following the revolution to deliver aid, economic reconstruction, and the stabilization of a network of distribution were generally too late, too few, and 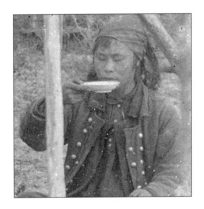 too poorly funded to match the grandiose promises of the Soviet instructors and inspectors. When the Russian Soviet Federative Socialist Republic had finally been secured and the civil war was officially brought to a close, the real work of building Communism began. While the revolutionary committees in Turukhansk and Eniseisk were surveying the interior forests and developing early cooperatives and soviets, they had no substantial presence in the taiga to the north and east of the Enisei River.[193] Throughout subarctic and arctic Siberia were many unexplored areas, seemingly boundless taigas, and tundras that were still the domain of mobile hunters and herders.

While representative governments were established in Krasnoiarsk, Sverdlovsk (Ekaterinburg), and other locales east of the Urals, the majority of the Siberian territory remained untouched by large-scale industry and even largely unexplored by Europeans. Industrial development had occurred only along major transport routes: rivers and rail lines[194] and the South were disproportionately populated compared to the North. In many ways arctic and subarctic Siberia was as unknown to those living in Krasnoiarsk, Irkutsk, and Sverdlovsk as it was in European Russia. While many of those Bolsheviks who found themselves in government had spent time in Siberia as exiles of the tsarist government,[195] few had any knowledge of the vast territories beyond the established villages and settlements located along Siberia's river highways.

The Soviet state was struggling with the implementation of socialist ideologies across a multiethnic landscape. At the same time, it was evident that in general most Soviet officials west of the Urals knew very little about the

Siberian taiga. The abundance of natural resources in Siberia was legendary, and it was widely noted that the north's unclaimed wealth awaited modern industry. It was clear that there was a great deal of work to be done before they could even conduct the necessary surveys that would confirm the extent, value, and cost of extracting natural resources. In the 1920s, large tracts of land were more or less unexplored, and major rivers, such as the Olenek, had not even been mapped.[196]

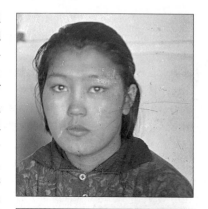

A group of ethnographers who were involved with Narkomnats (the Peoples' Commissariat for the Affairs of the Nationalities) were well aware of the status of the Siberian North, both as a potential resource bank and as a site of growing crisis among the indigenous peoples, who continued to suffer from exploitation and seemingly endemic poverty. Narkomnats, according to Francine

Hirsch, "relied on professional ethnographers from the imperial regime for ethnographic knowledge about the lands and peoples of the former Russian Empire."[197] This knowledge was built on late nineteenth-century ethnological theories as well as ethnographic and informal reports and museum exhibitions. Photographs also played an important role in documenting the margins of the Soviet state. By providing reliable forms of testimony and document, photographs not only illustrated oral reports but also populated the imaginaries of state socialism.

In 1922, the Peoples' Commissariat for the Affairs of the Nationalities already had plans for an "Ethnographic Bureau." A memo from the head of Narkomnats states that such a bureau:

was not an unscientific "humanitar-
ian" scheme that would impede local
development, but rather a bulwark
of economic modernization. . . .
"Without scientific knowledge about
geographical conditions and famil-
iarity with national particularities IT
IS IMPOSSIBLE TO GOVERN TO
THEIR BENEFIT different peoples
and not waste strength and resources
on unneeded experiments."[198]

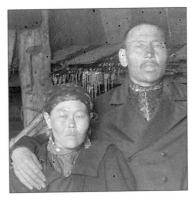

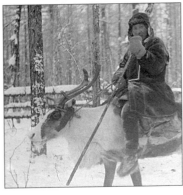

Most importantly the ethnographers in
Narkomnats argued for an organization
with authority that ran directly through
Moscow, rather than having to deal with
potentially corrupt and prejudiced offi-
cials in Siberia or at least Siberian officials
whose grasp of Siberia was beholden to
the connected southern swath of land
that was temperate and amenable to
more familiar European-style economies
(cities, farms, agriculture, mining, and so forth). The Siberian North was not
only seen as impenetrable and inscrutably other to European Russians, it was
also seen as such by those living in more populous and "civilized" places in
the south of Siberia.

Narkomnats was shuttered in 1923, many of its functions replaced by a
new unit called the Committee of the North. In response to the request to
create more direct channels between the Siberian North and Moscow, the
Committee for the Assistance to the Peoples of the Northern Borderlands (or
simply Committee of the North) was established.[199] In 1924, the first central-
ized body governing indigenous peoples in Russia was founded.[200]

I. M. Suslov was working with cultural-enlightenment projects when

the former members of Narkomnats
formed the Committee of the North.
In 1925, Suslov joined the Committee of
the North as director of its Krasnoiarsk
division. Given the importance of the
Siberian division to the Committee of
the North, it is remarkable how little
has been written on Suslov's role. I. M.
Suslov came into his position in the Com-
mittee of the North with considerable
experience on the "cultural front." The

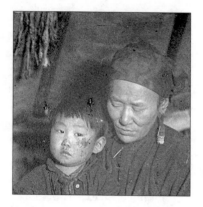

statewide prioritization of developing the economy through modern indus-
tries that included the exploitation of natural resources was not lost on the
Committee of the North. They acknowledged the great wealth located in
the North, but they argued "only the well-adapted natives could exploit that
wealth; hence, the disappearance of the natives would turn a potentially rich
country into a frozen wasteland . . ."[201] In this way a protectionist and pater-
nalistic program of culture shaping was presented as the most pragmatic way
forward. It was at its core a cultural enlightenment and civilizational mission.

The Committee of the North played a formative role in the development
of indigenous-state relations in the Soviet North. Its goal was to "realize the
legal equality that was proclaimed by the 'Declaration' of 1917 and by the
constitution of 1918."[202] It was the 1917 Declaration that proclaimed the "self-
determination" of the peoples of the former Russian Empire (along with the
abolition of various religious and ethnicity-based privileges). The Committee
of the North "was given the task of uniting and organizing the small peoples,
of awakening them to a recognition of their equality with other peoples,
and of elevating them to a high level of development."[203] Notwithstanding
the high rhetoric of the Declaration, it had the demonstrable power to mo-
bilize the idealism of Russians and indigenous minorities alike.

Until the establishment of the Committee of the North in 1924, the
enormous territories of Siberia and the Russian Far East were irregularly
served by a network of instructors and inspectors based out of administrative
centers such as Turukhansk and Krasnoiarsk. As I noted in the last section, so-

cialist work or development in the Enisei
North following the 1917 revolution was
limited. Their task of drawing the natives
into socialism was troubled not only by
language and cultural barriers but also
by the fact that the logic of Communism
translated poorly into the life experience
of nomadic hunters and herders. For this
reason the socialist project in the central
Siberian North was at first more of an
aid project and a project of institutional

reform than one of cultural transformation. There was simply no infrastruc-
ture to support a venture for an expansive cultural revolution. The Commu-
nists who did pass through promised that the new regime was one of equity
and fairness. They promised that Lenin would get rid of exploiters of all
kinds, and that they would provide stability, bread, sugar, tea, and rifle shot.
The many promises that were made were expressed by itinerant state rep-
resentatives; there was virtually no sustained presence beyond Turukhansk.

The Committee of the North had a central administrative unit based
in Moscow with regional units in major cities across Siberia. The Siberian
branch was founded on November 26, 1924.[204] I. M. Suslov was its director
though later he transferred to become head of the Krasnoiarsk Committee
of the North. The primary goal of the Committee of the North was the
sovietization of the North. With autonomy from regional level politics, they
brought new hope to a venture that was sporadic and haphazardly applied.

The Committee of the North prioritized the collection of "information
on the life and the needs of the small peoples and to study their history, their
culture and their way of life."[205] Prior to the establishment of the commit-
tee, early instructors and inspectors had offered provisional surveillance of
the Turukhansk North. Their reports and observations pointed to a compli-
cated social landscape that was threatened by the rapid deterioration of civil
and state institutions. Their recommendations called for an increase in state
intervention as well as the production of more detailed knowledge about
the inhabitants of the Turukhansk North, their economy, and the territory's

natural wealth. The Committee of the
North continued the work of the first in-
spectors as it organized expeditions and
conducted research on the various in-
digenous peoples living throughout sub-
arctic and arctic Siberia.

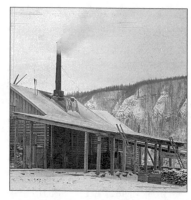

The work done by these expeditions
and the local materials brought back
by them made possible an accurate
listing of the groups belonging to the
"small peoples" and also served as
the basis for the most important steps
in their improvement (the organiza-
tion of soviets on the lower levels,
regional delimitation according to
nationalities, organization of land
management, reconstruction of the
economy, etc.).[206]

This statement is a significant articu-
lation of the paternalistic ethos of cul-
tural transformation. The idea of improvement, as I have shown, was a
critical element of Soviet cultural evolutionism. But improvement and self-
amelioration was not only expected of "backward" natives; it was an overar-
ching mythology of early Soviet culture. Attwood and Kelly trace the history
of the symbolically charged ideals of a "new man" and "new woman" to
the mid-1930s. The new Soviet person was "seen to have resulted not only
from private moral choices . . . but from coherent programmes of socializa-
tion and behaviour transformation, what Lunacharskii [the first Commissar
of Enlightenment] referred to as 'the process of production' of new types
of human being . . ."[207] Cultural construction promised pervasive and inti-
mate realignment of everyday moralities. These moralities were trained on a
universal ethos of Communism that proposed an entirely new social subject

which annihilated ethnic, racial, and class differences. It also shifted allegiance from family and clan to the state. Life at the most intimate level was thus subject to radical recalibration.

The Committee of the North emerged as the agency most capable of undertaking the cultural transformation of indigenous minority groups in the Siberian North. In the early days it helped to set up central cooperatives for purchasing goods and equipment and for selling furs, fish, berries, and meat. The committee helped to organize overland transportation, which continued to be an industry dominated by traditional forms of reindeer mobility until the advent of mechanized snow travel in the late 1960s. One of the first references to the Soviet use of reindeer caravans is in the inspector's visit to the Ilimpii Tundra. As I've noted above, prior to the Soviet era, reindeer caravans were hired for missionaries[208] as well as explorers[209] and other agents of the state. Reindeer were used year-round but were the only mode of transport in the winter. Boats powered by steam, sail, and oar plied the navigable waterways. When going against the current they were often towed with ropes, hauled by men who plodded the precarious riverbanks. Along the Lower Tunguska River there were only two times per year when the water was high and deep enough for steamers.

While protecting the natives from exploitation was one of the most important tasks, "the Committee's true and sacred vocation was to assist the small peoples in their difficult climb up the evolutionary ladder."[210] Evolutionism was a dominant idiom in official discourses as well as in popular culture. For the Committee of the North, "[c]ultural progress meant getting rid of backwardness, and backwardness, in the very traditional view of the committee members, consisted of dirt, ignorance, alcoholism, and the oppression of women."[211] In other words sovietization was a war not only on mentality but also on the very bodies of the people implicated. Immediately after its creation, the Committee of the North set about planning for the

construction of a network of socialist
outposts in the most remote areas of the
Russian North. This was identified as a
set of "concrete measures for delivering
aid to the natives."[212]

The Committee of the North oversaw
a number of critical projects until it was
formally liquidated in 1935. The cultural
bases had the most lasting and signifi-
cant impact of the committee's various
projects; they were significant for their
sustained and focused presence in the remotest areas of the Soviet North. It
was widely recognized that attempts to draw the natives into formally socialist
modes of exchange had failed. In 1925, according to I. M. Suslov, the Committee
of the North ordered the construction of three experimental projects in remote
areas of the Siberian taiga and tundra. These were to be established at the sites
of major native nomadic encampments. One of these was called the Tungus
Culture Base:

> The mouth of the Kochechum river was a central point for four to
> five thousand nomadic Tungus, dwelling on a territory of around one
> million square kilometers. The cultural base is located in the center of
> these nomads. It is an experimental and demonstrational scientific es-
> tablishment that carries out its work in organizing and demonstrating
> across a network of subsidiaries, which later will be organized among
> the majority of the remaining groups of nomadic Tungus.[213]

The Tungus Culture Base was a utopian socialist outpost situated in one of
the most remote locales of Siberia. Suslov played an important role in the
success of Committee of the North's projects in Krasnoiarsk. His knowledge
of the central Siberian North and his position within Soviet institutions as
well as the anthropological establishment allowed him to make informed
decisions about a little-known territory and to garner a powerful role as a
cultural broker and intermediary.

(C's own Ph.D. diss. research)

The Tura Culture Base

The Tura Culture Base stands as a beacon of the first socialist culture in the North.[214]

At the end of the 1920s, the Committee of the North began to build Culture Bases across the Siberian arctic and subarctic in an attempt to establish a solid foundation for Soviet power in the least populated and most remote locales of Soviet Russia. The Culture Bases had several key functions; chief among them was the staging of broader and more intense programs of forced cultural transformation or culture shaping. In 1929, at the Sixth Plenum for the Committee of the North, then director Petr Smidovich proclaimed that they would "draw the class line across the natives"[215] as soon as the edifices of Soviet power were developed in the northern areas of Siberia. As such, the Culture Bases were seen as a temporary staging point in a larger project; the Culture Bases provided the structural framework for developing Soviet power in remote regions where it was otherwise impossible to sustain programs of aid, instruction, and agitation.

The historian Amir Weiner defines the Soviet enterprise as an "unfolding revolutionary transformation of society from an antagonistically divided entity into a conflict-free, harmonious body."[216] This was certainly the case in the Russian North as it was elsewhere. It was also a very real enterprise, and though it failed in many ways,[217] it also had important successes and ramifications—not least of all the national mythology of a harmonious and progressive society. The initiative to build the Culture Base constituted a recognition that central Siberia (and the other northerly and remote areas

of Siberia) could not be successfully in-
corporated until there was a sustained
presence of Communist activists and agi-
tators. It was a response to the lack of a
centralized and orderly plan that could
accommodate what was seen as a special
situation in the North.

According to the Marxist philosophy
that underpinned policy and action in the
Soviet Union, society was seen as a mu-
table and historically particular assem-

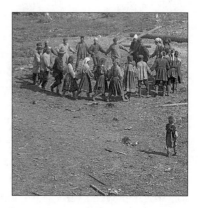

blage. Cultural revolution was a necessary rite of passage or travail across
which all nations (and proto-nations) had to traverse. This view of obligatory
cultural transformation "went hand in hand with a continuous purification
campaign seeking to eliminate divisive and obstructing elements."[218] The Si-
berian landscape itself was cast, perhaps not unsurprisingly, as one of the
major obstructions. Along with antagonistic groups and individual exploit-
ers, the land beyond the navigable rivers was seen as a major obstacle to so-
cialist enlightenment. The nomads had to cross a mountain of one hundred
years not only so they could participate as equals but also because they were
seen to be most suited to drawing out the primeval wealth of the land.

The central challenge in the vast Siberian taiga was the lack of state
presence. It was not enough for agitators and instructors to venture out into
the forests and along the rivers to work among the natives. They realized that
the construction of socialism would be impossible until they had a sustained
presence in remote regions throughout Siberia, especially areas with imme-
diate accessible natural resources. This meant surpassing the late-imperial
geographies that had limited state intervention to the river ways. It meant
building outposts in the least known places and the most remote regions in-
habited by indigenous peoples.[219] For the inspecting gaze of the Soviet rulers
to truly penetrate the primeval darkness of the tundra, they would need a
new sensory technology: the Culture Base.

In the years following the civil war, the failure of the Communist Party to
make transformative inroads beyond the major rivers in the Siberian North

prompted a call for an expansion of the
Soviet frontier. To do this, they needed to
build a new front line for Soviet civiliza-
tion. Towns at the confluence of major
rivers were no longer adequate to subju-
gate the enormous interior territories. It
was simply too difficult to enact cultural
change on the scale called for by Moscow
with so little sustained contact between
Soviet workers and nomadic reindeer
herders. They required a more sustained

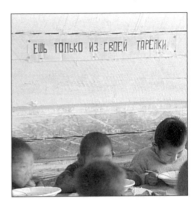

presence in the interior. As a sensory technology, the Culture Base operated
as a relay for information about the taiga and its inhabitants. As I have noted,
greater interventions would follow—though not necessarily based on the
knowledge produced by the sensory apparatus.

As a material intervention into the everyday lives of indigenous peoples,
the Culture Base was a technology of rule, but it was also a technology of
vision. Practices of looking spawned from and bound to Western science
were staged out of the Culture Bases, and sometimes these fed back into
policy that shaped further interventions into the lives and lands of the in-
digenous peoples. Francine Hirsch notes how "revolutionaries and experts
intentionally used census-taking and border-making (along with other means
of classification and delimitation) to transform local identities."[220] The Cul-
ture Base was designed as a technology of rule and transformation. Outside
of the Siberian context, colonial rule was, as Nicholas Dirks writes, "made
possible, and then sustained and strengthened, as much by cultural technolo-
gies of rule as it was by the more obvious and brutal modes of conquest."[221]
As I have shown, the more brutal forms of conquest were never part of this
particular colonial history. It is the more banal and co-optive practices of
domination that are shown here to have been most significant. Bruce Grant
notes that the Culture Bases were one of the central means employed by the
Committee of the North in achieving three goals: native self-government,
economic reorganization, and social enlightenment. He describes the Cul-
ture Bases as "all-purpose social service centers that would serve as the main

avenue for information collection and program implementation."[222] Program implementation as much as information collection required a sustained and specialized gaze trained to enumerate, evaluate, and represent.

There are instances where data were clearly collected and used for purposes of colonial rule or socialist development in the central Siberian North. Apart from the inspectors' reports I discussed earlier, censuses, maps, and photographs were all utilized to produce a constellation of information about an otherwise invisible landscape. The Polar Census of 1926–1927 provides a good example of what David Anderson has called a "geography of inscription." The enormous endeavor to make a census in areas barely under the influence of Soviet power through the North was haphazard and reliant on a good deal of variable skill, commitment, and attention of the enumerators themselves.[223] The maps in the introduction to this section demonstrate similar quirks, reminding us that all of these modes of knowledge production are also cultural texts that have diffuse meanings and uses. They were produced under specific regimes of interest and capacity and were accessed and used just as unevenly, especially in the tumult of Soviet administrative politics. There is no direct or inevitable connection between data and domination. Against the rush to produce information and knowledge there has often been an impoverished capacity for analysis and evaluation. While the information collected under the 1926–1927 Polar Census was unparalleled, it was also largely ignored: "The data generated from this huge program of inscription were never fully analyzed in their time, as the nuanced results contradicted the relatively simple picture of class stratification that Soviet state managers sought in the early 1930s."[224] It could be argued that photographs were even more unhelpful in practices of rule: fragmented by expedition and affiliation, dispersed indiscriminately in archives and private collections, awkwardly incorporated into archival registers, and ultimately ambiguous as signifiers. This is not to deny the instrumental role

of these technologies of representation in the banal expressions of rule (and even state-sponsored terror and violence), but they cannot be reduced to the category of the machinery of totalitarian rule either.

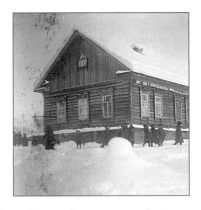

What the Committee of the North created was a mediating apparatus that was expected to buffer and protect the minority indigenous peoples from exploitation, starvation, and sickness. It was also interventionist, though, and was built to draw indigenous peoples in to the Soviet project and to prepare them for full participation in the imminent Communist utopia. The following, according to a memorandum from the director of the Krasnoiarsk regional Committee of the North, were the instructions or recommendations for representing the Culture Base in film:

Themes for a film on the North
Protocol for cultural construction in the North. December 6, 1928.

Category I: The first category includes special films that should be shown in the North among the native masses.

Native soviets and courts

Demonstrate the work of the best clan soviets. A general meeting of different tribes. Comparison of obsolete forms of collective rights with modern Soviet laws. Ideal native court and compare it with the court of the old princes. Promoting the best ways of collecting and organizing all-clan and parish meetings through comparison with existing methods. The reasons for the reluctance of the rich to attend the general meetings. Coverage of the individual moments of organized protection of the poor against exploitation by the rich. The Constitution of the USSR, illustrated with pictures of the various congresses.

Schools and questions of enlightenment

The challenge for ideal native schools. Popularization of the work of modern schools in native areas, Tomsk workers school [*rabfak*] and native workers school in Leningrad. Ideal "house of the native" [*dom tuzemtsev*] house, reading, Red Chum. Show the campaign against illiteracy in

the cinema and radio in action. Comparison of the rigidity and resistance of some natives to the need for sending their children to school, with the conscientious parents who understand the importance of school. Local cell of the Komsommol (youth wing of the Communist Party) among school children and its work. Anti-religious and anti-shaman work at the school.

Industry and hunting

Advantages of cooperation with Gostorg (State Trade Organization). Trade before and now. Influence of the rationalization of trade to increase food production and exchange. Comparison of old traps and new methods of hunting. The advantage of the collective over individual work. What is a veterinary cooperative and what is the structure of the entire system. Damage caused by shamanism in the fisheries and hunting.

Medical work among the natives

Comparison of the sanitary-hygienic conditions of housing of different peoples of the North. Illustrative facts concerning the grubbiness of separate tribes, especially Yuraks. Ideal results of health education in their adaptation to contemporary native dwellings. The advantage of cottages over tents [chum] in the forest zone.

Which epidemics exist among natives, how to fight them with the help of a physician, promotion of prevention and quarantine. Comparative methods for treatment used by the shaman and the physician. Popularization of the work of the hospital, itinerant clinics and the medical clinic at the Culture Base.

Veterinary help for the natives

Techniques and methods for the treatment of deer. Education of natives in the application of liniment. The advantage of treatment of the mange using the gas chamber. Promotion of the veterinary station at the Tungus Culture Base. Demonstrative facts about the propagation of epizootics in deer.

Zootechnical work on Reindeer

Demonstration reindeer nursery, including its profitability. Type and breed of deer by geographical area. Altai maral, Karagass deer, reindeer (Tungus, forest, Samoed). The degree of hardiness and the use of different breeds of deer. Influence of different methods of deer feeding on the development and improvement of its breed. Advantages of organizing nurseries over the individual production of large reindeer herders.

Category II: The film should consist of the elements listed in order in category I, invested with an artistic form with the inclusion of

aboriginal everyday subjects. Films in category II offer material for the promotion of life, welfare and economy of the North in the Russian cities and abroad.

<div align="right">Innokentii Suslov</div>

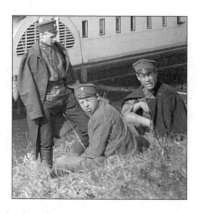

I. M. Suslov's "Themes for a film on the North" is framed as a project of cultural construction [*kul'turnogo stroitel'stva*] where he outlines two categories of film, the first being content produced explicitly for the "native masses of the North." The second category of film was to invest artistic form in the depiction of scenes from everyday subjects in the lives of northern natives. Films in the second category were to be used in the "promotion of life, welfare and economy of the North in the Russian cities and abroad."[225] The implication of the latter category was that it would not only be educational but would help to advertise the good works of the new socialist regime. From the earliest days, the Culture Base was identified as a significant project worthy of documentation and promotion. To some degree, all Soviet projects were deemed worthy of attention or at least were identified as potentially useful in the development of official Soviet visual culture.

While Suslov's instructions are more or less generic, they seem to have had at least one direct application: *Tungus s Khenychara,* a narrative film directed by Manuel Bol'shintsov and featuring an Evenki actor named Kevebul Kima. This film was shot in 1928–1929. According to one author, the film crew "traveled to a real village on the Lower Tunguska (not far from Turukhansk, possibly Noginsk or Tutonchani). The main roles were filled by Evenkis— two young men and a girl. At the time of filming it was their first time seeing a city, steam boat, and locomotive . . ."[226] The limited descriptions of this film that I have located indicate a close fit with the themes for a film on the North written by I. M. Suslov.

Suslov's instructions were consistent with ideas debated in the nascent Soviet cinematographic and cultural-enlightenment circles. In particular the

"cinefication" of the countryside and the documentation of Soviet cultural and economic construction were critical projects. Denise Youngblood, a historian of Soviet cinema, describes Soviet cinefication as a push to circulate films in the countryside primarily as a means of education—which she categorically demarcates from propaganda. The documentation of Soviet projects was to be represented in newsreels, which were "part of almost every cinema 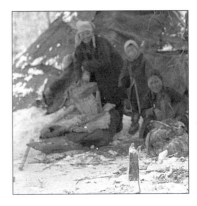 programme from the mid-1920s."[227] Although these newsreels were shown in theatres, they are also part of a category of ephemeral films that were never archived or deemed valuable enough to preserve. This includes nontheatrical media that were made for highly specific audiences, from worker collectives to amateur hobby associations. Newsreels and other films promoting state projects were important in developing a sense of Soviet community; as Sheila Fitzpatrick writes, "the Soviet government had positioned itself as the repository of national sentiment and patriotism" with its various "nation-building and national-strengthening projects."[228] The recognition of the promotional and historical value of the Culture Base indicates the degree of sophistication brought by the Committee of the North to this project.

A 1925 budget plan for the Tungus Culture Base included photographic, phonographic, and cinematographic equipment and supplies. Nearly two thousand rubles were budgeted for three thousand photographic exposures—a "meager" ration for up to twelve workers. The budget notes the expectation that some of the wealthier workers would bear the cost of more photographs on their own. The photographs were split into 1,800 glass plates and 1,200 frames of Kodak roll film. They also called for two thousand meters of reel film (for a cinematograph) and one hundred cylinders for audio recording.[229] While I have not encountered any suggestion that film reels and audio recording supplies have survived, there are many photographs in the various archives that not only document the history of sovietization in the Turukhansk North but that also conform to Suslov's thematic categories.

Elsewhere I discuss the work of the pho-
tographer Baluev, who produced pho-
tographs in the 1930s that most clearly
embody Suslov's visual narrative. I. M.
Suslov can be characterized as the patron
(if not patriarch) of sovietization in Even-
kiia. This is evident in his role as a cul-
tural broker, shuttling between tent life
in Siberia and the government meeting
rooms in Krasnoiarsk and Moscow.

The Culture Bases were never simply
implemented as demonstration villages, designed for internal and interna-
tional propaganda. At best the propaganda value of the Culture Bases was
a fortuitous byproduct of socialist construction, a convenient spectacle of
modernization that offered the always-popular visual juxtaposition of tra-
ditional and modern, wood and steel, simple and complex—these are visual
tropes which were central to Soviet cultural revolution as well as an emerg-
ing representational regime. The Committee of the North developed the
Culture Bases as a project that simultaneously satisfied the need to create
exploratory bases for resource evaluation and extraction in remote areas of
the North, to support the growth of a native intelligentsia through direct and
regular contact with ideological and procedural instructors, and to help guide
the general indigenous population out of their "backwardness" and straight
into modern industrial Communism.[230] The Culture Base was to be an elabo-
rate set that was mounted as drama and spectacle; it was an intervention that
relied on socialist realism's master plot of a triumph in a war against back-
wardness.[231] The temporal play of visual juxtaposition of primitive/modern
is important because the Culture Base was built as a satellite in what was
understood to be fundamentally anachronistic space. The Tungus Culture
Base—the seed for the so-called "city of the Tungus"—was the epicenter for a
new sociospatial relationship that remapped the landscape and monopolized
the mundane cartographies of everyday nomadic life as it was lived in the
northern forests.[232]

City of the Tungus

> We will give our children to be
> taught when the city is built.[233]

The Culture Bases built by the Com-
mittee of the North were different from
other colonial instruments of subjuga-
tion, assimilation, and rule (including
reservations, missions, and residential
schools) found in other parts of the cir-
cumpolar north. The Culture Base repre-
sented a modern socialist complex aimed
at raising the cultural [*kul'turnost*] level
across all aspects of life.[234] The "City of
the Tungus"[235] superceded the Culture
Base as the promised cultural, economic,
and political capital for Evenkis. It was
a direct result of implementing the na-
tionality policy cautiously advocated
by Lenin.[236] As I have noted elsewhere,
Soviet nationality policy was based on

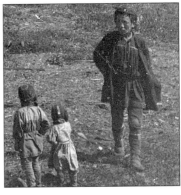

the assumption that the Soviet Union would be a multiethnic state, "that all
ethnic groups were entitled to their own duly demarcated territories, that
all national territories should have political and cultural autonomy, and that
the vigorous development of such autonomy was the only precondition for
future unity."[237] This was undertaken in a practical sense by developing a
broad base of support for Soviet power "beginning with the intelligentsia."[238]
Where there was no intelligentsia, one had to be made. The Culture Bases
fit into the scheme of the nationality policy by providing an environment
to foster and shape this new intelligentsia and to create the foundation for
a future national capital—a prospect that would be realized in the 1930s.
Mixing techniques of cultural amelioration developed for Russian peasants

with strategies for offering support to the
sympathetic intelligentsia of non-Russian
nations, the Committee of the North set
about their plan to build Culture Bases
in remote areas of Siberia that fell out of
the immediate influence of larger admin-
istrative centers.

The Tura Culture Base operated as a
locus for both Evenki and Russian imagi-
naries. It was productive of anachronistic
spaces that provided a foil for the bur-
geoning socialist realism and utopian dreams of plenty. Evenkis coalesced
around the carefully chosen locale of the Culture Base, which operated as a
dispensary for modern goods, services, and entertainment. They were fur-
nished with a radio station and photographic, cinematographic, and audio-
graphic gear, as well as a panoply of wondrous and strange devices needed
for medical and veterinary practice. Up to twice a year steamships could plod
against the strong current of the Nizhnaia Tunguska River, carrying laborers
and supplies of food and other things rarely seen before the late 1920s. It was
a spectacle, a sight to be seen—and one that was engineered to be seen, as
Suslov suggests in a guide he drafted, designating the proper themes and
subjects in the visual representation of the North.[239] Like a magnet, it drew
together new machines and new people. It generated promises and hopes,
some of which were fulfilled. Others were abandoned and festered into a
growing culture of cynicism. It also marked a bidirectional staging point.
Indigenous peoples who eagerly joined the brave new project—as well as
those who were co-opted into management, not to mention those who were
forcibly carted away for crimes or service—began their journey out of the
taiga at the Culture Base. It was the departure point where they embarked on
the future of Soviet modernity.

The new space carved out by the Culture Base had become a place in its
own right. It was constituted through an array of histories and intersecting
social relations. The rapidly increasing density of experiences associated with
the buildings, events, bodies, obligations, and promises located at the conflu-

ence of the Kochechum and Lower Tun-
guska Rivers marked the Culture Base as
a place where things happened, an epi-
center of sorts. In her exploration of the
idea of place, geographer Doreen Massey
describes scope and effect as elements in
the definition of place:

> one way of thinking about place is as
> particular moments in such inter-
> secting social relations, nets of which
> have over time been constructed, laid down, interacted with one
> another, decayed and renewed. Some of these relations will be, as it
> were, contained within the place; others will stretch beyond it, tying
> any particular locality into wider relations and processes in which
> other places are implicated too.[240]

As Massey's quote suggests, a place needs to be understood simultaneously
through spatial and temporal registers. The Culture Base was more than an
instance of Soviet colonialism; it was more than a cultural technology of
rule. As a focal point for historical inquiry it is useful, but only insofar as it
points out the myriad activities and movements of Evenkis and newcomers
as they renegotiated their situations vis-à-vis one another.

The Culture Base mattered also in terms of local-level allegiances and pol-
itics. Most importantly, it mattered as a dynamic site of affective and sensu-
ous encounter. Local people were relationally and spatially reorganized. The
Culture Base as complex apparatus mediated revolutionary change. In the be-
ginning there was nothing that compelled Evenkis to visit the Culture Base:
they went there of their own volition, some to satisfy curiosities, and others
to escape poverty, hunger, and sickness or to join in the construction of a
new world order. Multiple clans and families were brought together under
the organization of the Culture Base, which fostered an ethno-nationalist dis-
course that cut across clan and family affiliations, remapping identity accord-
ing to emergent expressions of modern ethnic national affiliation.[241] Local

politics began to reorient around this
disruption to established forms of power
and authority. The Tungus Culture Base
was imagined by its Soviet planners as a
cultural and political center for the Even-
kis as an emergent nation. The transition
and transformation from noncentralized
ethnic/linguistic group to a fully articu-
lated modern ethnic nation (under Com-
munist permissions) characterizes the
Soviet project, which actively sought to
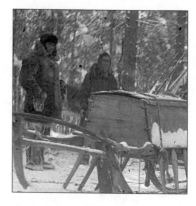
reinscribe the established rules and orders that governed life in the central
Siberian forests. The emplacement of the Culture Base was a crucial move
and an anticipation of a particular form of remote modernity that hybridized
techno-scientific practices and performances with reformulated traditional
economies.

In a 1925 meeting of the Turukhansk Executive Committee, the former
inspector Savel'ev disagreed with creating a single Culture Base to serve the
entire region. He is noted as saying that there should be not one but several
Culture Bases built to serve not only the Tungus, but also all the peoples of
the region. This position was also articulated in a 1928 planning document
from the Committee of the North: "For peoples who are very widespread,
split into several diverse branches, several bases are necessary."[242] Arguing for
several Culture Bases for a single nationality was at odds with one concept
of the Culture Base: as a staging point to becoming a national capital. In
the Soviet "empire of nations," each nation would be equal, and in the op-
tics of the state real "self-determination" was crucial. In the early 1920s, the
Communist Party affirmed that the "Soviet state would maximally support
those 'forms' of nationhood that did not conflict with a unitary central state,
namely national territories, national languages, national elites, and national
cultures."[243] In the context of "backward" national minorities, as I have
shown, the Culture Base would be the first step toward fulfilling this goal.
Thus ethnic groups who previously had little sense of themselves as modern
"nations" were directed in the appropriate ways of presenting themselves.

They were directed to think of themselves in terms of Marxist idioms of nationality born of Western philosophy and political thought.

Soviet writer Nikolai Nikolaevich Mikhailov wrote about the Culture Base in his English-language book *Land of the Soviets*. With characteristic promotional flair (not unlike descriptions of the Canadian North from this time), Mikhailov describes the Culture Base in action:

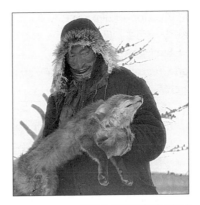

> When a hunter or a reindeer breeder arrives at the Culture Base, he is provided with food and a bed. He is taken to the museum showing the natural resources and economy of his region. He is shown the workshops, and if necessary his gun, sledge, or clothing is repaired. He learns how to look after the animals in a nursery, how to skin the animal and how to cure the skin, how to stock fish and how to treat sick reindeer. A physician examines the hunter in a clinic and gives him medication if he requires it. The new arrival goes to a bath, visits the cinema, and listens to the radio.[244]

What precisely did the herder or hunter think about being shown "the natural resources and economy of his region"? How bizarre it must have been to see newcomers take such a detailed interest in Evenki affairs and such an arrogant accounting of their lands. Whatever the perception of this queer spectacle on the part of the nomadic hunters and herders, it was soon evident that Communists didn't just come to dispense aid indiscriminately; they came to purify the Evenkis, whom they saw as having been polluted by centuries of

oppression under exploitative capitalism. As Ssorin-Chaikov notes, the condition of backwardness was marked—only second to capitalism—as the "state's most significant 'other.'"[245]

In the excerpt from a letter to the Committee of the North that opens this section, the Evenkis of the Turyzh clan are presenting their case against another Evenki clan. They are each vying for the Culture Base to be built in the their own territory.[246]

> We aliens—Tungus of the Turyzh clan, Ilimpei region all as one deliver our "thanks" to the Soviet government.
>
> We wish for a city to be built at the mouth of the river Tura. This is closer for us to come in the winter. The road is good and near. Tura we know . . . At Vivi a city is not needed, we have never been to Vivi. We do not have many reindeer. To go to Vivi is far.
>
> We need schools, we also need a hospital to heal people and reindeer. We need cheap bread and other products.
>
> We will give our children to be taught when the city is built.
>
> Turyzh clan meeting,
> January 13, 1926.[247]

Such proclamations of fealty to Soviet power are common in the archival documents from the 1920s and '30s. The exchange of children for access to the promised security of state sponsorship is particularly ominous in hindsight, knowing the degree to which everyday life was rendered under Soviet cultural reconstruction. By the time the first stage of the Culture Base was completed, some Evenkis had already begun to be incorporated into Soviet society. As I have noted above, the agitators and instructors had been working and consciousness-raising in the Turukhansk North since the October Revolution. It is impossible at this point to separate "genuine" expressions of

Soviet affinity from those voiced by the literate and typically nonindigenous secretaries that wrote such letters on behalf of nonliterate nomadic and clan soviets. The development of a fully invested Evenki intelligentsia was in full advance. Specialized training schools were being established, and Soviet culture was being fostered on an increasing number of fronts.

Building the Tungus Culture Base

> In the life of the Turukhansk krai, since the moment of its conquest by Russians, there has not been seen such work and such construction as is currently being undertaken by Soviet Power. By granting full political rights of small nationalities of the North, Soviet Power has fully raised the economic and cultural lives of the natives of the Turukhansk North. From eight different nationalities, with 15–16 thousand people nomadically travelling over the tundra and the forest-tundra on an area of approximately one million, six hundred thousand square kilometers.
>
> Work plan of the Turukhansk Culture Base.[248]

The Committee of the North expressed an interest in situating a Culture Base between the Enisei and Lena river basins in a place that would be an ideal staging point to extend permanent cultural aid for the local native population of Tungus[249]—"cultural aid" meant *pod'em:* cultural uplifting, with all its implicit connotations of progress and backwardness, modernity and tradition. The area between the Enisei and Lena Rivers was identified as a place that escaped the gaze of the state, where capitalism and backwardness could fester. The Tura Culture Base was located at a distance of around 2,700 kilometers from Krasnoiarsk in a location where around five thousand small, dispersed groups of Evenkis congregated.[250]

The location eventually chosen for the Tura Culture Base was at the

conjunction of the Nizhnaia Tunguska and Kochechum[251] Rivers. This was the location, or near the location, of a former trading post operated by an apparently exploitative trader. Prior to the revolution, at the mouth of the Taimura River, which flows into the Nizhnaia Tunguska River, the merchant [*kuptsa*] Suzdalev (or Savvateev) maintained a trading post [*torgovaia zaimka*].[252] A site for capitalist trade was also considered to be a good site for socialist enlightenment. At the apex of capitalism, Communists in Siberia routinely criticized trading posts as being an exploitative, cruel, and immoral form of social organization.

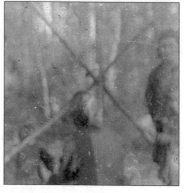

The site for the construction of the Tura Culture Base was chosen after a special expedition to the encampment of the Chapogir clan Evenkis who travel around the confluence of the Kochechum and Nizhnaia Tunguska, in the very spot where the Russian merchant, Tungusnik Savvateev built a cabin where he sold to natives. The natives traded their furs for flour, oil and other products.[253]

The elimination of the trading post and its replacement by the Culture Base must have been seen as a properly revolutionary act. Assuming the merchant's operation was truly exploitative, many Evenkis no doubt saw some continuity in the hegemonic presence of newcomers. But where one merely had the upper hand in exchange for foreign trade goods, the other undertook an audacious expansion of this monopoly that would supersede the traditional system of paths and replace it with new ways of being and new forms of sociality.

Constant Ethnographic Observation

The Culture Base promised to supersede the documentations and observations of earlier expeditions by offering a stable base for ethnographic scrutiny. The Culture Bases functioned as singular points of surveillance for great territories; their situation was critical. Locating the ideal location to service a broadly distributed population of mobile hunters and herd- ers was far from an easy task. One planning document from the Committee of the North emphasizes the uniqueness of the circumstances facing development in the Siberian North:

> Choosing the sites for a network of native Culture Bases in the North above all is dictated by ethnic details. . . . It is important to note that remote and out-of-the-way regions require a special approach rather than the typical approach to Soviet construction.[254]

As I note elsewhere, the Committee of the North attempted to draw attention to the distinct character of native minorities in the North. Remoteness was one of the defining features of projects undertaken by the Committee. In order to fully carry out its required tasks, instructions for choosing the placement of a Culture Base included:

1. Locating it at the heart of the bulk of nomadic natives.
2. Accommodating a large number of reindeer, including those in a reindeer nursery, experimental deer, reindeer at the veterinary clinic, and the reindeer of visiting natives. All of this requires the necessary pasturage.
3. In order to fully guarantee that the Culture Base has fuel and to achieve its tasks a site should be chosen that has a good forest (or peat or coal).

4. Must be able to develop ways and means of communication between the director of a Culture Base and the centers, which offer provisions.
5. The possibility of harvesting local sustenance (meat and fish).
6. Remoteness of the Culture Base to the most well known and already established places of trade (furs and wild deer).[255]

In the mid-1920s, engineer M. I. Penin was contracted by the Committee of the North to choose the site for the construction of the Tungus Culture Base. He writes that he received instruction from Moscow to search for a site for the outpost, with a comfortable route of communication that would become a cultural center that could serve the maximum number of Tungus natives who needed cultural and material aid.[256]

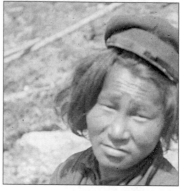

A 1925 meeting of the Turukhansk Executive Committee was called to discuss Penin's expedition to locate a site for the Tungus Culture Base. According to Penin's report, the Culture Base would concentrate on offering medical and veterinary services as well as a school. He also noted that the Culture Base could broaden the capacity of expeditions to explore remote areas of the tundra. It was further argued that scientific research at the Culture Base could speed up significant advances in reindeer hunting and trapping industries,[257] which were the most immediate way of incorporating and helping the Evenkis into socialist modernity.

In response to a claim that the central task to the Tura Culture Base should be cooperative and economic work, the future director of the Tura Culture Base, Filipp Babkin, responds that they are heartily interested in raising the

cultural level of the "aliens"[258] and that the central concern of the Tura Culture Base will be the reindeer economy. In the transcripts from this meeting one member of the committee states that the Culture Base would be a site for constant ethnographic observation.[259] This observation further demonstrates how the imbrications of ethnography and statecraft created a remarkable ethnographic laboratory for the study and transformation of culture. The Culture Base was an instrument in this laboratory, its purpose not only surveillance but also the enactment of an activist social science.

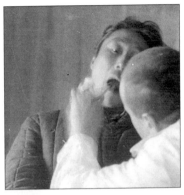

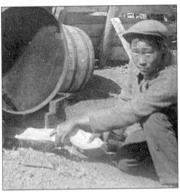

Another engineer, named Sokolovskii, was contracted to plan and build the Culture Base in Tura. The first stage of the Culture Base was to have three buildings: a veterinary station, a medical station, and a learning station.[260] Two steamers, the "Kooperator" and the "Dudinka," were sent to build the Culture Base in 1927. These boats carried workers and supplies. The construction crew was augmented with local Evenkis, some of whom had already settled more or less permanently in the area. It is proudly noted in the caption to one archival photograph that Evenkis helped to build the Culture Base, they were the first laborers, and they were paid the same as Russian laborers.[261]

Tungus Culture Base in Action

Let us hope that this young man will not become a shaman, as there is a centre of cultural work organized by the Soviet power at the mouth of the Kochechumo River, which is able to deter the ayami,

khargi and khovon, who are trying to settle in him.[262]

In the passage above, I. M. Suslov is making a reference to the Culture Base, which was at the time in its earliest incarnation. Suslov not only offers the nascent Culture Base as a prescription for "backwardness" but he also legitimates the Evenki worldview and spirituality through his recognition of their spirit world. In other words, for Suslov anyway, the battle between progress (Communism) and backwardness (shamanism and traditional forms of clan organization) was a battle between legitimate worldviews. There is little doubt that Suslov felt his worldview was singularly correct, but in this statement we see recognition of ideology and culture that was not ubiquitously held. It is an important nuance in mentality that does not condescend to Evenkis (and

Evenki ways of knowing the world); rather it attempts to work within their logical framework to undermine elements of Evenki spiritual culture that Suslov felt were disempowering forms of mysticism and false consciousness.

Crucial roles in the administration of the Tungus Culture Base were given to those with records of service to the revolution and the Bolshevik Party. The first director of the Culture Base, for example, was Filipp Iakovlevich Babkin (Red Partisan and hero of the civil war, former chairman of the Turukhansk Regional Soviet). While Innokentii Mikhailovich Suslov was another proven agent of socialism, his experiences and interests made him a relatively unique interlocutor. Whereas Babkin and others had shown dedication and loyalty as Bolsheviks or through their service in the Red Army, Suslov was also a

proven ideologue, scholar, and socialist
missionary. Vladimir Bogoraz, one of the
founding figures in Siberian ethnogra-
phy[263] (and a Bolshevik revolutionary),
described in 1925 a new program for
northern Siberia:

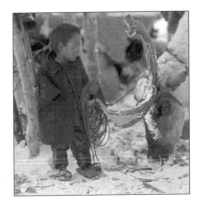

> We must send to the North not
> scholars but missionaries, missionar-
> ies of the new culture and new Soviet
> statehood. Not the old ones but the
> young ones, not the experienced professors but the recent graduates,
> brought up in the new Soviet environment and ready to take to the
> North the burning fire of their enthusiasm born of the Revolution,
> as well as the practical skills perfected by revolutionary work. Before
> they begin their work, these young agents of the Committee of the
> North must receive complete and thorough academic instruction—
> primarily in ethnography—but in the North their main work will be
> practical, not academic, in nature.[264]

Bogoraz could have been describing Innokentii Mikhailovich Suslov in this
passage: he was young, experienced, trained in ethnography, was proficient
in Evenki, was knowledgeable of the North, and was committed to practical
work.

In the same year that the construction crews arrived with materials to
build the Tungus Culture Base an epidemic of measles, transmitted through
Turukhansk, swept through Agata, Chirinda, Murukta, and Essei. A report held
in the Krasnoiarsk state archives notes that in 1927, 326 natives living along the
banks of the Enisei River and along parts of the Nizhnaia Tunguska river died
of measles.[265] While epidemics raged through the taiga, reindeer herders had
to contend with epizootics as well. Their reindeer were suffering from sickness
and disease. One of the first Culture Base meetings called together Evenkis liv-
ing in the area to talk about the mange, a sickness that was killing off their deer:

Comrade F.Ia. Babkin asked them "do you want your reindeer to be healthy?" the natives all answered "we want." "Did you understand everything that was said?" the answer: "we understand." . . . Beginning on the 2nd of December until the 12th of May from afar, by themselves and in groups or three or four people, there was an almost endless stream of visitors to the Culture

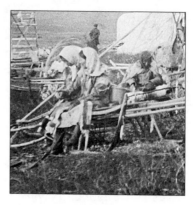

Base. . . . In all there were 84 visitors . . . from morning till night they were wandering around the buildings of the Culture Base . . .[266]

In 1929, in its second year of operation, there were 4,956 Tungus in the area of the Tura Culture Base. The Culture Base serviced 1,852 of them. Most of those not served by the Culture Base— that is, those who did not visit the Culture Base (either due to distance or refusal)—were from the territory to the south of the Nizhnaia Tunguska river, closer to the Podkamennaia Tunguska River.[267]

Many of the men in charge of the operations of the Culture Base had certifiable socialist credentials: the first director of the Tura Culture Base was the revolutionary F. I. Babkin. Babkin had participated in the Enisei uprising in the early years of the revolution and was active as a Bolshevik. The first doctors were S. N. Bushmarin, D. A. Kytmanov, and L. A. Simonov. They came to the Culture Base armed with an array of equipment not only for healing the bodies of the native workers but for conducting scientific experiments as well. They were physicians and adventurers. Apparently Simonov came to Tura as a doctor. One document, however, suggests he had a much broader interest: "Simonov didn't only heal and medicate, he also studied the people's language, folklore, and Evenki ethnography, knew songs, stories, legends, and history."[268] The veterinary support was identified as an essential part of the Soviet outpost and was a component in the rationalization of local economies. The first veterinary doctor was V. I. Pal'min.

Along with the veterinary center, the medical clinic was a crucial and relatively straightforward operation. That is, unlike the cultural-enlightenment projects—criticized for their weakness and failure of implementation by Babkin in his report on the 1927–1928 work year[269]—these operations had readily developed tools designed to meet the needs of the populace. This is not to say that the application of modern medicine was unproblematic. With forty to fifty percent of the Tungus suffering from tuberculosis,[270] there was an immediate and pragmatic call for efficacious cures. A resolution to the tuberculosis problem, however, has proven to be elusive, and the disease continues to disproportionately plague Evenkis and other northerners almost a century later.[271]

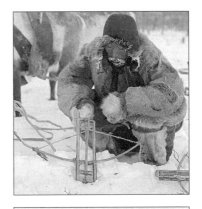

The immediate concerns of the Culture Base seem to have been medical and veterinary operations because of their relative ease of identification and the more or less technical resolutions offered. Though education was valued, it was less tangible and would pose different problems than the manifest and corporeal misfortunes of sick bodies. Most reports from the early years (until the early 1930s) are about curing sicknesses and fighting epizootics. The battle with epizootics and a reconstruction of the reindeer industry were targeted for expansion in anticipation that they would contribute to the economy of the fledgling state. Reindeer (more than furs and fish) were identified as the primary source of capital in the region. Indeed, trapping and the pelt industry are rarely mentioned in these early years—perhaps tainted through its association with tsarist imperialism, which built its system of dominance and exploitation around the production of animal pelts.

This, however, would not last, and fur farming would soon became an important (or at least symbolically important) component in the reconstruction of northern economies.

Enlightenment in the Cabin of the Native

The Culture Bases were engines of cultural transformation that were tied to a powerful mythology of socialist enlightenment. Consider the full title for the Culture Base: Institution of Cultural Enlightenment [*kul'turno-prosvetitel'nye uchrezhdeniia*]. Education and enlightenment were identified as primary tasks of the Culture Base. In the socioevolutionary rush to modernity, the indigenous minorities were seen to be in need of enlightenment and cultural uplifting. The liquidation of illiteracy and a broad program

of ideological construction were core activities undertaken in the full-service institution. The director of the Tungus Culture Base, F. I. Babkin, has left a trail through the archives that provides fascinating details of the day-to-day workings of the outpost. In the following passage, he carefully documents the operations of the Culture Base in a work plan for the years 1927–1928:

November
1. Opening of the night school for adult Tungus and Russians so as to evaluate the number of people interested in learning.
2. Prepared a report on the sovietization of the natives of the Turukhansk krai for the day of the tenth anniversary jubilee of October . . .

3. Opening of a library in the Cabin of the Native.
4. Organization of checkers and chess games in the Cabin of the Native with a maximal attraction of the natives.

December

1. Led a discussion whenever Natives arrive about the Committee for the Small Peoples of the Northern Borderlands.
2. Led discussions on medical questions.
3. Led discussions on the question of reindeer mange and the struggle against it.
4. Led discussions about why native co-operatives are necessary.

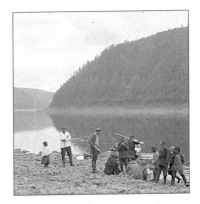

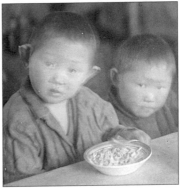

January

1. Led discussions on veterinary questions.
2. Led discussions on medical questions.
3. Led Lenin-day, prepared a report on the life and actions of Lenin.
4. Led discussions on shareholder co-operatives with many of them in the Integral [co-operative] "Chuvaka."

February

1. Led discussions on the Communist Party.
2. Led discussions on medical questions.
3. Led discussions on veterinary questions.
4. Prepared a report on the work of the Culture Base for the volost Native Congress.

March

1. Led discussions on medical questions.
2. Led discussions on how the Rights of Co-operatives are supposed to work.
3. Led the international day of women, 8 March, with a maximal attraction of natives. Prepared a report on the meaning of this day.
4. Led discussions on veterinary questions.

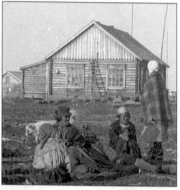

April

1. How should the Native VIKs work?
2. Which sicknesses are suffered in the co-operative and how do they need to be healed?
3. Led discussions on medical questions.

4. Led discussions on veterinary questions.
5. Prepared report on the results of the work of the residential school.

Culture Base director—Babkin.[272]

Rituals and routines stand out in this ledger. The thin description of what was a truly momentous year is vexing, though. While it is particular to life on the Nizhnaia Tunguska River, it is also comparable to other Communist development endeavors. Soviet cultural projects and the transformation of everyday life is described by Sheila Fitzpatrick as a litany of civilizational imperatives that includes: "spreading literacy, introducing hygiene, abolishing superstition, encouraging a rational scientific view of the world, discouraging drinking and wife-beating."[273] The Culture Base was a mechanism con-

ceived to deliver the formal imperatives of Soviet everyday life in regions that had heretofore fallen out of the pale of cultural construction.

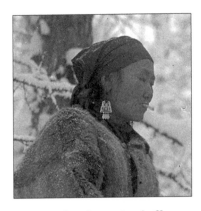

Comparing twentieth-century history of the Canadian North to Siberia, Dunn and Dunn[274] generously characterized the cultural revolution in Siberia as a program of "directed culture change." It was a broad and sweeping program of cultural modernization and sovietization, and the Culture Bases marked the first concerted and sustained effort to actually institute directed culture change among the natives.

> Native cultural bases have the goal of quickening and facilitating the attraction [*privlecheniie*] of small numbered peoples of the northern regions of the RSFSR to the general work of labourers in the Republics for the construction of Soviet culture under the conditions of national self-determination. In the future the cultural bases should become political and cultural centers for these nations.[275]

Alexia Bloch's book *Red Ties and Residential Schools* explores the Soviet system of residential schools that were established to educate the children of nomadic hunters and herders. These boarding schools housed Evenki children and educated them according to the latest pedagogical programs emanating from the central organs of Soviet power. Bloch notes that the residential schools "brought indigenous Siberians under the purview of the state, and more than any other institution, came to define the identities of the Evenki."[276] The intervention of the residential schools in the lives of young indigenous peoples was near total, but they need to be understood as part of the larger program of cultural change. The pedagogical assault on the young was formative and formidable, but it took place as part of a larger campaign to transform everyday life. In the rush to socialism it was deemed ineffective to educate only the children; everyone was required to participate in the project of cultural

modernization. The residential schools emerged out of the Culture Base. According to the construction plan reports, due to a lack of construction materials, the residential school, which was to be built in 1927, had been deferred. Nonetheless, with a teacher and teaching supplies they were able to begin schooling ten to fifteen Tungus in November of 1927.[277]

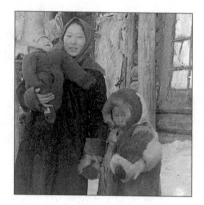

As I've noted above, Babkin complains in a report on activities for 1928–1929 that cultural enlightenment was the weakest of all the activities undertaken by the Culture Base. He ascribed this weakness to the "objective character" of the situation. The Tungus, he writes, are constantly moving about and are scattered and would only come to the Culture Base from time to time.[278] The best time for this work, he notes, is when the Tungus are sitting in one place—fishing, for instance—and they can be gathered together to talk to about various things; in the winter, this is simply impossible.[279] The revolutionary celebrations held at the Culture Base, however, attracted the Tungus, especially when there was food and gifts.[280] The complaint against nomadic mobility intensified the sense that nomadism was thoroughly incompatible with modern Soviet life. This is an example of the underlying ideology that would give rise to enforced sedentarization of the 1930s, along with the "rationalization" of the economy through the organization of collective farms and, later, state farms. As the Culture Base became a settlement, it provided the framework to advance the liquidation of nomadism and its replacement by industrially driven schemes of mobility.

By the time the Tura Culture Base was constructed, there was already a heavy concentration of impoverished [*bedniak*] Evenkis living near or along the Nizhnaia Tunguska River, where there were both fish and the possibility of receiving aid from Ensoiuz (Yenissei Union) or other organizations set up on an ad hoc basis to fight starvation exacerbated by epidemics.[281] A key component of impoverishment, of course, was immobility due to a lack of reindeer. The soviets seized on the idea that class war among nomadic

hunters and herders needed to be tied to reindeer ownership. Their surveillance practices in the first years tended to focus on the documentation of wealth accumulation in the form of reindeer. The Culture Base was thus an important tool not just for drawing in indigenous peoples for transformation and cultural purification but as a staging point to further penetrate the territory of central Siberia. By 1930, the Committee of the North 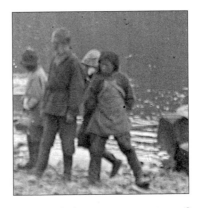 was calling for the collectivization of reindeer and the reconstruction of the rural economies. This centrally mandated dictation of economic reconstruction meant the subjugation of previously autonomous reindeer herding cooperatives. Such an act of overt transformation required policy and muscle. Anticipated resistance to the plan was dealt with by calling for the programmatic elimination of the wealthy classes [*raskulachivaniia*] through the liquidation of the kulaks and the rich.[282] Such class warfare or declassing was central to the first Five-Year Plan following the death of Lenin. The Communist Party under the leadership of Stalin began an intensification of centralized economic planning and acceleration of industrialization under the rubric of five-year plans.

Decisive Successes: Living Socialist Realism

The Culture Base was meant not only to draw indigenous peoples into Soviet modernity but also to function as a staging outpost for natural resource exploration. The scientific gaze that looked out from the Culture Bases sought glimpses of desperately needed resources that could help to fill the coffers of the Soviet Union. Of course, identifying potential founts of wealth was one thing; the real impediment was the challenge of expansion in remote places and environments challenging to industrial development. Rendering the wealth of Siberia visible was only the first step.

The role of the Culture Base and later the Evenkis' national capital as a

staging point for natural resource expe-
ditions presented a decisive rationale for
continued state subsidy and support. It
was a consistently circulated point that
Siberia contained untold wealth and
that the underdeveloped transportation
network[283] was the main obstacle to a
direct flow of wealth from the coffers of
the taiga and tundra. The Culture Base
offered an ideal staging point for geo-
graphical and geophysical expeditions.

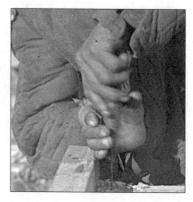

The pool of local experts as guides together with overland transport (rein-
deer) was essential for expeditions. The primary and most efficacious form of
transport in the taiga continued to be reindeer, which remained in the control
of indigenous minorities. Constantine Krypton, writing in the mid-1950s, also
notes this: "The only means for penetrating and crossing the northern spaces
are the reindeer, and they are controlled by the northern nationalities."[284]
Furthermore, the Culture Base offered a stable locale to store gear, recuper-
ate, and stage further expeditions.

The scientists who based their operations out of the Culture Bases were
not only mineralogists and other natural resource scientists. The Culture
Bases were also important for a whole generation of ethnographers who
made use of these remote outposts to launch ethnographic research. Sergeev
lists a number of ethnographers who made use of Culture Bases as stag-
ing points for their research: A. Apollov, I. Arkhincheev, N. Bilibin, N. Nau-
mov, N. Nikul'shin. He writes that prior to the Great Fatherland War, "the
so-called 'Culture Bases' were devoted to the study of general culture and
the culture of local nationalities, within the framework of Soviet reality."[285]
The broad mandate of scientific research was aligned to the enlightenment
commitments and aspirations of the Soviet Union.

In 1929, the Turukhansk District appears to have had four Culture Bases
(Turinskaia, Khatangskaia, Tazovskaia, and Piasinskaia). The Committee of
the North was moving ahead with their network of Culture Bases in remote
and out-of-the-way locales. They presented a plan to build sixteen Culture

Bases between 1928 and 1933, as part of the first Five-Year Plan.[286] In his work on art and propaganda at the time of the revolution and subsequent civil war, Richard Taylor describes the Russian Republic immediately after the revolution as a "vast country with a widely scattered population and a rapidly changing front [that] required above all a mobile and reliable medium of communication between the centre and the regions."[287] This was a situation that lasted only long enough to secure political stability. The goal was to establish more permanent organs of representation and power as quickly as possible.

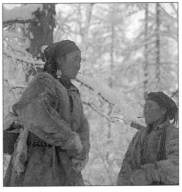

In the absence of any historical work on the Culture Bases, the passing references to this technology of rule have been reproduced over the years, for the most part, from secondary sources. The most significant of these comes from basic descriptions of the services offered by the Culture Base model in the publication of the Committee of the North entitled *Soviet North (Sovetskii Sever)*. Under the heading of "Evenk" in James Stuart Olson's *An Ethnohistorical Dictionary of the Russian and Soviet Empires,* the Culture Base is described in typical fashion:

> In 1927, the Soviet Union began establishing "Culture Bases" in Evenki territory. The first opened at the mouth of the Tura River in October 1927 and included a boarding school for Evenk children, a health clinic, a bathhouse, and a community center. A library and theatre were quickly added, and more Culture Bases were soon established for the Evenk.[288]

This imitative summary of what the Culture Bases offered is a repeated refrain, cribbed from official Soviet historiography. From their inception, the Culture Bases have been simply and inadequately described as a roster of services with the rough implication of state-sponsored indoctrination. Of the Culture Bases and other Soviet cultural interventions, Krypton notes the preparation of a special native cadre or intelligentsia was a parallel to the "re-education" of the northern nationalities through "Culture Bases, traveling so-called 'red tents,' agitation stations, lectures, and wherever possible, radio."[289] By the late 1940s, these interventions functioned as a kind of belated sovietization. Even the Tura Culture Base, which began operations in the late 1920s, represented a late intervention relative to cities and villages accessible by more conventional modes of transport.

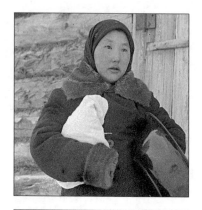

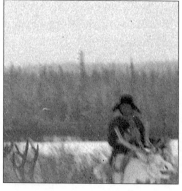

The bias toward Russian cultural expression and logics was at odds with the rhetoric of support for national autonomy. But Krypton is noting a significant change in state ideology. At least among minority native peoples, there was a strong effort to acquaint them "with the cultural achievements of the great Russian people."[290]

An example of the unacknowledged importance of the Culture Bases can be seen in P. L. Trofimov's article "The history of public education in Siberia at the time of the second Five-Year Plan (1933–1937)." Though he notes advances in the liquidation of illiteracy, giving statistical figures and context to the history of the literacy movement, he makes no reference to the Culture Bases in the construction of socialism in the North. He writes that according to the 1926–1927 Polar Census numbers, prior to the first Five-Year Plan, 13.6

percent of Evenkis in eastern and western Siberia were literate (twice as high as the rate among Nentsi, Mansi, and Khanti).[291] This date is significant, for it is the year before the construction of the Culture Base in Tura began in earnest. It marks a moment prior to the initiation of literacy education as part of a sweeping drive for cultural enlightenment. Furthermore, it is these statistics, among others, that were used to demonstrate the urgent need for state intervention.

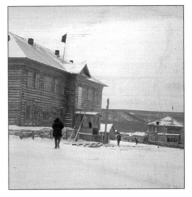

A. P. Kurilovich offered a description as well in his report on the Culture Base from 1928:

> What is the Tunguskaia Culture Base? The Culture Base is a cultural village: school, hospital, vet clinic, zoo clinic, house of the native, cooperative, Clan Soviet, meteorological station, banya, leatherwork shop, canning shop, radio station, reindeer and water transport, emergency grain-supply store, hunters supply, nurseries, etc. Agencies gathered in the centre of the Tungus nation, under the direction of the All-union Communist Party.[292]

To suggest that the Culture Bases were simply a kind of community center is to undervalue their vital role in the first stages of sovietization. In the Soviet view, the Culture Bases were engines of positive and progressive change. As I noted previously, Dunn and Dunn describe the project as "directed culture change." Is it more appropriate to speak of forced culture change or directed culture change? The nationalities policies and the basic ideological support for international socialism, as opposed to the more chauvinistic and fascistic

tendencies of the single-party state, deco-
rate this question with a variety of im-
portant differences. To be sure, there
were Evenkis who were very quickly in-
corporated into systems of governance.
This affirmative action to create an au-
tonomous and self-determining modern
political nation was a far cry from the en-
forced ghettoization and assimilationist
policies of the British Empire, the United
States, and Canada.

The infrastructure established in Tura, as in the other Culture Bases,
was staffed by Soviet personnel who were determined to encourage
literacy, instill European ideas of hygiene and medicine, promote
new veterinary cures for reindeer, and create structures for indige-
nous self-government. The system of residential schooling, as one
component of the 1920s culture bases, was meant to funnel children
from their herding groups into town centers for education.[293]

This repetitive list of features was not only a casual recitation of features of
the Culture Bases; it also referenced earlier cultural-enlightenment projects.
The list of features is remarkably similar to that noted by Richard Taylor:

... the design included a library, schoolroom, canteen, cinema and
stage with, for larger centres, the addition of Komsomol and party
rooms, a chess room and a music room; in many ways they resem-
bled a modern community centre in their amenities.[294]

This kind of a list might be seen as a literary subgenre, the intended effect
being a recapitulation of Soviet achievements and advances—a kind of man-
tra for success. This description of the Culture Base is formulaic and appears
over and over again in the literature.[295] In a similar fashion, the Culture Bases
themselves were formulaic; they were essentially a Communist franchise for

sovietizing remote regions of Siberia and the Russian Far East.

In *The Road of the Northern Peoples to Socialism* (1971), Evenki author V. N. Uvachan wrote in a celebratory tone that "The Evenkis, in a single nomadic migration, crossed a mountain of one hundred years from clan organization to socialism."[296] The language of Uvachan's book is typical also for its formulaic praise of the Soviet state. Bruce Grant has noted that native

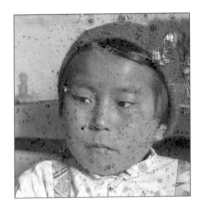

voices for most of the Soviet era offered "effusive testimonies to the success of Soviet government, which tell us mainly about the formulae of patriotic texts."[297] A more or less typical example follows:

> We, the Tungus of the district of Agata, recognize Soviet power as our working people's power, we need it. . . . Soviet power does not allow the poor to be cheated, it looks after all peoples. . . . The Tungus meeting of the Turyzh clan regards tsarist policy as unjust. We heartily greet the Russian workers and peasants who have overthrown the tsar and the bourgeoisie. The meeting expresses its belief that communists and Bolsheviks are the real defenders of the working people.[298]

V. N. Uvachan was in a fairly unique position as a representative of the native intelligentsia. In the foreword to *The Peoples of the North and their Road to Socialism*, Soviet historian A. P. Okladnikov writes of Uvachan: "This son of an illiterate Evenk hunter became a college instructor! Those who regarded the Tungus as an inferior people, doomed to perpetual backwardness, would have never believed it."[299] Whereas many early native voices were more or less ciphers (editorially selected, transcribed, and represented by nonnatives), Uvachan carried the authoritative weight of ethnic belonging; furthermore, he was not only a "voice" but an author, if one who was fully committed to the narrative of Soviet enlightenment. Notwithstanding some Yakuts

(Sakhas) living on Lake Essei,[300] the Tura Culture Base was, for most purposes, an Evenki (or "Tungus" as it was typically called then) Culture Base. But it was not just an outpost for reindeer herders; it was to be the Tungus city, the national homeland for the Tungus—soon to be fully modern Evenki—people.

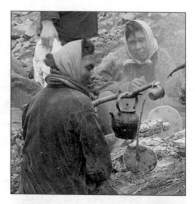

The Culture Base is a widely cited example of Soviet modernization projects in Siberia. Given its importance as the largest material intervention and the first real staging of Soviet power and ideology in remote locales, it is a remarkably understudied institution. Though it is widely acknowledged and referenced, the Culture Base has not been explicitly studied. It exists largely (in both Soviet and Western scholarship) as a portable list of services. As I have shown, it was much more than this—not only a technology of surveillance but also a care-

fully constructed apparatus for cultural transformation. Many of the Culture Bases seem to have simply transformed into settlements and villages. "Soon the bases became real towns, 'centers of economic and cultural life' of the northern peoples."[301] Some, such as the Tura Culture Base, became administrative centers of the autonomous ethnic regions. Over time as industrial mining and exploration expanded, waves of foreign workers and their attendant support structures arrived.

It is important to consider at this point how little the Culture Bases have been explored in the historical literature. The reason they have not been recognized and studied as critical moments in the northern cultural revolution might include the fact that they were by and large ephemeral; they were a staging process and may be seen as only a bureaucratic detail. Within ten

years most Culture Bases had become villages, towns, and administrative centers. The entire project of sovietization of remote areas of the North is the principal story, but the Culture Bases mark the beginning of this story insofar as they were the first concrete signs of state presence. Although the Orthodox Church had built missions (Turukhansk) and chapels (Essei, Chirinda) and the market system under tsarist rule had produced irregular trading posts (often nothing more than small cabins), it was with the construction of the Culture Base that the Evenkis experienced a truly sustained presence of Russians and other Europeans.

Along with the Culture Base came new demands for compliance. The old system of "princelings" and tribute payments was replaced by chaotic regimes of collectivization, taxation, debt relief, state gift giving, and residential schools.

The new Soviet life was characterized by constant shifts in policy and performances of reward and punishment. It offered sustained support in the form of grain-supply stores and warehouses (though not richly provisioned), as well as regimes of entertainment and enlightenment that included reading corners, clubs, movies, music nights, and schools. Emergent socialist codes of behavior were more deeply and profoundly applied than those of the old church. Advocating for the rights of women, the necessity of scientific education, and ideological consciousness-building were all part of the new ordinary.

One of the most profoundly interesting questions is one that cannot be answered in this work: what did the Evenkis think of all this? What did they make of the parades? There are, to my knowledge, no Evenkis who have

written counter-narratives to the domi-
nant mythos of socialist salvation from
primitive ignorance and poverty. The
Hobbesian notion of "primitive" life as
nasty, brutish, and short continues to hold
power through analogy in the historical
imaginary of many Evenkis with whom
I have spoken. Indeed, almost fifty years
after the anthropologist Marshall Sah-
lins proposed the idea that hunters and
gatherers were the "original affluent so-

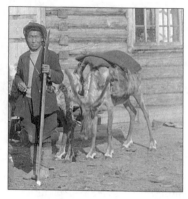

ciety,"[302] the mythology around pre-Soviet life continues to denigrate indige-
nous peoples and economies in Siberia. The offers of state support and the
imperatives to adopt new ways of living were most likely a spectacle observed
with as much interest as it was with circumspection. There had, however,
been several generations of Evenkis acquainted—albeit to a much less inten-
sive degree—with Russians and with indirect rule in the form of demands of
tribute payments, support for the church or mission, and so forth. If trade was
never undertaken on equal terms for the Evenkis of eastern Siberia, it was
nonetheless cast as trade.

The new conditions brought about under socialism were something al-
together different. The means of production would be collectivized and the
collective wealth handed over to the state for redistribution. Reindeer, traps,
rifles, fishing gear, and tents were donated to (or appropriated by) the new
collective farms and state farms, only to be redistributed again on new terms.
The modification of class structures for the result of cultural and economic
restructuring followed the lines of imposed hierarchies from the tsarist era.
Dunn and Dunn note:

> These features, particularly the artels [co-operatives], were used
> by the soviets as a basis for reconstruction. For instance, reindeer
> herding brigades were at first set up along clan lines even in kolkhozy
> [collective agriculture] where a number of clans were represented.
> It was found that in one clan brigade the earnings were being shared

out equally, according to clan cus-
tom, rather than being allotted on
the basis of work actually done . . .[303]

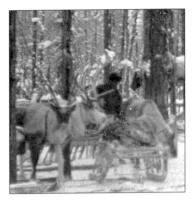

Soviet authorities used sovietization to
demonstrate to themselves and the rest
of the world how generously the state
cared for the well-being of the indigenous
peoples and minority ethnic groups.[304]
Their work was compared with capital-
ist imperialism and the persistent colo-
nial regimes of the early twentieth cen-
tury. Siberia was alternately seen as an
indivisible part of Russia (and hence not
colonialism at all) or as a site of Russian
socialist benevolence, whereby Commu-
nists worked to raise the cultural level of
the primitive and backward peoples to
that of the modern partners in the Soviet
project. This later point was explicitly
weighed against the histories of discrim-
ination, conquest, and outright genocide

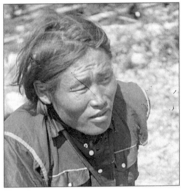

that were generated in other colonial encounters. In this context colonialism
carried its most pernicious and polluted connotations. It is ironic, then, that
in some cases the term was used, albeit in a carefully circumscribed manner,
by Communists to describe their own projects.

The Marxist-Leninist focus on international Communism gave way to a
surge of Russian chauvinism under Stalin in the 1930s. The first years immedi-
ately following the October Revolution were concerned primarily with offer-
ing material aid and securing the borders against opponents to the Bolshevik
Party. After the end of the civil war, with the advent of the Committee for
the Assistance to the Peoples of the Northern Borderlands, the policy toward
indigenous minority groups shifted to fostering local elite and drawing them
into the lap of Soviet culture. As Shnirelman writes, "From the late 1930s the

main goal of the central authorities was
to finalize integration of the ethnic mi-
norities into mainstream society."[305] The
more militant interventions came in the
1930s and '40s with rapid economic ratio-
nalization, nationalization of property,
the intensification of the struggle against
so-called kulaks and shamans, and forced
labor to support the defense of Russia
against the menace of invasion by Ger-
many and Japan.

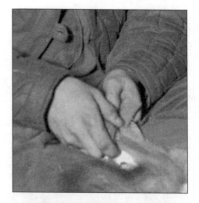

In the first years following the Octo-
ber Revolution in the Turukhansk North,
the management of industry and wealth
distribution under a nascent bureaucracy
had led to considerable overlap and con-
fusion over jurisdictional boundaries and
policy enactments. The Committee of
the North had been created to give some
supervision to the expansive northern
lands of Siberia and the unrepresented
indigenous minorities living there. The

committee's initiative to create cultural bases as sustained technologies of su-
pervision and intervention established critical inroads for cultural transition-
ing. The completion of the first phase of the Tura Culture Base in 1928 coin-
cided with an ambitious project to overhaul the economy of the Soviet Union.

A five-year plan developed in 1927 proposed a universal project of recon-
struction, modernization, and industrialization that was dictated by resolu-
tion of the Central Executive Committee in Moscow. This became known
as the first Five-Year Plan (1928–1932). At this time, under the increasingly
autocratic rule of Stalin, the economic planning and development of the
RSFSR became more and more improvisational, acquiring "a dynamism of
its own."[306] At a time when local representations of state institutions and
bureaucracies were becoming entrenched and pervasive, creating a kind of

stable government presence, policies es-
tablished by an increasingly centralized
government created an environment of
near continual reinvention and instability.

Sheila Fitzpatrick has written that the
"transformational rhetoric of 'mastering'
[*osvoenie*] the vast underdeveloped re-
gions of the Soviet Union" thinly veiled
the fact that "its 'backward' targets were
often explicitly identified as non-Russian,
and the reality of the situation was that a
model from the (Russian) capitals was being brought, with crusading zeal and
sometimes with violence, to the (largely non-Russian) hinterlands."[307] As I
have shown, the imperialist rhetoric was already present in the Soviet enlight-
enment projects. The perception that Russia was in an economic crisis due to
cultural stagnation became a matter of national security. The RSFSR's hinter-
lands were the most "underdeveloped" territories, distant from navigable
waterways and other systems of communication and effective surveillance.
The transformational rhetoric of the first Five-Year Plan supported the efforts
of the agitators, inspectors, and instructors who set out to survey and remake
Soviet Russia's largely unknown inland empire of the Turukhansk North.

The increasing centralization of state power and policy under Stalin was
at odds with stated efforts to build and foster semiautonomous socialist na-
tions. While the rhetoric of socialist internationalism was not diminished, the
capacity for anyone other than the Russian Communist Party to offer di-
rection in the project was increasingly weakened. The general character of
social transformation and economic reconstruction in the North appears to
trace a line toward the implication of indigenous peoples in the surge toward
universal sovietization. Joseph Stalin's rise to power, for example, marked the
beginning of the end for the "ethnographical approach" to northern devel-
opment.[308] The Committee of the North was no longer able to act as a buf-
fer to the state's headlong rush to modernization, easing nomads through
evolutionary stages and honing national consciousness and identity. Under
Stalin a new Russian chauvinism emerged that tended to equate progress

with Russianness, which according to
Slezkine "was assumed to be largely trans-
parent, meaningless, and therefore equal
to modernity (the default culture, as it
were)."[309] Non-Russian cultural manifes-
tations tended to be seen as backward and
abhorrent when they were not directly
mirroring the Russian tinged cultural or-
thodoxy of socialist modernity. In many
ways, though not all ways, the interna-
tionalism that had been a part of the ear-

lier revolutionary cultures and movements fell away. Fitzpatrick notes that
the cultural revolution "unleashed a utopian internationalism opposed to
all national cultures and, above all, Russian culture."[310] The fear of Russian
chauvinism was noted by Lenin, who argued that Soviet internationalism
needed to actively avoid a noted conservative tendency to privilege Russian
culture. After Lenin's death, however, this began to change. "Though it was
still claimed that all nationalities were treated equally, by the late 1930s, refer-
ence to the 'leading role' of the Russian people in Soviet society had become
common."[311] The rise of Russian chauvinism in the 1930s, while tempered
by official policies of internationalism, was largely unabated due to its he-
gemony within the ruling elite of the RSFSR. Thus, by the mid-1930s many
forms of internationalism were scuttled and a new program of "Russifica-
tion" was unleashed in a "great retreat" from a nationalities policy that did
not give primacy to Russian culture.[312]

In 1931, the Tura Culture Base became the capital of the newly formed
Evenki National District. The transformations in Soviet policy under Stalin
re-visioned the character and direction of the Soviet Union. In a speech from
1931, Stalin stated: "We are fifty or a hundred years behind the advanced
countries. We must make good this distance in ten years. Either we do it, or
we shall go under."[313] In the 1930s, investments of capital for infrastructure
development of natural resource extraction had intensified. The journal for
the Committee of the North, *Sovetskii Sever*, documents the increases and
intensifications of development and resource extraction for this period. In

addition, the journal outlined cultural advancements and successes in the North.

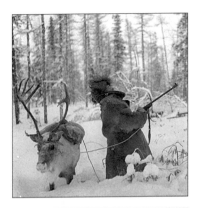

The cultural bases represented a moment of Marxist-Leninist internationalism that gave way under Stalinist autocracy to a Russian nationalist chauvinism. Sovietization shifted its emphasis from the development of instruments for co-optation and cultural promotion to instruments of forcible culture change. This shift, however, was tempered by the continued reliance on the rhetoric of equality among nations and the national mythology of progressive Communism. National self-determination had become the founding narrative of the Soviet Union; its progressive rhetoric was aggressively promoted within and outside the state. The actualization of this in central Siberia finally arrived with the establishment of National Districts. The Evenki National District was officially

formed on December 10, 1930, with Tura as its administrative center. Ultimately the Tura Culture Base saw only three years of full operation before it was refashioned into a national capital. The transition from cultural base to administrative center meant increased statewide recognition. The implication of this was a greater degree of state subsidization but also an increase of scrutiny and an overall increase in the intensity of external intervention.

Evaluating the lack of actual autonomy of the National Districts does not preclude consideration of some of the significant benefits. Even in the absence of actual autonomy or *real* self-determination (instead they received a quasi self-determination within a highly structured and limited field of possibilities), the affirmative action of the state created opportunities and delivered services and support that were unimaginable in other areas of the

Soviet Union and that had never before
been offered to indigenous peoples of the
Turukhansk North. The rapid incorpora-
tion of indigenous peoples into a leader-
ship cadre alongside the development of
indigenous intelligentsia has made it im-
possible to make any kind of pronounce-
ment concerning state colonial domina-
tion. Soviet nativization [korenizatsiia]
was specifically designed to implicate
non-Russians in the Soviet administrative
apparatus. "The nativization policy was a
clear attempt to create, with the utmost
speed, a larger and better educated labor
force so as to rapidly industrialize the
country."[314]

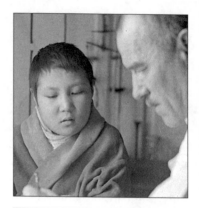

A cadre of Evenki intelligentsia was
already in training when the Culture
Base was built. The first group of stu-
dents (including V. N. Uvachan) began
studies in Irkutsk in 1928; soon fluent
speakers of Russian were participating in
the administration of the Evenki Autonomous District. They became the
cultural brokers for their brethren—though the field of articulation of spe-
cific needs and political direction existed in an increasingly limited horizon
available to nominally autonomous regions.

By the 1930s, the Soviet Union was deeply engaged in the performances
of modern statehood. It crafted its identity through both internal and inter-
national discourses. The Soviet Union's social imaginaries and their inter-
pellated audiences produced a number of registers through which subject
positions were established. Direct and sometimes brutal state power was off-
set by diffuse implications of social actors, all of which were filtered through
collective experiences and aspirations. Spectacular feats of industrial progress
were often at the forefront of national mythographies, which were more or

less reliant on the foundational story of revolutionary triumph over nonprogressive traditions. Maurice Meisner notes, "Lenin always deplored Russia's cultural backwardness—and, indeed, at the end of his life partly attributed the spiritual and political degeneration of the Revolution to the lack of *kul'turnost* [culturedness]."[315] In this sense, *kul'turnost* can be seen as an intimate branch of sovietization that above all else valued an enigmatic and effuse sensibility that would temper bare commitment and sacrifice. "In the 1930s, proper behavior and deportment were nearly as important as one's class origin. Good Soviet citizens did not drink to excess, were tidy and dressed appropriately for the occasion, maintained a good household, were polite and courteous, and more."[316] Photographs taken at the Culture Base in the 1930s bear testament to the new Soviet in-

ducements to a "cultivation of the self." Images of well-dressed, happy, docile, and engaged Evenkis are numerous. Education and culture were an important gift of Soviet civilization bestowed upon the indigenous peoples, and they were expected to be grateful to receive it.

Siberia, as I have shown, offered a provocative illustration of Soviet power. Vast geographical distance, cruel inequalities, deeply spiritual beliefs, and an ignorance of the "outside world" presented a formidable, if often fabulous, opponent. The tropes of triumph that reinforced the apparent successes of Soviet modernity abound. Geographical expeditions and the scientific development of new technologies came together with major long-distance flights that were publicized as the victorious annihilation of space. More than this, the extremes of the Soviet Arctic presented another degree of challenge. One

class of cultural revolutionaries working on the front for sovietization were the so-called heroes of the air whose "polar exploits were featured almost endlessly in the mass media."[317] In the central Siberian North one of these pilots was Jan Stepanovich Lipp. Along with land and sea-based polar explorers, Lipp participated in the production of a new narrative of Siberian mastery.

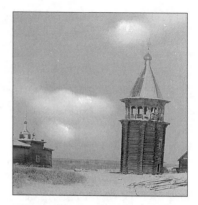

In 1935, Lipp made a stopover in Tura on one of his aerial expeditions. In a plywood open-cabin Polikarpov biplane, he navigated an aerial route from Krasnoiarsk to Tura. This first aerial vehicle to appear in Evenkiia reinforced the Soviet narrative of progress. The victory over space was significant not only as a propaganda exercise but as a matter of state rule. The impracticality of governing the boundless inland territories of Siberia through steamships and reindeer routes

was more than a little incongruous with the self-image being crafted by the state. Long-distance air travel was clearly more than a promotional stunt; it had the additional goal of extending the capacity of the state to survey its most remote territories. Finally, the graphic effect of representing these new "aerial routes" on maps threaded together developing capital regions, legitimizing them and cementing them in the popular imaginary.

Just as the Soviet Union crafted its identity in its mission, Tura and the Evenki National District were encouraged and instructed to do the same. The program of official national identity construction included support and promotion of national languages, arts, economies, schools, libraries, and archives. The status of a National District carried with it the expectation to adequately perform the rituals of state representation. Such performativity

included the preliminary services offered
through the Culture Base (school, physi-
cian, veterinarian, library, theatre, post,
and so forth), which institutionalized
novel rituals and celebrations, many of
which are documented in photographs.
The modern nation required a press as
well. In 1933, a regional newspaper was
established: *Evenki New Life*.[318] From
its inception, it featured articles in both
Russian and Evenki, thus marking a clear

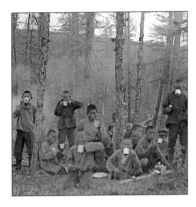

commitment of the Soviet state to support the capacity of nations to develop
their own (limited) autonomy. Radio communication was well established
by this time as well and was beginning to find its way to connect remote
communities with Tura, the regional center. One example of this is a re-
quest from 1934 to have a radio tower built in Chirinda, the center for a native
soviet [council] located several hundred kilometers north of Tura. Chirinda,
along with other small waypoints and nascent villages, was recognized as
an emerging center of native life in its own right, which required more than
the weak connection of a postal system reliant on reindeer caravans.[319]

Yuri Slezkine argues that while the Committee of the North was com-
mitted to the idea of long-term education, it was never fully implemented be-
fore the committee was liquidated.[320] The idea was not entirely abandoned;
rather, the institution and to some degree its vision for cultural transformation
were forsaken in favor of more aggressive forms of culture shaping. For the
most part the focus was on education and sedentarization of nomads, though
various attempts to support migrating schools were experimented with. In
1930 a request for three thousand rubles to maintain the "Red Tent" program
in the Turukhansk region was submitted to the ministry of education.[321] The
Soviet government "worked out written alphabets for these groups and es-
tablished numerous schools and cultural bases in the different National Dis-
tricts."[322] The progress was by no means straightforward—the Great Father-
land War interrupted Soviet industrialization, and the total restructuring of
the reindeer economy in Evenkiia was not fully realized until the 1950s and

'60s. Despite great pronouncements of expectation and achievement, development in the Turukhansk North rarely lived up to the hype. Decisive successes described by V. N. Uvachan were not revolutionary but were instead the result of a decades-long quasi-systematic project of cultural shaping. Kolarz comments on some of the problems in articulating the state's plans for affirmative action:

A school inspector of the Evenki National Area still complained of the "acute shortage of national teaching cadres." These cadres were trained by the teachers' training college of Igarka, but hardly any graduates came from there into the Evenki area. Nor could the Evenki area send anyone to the Leningrad Institute because no young people with sufficient education were available. Under these circumstances, said the inspector, the overwhelming majority of the teachers in the Evenki National Area were Russian, of whom only a few had good command of the Evenki language.[323]

Sovietization was about the construction of a new social body. It involved a radical restructuring of social relations that actively sought to draw in the most disenfranchised of people living in the realm of the Russian Empire. The Communists were not only concerned with the construction of this new body, from the individual to the collective and from the cradle to the grave—cutting right through cultural, ethnic, clan, tribal, and familial ties—they were also concerned with making this transition as dramatic and celebratory as possible. The Soviet cultural revolution[324] in the North linked political change to all aspects of life, implicating material and spiritual culture as well as social relations. Sovietization was centralized, and it was paternalistic. Decrees, mandates, and protocols were communicated to the remotest outposts. The wild documents sent back from remote cooperatives and fledgling settlements are some of the most remarkable artifacts to be found in the archives today. They are few in number

but stand out as unique, if ambiguously authentic, expressions.

While great Soviet exhibitions are often lauded for their spectacular displays of socialist aspiration and triumphalism,[325] there were myriad localizations of cultural-enlightenment work. Libraries, museums, school entry halls, and former churches were appropriated as public spaces suitable for propagandizing the masses. In 1930, when I. M. Suslov was head of the Krasnoiarsk Committee of the North, he developed a museum exhibition that would celebrate "five years of activity for Soviet power in the North."[326] It is unclear if this exhibition was ever mounted, but as a point of fanciful historiography, we might imagine what this show would have looked like in 1930.

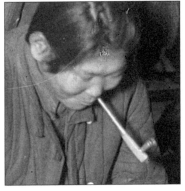

The first Five-Year Plan was coming to a close, as was the tenure of the Committee of the North. Fifteen years of violence and turmoil caused by social and economic reconstructions were represented through the filters of propaganda and socialist realism. These representations produced historical mystifications and alchemical transformations of memory and experience. Class war mixed liberally with a war on perception. It must have generated a kind of profane illumination—the world as remembered through the greasy lens of postrevolutionary Soviet imagineering. Through exhibitions as well as posters and other circulars, both history and the everyday were refashioned as sites of perpetual exploitation and struggle. Soviet modernity delivered a new symbolic order that collapsed time and difference. Bolstered by the triumphs of the Communist Party, Soviet modernity was propelled by revolutionary zeal and righteous momentum; it offered a narrative of mastery and messianic inevitability. The mundane experience

of everyday life in the Turukhansk North was drawn into a charged moral field of stagnation and progress. The projects of cultural enlightenment were pervasive, though not always necessarily persuasive. Regardless, these projects were backed by the unprecedented investments of a state that had suddenly become preoccupied with each of its citizens. Bureaucratic organizational culture—the institution-alization of power through the rationale of paper, communications, and archives—was the unmarked category of order upon which Soviet modernity and socialist realism were staged. Even in the most remote depths of primeval Siberia, socialism was performed in a spectacle of colored posters, new technological artifacts, and the looming promise/threat of overwhelming change.

Dangerous Communications

Archival photographs are like any artifact consigned to a museum, archive, library, or collection—whether they are carefully wrapped, labeled, and placed in archival-grade boxes, or casually stacked in a corner amidst other historical debris. They lie mostly unknown and ignored until a day comes when they might be pressed into service. Archival photographs are brought into the light by someone preparing a monograph, research report, calendar illustration, slide show, exhibit, article, or argument, and then circulated and seen in

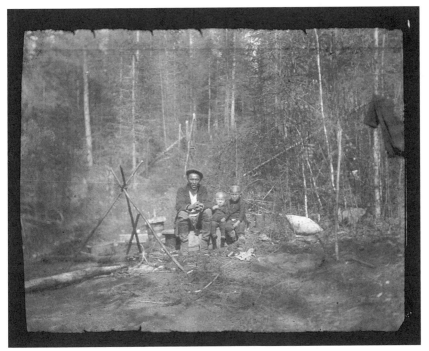

Figure 9. Portrait at a "stopping place" in the taiga. Image courtesy Krasnoiarsk Krai Regional Museum.

ways that neither the camera operator nor the photograph's subjects could ever have anticipated. Discrete histories of photographic encounter and reproduction outlive individual lives and institutional memories. The myriad encounters between spectators and images are generally unaccounted for, their relational proximities rarely more than ephemeral or momentary affairs which leave few traces, if any at all.

The photographic negatives held in the Krasnoiarsk Krai Museum and Tura Archives depict scenes of everyday life in Siberia in the first decades of the twentieth century. As artifacts of institutional archives, negatives and their print and digital surrogates function as agitational agents with the capacity to frustrate the words that we use to construct and contest the past. While focusing on this revolutionary and tumultuous period of Siberian history, my goal is also to draw attention more generally to how the project of writing the past is affected by the circulations and noncirculations of archival photographs.

This study of photographic circulation and representation begins with an exploration of the historical circumstances surrounding the production of photographs in the first decades of the twentieth century. I look at the sites of photographic encounters in Siberia and explore the implications of their subsequent circulations and trajectories, of the paths they took to the archives, where they have been kept, and beyond. The photographic encounter can be defined in two principal categories. The first order is defined as the photograph's originary event: the exposure of a light-sensitive plate or film to a scene. The second is the diffuse and intimate aggregate of (equally site-specific) encounters between spectators and the image-instances.

In 1917, indigenous peoples were "liberated" by Bolshevik revolutionaries and became the target of highly ambitious programs of radical cultural change that sought nothing less than the transformation of everyday life and which included the cultivation of native leaders and representatives. While there is a powerful critique of the Soviet regime for its oppressive techniques of domination,[1] the rhetoric of liberation should not be read as merely a cynical linguistic trick. For all the implicit and explicit critiques of the Soviet era, the Communist Revolution was not a simple exchange of colonial masters. Rather, it brought into existence an entirely new paradigm for struc-

turing intercultural relations, exerting state power, and enacting everyday life. This new paradigm was forged under the rubric of Soviet Nationalities Policy—a bureaucratic, philosophical, and political challenge for the Bolsheviks, who conceived autonomy on a "national" level. Nations, in this sense, were defined by convoluted historical, linguistic, and cultural divisions. As I have noted elsewhere, the ascription of nationhood to groups of people who defined themselves principally along clan lines was rarely easily achieved. The new paradigm, however, was based on a much more profound revolutionary élan and zeal for collective emancipation.

The transition period following the 1917 revolution and subsequent civil war (1917–1921) was described in the language of the day as an era of socialist construction [kul'turnaia stroitelstva] and, later, sovietization [sovetizatsiia]. It was a process broadly understood to be advancing the collective of nations on a singular path of development toward a future form of Communism. In the northern forests of Siberia, sovietization took the form of both economic modernization and state-sponsored evolutionism,[2] articulated according to the "Marxist-Leninist norms of social, economic, and political behavior."[3] Men and women acting as Soviet agitators, revolutionaries, and cultural workers dispersed across the Siberian North, tasked with the goal of asserting Soviet dominance and power through the establishment of Communist ideologies. The terrain was hardly certain, though, and historian Abbott Gleason has characterized the Bolsheviks' position as "extremely precarious" in this era.[4] While these agents of Communism were active in all corners of the former Tsarist Empire, the ruling Bolshevik party continued to develop programs of rapid economic modernization. The programs were designed to permanently transform the so-called backward economies of the region. In effect the burgeoning Soviet regime implemented a new form of colonialism, though it took pains to distinguish itself from the imperialism of the tsarist era. Socialist colonialism in the Siberian North was characterized by social and industrial development that sought the rapid incorporation of indigenous peoples into the state project.[5] It was distinguished from colonial projects in other areas by the radical cultural-evolutionary leap into high modernism that was expected of the "natives."

Evenkiia is located in the geographical center of the Russian Federation,

and in the early twentieth century it was generally known as the Turukhansk North (or sometimes the Enisei North). It is a vast boreal landscape located between the Enisei and Lena Rivers, a great distance from both minor as well as major hubs of transportation and cultural exchange. Small cities like Ekaterinburg, Novonikolaevsk, Irkutsk, and Krasnoiarsk had grown up along the Trans-Siberian Railway. They were connected to the flows of global culture: trading in practices, performances, and commodities that connected them to the great metropolises of the day. Images, ideas, and things circulated not only through Moscow and St. Petersburg but also Paris, London, Vienna, and Berlin. The Siberian North, however, remained remote from these cultural influences, largely because of a poorly developed system of mechanized transport. The primary means of communication in the Turukhansk North was the Enisei River, which flows north to the Kara Sea. Steamers navigated the Enisei but rarely travelled up its tributaries, which were treacherous with seasonal variations in water flow and made worse by the hazards of unmapped rapids. Rivers like the Podkamennaia Tunguska and Nizhnaia Tunguska were only accessible by small boats pulled by hand, rowed with oars, and aided by sails. Many of the smaller tributaries (such as the Olenek in Yakutiia) were not mapped until the Soviet era. Beyond these rivers were forests that were known to reindeer herders and a handful of missionaries, but few others.

The implementation of sovietization in the Siberian North was initially dependent upon the organization of Soviet outposts called Culture Bases (*kul'tbazy*).[6] While very little historical research has been undertaken on the Culture Bases,[7] we do know that they were built as an initiative of the Committee for the Assistance to the Peoples of the Northern Borderlands (or simply the Committee of the North). Culture Bases were built in key locations, forming a broad network across the vast expanse of Siberia. The first Culture Base was built along the Nizhnaia Tunguska River in the Enisei North. It was conceived of as a cultural and political center for the nomadic Evenkis who lived in the area. In 1927, after several years of planning, the director of the Krasnoiarsk Committee of the North, I. M. Suslov, authorized a team to begin construction of several buildings at the confluence of the Kochechum and Nizhnaia Tunguska Rivers.

This outpost was officially called the Tura Culture Base [*Turinskaia Kul'tbaza*], though it was also sometimes called the Tungus Culture Base [*Tunguskaia Kul'tbaza*]. The latter moniker is a reference either to the dominant ethnic group in the region, the Tungus (now Evenkis), or simply to the fact that the Culture Base was built on the Nizhnaia Tunguska River. The misnomer, Tungus Culture Base, is instructive both for revealing one of the central aims of the Culture Bases—to serve a single ethnic nation—but also for the manner in which the language of Russian imperialism persisted. According to Soviet policy, indigenous peoples would be called by their ethnonyms. There is a report in the State Archive of Novosibirsk Oblast (known by its Russian acronym GANO) where every usage of the term "other" (*Inorodets*) is marked through with a line and replaced with the then more politically correct "native" (*Tuzemets*). All of the Culture Bases were operated by the Committee of the North until its liquidation in 1935, at which time they transitioned to full-fledged village or settlement-type village status. The Tungus Culture Base, sometimes called the Tura Culture Base, was officially named Tura in 1935 when it became the capital of the newly formed Evenki Autonomous District.

The Committee of the North was established under the authority of the Central Executive Committee of Russia (VtsIK) to "help" the indigenous peoples of the taiga and tundra in their cultural upbringing and to ease them out of their "backwardness" [*otstalost*]. From the earliest days of the revolution, efforts were underway to generate support for socialism amongst the indigenous peoples. As M. A. Sergeev noted,

> The committee was called upon to help realize the legal equality that was proclaimed by the "Declaration" of 1917 and by the Constitution of 1918. It was given the task of uniting and organizing the small peoples, of awakening them to a recognition of their equality with other peoples, and of elevating them to a high level of development.[8]

In the 1920s, efforts were made to create indigenous representative organizations (clan and nomadic soviets), which in many cases simply replaced existing political and organizational structures developed under the tsarist tributary economy. These projects were frustrated by the mobility of the

"natives" through their vast inland territories, resulting in a nearly ungovernable remoteness from state power. The project to build Culture Bases was a resolution to this problem. The Culture Bases were one of the soviets' first concrete steps in advancing the goal of cultural transformation and incorporation. The locations of the Culture Bases were chosen with the dual criteria of remoteness from urban areas and accessibility for a dominant local indigenous population.

The Culture Bases were not solely dedicated to cultural enlightenment; they were also meant to be centers for regional development and scientific exploration.[9] In this way they differed from earlier colonial outposts like forts, missions, trading posts, and churches. Not only was the Tura Culture Base a new kind of project but for the indigenous Evenkis living near the Nizhnaia Tunguska and Kochechum Rivers, the Tura Culture Base became the first major and sustained colonial project in the area. In a territory that measures over one hundred thousand square kilometers, only a handful of small cabins and chapels were ever built. Since the arrival of the tsar's forces hundreds of years earlier, the inland territories of central Siberia were inhabited primarily by nomadic hunters, reindeer herders, and semi-peripatetic fishermen. To the Evenkis living in the area, the Culture Base was a truly novel construction that marked the arrival of an altogether different kind of newcomer. It was also soon to become evident that the Tura Culture Base represented merely the tip of a massive cultural, military, political, and economic effort that would lead to unimaginable changes in the social-cultural landscape of east-central Siberia.

Archives

The counter-narratives of sovietization in central Siberia—those that are not part of the more or less official historiographical projects of Soviet scholars—exist through informal family histories, in popular media, and to some degree in post-Soviet scholarship. Restorative (or revisionist) histories that avoid the panegyric of Communist boosterism are reconstituted through archival and ethnohistorical research.[10] Soviet practices of documentation and consignation of documents to archives appear to have been thorough. The anthro-

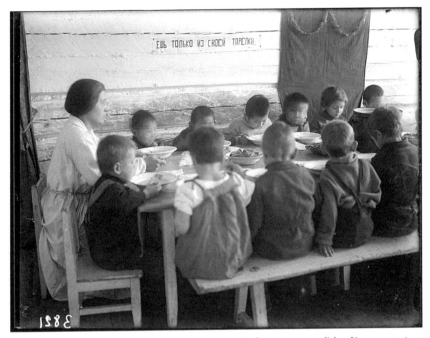

Figure 10. A cafeteria in Tura. Text on wall reads: "Eat only from your own dishes." Image courtesy Krasnoiarsk Krai Regional Museum.

pologist Ann Stoler argues that colonial archives should be examined as "both transparencies on which power relations were inscribed and intricate technologies of rule in themselves."[11] Reading the socialist colonial archives against the grain allows for the production of counter-narratives precisely by revealing the power relations that were implied and produced in archival acts. The sovietization of Siberia was an extension and transformation of imperial-era colonialism. While the soviets reinvented much of the colonial administrative structure (mostly to suit novel organizational units), other practices were maintained and expanded. The persistence of a colonial relationship between indigenous Siberian peoples and Russian power was complicated but not entirely displaced by the politics of national autonomy and the effort to create cadres of leaders that could represent emerging ethnic nationalities. Traces of tsarist relations and organizational structures were ample. As such, many

of the Soviet-era standards for documenting and archiving had already been established in the nineteenth century. As Olga Glagoleva notes, "Russian bureaucracy was notorious for its strictness and exactness in documentation."[12] This rigor carried through in Soviet practices as well; the importance of form and language in the structure of official documents was critical (and critically policed) in the Soviet era. This is evidenced in the remarkable conformity of documents found in both state and regional archives across the former Soviet Union. It is also demonstrated by what Stephen Kotkin has called the "terrible immensity of this administrative Cyclops" with its "bloated ranks and mandate of Soviet agencies and functionaries."[13] V. I. Lenin was famously scrupulous in his approach to documentation and is renowned for his 1918 "archival decree," which nationalized archival documents and called "for the complete centralization of archival records through the organization of archival institutions, the better scientific utilization of records, and their ultimate preservation, once they are appropriated by central authorities" (under the Ministry of Enlightenment).[14] Following Lenin's decree, the rules of "Soviet office management . . . attempted to regulate all steps from the initial stages where documents emerged to the final procedures of turning them over to archives for deposit."[15] The trace of Lenin's advocacy and authority produced a legacy that fortified institutional practice with moral labor.

There are two important points to be taken away from these observations about Soviet archives. Firstly, the material that has been consigned to most archives is highly structured and ordered, resulting in the production of particular kinds of readings, knowledge formations, or discourses. The historical gaze structured through archeographic technologies is remarkable for its focus on conventional matters: namely, great men and events. Documents from the institutions empowered to leave material traces—anointed with importance as they were accessioned into the archives—tend to direct and produce histories that reinforce the import of these institutions. A contrapuntal reading of the archives, or reading them against the grain, is necessary to avoid the typical blind spots that are generated by the structuring effects of archival order and that have helped to shape Soviet-era historiography. The second point about Soviet bureaucratic standardizations involves the production of documents on the local level or, as Stoler calls it, the production

of archives as the "intricate technologies of rule." In the case of the Soviet archives, I would qualify the claim to intricacy, as they could also be simple, performative, and deeply banal. Furthermore, expeditionary photographs in the archives appear to be not so much intricate or effective but flawed technologies of rule.

Given the importance of documentation in the burgeoning Soviet bureaucracy, the role of instructors and other agents in early native soviets was crucial—especially where there was almost universal illiteracy. Letters and correspondences from native soviets to the Committee of the North, for example, bore a powerfully ambiguous authorship. The words, laudatory and deferential (if not obsequious), presented a unified native voice that was probably not unified and quite possibly not even native. The drive to create native intelligentsias, when not altruistic, was surely facilitated by a desire to off-load necessarily meticulous and typically tedious paperwork. Official records, however, primarily determine the texture and character of the archives. Such records document apparent complicities of indigenous peoples in their own "colonization." Thus the records of indigenous soviets and indigenous secretaries are not necessarily representative of larger indigenous assent to the Soviet projects. Conversely, there is scant evidence that such complicities can be read simply as falsified participation records. My own reading of the historical record suggests that they are best read as a rapidly emerging co-optation of indigenous peoples into a burgeoning intelligentsia.[16]

Francine Hirsch notes that in 1922 the State Colonization Research Institute (Goskolonit) was tasked with explaining how "in a Soviet socialist context . . . Soviet colonization policies would enable indigenous peoples . . . to 'attain a higher level of material and spiritual culture.'"[17] The history of the term *colonization* is contentious in the history of socialism, as it was tied to histories of imperialism and subjugation. Hirsch's work masterfully details the complexities and contradictions that embroiled various levels of Soviet administration in debates over the framework for implementing Communism in a multinational state.

The documents consigned to Soviet archives have provided invaluable material for historians. Memoranda, agreements, notifications, policies, attestations, biographies, and reports are among the documents that help to

trace the labyrinthine history of shifting bureaucratic structures. They also provide oblique reference to everyday histories and experiences that are not to be found in official narratives. After all, quotidian life cannot be caught in passing and preserved in archives; there is actually very little that is harvested and processed through accession. Even in this era when recording devices are proliferate, when records are saved and archived indiscriminately by machines, the simple impossibility of an archive of everything is barely fodder for absurdist fictions. That which is not admitted into the repositories of official memory is ingloriously lumped together as ephemera, if noticed at all. Using archival records to reproduce histories that have been permitted to dissipate into effuse pastness as ephemera is a matter of lateral methodologies. The fact that archival documents point intertextually as well as extratextually help us imagine what is not in the archive—both conspicuous and inconspicuous absences mark what was allowed to pass as ephemera and what was consigned to the archival matrix.

The onerous task of drawing inferences out of stubborn policy statements has been the work of many contemporary cultural historians. Writing history out of state archives is a challenging endeavor frustrated by the inherent limitations of the material, which by and large is constituted by interdepartmental correspondence, policy papers, and other textual artifacts. Soviet state archives preserve and naturalize institutional histories as much as they inform and determine our understanding of Soviet history in general. The primary streams of Soviet history are marked by the conditions of access to archives, which even after the era of Glasnost in the latter half of the 1980s have been tightly controlled and circumscribed by dedicated bureaucracies. The historian Donald J. Raleigh convincingly argues that the opening of the Soviet archives was so significant that it changed the very practice of Soviet historiography.[18] Clearly gaining access to documents once proscribed and hidden from the view of most scholars allows for a greater degree of historical accuracy and nuance. A more general shift noted by Raleigh, however, is the degree to which accommodation and integration as aspects of everyday life in the Soviet era have been overlooked by ideologically motivated desires to find opposition and resistance. Even so, the search for opposition and resistance "remains a popular theme not only because opposition is easier to

document than accommodation, but also because opposition reveals histori-
cal agency, challenges stereotypes of a passive population, and further calls
into question the totalitarian model."[19] My examination of the Culture Base
as a technology of rule uses multiple historical narratives while recognizing
the remarkable imbalances of power implicit in the expression of a highly
centralized and militant state that sought at various times to accommodate,
assimilate, and promote its subjects. It also uses oblique historical narratives
inferred through a carefully curated selection of photographic images. My
encounters with archives in Siberia support and complicate Stoler's claim that
they are an intricate technology of rule. Of course, they are not always dis-
passionate and cold but also intimate and disarming in their capacity to reveal
the unexpected. Finally, and perhaps most importantly, the archives are also
ultimately flawed and inconsistent technologies of a kind of rule that was
itself flawed and inconsistent.

Archival Photographs and Photographs as Archives

The photographic image is a peculiar artifact and intermediary in the archive.
Ill-fit and categorically awkward, the photograph in the archive seems to re-
sist the very structure of the archive as a place of consignment. It reaches out
of the archive in ways that textual artifacts rarely ever do, and it presents a
queer logic that both duplicates and annihilates archival orders. The queer-
ness of the photographic image is an order that troubles the archive; it is a
body in the archive, but one whose queerness has the capacity to undo the
often overwhelming pretense to orderliness and normativity of documents.
With the aim of apprehending and examining this queer logic, I reference the
two sets of photographs from my research in Siberia: the Suslov collection
and the Endangered Archives Programme: Siberia ethnographic collection
(hereafter referred to simply as the EAP 016 collection).[20] The former is a
collection of images gathered and curated by an individual (ethnographer
and Soviet administrator I. M. Suslov); the latter is a collection of images that
can only be considered a collection because of a loosely applied and broad
classificatory scheme rather than any deep curatorial intention. They are very
different kinds of collections, and the photographs that are organized under

their titles represent similarly different goals. Nonetheless both sets of photographs adhere in their anxious service to their respective archives; they are domesticated and ordered not only by categorical indices, but also by the formal and informal archival rules that govern access and distribution.

A box of two hundred and thirty-eight photographic prints is held in the archives of the Evenki Region's Museum of Local History in Tura. These constitute what I refer to as the "Suslov collection." This collection consists of carefully annotated photographic prints that were donated to the museum by ethnographer and administrator I. M. Suslov in 1970. Suslov sent the photographs at the behest of the museum director, who was in the midst of preparing an exhibition celebrating the thirty-fifth anniversary of the Evenki Autonomous District. Although he was unable to attend the ceremony or exhibition due to deteriorating health—Suslov was in his seventies at this time—he responded to the director's request by providing hundreds of photographic prints with commentary. Each print was carefully annotated on the back and had a corresponding annotation in longhand. This collection of photographs and memories is particularly interesting because it represents a history remembered and articulated through photographs. It was a history curated and assembled with the particular goal of exhibition.

The EAP Siberia collection is quite another kind of archive. In 2005, with funds from the British Library's Endangered Archives Programme, David G. Anderson and I initiated a project to digitize glass plate negatives located in "colonial" archives around Siberia. The goal was to digitize negatives depicting peoples, artifacts, and scenes related to the theme of indigenous Siberians prior to industrialization. This project resulted in a collection of over four thousand glass plate negatives from five regional archives. Digital copies of these negatives have been sent to the British Library for archiving, and copies have been shared among the partnering archives.

The highest level of organization within an archive is typically called a fond. The fond is an aggregate of documents (of various kinds). As a unit of organization, the fond is also recognized as a kind of limit point for authenticity. Michel Duchein famously defines the archival principal of *respect des fonds* as an injunction to "group, without mixing them with others, the archives (documents of every kind) created by or coming from an adminis-

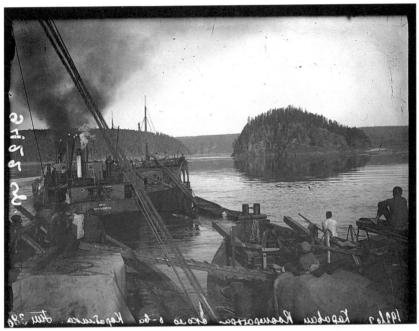

Figure 11. Shipping supplies to the Tura Culture Base. Photograph is dated 1926. Image courtesy Krasnoiarsk Krai Regional Museum.

tration, establishment, person, or corporate body."[21] Beyond the cultivation of the integrity of fonds as archival groupings, the status of fond itself is important. Fonds within archives have legacies of use that maintain their popularity. As any researcher knows, investigation builds on the investigations of others. Publications point back to their sources, not only archives and fonds, but particular documents and passages within documents. There is a dense mass of *stuff* in the archives, thick folders of yellowed paper . . . cracking and brittle from age: thousands upon thousands of leaves, millions of leaves. In the Soviet archives, the leaves are often stitched together, destroying the original unity of the paper but at least keeping them in once place. The method of storage ensures a more rapid degradation of the material, as though the archivists were secretly hoping to divest themselves of the burden of the documents. Let them crumble into dust! Maybe this is my own wish, too.

The dull monotony of telegrams between departments clarifying the cost of a shipment of butter, letters requesting information on the number of books held by the local library, a statistical analysis of the productivity of a fur farm or an outbreak of anthrax among reindeer. Each of these was potentially interesting, but each one represented a thread leading to a mountain of interpretation riddled with speculation. Most of the archives I've worked with are packed with tens of thousands of documents, many of which I've skimmed over, looking for key words that will stop me and encourage me to linger. On "bad" days, the value of an entire page can be weighed by some mystical gaze that rapidly evaluates the constellation of stamps, paragraphs, signatures, and marginalia. The serendipity necessary to this process does not call for greater rigor but rather attention to the archival excess endemic in the system of research. Evidence of something emerges eventually: "This film was shown on this day" or "such and such a photographer tried to get funds to make an expedition." Working in the archive is a perennial effort to "keep on track" to separate the wheat from the chaff. Technically it is all important, but the more you work it the more you realize what a strange project it is to write the history of something, to fabricate its boundaries through the cultivation and arrangement of blind spots.

In the era before searchable digital databases, images depended even less on description and more on systems of class-marks and catalogue numbers, which typically differ from archive to archive and are often internally inconsistent. Photographs in archives are treated more as artifacts than images. As artifacts they are material instances of photographic images, which are fundamentally peripatetic and promiscuous. They are subordinated to the archival system of descriptors and class-marks that requires them to be described so that they can be effectively rediscovered. In Soviet archives, class-marks were often applied directly to the documents and photographs accessioned by the institution. Class-marks help to generate a relational index from a catalogue or inventory to the artifact. Given their powerful rejection of simple classificatory schemes and taxonomies, photographs are susceptible to being hobbled by the application of simplistic descriptive categories: "native woman," "men working," or "rural house." Where the tool of taxonomy is most blunt with photographs, they are merely grouped together under a single rubric such

as "ethnography" or under the name of a particular expedition. The driving force behind the grant that funded the EAP 016 collection was the category of "pre-industrial."

A photographic collection in an archive is only as good as the descriptors applied to it. These descriptors vet and filter who, of those few already privileged and predisposed to be undertaking research in the first place, has access to it. The photographic descriptors serve to structure systems of meaning and interpretation. Following the publication of Michel Foucault's *Discipline and Punish*, the scholarly discourse around archives began to shift. Archives are no longer seen as an unmarked repository but rather as an active agent in history.[22] The archive has come to be seen as both a technology of rule and a site of knowledge production. After all, it is not only historical researchers who access archives but government officials, legal researchers, designers, and myriad other people comprising both individual and institutional interests. Following the Foucauldian critique, anthropologist Elizabeth Edwards writes that the "archive not only preserves, it reifies, it frames and sets meanings; it also structures silences."[23] She cautions, "this does not mean that meanings in the archive are necessarily static."[24] Her caution draws attention to the relational complexity of documents, storage, access, and agency.

Carolyn Steedman also considers the materiality of the archive. She claims that in Foucault's *Archaeology of Knowledge*, "the archive does not so much stand in for the idea of what can and cannot be said, but rather is 'the system that establishes statements as events and things.'"[25] If this emphasizes stasis, a weight implied by "materiality," it is necessarily situational. The production of historical events and historical things requires a coalescence of statements (documents); the milieu in which such coalescence happens is the same milieu that allows it to come undone. The materiality of the archive is shorthand for the way that things are imbricated in relational complexities of human projects including the enduring struggle for meaning, history, and remembrance. As I have stated before, however, the archive is also a flawed technology of rule. Thus while Ann Stoler reminds us that colonial archives "were both sites of the imaginary and institutions that fashioned histories as they concealed, revealed, and reproduced the power of the state,"[26] colonial archives have also been fragmented and dusty ruins of forgotten projects

and failed schemes. The interplay of photographs and colonial imaginaries is critical here, but it is critical because photographs have largely been lost in the archives. Whereas many critics such as John Tagg and Elizabeth Edwards[27] have noted the impressive ideological power of photographs to contribute to colonial imaginaries as well as exertions of state power, photographs in the archives have also been crippled due to their fundamental incompatibility with the textual frameworks that govern archival research. Notwithstanding the exceptional form of socialist colonialism, photographs in colonial archives were often unable to reproduce the power of the state and often failed to play much of a role in the production of a socialist imaginary.

Photographs and archives share a host of other visual metaphors that are intimately tied to modern state enlightenment thinking; they are clearly ordered under similar logics. I would like to push this comparison further: to suggest that a single photograph is not only like an archive but that it actually shares many of the same conditions of the archive. A photographic image is an archive in its own right. It bears all the markings of what is broadly considered archival, not least of all the fundamental aspects proposed by philosopher Jacques Derrida in his book *Archive Fever*. While there is a good deal more to archival theory than Derrida's intervention, *Archive Fever* provides a compelling angle for thinking around the edges of institutional archives and broader archival metaphors. The archivist Verne Harris reminds us that Derrida describes

> the structure of recording, of archiving, as involving a trace (text, information) being consigned to a substrate, a place (and it can be a virtual place) of consignation. So that for Derrida the archive is a conjoining of trace and substrate—writing on paper, painting on rock, cut on skin . . . there is no archive without some location, that is, some space outside. Archive is not a living memory. It's a location . . .[28]

Location is critical for historicizing, and I see this as a move to insist on the primacy of the locative. With photocopying and digitization the location of the archive, however, becomes confoundingly problematic. While the per-

meability of the boundary that marks the edge of the archive has always been present, the degree to which circulation has begun to complicate insides and outsides is altogether new. Nonetheless, the structure of thinking around archives continues to be dominated by metaphors of marks and traces.

The language of traces and substrates is part of not only a post-structural critique but the language of printmaking: the manual and mechanical mass production of figures on paper. Printmaking is a practice that includes, but is not exclusive to, photography, that technique which fixes light and shadow. Traces and substrates imply originary encounters, though not origins in and of themselves. They imply mobilities, circulations, and trajectories but also pauses, imprints, and other forms of static being. The logic of archives within archives, of the photograph as archive, points to an intersection of gazes as well. Catherine Lutz and Jane Collins deploy this concept in their consideration of photographs from *National Geographic* magazines. They note that *National Geographic* photographs of the non-Western other are,

> dynamic sites at which many gazes or viewpoints intersect. This intersection creates a complex and multi-dimensional object; it allows viewers of the photo to negotiate a number of different identities both for themselves and for those pictured; and it is one route by which the photograph threatens to break frame and reveal its social context.[29]

Archives, too, are suspended in such intersections: disciplinary gazes and undisciplined gazes, historical, nationalist, affective gazes in the archives searching for fragments and evidence, or something else.

Archival interlocutors foist their own disciplining practices on the closed-stack archives, mediating the information that emerges (or doesn't) from the depths. Photographs and archives, then, function in the same way, most significantly in the action of "fixing." In photography, this term refers to the technological innovation that allows once ephemeral images to be secured to metal, glass, paper, and cellulose. As Joan Schwartz notes, "archives [have] also 'fixed' a moment in time, fixed the actions and transaction of state and church, corporate and private interest, 'fixed' recorded information in its administrative, legal, and fiscal context."[30] Furthering the connection between

photographs and archives, Schwartz continues, "[a]rchive and photography promised possession and control of knowledge through possession and control of recorded information."[31] This promise of possession and control, of an establishment of history, returns us to the trace and its role in the production of historical knowledge and authority. The trace is something that is observable. Paul Ricoeur, noting Marc Bloch's interest in the idea of the trace, remarks that apprehending the past "in and through its documentary traces is an *observation* in the strong sense of the word—for to observe never means the mere recording of a brute fact. . . . Not only does the historian's inquiry raise the trace to the dignity of a meaningful document, but it also raises the past itself to the dignity of an historical fact."[32] This raising is about raising events from oblivion, ephemerality, and marginality. Looking at documents as marks and traces, like looking at photographs, implies situated and embodied gazes. Looking is always an act of positioning, though as W. J. T. Mitchell reminds us, "vision is itself invisible . . . we cannot see what seeing is."[33] Seeing vision in the archive is never as simple as locating the spectator. Documents in archives (including photographs)—though they may have never been touched by a historian—are preestablished as historical facts by dint of inclusion in the archive. It is a presence that can dampen the deafening clamor of all that was not archived. While the archives can structure the historian's experience, Ricoeur located agency principally with the historian:

> The document was not a document before the historian came to
> ask it a question. Thus, on the basis of his observation, the historian
> establishes a document, so to speak, behind him, and in this way
> establishes historical facts.[34]

Wild documents are perhaps salvaged from oblivion in such a way as outlined by Ricoeur, but those in the archive already bear the embossed mark of authority. If my focus thus far has been on the question imposed by the archive onto research and the sort of struggle historians must make against the tide of preestablished historical facts, Ricoeur points us back to the complicity of the historian in producing documents. To be clear, the archive is built on documents, but these are not the sort of documents described by Ricoeur.

They are languishing records, the entirety of paper products caught up in the indiscriminate dragnet of accession. Ricoeur's documents are transmogrified. Where the archive says, "these might be important," the historian holds aloft a sheaf of references and quotations and says, "these are important." Photographs are structured and framed by their presence in the archive, in the archival order's systems of enclosure.

There are differences between an archive and the photograph-as-archive, of course. Principally this is so in that institutional archives are notoriously solid and permanent technologies, whereas photographs are promiscuous and ephemeral. The mobility of the photographic image—its capacity to circulate beyond the archive—is antithetical to the static location of the institutional archive. The metaphor is complicated by the fact that photographic images are also part of the material configuration of many institutional archives. In considering the photograph in its archival-institutional setting, however, we can see how the archival edifice operates as a waypoint in the circulation of photographic images—and most importantly how this intersection, this stopping point, is tremendously important to the production of history. After all, archives present ideal configurations of documents,[35] records collected together, consigned to a site and coordinated in a single body: the archive of the Krasnoiarsk Territory Regional History Museum, Municipal Archive of Evenkiia, Moscow State Literary Archive, the Russian State Documentary Film and Photo Archive at Krasnogorsk, and so forth.

The general lack of accessibility to archival photographs by historians, mixed with a general lack of methodology for conducting research on photographs, has rendered many photographs circumstantial to historiographical projects. Accessibility is partly determined by the technical and historical need to subordinate the photographic image to systems of writing, making the usefulness of photographs in archives largely contingent on the quality of descriptive techniques employed at the time of accession, of the creation of the archive, or of the photograph itself. Typically, photographic images have been treated as illustrative matter (decoration for the text) that is either meant to convey a kind of documentary truth to the essay ("this is real"), to stand as evidence of an event ("this really happened," "she was really there," and so forth), or to simply be decorative (included as design elements to make

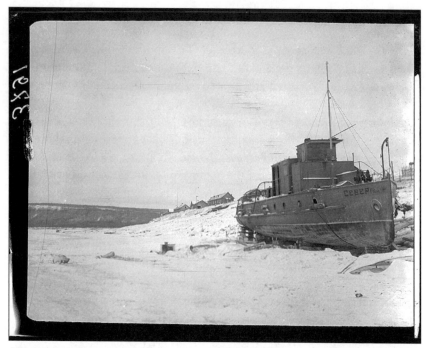

Figure 12. On the bank of a frozen river. The boat on blocks is named "North." Image courtesy Krasnoiarsk Krai Regional Museum.

the experience of reading better or more interesting). All of these have their uses, though they are implicated in the hegemony of "plain style" that slips past unreflexive scholarship. The "plain style" here refers to naive realist photography that seeks to minimize lens distortion, strange angles, and weird subject matter, in the belief that this delivers a greater degree of authenticity or objectivity. It is when photographs are used as illustration (in any combination of the ways noted) that the text is most susceptible to interpretive dissonance. In this sense they can act as *agents provocateurs,* volatile agents parading as innocent illustrations. Good scholarship no doubt accounts for this (even if it is not explicitly theorized or discussed). Response to this volatility of images ranges from the total avoidance of photography to careful selection of images that might be less likely to undermine a written argument. More

rarely, photographic images are framed by tentative or speculative writing. Nonetheless, I would suggest that a lack of clearly defined methodology for the use of photographs in many academic disciplines has more generally led to an aversion to facing the challenges of dealing with photographs. Without strategies for working with the unwieldiness of images, those who use archival photographs in their study of the past are gravely susceptible to replicating the blind spots of the archive. Not least of all, photographs from the archives are easily mobilized under a methodological rubric of content analysis that lacks more keenly focused and skeptical modes of inquiry.

Soviet Photography

Susan Sontag, among others, has argued convincingly that photography is one of the central arts of modernity.[36] Born in Europe at a time of intense industrialization and technological advancement, photography developed as a practice dominated primarily by scientist-artists. Until the development of popular Soviet photography after the Great Fatherland War (known as the Second World War in the West), Soviet photography was institutionalized in studio photography, art photography, and photojournalism, as well as expeditionary and scientific photography. Outside of the institutional context was a broad spectrum of amateur photographic practices. Amateur photographers and the images they produced have been one of the least studied classes of Russian photography, especially in the Soviet era. Later, in the 1930s, the emergence of an overtly propagandistic style of photography—whereby photographs were produced to carry particular messages and to manipulate belief—eclipsed many other forms of picture making. Meanwhile, amateur photography continued its steady rise in popularity.

Within the world of avant-garde art, theory, and criticism, Alexandr Rodchenko is perhaps the most famous and versatile of Russia's artists. While he was known as a painter, designer, and sculptor, he also championed a revolutionary style of photography. His photographic modernism sought to treat the relatively new art on its own terms. As opposed to photographers who attempted to replicate the conventions of painting (through still life and landscape, for example), Rodchenko and others were interested in discovering

a unique voice to the medium itself. Such revolutionary photography was meant to provide transformative experiences and to help in the effort to upend false consciousness. "Plain style" photographs were created, framed, selected, edited, and manipulated to present a focused message, though they were at the time resolutely presented as transparent and free of ideology. Instead, they occupied an unmarked ideological category that challenged the West's histories of capitalism and imperialism. It is expeditionary photography that most concerns my work. As with photojournalism, expeditionary photography was typically governed by the necessities of "plain style" documentation, which nonetheless announced itself through its very claims to greater objectivity by means of repetition and standardization in the service of comparability, which were the hallmarks of all "scientific" photography.

I use the term *expeditionary photography* to include a range of photographic practices tied to scientific exploration in the North. My consideration of expeditionary photography is also meant to draw attention to the mobility of both the photographer and the photographs. The photographer's mobility is tied to institutional histories and affiliations in this work. These circumstances leading to the production of a photograph can be thought of as a kind of photographic prehistory that complicates the singular authority of the camera operator. Thus patron or manager, as much as cultural milieu and training, come to participate in the agency of any particular gaze. Once the photograph has been taken and the exposed photographic plates travel away from expeditionary sites, they begin their paths of circulation, leading us to the consideration of second-stage photographic encounters. Soviet historian of photography S. A. Morozov used the term *expeditionary photography* to describe a subset of scientifically led photography as well.[37] His interest was principally in classifying photographic practices and framing a history of photography in Russia. Of course, scientific inquiry was not ushered in by Lenin and Stalin. The pre-twentieth-century history of photography in Russia provides ample evidence of this. Under the ideological struggles following the revolution, however, Soviet science differentiated itself from previous work, which it characterized as bourgeois: a broad net that caught up both methodology and actors in accusations of naive realism, bourgeois fascination, and imperialist and racist representation.

Because of cumbersome equipment, limited supplies, and the remoteness of many shooting locations, great deliberation underwrote every decision about what would or would not be captured by photographers in the field. The photographs themselves were inevitably transported away from the location and moment of capture to a laboratory, where they could be developed and printed. Photographs produced in the central Siberian taiga were hauled thousands of kilometers to be processed in distant cities. Aside from the mobility of equipment and operators implied in the term *expeditionary photography*, the name is superior to *ethnographic photography* because many of the early Soviet-era photographs, especially in the EAP Siberia collection, were not taken by trained ethnographers such as I. M. Suslov and they had few explicit connections to emerging and shifting discourses of Soviet ethnography. Expeditionary photography is thus a more capacious and accurate term to describe a variety of photographic intentions and expressions. In addition to this, "ethnographic" is used in Soviet archival practice as a sort of category dump for images portraying non-Russians and "premodern" scenes. This terminological contamination is certainly instructive, but it also complicates any attempt to salvage "ethnographic" as a general term.

Expeditionary photographs can include pictures taken by geographers, anthropologists, geologists, and biologists, as well as by census takers and other government agents, and thus can represent a less formulated and purposeful gaze. While early twentieth-century anthropologists tended to have particular agendas when they photographed indigenous peoples (such as tracing ethnogenesis through the study of faces and bodies, decorative patterns, or tools) expeditionary photographers represent a much wider range of intent and education. However, despite this range of intent, one thing we can see in the expeditionary photography from the period of sovietization is how the institutional gaze of photography shifted from the representation of an exclusive or colonial "other" to an inclusive (though still other) state subject. One way of reading this shift is through the greater attention to naming the subjects of photographs. With earlier expeditionary photography, the subjects tended to be represented as ethnological types rather than individuals. This follows an international trend in photographing colonial subjects. The becoming-modern subjects of the Soviet multinational state were often

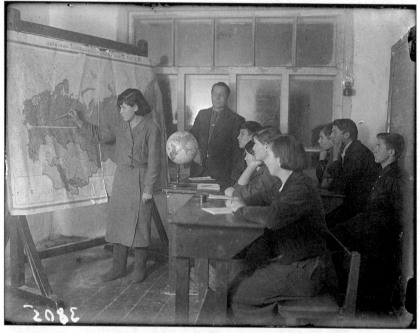

Figure 13. Geography lessons in a classroom, Tura. The large map is titled "Political-Administrative Map of USSR." Image courtesy Krasnoiarsk Krai Regional Museum.

named in photographs, especially as they began to take up official positions in the provincial state apparatus. For example:

> Feodor Stepanovich Khukogir, Head of the Ilimpii Executive Committee
>
> Andrei Udygir, Head of the Volost Executive Committee

This shift in naming practices can be read in a number of ways, not only because captions and interpretations are most elusive, but also because the very idea of an institutional gaze collapses multiple practices of looking and being looked at. Aside from naming, the inclusivity of the "other" was also constructed by proximity to modern affects. One photographer named I. I. Baluev produced numerous images of Evenkis in the 1930s as fully engaged

participants in Soviet high modernism: from the bodily discipline of exercising children under the watchful gaze of Stalin to orderly pupils gathered together for a geography lesson. Are these subjects learning their place in the world? Perhaps they are meant to be pointing their home to us: the absent presence in the room embodied by the photographer and the photographic apparatus. Surely this is staged: a performative modernity that documents the truth of a moment but one that is haunted by its implicit claims to universality and hope. Although it is unclear how these photographs were used and whether or not they were published in any popular journals or newspapers, they adhere to the emerging conventions of propaganda and socialist realist photography.

Photographic Encounters

In an article from the early 1930s, Innokentii Mikhailovich Suslov wrote that essentially nothing was known about the arctic and subarctic areas of Siberia prior to Soviet times: "Bourgeois science of Tsarist Russia left us with an inheritance of completely insignificant and questionable facts."[38] Suslov was expressing a tension among academics across disciplines, some of whom were preoccupied with new regimes of knowledge production, and who were making more or less radical changes in their practice and rhetoric to meet the shifting demands of Soviet politics and philosophy. In the increasingly acrimonious political environment of the Soviet Academy,[39] the intellectual tradition of ethnography in Russia—once a more or less typical nineteenth-century evolutionist school[40]—had become infused with a Marxist critique and a radical demand for praxis. Ethnography in the Soviet era was invested with a "great ideological significance" that was a direct outcome of the "theory of inevitable and universal social evolution from pre-class to post-class communal society [which] was at the very foundation of official Soviet ideology."[41]

Suslov's condemnation of the "bourgeois science of Tsarist Russia" should not be dismissed as mere Communist polemic or cynical vitriol; it expressed a deeply felt commitment to a new political and cultural project. Many key figures in Russian anthropology were socialists who, in the years

following the revolution, came to make important contributions to the establishment not only of Soviet social sciences but of Soviet policies as well.[42] If pre-Soviet ethnography was concerned with the ideal of a nonpolitical pursuit of knowledge, Soviet ethnography, particularly in the 1920s and '30s, was focused on the identification and transformation of what it considered negative cultural elements. More generally, early Soviet anthropologists were engaged first in an attempt to theorize human social conditions and second to explore and recommend practical solutions to perceived problems. The dominant pre-Soviet Russian ideology categorized indigenous peoples as primitive and backward (occupying a pre-feudal evolutionary stage), and while this idea persisted in the Soviet era, the soviets viewed the so-called primitivism in different ways. Early Soviet anthropology was dominated by an interest in pre-class societies and an "uncompromising evolutionism" relying on Marx's anticipation of the "reemergence of the archaic social type in the highest form."[43] The "archaic social type" was a primitive Communism.[44] This ideology, while generally celebratory, engendered a kind of ethnographic urgency for fear that the material and spiritual culture of "primitive" peoples would soon become difficult or impossible to study. This was generally seen as an inevitability in the face of modernization, development, and cultural evolution. The battles over the legitimacy of scholarship and the primacy of Marxism-Leninism led to a total overhaul of the Soviet study of culture and history. When the Ethnological Department at Moscow University was shuttered in 1931, "ethnology was proclaimed a 'term of bourgeois ethnographic science rejected by Marxist-Leninist ethnography.'"[45] Conflicts had arisen between a salvage project (which threatened to be seen as a nonpolitical "bourgeois" endeavor) and an unscientific propaganda or development campaign. A rhetoric of discontinuity became essential for ethnographers in the 1920s and '30s, who learned to disown a broad, murky, and mercurial category of scholarship labeled "bourgeois."[46]

Ethnographic photography concerned with documenting cultural difference (through material culture and the material representations of spiritual and social formations) seems to have been accommodated as a didactic tool for replicating historical "facts" already decided under Marxist-Leninist his-

torical doctrine. Photography, in most of its applications and guises outside of the frame of "art," was sanctioned as a practice. It was difficult to pin down as a subjective representational form, especially as scientific and journalistic photography was considered to be a principally technical operation that produced documents rather than pictures. In photography for mass reproduction there was, however, an emerging pressure to articulate socialist concerns and party doctrines. Indeed, many of the expeditionary photographs can be seen to parallel a kind of Soviet salvage paradigm.

Pre-Soviet ethnographers had shared many of the same interests as their colleagues from other nations (especially those from Germany and the United States), and the Russian Geographical Society published instructions for taking ethnographic photographs in 1872. On the subject of taking ethnographic pictures, it recommends that photographers attend to the following list of interest points: "people's costume, every single pose, tools and household goods, and also paintings showing the use of any individual object; also dwellings, settlements, towns, etc., various paintings, scenes from public life, and pets."[47] These typical prerevolutionary ethnographic methods that later came under fire from the Bolsheviks are also outlined in this letter from Waldemar Jochelson to Franz Boas during the turn-of-the-century Jesup Expedition in Siberia, where Jochelson writes:

> There are fewer measurements of the Yukaghir than the Koryak. There are so few Yukaghir in the first place, they are dispersed and move continuously so that the ethnologist in this polar country must be in constant search of them. Often we had to cover great distances just to get from one camp to the next. It often happened that we didn't find the tents at the specified location any more. However, every nomadic Yukaghir or Tungus we met, was held, measured, photographed and questioned.[48]

Prerevolutionary expeditionary photography espoused conventional goals of documentation; this extended to ethnographic photography, which was no less concerned with demonstration than it was with comparison.

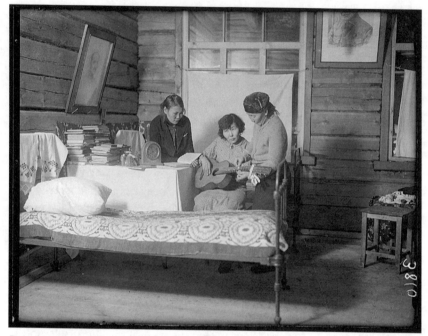

Figure 14. Three women in a dormitory at the Tura Culture Base. Image courtesy Krasnoiarsk Krai Regional Museum.

Socialist ethnographers, on the other hand, were starting to reject pre-revolutionary modes of inquiry and engagement; some advocated a new science that posed a different set of questions, but more often and most significantly they advocated for political praxis above all. It would be a science in the employ of politics. New questions that did arise usually became mired by the constricted research framework imposed through Soviet (Marxist-Leninist and Stalinist) political theory that demanded (or at least expected) the "criticism of bourgeois concepts."[49] This in turn seems to have undermined the capacity to generate more reflexive ethnographies and nuanced research. Ana Sirina notes that when she undertook her studies in the 1980s, Soviet ethnography was "devoid of life that, in keeping with established canons, did not allow authors to show their positions or attitudes to the phenomena,

events or facts they described."[50] Artemova notes that in early Soviet ethnology, "pure analytical criticism gave place to ideologically motivated charges. Now it was not a shame to rely on insufficient data or to distort the data, but it was frightful to be accused of 'anti-Marxism' or bourgeois delusions such as 'relativism', 'diffusionism' and so forth."[51] Concerning photographs taken by ethnographers, such pressures might also be read in the shift away from earlier anthropological photography that focused on recording and cataloguing cultural "types" for comparative purposes.[52] From a Bolshevik perspective, the old style of ethnography could do little to help the indigenous peoples on their path toward progress; in Soviet ideology, they were to be seen as "others" in the midst of a transformation, no longer identified as hunters and herders, but as named partners in sovietization who were to be participants in the development of a standardized form of nationalism. Soviet-trained ethnographers were sent to Siberia as "the first missionaries of socialism to the primitive peoples of the North."[53] It was important for Soviet expeditionary photography not to appear to be replicating the bourgeois habits and interests of imperial-era photographers.

Surveillance and the Performative Aspects of Ethnographic Photography

A stranger trains his gaze upon the "native" subject, culminating in an anticlimactic snap of the shutter and a pronouncement that the exposure is complete. The device and its products, in this generic colonial encounter, moved on with the photographer and rarely made the return journey to the site of exposure. After processing and printing in a laboratory, the photographic negative was typically put into storage and archived for future use. From one perspective, the photographic negative lends itself to the logic of the archive. Its superstructure provides a relatively stable medium for perpetual return. In the typical photographic workflow, a negative is the ultimate site for reproducing positive prints. It is ideally secured and saved for posterity.[54] At the same time the negative image becomes the site of archival anxiety; for most eyes it can be satisfyingly reproduced, thus rendering the original

superfluous. The original in photography is not equivalent to the most authoritatively replicable image. In either case, the negative image eclipses the moment remembered as a site of authenticity; it overwhelms the passed moment with its sensuous reference. The negative somehow mediates between the image and the imaged: a semantic waypoint. The photographic encounter reproduces what Derrida has called the "archontic power"—the power to consign artifact to archive, but also to gather and collect together within a unitary principle of location: "*Consignation* aims to coordinate a single corpus, in a system or a synchrony in which all the elements articulate the unity of an ideal configuration. . . . The archontic principle of the archive is also a principle of consignation, that is, of gathering together."[55] The archon in my scenario is not only the photographer but the technology of the archive itself. Being invested with the power to conserve (and to reject from conservation) the archontic function is as repressive as it is expressive. In the Soviet photographic archive, this implicates the strangely anachronistic colonial gaze and the colonial powers of surveillance as well as the anticipatory construction of history and memory through photography. The archive is, after all, as much about what is *in* as what is *out*. Photographs frame a "scene," and framing is always about exclusion. As Susan Sontag eloquently put it: "to photograph is to frame, to frame is to exclude."[56]

The technology of photography is also a technology of privileged viewing positions, of surveillance. The subjects represented and produced through the photographic apparatus are not dissimilar to the prisoners in Bentham's panopticon or "society" in Foucault's elaboration and model of modern disciplinary power. Alan Sekula—one of the earliest photo-theorists to explicitly tie Foucault to the camera—notes how "photography came to establish and delimit the terrain of the other . . ."[57] Sekula's take on photography and discipline helps to demarcate the potential for implicating photographs in forms and expressions of power. The geographies of power/knowledge articulated through critical readings of photography have since multiplied. Christopher Pinney remarks how photography and Foucault's notion of discipline not only "coalesce in a common language"[58] but are effectively interchangeable: photography can be "substituted for the idea of discipline/surveillance in al-

most all of Foucault's writing."[59] To further this comparison, we can look at James Faris's study *Navajo and Photography,* where he shows how the registers of surveillance-through-photography are marked as the normalizing gaze of the Western subject measured off the native other.[60]

The majority (if not all) of the photographers whose expeditionary images are collected in the archives I am writing about were nonnative male scientists or government agents. They were the men with cameras. Of course, this doesn't preclude women or children from operating the device (even if it wasn't in their possession) or from choreographing the production of an image. But in general, in Siberia the camera was a man's tool; men's interests as well as their opportunities directed the photographic record. The cameras and their associated equipment and needs were costly and were typically only accessible to the rapidly disappearing bourgeoisie or people affiliated with the government. At the same time, popular photography was on the rise as it was in the rest of the world, though not nearly at the same explosive rate. The expansion of film and photography supply stores across Siberia are documented in the archives of the Kinosibir Joint Stock Company but have not to my knowledge been written about.[61]

Indigenous Siberians in all cases I have studied were the subject of the photographs and not the photographers. The photographic encounter typically had indigenous peoples at only one end of the operation. In his exploration of photography and anthropology, Christopher Pinney lays out a structural relationship that ties photography and vision to Western knowledge and power.[62] He writes, "in the context of colonialism, the 'divine' power of photography comes to reflect a Western technological and epistemological prowess."[63] Reexpressed in terms of socialist colonialism, the "divine" is merely replaced with "scientific" and "Western" with "Socialist" to produce a parallel map. Indeed, I wonder if one persistent mistake of colonial studies has been to tie the critique too tightly to capitalism rather than enlighten- ✓ ment and industrialism. One is tempted to see this as an ideological blind spot of Western-Marxist historians.

While photographs are documents with an indexical relationship to a particular place and a particular time, they are also—like the archive—

exclusionary. Though they are rich in detail in comparison to other forms of representation, they are also formative of partial and constructed ways of seeing and knowing. These photographs have as much to tell us about individuals, ethnic groups, and economies as they have to tell us about the specific power dynamics in which one group of people had the means to represent another. In the same way, we note that Soviet expeditionary photography was dominated by men who were likely to shoot pictures that figured into the particular vision and ways of seeing that were typical to men of that era.[64] The situated gazes of women and indigenous Siberians, as well as peasants and other people on the margins of power and society, are not present in the framing of the photographs. However, because photographs present a uniquely sensual index to the past, because they present an excess of detail that speaks beyond our capacity to describe them, it is possible to read pictures "against the grain" and to look into them for other histories. This implies an inquiry into the framing of a photograph as ideologically significant or meaningful. Photographs are volatile documents that refuse interpretive projects that seek to provide neat, closed, and cleanly bounded historical claims. Their openness renders them available to a variety of readings, does not stop with social critique, and ultimately leaves the door open for a sense of interpretive dissonance.

It has been well documented that photographs have been used as a technique of a state's surveillance of its subjects,[65] particularly in colonial contexts.[66] However, the power of photographs to represent and contribute to a political or even disciplinary imaginary is nebulous and difficult to trace. It is critical not to overstate the role of photography in the context of colonialism, imperialism, and other repressive regimes. Looking at a collection of photographs from various regional archives in Siberia, it is nearly impossible to generalize concretely or to reduce photographs to a single articulation of meaning at the time they were taken. Indeed, the very profusion of images deflects this kind of work and points to a core problem facing the analysis of historical photographs: they expose the violence of abstraction and generalization, and their irreducible particularity is a volatile agent in the work of interpretation. But it is not just a profusion of images in an archive that does

this; individual photographs contain the capacity to agitate on this level as well, rejecting forms of reduction. A more effective approach to this problem is to consider photographic images as cultural artifacts, instances in a repertoire, themselves suspended within the continuous possibility of circulation.

The digital photograph as data file displaces an approach to photographic materiality. It does not, however, dematerialize photography. As Peter Osborne argues, *[margin handwriting: jargon]*

> If there is a meaningful site of "dematerialization" at stake here, it does not lie in the data file, nor in the conceptual dimension of the work (the originally postulated site of dematerialization)—which is actually always tied to specific materializations—but rather (ironically) in the image itself, insofar as the image is the name for the perceptual *abstraction* of a visual structure from its material form.[67]

Such an open circulation of meaning, however, need not preclude critical attempts to connect power to representation; it only requires realignment toward a more tentative or nervous modality. Here Osborne recognizes not only a dematerialization of the image but also its "derealization." This is a situation where the familiar is rendered uncanny—where, in the famous description of the commodity by Karl Marx, the wooden table both stands on its feet and stands on its head. Just as the photograph seems to recede into materiality as an "ordinary sensuous thing," it slips through simple apprehension, evolving out of its silver halide brain queer ideas, far more wonderful than if it were to begin chattering of its own free will.[68]

Given appropriate conditions and resources, some comments (both general and specific) can be articulated about the reasoning behind the creation of the photographs in my study. Many of the photographs in the EAP and Suslov collections document events, individuals as "cultural types," landscapes, or artifacts and buildings. However, even if the photographer's original intention is known, an image (once it is produced) has a life of its own, quite apart from that of the people involved in the original photographic event. Reading the politics of the colonial encounter into the photograph is

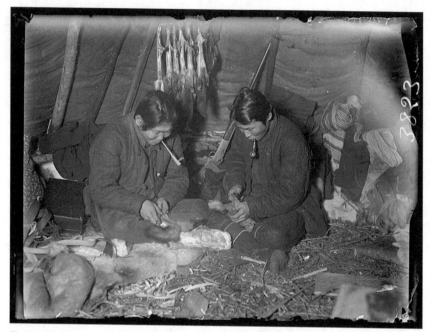

Figure 15. Inside an Evenki D'iu (conical tent). Image courtesy Krasnoiarsk Krai Regional Museum.

feasible, even necessary, but should not be the end point. As Sontag reminds us, "[w]hether the photograph is understood as a naive object or the work of an experienced artificer, its meaning—and the viewer's response—depends on how the picture is identified or misidentified; that is, on words."[69] It is on this basis that I suggest that more flexible and tentative analytical claims should be applied to the manner in which photographic images are used and how they are variably interpreted. As I have shown above, photographs in archives have tended to frustrate such analyses. While they represent putative origins and are most frequently apprehended as stable historical referents, they in fact point more deeply down paths of deferred inter-pretation. In *Drawing Shadows to Stone*, the authors articulate this in the following way:

for all its power to capture detail and represent reality, the photo-graphic image—a unique impression of a single moment in time from a single vantage point in space—resists this urge to idealize the particular.[70]

The selection and staging inherent in the photographic act, the way it is framed, always point beyond the moment captured in the photograph. Detail in this case emerges as a foil for what is called an "idealization of the particu-lar" but which I read as an *appropriation* of the particular—a violent rendition or inverted synecdoche that takes the whole for the part.

While the secondary life of interpretation compares the image back against the original intentions of the photographer (if they are known) or the cultural milieu in which they were produced, there is no binding authority to these interpretations. Most of them are based on generalizations about cer-tain cultural or gendered gazes. Where explicit historical information about the intent of the photographer is available, the next barrier of audience per-ception is encountered, further frustrating the analysis. That is, just as the analysis seems to close in on a dominant gaze, a preferred interpretation, the seemingly transparent generation of meaning slips away to counter-readings produced by photographs being presented in new and different social con-texts. In many ways histories of photography have much to learn from the post-structural turn and the "death of the author" literature.[71] For this proj-ect in particular, the most critical move is the reorientation of critique itself and the development of sophisticated multimodal analyses. The intersection of gazes that constitute photographic meaning are multiple and mobile. It hardly suffices to claim that viewing images is so particular that we cannot in-terpret them apart from the individual viewer. Indeed, this radically individu-alist (antihistorical and anticultural) reading was not the thrust of either the work of Barthes or Foucault. For the sake of my work here, what I wish to take away from the "death of the author" moment is contingency of mean-ing, not abdication of interpretation.

Generalization is a bidirectional problem. Thus, when looking at photo-graphs it is important to avoid confusing the part for the whole—a particular

instantiation of the image, the print, for the photographic image itself. Chris Morton articulated this point, in terms related to the publication photographs in anthropological monographs. Morton cautions us not to

> elide the distinction between the published image and the photograph as a cultural object . . . The conflation of these two categories with related but essentially separable trajectories means that object-led archival research is often replaced with image-led "phototechnical" observation . . .[72]

Morton's distinction of object-led and image-led research is useful in the instance of his argument but problematic if taken separately. Image-led research, for instance, is not necessarily dominated by "photo-technical observation." In fact, Morton himself demonstrates that this does not need to be an either/or situation of looking at the image or looking at the image-object. If we shift the terms slightly to think of the image-object as an image-instance, we can reconnect two sides of what is ultimately the same coin. This further opens a space to think about encounters with projected images and, indeed, to think about an encounter-centered model rather than an object-centered model. This denies the transcendental thinking that may accrue around the object or artifact, as Morton critiques with regard to the image. The image encounter typically privileges the circumstances of spectatorship: subject position, framing, context, and environment. The same photographic image and photographic instance or object—of Evenki children learning to read in a newly built classroom, for example—will be variably interpreted in accordance with the social situation. It is this typical interpretation—surely not inevitable, but perhaps likely—that I hope to agitate and challenge.

In one of his reflections on photography, Jean Baudrillard wrote that "most images speak. Indeed, they chatter on endlessly, drowning out the silent signification of their object."[73] I take this to mean that photographic images are like the world they represent: they do not mean anything; they are always awaiting interpretation, or the ascription of meaning; they have the capacity to signify without end. "Chatter on endlessly" is also a reference to their excess: their capacity to exceed whatever it is we try to say about them.

It is the icon—where image and meaning are indivisible—that becomes the successful model of embedded or foregone interpretation, but even icons fade over time and require work to sustain their status and capacity to obscure image with interpretation. As Cornelia Brink has noted in her exploration of photographs from Nazi concentration camps: when photographs become iconic, they "condense complex phenomena and represent history in exemplary form."[74]

The tackiness of meaning is tried by the slipperiness of the photographic image. Susan Sontag remarked on the fragmentariness of the photograph whose textual or interpretive moorings detach, allowing it to drift "away into a soft abstract pastness, open to any kind of reading."[75] Binding meaning to image as much as meaning to event is a rhetoric of coercion. Event in this case is already a construct, a historical idealization. The photographic image, on the other hand, is a hybrid creature, meaningless in its sensuous reproduction of that which once was and meaningful only in its encounter with an interpreting agent, in its affiliation with an author (or an authorial apparatus). What we *can* do with photographs is talk about interpretation; we can talk about dominant meanings, preferred interpretations, and we can talk about gazes (politics of desire and privilege embedded in modes of seeing) rather than pursuing a narrowly specific engagement with one particular theory of photographic practice. We constitute them in histories of production and interpretation. I am troubled by any instrumental appropriation of images that strips them of their particular histories and uses them to tell one story (articulated as truth or reality), using them as simple reflections, illustrations, or icons.

To some extent the curious effect of this can be seen in James Faris's examination of Navajo photography mentioned earlier. In this work Faris levels a powerful critique against the colonial appropriation of Navajo images (and subsequent construction or representation of Navajo) through the *misuse, misrepresentation, misunderstanding* of photography. Faris claims (correctly, to my mind) that photographs can be read against the grain to discover alternative narratives about their meaning. But he never quite extricates himself from the muscular language of interpretive closure. Thus photographs are (re)captioned with Faris's own commentary: *"Figure 50. 'Medicine Man.' W. L.*

Fetter, photographer 1890, Gallup NM. The man appears to recognize the complete absurdity of posing with bow, arrow, and quiver in the studio setting. . . ."[76] The facetious tone undermines Faris's own position that Navajo have been misrepresented. By attempting to read a man's facial expression, "words do speak louder than pictures. Captions do tend to override the evidence of our eyes; but no caption can permanently restrict or secure a picture's meaning."[77] This is not simply my criticism or preferred approach to photography. I believe that the nature of photographs is such that they passively labor against interpretation. Thus Faris's accusatory rhetoric only serves to awkwardly highlight a counter-narrative. It eclipses one ideal interpretation with another, rather than allowing them all to gather in their queer indeterminacy. As with Baudrillard's insistent exploration of representation and the *real,* the photograph replicates the fundamental relativity of human experience.

Propaganda and Socialist Realism

Remembering that the "backward" indigenous minorities were effectively (and sometimes explicitly) considered to be childlike in their ability to rationalize and apprehend complex Marxist-Leninist politics of international socialism, the visual rhetoric of socialist realism, which was already about social becoming, was even more poignant. It was about growth (*podem*) and cultural upbringing, with its attendant paternalism.[78] The messianic becoming of socialist realism is described by Sheila Fitzpatrick in *Everyday Stalinism:* "Writers and artists were urged to cultivate a sense of 'socialist realism'— seeing life as it was becoming, rather than life as it was—rather than literal or 'naturalistic' realism."[79] Emphasis was both on the recognizability of "realist" representation and on the subject matter. Although socialist realism was not institutionalized until the mid-1930s, evidence of it as a form of propaganda and politically cautious expression predates that.

Photography played a central role in documenting and propagandizing the Soviet way of life (both to itself and to the world at large). V. I. Lenin is frequently cited as locating cinema in a position of superiority in the arts, presumably for its capacity to operate as "political education."[80] In his 1922 "Directive on Cinema Affairs," Lenin is quoted as stating:

Not only films but also photographs of propaganda interest should
be shown with the appropriate captions . . . We should pay special at-
tention to the organization of cinemas in the countryside and in the
East, where they are novelties and where, therefore, our propaganda
will be particularly successful.[81]

Soviet photographers did not suddenly succumb to the modes of fascist aes-
thetics that were implicit in socialist realism, and as such the categorization
of any photographs as socialist realist is problematic. There were parallel
photographic discourses and emerging ones; at the time of the 1917 Octo-
ber Revolution, the research and development of photographic technologies
around the world was progressing at a quick pace; chemical improvements,
lens advancements, and the rapid evolution of machinery were being made
by professionals and amateurs alike. Relatively obscure chemical experiments
that led to the development of photography in the early 1800s rapidly trans-
formed the way that people apprehended the world. In the years leading up
to the revolution, photography had been undergoing its own populist de-
velopments, especially seen in the forms of dry-plate photography, cellulose
film, portable cameras, faster lenses, and shorter exposure times. It was also
at this time that Sergei Mikhailovich Prokudin-Gorskii was developing his
famous color photographs of the Russian Empire while in the employ of
the tsar. Prokudin-Gorskii was only one among many innovators and ex-
perimentalists who strove to take better pictures or cared for and fixed old
cameras. In many ways the revolution and civil war derailed photographic
innovations in Russia while developments continued in the rest of the world.
Most notably is the transformative introduction of inexpensive film cameras
and image processing in North America and Western Europe. In the Soviet
era, especially in Siberia, access to these new technologies was frustrated by
acute economic crises, disruption of supplies and complication of purchasing
out-of-country supplies, Communist expropriations of equipment, and the
widespread disarray of professional practice. It was decades before the Soviet
film industry became self-sufficient in producing its own materials. Cellulose
film photography, for example, was adopted much later in Soviet Russia than
it was in the West. The ironic outcome of this is that glass plates, which were

still being used in expeditionary photography into the 1940s, have proven to be more stable and easier to preserve than the cellulose nitrate film that had gained popularity in Europe and North America decades earlier. By the 1930s and '40s, photographers in the Canadian North, freed from the weight of glass plates and heavy cameras, were shooting dynamic scenes of indigenous peoples inside tents, igloos, and houses, as well as difficult action scenes taken during the hunt.[82] There are relatively few examples of such projects from prewar Soviet Siberia. The parallel development of the Communist Revolution and techniques for the mass reproduction of photographic images (the half-tone printing process, for example) fit tidily with the Soviet embrace of photography both as a symbol of the new order of socialist modernity (evidence of technical mastery) and as a tool in the propaganda of the former Russian Empire. In 1923, around the same time that the new Bolshevik government settled into power following the revolution and civil war, photographs began to appear regularly in the Soviet presses.[83] An examination of journals, though, suggests that the use of photographic images in publication was not regular and was tied to an unpredictable flow of capital. The journal *Bezbozhnik*, for example, has fully illustrated issues followed by issues with no or almost no photographic plates.

In parallel with the rise of the socialist realist aesthetic was the expansion and emerging hegemony of a scientism imbricated with Communist principles. The belief that science tempered by Communism was the single and authoritative method for knowing the world underpinned Soviet Russia's exaltation of the technical mastery of nature. It "embraced the Baconian ideal of technoscience—albeit in secular clothing—with unparalleled enthusiasm. Technology would not merely permit the building of the Soviet state, but would define its very character."[84] This was a vision that bound the success of the Soviet Union itself to the degree to which nature could be subdued and exploited through socialist industry. More than even collectivization, Soviet cultural narratives elevated technological mastery. A typical example of this in popular culture can be seen in the remarkable feats of human industry that are displayed in Victor Turin's film from the late 1920s, *Turksib*. The movie celebrates the construction of the *Turksib* rail line from Central Asia to Siberia as a monumental victory over the immensity and force of nature,

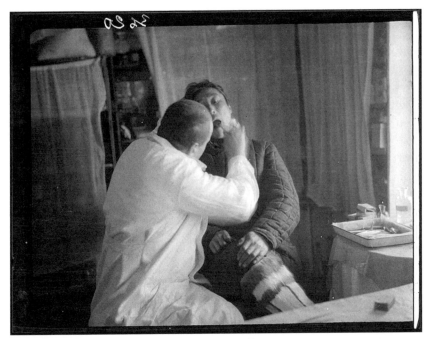

Figure 16. Dental services offered at the Culture Base. Image courtesy Krasnoiarsk Krai Regional Museum.

as embodied in the "wastelands" of Siberia and Central Asia.[85] The cultural imaginary articulated in *Turksib* was manifest across visual and literary media and persists as a dominant visual trope in the North: technology penetrates (with light and power) the dark remoteness of the wilderness. Photography drawing on technical innovation and machine aesthetics was clearly a great beneficiary of enlightenment rhetoric.

The photographic truth-value ascribed to photography ensured that it had a place as an objective tool for the observation of natural and histori-cal phenomena. This in turn reflected its elevated role in the representation and construction of a unified Siberian imaginary[86] in Soviet times. Photog-raphy's role in constructing "imaginative geographies"[87] has been explored in relation to imperial projects in Africa[88] and North America[89] but is largely unwritten in Siberia.[90] Indeed the peculiar form of what I have (somewhat

ironically) labeled "socialist colonialism" promises a novel twist on the study of photography and the colonial imaginary. The Soviet efforts, both real and rhetorical, to produce native self-governing bodies, framed by their vehement rejection of imperialism and colonialism, produced what many foreigners sympathetic to the Communist project saw as a model of local-national partnerships in modern governance.[91]

If socialist realist photography replaced anything, it was the kind of amateur expeditionary photography seen in the work of Konstantin Dmitrievich Nosilov (1858–1923). Nosilov was an explorer, geologist, geographer, and writer who is perhaps most famous for writing about his expeditions to the Yamal Peninsula in the western Siberian Arctic. The move away from amateur expeditionary photography may not have been an intentional shift *per se* but an outcome of state-sponsored class warfare: there could be no more gentlemen travelers with cameras. Furthermore, economic crises reduced the capacity of those with cameras to actually use them—especially considering that most chemical and photo supplies needed to be imported and were consequently expensive. In the Soviet era, until the 1950s, there were few amateur photographers: photography was institutionalized and professionalized, being used primarily by journalists, portraitists, and scientists.[92] This is not to say that there was no popular photography. In fact, there are published cases of a critique of amateur bourgeois photographers. In 1927, its second year of printing, the illustrated journal *Sovetskoe Foto* published the following statement:

> The photo-amateur in the pre-revolutionary period was largely representative of the privileged and wealthy classes. . . . The October revolution presented firm new challenges . . . Photography should be closer to the masses and find applications and tasks that are more broadly relevant to contemporary issues.[93]

Although there is some evidence that amateur photographic movements persisted even through the most difficult periods of Soviet history,[94] most of these photographs have never been accessioned by state archives and thus remain in fragmented public collections as more or less ephemeral records.

The critique of "bourgeois photography" suggests not only a critique of the operator but also a critique of the subject matter—what we might today call the "bourgeois gaze." This connects directly to the implications of Suslov's directions for making a film about the Culture Base that were discussed earlier. The clarity of his ideas for how photography was supposed to meet a kind of visual regime developed out of a direct critique of the wrong kind of photographs.

From Pictorialism to Socialist Realism, or a Nostalgia for the Future

If pre-Soviet expeditionary photography presented natives as anachronistic relics of an earlier evolutionary stage, a kind of socialist pictorialism showed them in a state of becoming. Photographs and photographers labeled as "pictorialist" in the West (North America and Europe) were derided by a modernist school of photographers who sought to distance their art from painting. Pictorialism itself was a movement of artists who sought to distance their practice from the casual documentation of the world and the raw scientific recording of data and events that had become so common. They strove to define themselves as artists rather than technicians and operators. They lauded intention and artistic precedent over experience and observation. They sought to leave their mark on the plane of the image, so the identity of the photographer-artist was as evident as the peripatetic image secured on paper. As one manual about pictorialist photography from the 1930s notes: "Intelligent and enthusiastic search for beauty in nature interpreted by beauty in art is perhaps the worthiest of all pastimes that are not of a strictly scientific character."[95] In Russian photographic history there are certainly disputes about schools of photography, but pictorialism appears less forcefully as a category. Instead, Russia had developed a tradition of "genre photography." While genre photography is discussed in some Western histories, it appears to have a more central place in Russian photo history. There was a brief period when the aesthetics associated with photographic pictorialism was attacked by radical constructivists in Russia.[96] Pictorialism itself might actually be thought of as essentially bourgeois, as presenting a bourgeois vision of the idealized world. Pictorialism in this sense was seen as nostalgia, a

particularly bourgeois feeling. We might also consider Soviet propaganda as a kind of socialist pictorialism. Western art historical discourse has defined pictorialism as a movement of art-inspired photography that followed more or less conventional rules developed through figurative and expressionist painting. In many ways it was a style defined by the rebellion of photographers and art critics against its overt manipulation. Much of the rhetoric underpinning the truth and authority of the photograph was forged in this time. According to this rubric, allegory and expression, for example, had primacy over documentary representation. What I'm calling socialist pictorialism can be seen to reflect a similar sentiment, but one that was governed by specifically Communist and utopian ideals. Just as in Japan, Europe, North America, and elsewhere, Russia was part of a cosmopolitan and global flow of photographic visual culture. Photographs as well as ideas about photography at the beginning of the twentieth century were circulated through a variety of media, including *cartes de visite,* newspapers, magazines and journals, books, pamphlets, films, and photographic exhibitions.

A typical articulation of pictorialism in Russia was the representation of the figure of *the peasant:* "Sergei Lobovikov (1870–1942) adopted [pictorialism] to render traditional peasant life, not as ethnographic data, but as an expression of nostalgia for nature and simpler times."[97] Under Socialist pictorialism, peasant life was exchanged for worker life, the scythe for the combine, and the *kosovorotka* shirt for the *gymnasterka* and the *kombinezon.*[98] The idealizations were there, but the nostalgia was gone; that too was replaced with the messianism of Marxism-Leninism.

The photographer I. I. Baluev can be seen to have produced the most significant body of propaganda style or socialist pictorialist photographs in the EAP Siberia collection. The photographs taken by Baluev generally represent a different representational impetus than the expeditionary photographs. Many of them would fit within the ideology of socialist realism. Quite possibly following the explicit directives of I. M. Suslov, Baluev produced a series of staged photographs within the Tura Culture Base in the early 1930s. The images, some of which illustrate this part of the book, show the mark of a skilled photographer. These were not expeditionary photographs. To the contrary, the images bore the explicit mark of ideology.

Orderliness and privilege was certainly not the norm in the first decades following the 1917 revolution. There were hundreds of Evenkis travelling about this region of the taiga, and the Culture Base counted its beds only in the dozens in those days. This was an idealized vision, a selective imaginary. It was life as it was becoming: a hybrid statement of faith and fact; a socialist worlding, even. There is no doubting *that* man, *those* children, or *that* woman and her child, were there in *that* place, but what that meant and how that aligned with the actual/historical work of the Culture Base is open to debate. While Baluev's photographs represented ideal moments in the Culture Base, they were not fabricated out of thin air. They participated in a broader representational regime. Almost certainly these photographs were reproduced and circulated, and more likely than not they were used to extol the successes of this first foray into the sovietization of the North and the cultural upbringing of the natives. But as with all photographs, the distance between the intended meaning of the image and its deployment in the world obscures a greater violence. As Roland Barthes argues, the "photograph is violent: not because it shows violent things, but because on each occasion *it fills the sight by force,* and because in it nothing can be refused or transformed."⁹⁹ Such force has a tactility that is not dissimilar to Benjamin's nearly abandoned term *innervation,* which sought to mediate in a politics of alienation and engagement.¹⁰⁰ In this way, the willfully perverting realities of socialist pictorialism generate fantasies of the present-becoming, which must have been perceived as intimate otherings and outright fabulations. The doctrine of socialist realism was couched in Communist morals: "the cause of building socialism was greater than the individual, that the individual found self-realization only by denying selfish interests, by dissolving individual will into the will of the collective, and by giving the self completely to the cause for socialism and in the striving for socialism."¹⁰¹ Baluev's pictures were also significant for their portrayal of the Communist International, the specific mythology of inclusivity that promised the world domination of equality and peace. The indigenous peoples were presented as novelties dressed up in the finery of civilization. Not only did they wear the fashionable suits and hats of the day, but they were portrayed using (and marveling at) the technological artifacts of modernity. In Vadim Volkov's exploration of culturedness [*kul'turnost'*] he

describes the cultivation of Soviet civilization—an emerging biopolitics and governmentality—whereby an individual's behavior was modeled on specific regulations, rules, and codes that governed bodily affects including manners, hygiene, dress codes, and modes of dialogue.[102] Photography shifted in this era; the inclusivity of the Communist International pushed out the depiction of visible difference and replaced it with inclusion and cooperation. Photography came into the service of the new empire of nations.

At the forefront of the propagandizing of nonliterate peoples were photographs and films. The photograph was marked from the first days of the Soviet era for its capacity to show the world "as it is." Yet at the same time—though in different contexts—bourgeois photography from the West was critiqued. American photography, as it was understood, replicated a commodity fetishism that veiled the inequalities inherent in capitalism; photography in service of capitalism effaced myriad problems such as poverty, racism, and sexism. A Soviet or proletarian photography would not do this. Rather, it would propagandize the successes of Communism, even if they had not yet been achieved. The hypocrisy of this position was conveniently ignored, and possibly argued away in the pragmatics of revolutionary Communism and the subsequent programs of sovietization. The growing bureaucratic oppressions and political repressions under Stalinist rule are well documented and belie the rosy picture of plenty that came to occupy a central place in Soviet visual culture. There was, of course, no single voice in photographic practice. The many aims and goals related to photographs and photographers were divergent. The ontological status of the photograph also fits into an international visual discourse that leveraged the never-boring trope of the "savage" in European clothing and operated as one of the foundational images in the visual culture of modernity.

While the fantasy of techno-social modernity, peace, and wealth was apprehended as a real possibility and an imminent future, the spectacular and obscene performance of this eventually came to eclipse other forms of representation, leaving little more than fantasy. Slavoj Žižek makes a similar point in *The Parallax View* and *The Pervert's Guide to Cinema* when he comments on the obscene spectacle of the Stalinist "kolkhoz musical." Žižek connects the psychoanalytic idea of the superego—"excessive terror, unconditional

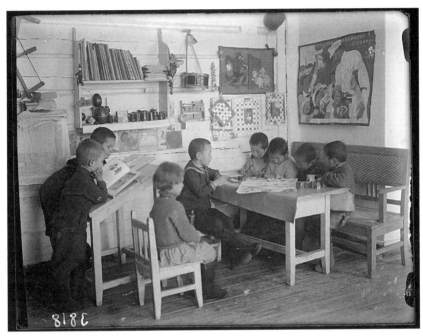

Figure 17. Children in school at the Tura Culture Base. One poster opposite a depiction of the fairy tale of the Big Bad Wolf and the Three Pigs, reads: "Thank you beloved Stalin, for a happy childhood." Image courtesy Krasnoiarsk Krai Regional Museum.

injunction, demand of utter sacrifice, but at the same time obscenity and laughter"[103]—to Stalin's favorite genre of movie. In *The Universal Exception* he writes that these kolkhoz musicals were the public face of Stalinism: "There are no traitors in these films, and life is fundamentally happy in them: the 'bad' characters are merely opportunists or lazy frivolous seducers, who are, at the film's end, re-educated and gladly assume their place in society. In this harmonious universe, even animals—pigs, cows and chickens—happily dance with humans."[104] The obscenity of propaganda (including the photographs from the Tura Culture Base taken by Baluev) is typically analyzed as a measure between lived reality and the obscene fantasy. By "obscene" here, we have the distance the fantasy falls from the reality. The danger in historical representation is that the obscene image produces a hazardously

solid-looking opposite. A more productive examination of Communism's dreamworlds is delivered by Susan Buck-Morss as she investigates the passing of the Soviet mass utopia: "It could be said that the Soviet phantasmagorias of production generated a new 'dream-sleep,' this time falling over the Revolution itself."[105] In other words, the anaesthetics of a dream-form were built on production that failed to provide much more than the absence of material scarcity. Alternately, we might look to Sheila Fitzpatrick's *Everyday Stalinism* and the way it uncovers innervation in another register. Noting the entitlements enjoyed by Stalin's *"intelligentsia,"* Fitzpatrick remarks that the misrecognition practiced by privileged classes was broadly remarked upon and met with popular grumbling and complaint.[106]

The historian Erika Wolf examines the development of Soviet photojournalism between 1923 and 1932. She notes how "ideologically loaded" images were part of a dynamic and emergent form of photography.[107] In her work on the fantasy worlds produced through the "lavishly printed Soviet photographic propaganda magazine" *USSR in Construction [SSSR na stroike]*, she challenges the message that was presumed to be inherent in the propaganda and ties it to an emerging "Stalinist elite as the primary ideal readership."[108] Wolf argues that as a publication for the Stalinist elite, *USSR in Construction* helped to produce "an image of Soviet society and industrialization that bolstered their sense of mastery and leadership."[109] Wolf's attention to audience is critical. The Culture Base photographs produced by Baluev bear all the characteristics of the photographs produced for *USSR in Construction*. While the audience of these photographs is unclear and indeterminate, the primary message of socialist plenty, civilization, and success is not. In *The Red Atlantis,* J. Hoberman identifies the core of socialist realism as a "combination of strict idealization and naïve, almost goofy idealism."[110]

As director of the Krasnoiarsk Committee of the North, I. M. Suslov produced his own vision for representing indigenous peoples through photography in the memorandum discussed earlier, "Themes for a film on the North." This memorandum, probably written in 1927 or 1928, frames a project of cultural construction where Suslov outlines two categories of film. The first was aimed at displaying the North and the toiling native masses. The second category of film was to build on these depictions to include "native everyday

subjects in order to popularize the lives, customs, and economy of the North in Soviet cities and abroad."[111] This can no doubt be seen as simply and cynically ideological stagecraft: a Potemkin exhibition of faked plenty. Indeed, there is little doubt that the photographs were crafted to communicate a particular set of ideas. They evidently lack the candid energy of life that is lived under conditions as they are experienced in the everyday. The force behind these photographs also reveals a regime of socialist pictorialism, a Communist dreamworld that bound the depiction of the present-past through photographs as the emerging present of a socialist promise.

Archives and the Circulation of Images

Archival photographs are rarely singular entities; they tend to be gathered together as part of larger collections. They are placed in proximity to other images . . . archival acts of collage producing surrealist automatism (or automatist writing). The juxtaposition of images is partly fascinating for the way that archival (dis)order produces new and unexpected juxtapositions. These collections are composed of a sometimes surprising and peculiar assortment of images. They have been brought together in response to an impetus for preservation as well as procedural bureaucracy and performative modernity. Benedict Anderson famously marked out some of the accoutrements of modernity in *Imagined Communities*. Deborah Poole notes this as well, though she cautions against reading these too functionally. In her examination of photographic *cartes de visite*, she notes that their importance in Peru was greater than the simple reproduction of social ties: "In exchanging cartes de visite, friends or acquaintances were offering not just things with a detached symbolic value or an arbitrarily defined monetary or exchange value. As emotionally invested images of the self these cartes contributed to the formation of a diffuse and powerful cultural and sentimental identity . . ."[112] There is not always a visible, comprehensible, or remembered logic to the vast collection of images bound together under the umbrella of a single archival fond, let alone a technical category.

The situation in the Siberian archives is not unlike that of colonial archives in Namibia as described by Carolyn Hamilton. Hamilton asks:

what happens when the photographic archive has not been organised on longstanding bureaucratic principles (as is the case in Namibia) but has been assembled unevenly, haphazardly, anonymously—and is not easily rendered up for scrutiny, not through design but through lack of prioritisation? An entire new historiography has emerged about the metropolitan and imperial archive . . . but the Namibian case forces us to ask about the nature of the peripheral colonial archive.[113]

There is typically a logic to archival order (even if it is obscure or merely presumed to be present). Archivists generally have very particular techniques for justifying what should and what should not be accessioned into the archives, but these are not always universal or agreed upon and they are often simply unknowable. In the peripheral archive, often underfunded and staffed with untrained or minimally trained archivists (though no less likely to be dedicated), photographs, especially glass plate images, have been a burden.

Given these conditions, I propose a methodology that embraces the hodge-podge of photographic images in archives and eschews a fetishization of the arcane orders imposed on images. To be sure, order is imposed on the collections, but it is an order that is constantly in danger of being subverted by the meaninglessness underpinning the documents themselves. Archival order is a path in to a relational complex of historical traces, not an a priori historical structure. As I've argued throughout this book, the agitational character of photographs, their absolute particularity, refuses order and meaning. They are repeatedly categorized and tagged, subordinated to textual forms of representation, but they invariably exceed these—as though they were oblivious to our projects of history making.

Archives are technologies of discipline and order. The basic units and structures of their disciplinary power are not only the document but the guidebooks and indices used to navigate the mass of documents that compose the archive. It follows, then, that the practice of history involves the regulation of documents, their arrangement into a sensible array. This production of historical assemblages informs a "vocabulary of modernity" shared by both photography and archives. This vocabulary is described by Canadian archivist

and historical geographer Joan M. Schwartz as a "zeal for inventory and tax-onomy" that emerged in the late eighteenth and early nineteenth centuries and paralleled "the natural sciences' obsession with collecting and classifying specimens."[114]

The voice of the archive is not the voice of the documents but the voice of the imposed order and discipline. It is the ongoing construction of in-sides and outsides negotiated by the institution and the archival interloper. The voice of an archive is the order it imposes on the researcher's gaze with subsequent effects on interpretation. The categorical frameworks and foun-dations developed in archives streamline and guide the writing of history and other sense-making projects. "There is no archive without a place of consignation, without a technique of repetition, and without an exteriority. No archive without an outside."[115] The archive as a technology of discipline orders both the collections and the representations that end up being struc-tured by these disciplines; thus, there are reverberations that become almost imperceptible as they become more and more lodged into discursive frame-works. The more or less rigid parameters that index archival photographs are not simply about the organization of collections but rather the organization of knowledge. Just as the voice of archives is shown to be a technology of order, the archive's gaze can be seen as disciplinary technology. The classifi-catory schemes used in Siberian archives can serve as an example; mastery and skill in an archive are related to knowledge and intellectual creativity (but also to social relations and luck). The guidebooks [putevoditeli] provided by each archive, for example, are critical forms for the production of history and knowledge, though in truth I've just as often found guidance elsewhere, especially through the help of living archivists. Such informal knowledge and guidance belies the greater structuring power of archival order. Nonetheless, informal guidance permits for oblique access, unanticipated connections, and happy accidents—in other words, serendipity.

Thinking about the archive's gaze implies the various imaginaries pro-duced by archival collections. For photographic archives, two distinct gazes are in operation. Firstly, the historical institutional gaze constructs social worlds, and in the case of Siberia, it constructs these worlds through repre-sentation and symbolic control. In the late 1800s when photographers first

traveled to northern Siberia and other far reaches of the Tsarist Empire, few of the ruling elite who actually made decisions about the lives of Siberians ever visited Siberia or knew much about the everyday lives of Siberians, especially those living in the taiga and tundra lands of northern Siberia. For these remote rulers, photography played an important role in extending the imaginary, making it both more accurate and more efficient. Photography gave a complicating visage to rule that had previously been dominated by textual description. Meanwhile a second kind of gaze emerges from the metaphorical consideration of archives: the consideration of a collection of documents as an archive. The visual archive of Siberia consists not of written documents, but visual documents: mostly photographs, but also illustrations and films. This imagining produces my own archive, even if that personal archive consists only of references to particular documents. The technique of the archive—of any archive—is to put boundaries around a subject: to say that this is inside and that is outside.

Photographs from archives have the potential and ability to become mobile, to circulate. Over the space of many years, photographic reproductions made their way into personal collections, museums, and archives throughout the Soviet Union. Some have had years of active service, their images illuminating the walls of museums, mounted and displayed, or pasted into photo albums. Some of the photographs were used as material for lectures: "Soviet Reindeer herding," "How to battle shamanism."[116] Still others were used to illustrate journal articles or books, as with Sergeev's *Non-capitalist Way of Developing the Native Minorities*. But most of the photographs have been quietly filed away amidst an ever-growing collection of visual records. Some of the photographs in the Siberian archives have continued to experience limited circulation. Through duplication and copying, the proliferation of each photographic image is potentially limitless. Conceptualizing their various trajectories and their connections to one another produces a vast and complex network of the imaginary.[117] The situation of the photographic image in the archive should be considered as the situation of an expansive surrealist juxtaposition of disparities and incongruities.

The photographic images in the archives chronicle thousands of moments, frozen in time, which are more or less haphazardly brought together

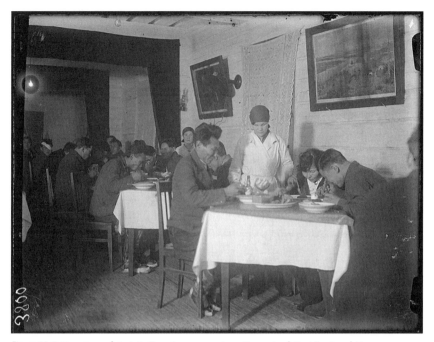

Figure 18. Eating at a cafeteria in Tura. Image courtesy Krasnoiarsk Krai Regional Museum.

under the organizing logic of the archive. They provide a fragmentary but compelling point of access to an indisputably past world, what Roland Barthes called the "photographic referent" and "that which once was," or simply the "absolute Particular."[118] They serve the double function of referring to the past but also *being* the past. Susan Sontag has characterized photographic collections as "an exercise in surrealist montage and the surrealist abbreviation of history."[119] The photographs, apprehended in the chaotic disorder particular to these archives, also remind me of how William Burroughs describes the everyday "facts of perception":

Take a walk down a city street and put down what you have just seen on canvas. You have seen a person cut in two by a car, bits and pieces of street signs and advertisements, reflections from shop windows—a

montage of fragments. . . . Writing is still confined in the sequential representational straitjacket of the novel . . . Consciousness *is* a cut-up; life is a cut-up. Every time you walk down the street or look out of the window, your stream of consciousness is cut by random factors.[120]

Researching the collections of photographs from the archives can be powerfully destabilizing as well as compelling, if exhausting, work.

If surrealist montage and dadaist juxtaposition are the effects of working with photographic archives, then as a historical researcher I am faced with the dilemma of my own normative gaze. The task at hand is always imposing an order on the collections, of extricating meaning from the morass. In her book *Dust,* Carolyn Steedman reminds us that the archive

> is not potentially made up of everything, as is human memory; and is not the fathomless and timeless place in which nothing goes away that is the unconscious. The Archive is made from selected and consciously chosen documentation from the past and also from the mad fragmentations that no one intended to preserve and that just ended up there.[121]

This serendipity speaks to excess and a potentially limitless subject. But Steedman is not talking about photographs. A photograph, if it is not potentially made of everything, certainly comes closer to it than colonial reports, ledgers, and other artifacts found in most archives. The "mad fragmentations that no one intended to preserve and that just ended up there"[122] not only describes the photographic collections but the individual photographic image as well. It speaks to the excess of meaning that haunts interpretation by reminding us that "life is more complicated than those of us who study it have usually granted."[123] Finnish artist Jorma Puranen has articulated this sensibility as well:

> Working in a photographic archive is a strange experience: you are faced with boxes and boxes of images of dead people, even entire

nations. At times, these material objects—faded, ripped and worn-out photographs of people long deceased—become vivid and strongly present. The faces are either un-named, or accompanied with careless translations and, frequently, misunderstandings. Some faces look familiar, as though one had seen them in other archives or on the pages of books.[124]

The strangeness of the experience of working with archival photographs is, despite an impulse to order, essential to the texture of knowledge. To omit this strangeness through practices of representation is reductive of the everyday. Michael Taussig has observed the tendency in ethnography to write away the bits that don't fit, and he argues for a practice that doesn't efface the untidiness of history:

> As with any social science, including history, anthropologists explain the unknown in terms of the known. There is resistance to leaving weirdness weird, and no recognition of the stuff that won't fit. For that would threaten the basis of the academic claim to mastery underlying our professorial—no less than professional—claims to authority.[125]

Photography complicates this picture by providing what appears to be the known. As apparently simple documents of truth and precision,[126] photographs are mobilized to anchor textual arguments in something more real—something like evidence or witness.

Agitating Images

The intentionally nervous and tentative historiography I propose is built on a critique of representation and the scholarly imagination. Following Jean Baudrillard, John Jervis argues that "the image can be dangerous because it fails to fulfill the promise of representation, it is deception, illusion; but it can also be dangerous because it succeeds too well, becomes simulacrum, a replacement or substitute."[127] Such dangers haunt this work, which also shares

some intellectual lineage, perhaps counterintuitively, with modernist artists, activists, and theorists. In Russia we can look to Dziga Vertov, Aleksandr Rodchenko, and Viktor Shklovsky to recognize a similar impetus to dislodge the mundane practices of looking that prevent us from seeing the world as it is. But where these figures offered a positive response, a "real" world that was veiled by ignorance, I see fields of dissent and contention: irresolvable processions of signification. Photographs in the archives do this for me more than any other artifact. Their relentless pull to the absolute particular, paradoxically existing only as the image, seems to mock interpretation. It is tempting to respond that it is the task of the researcher to put order to folds and fissures of meaning and interpretation, to make sense out of it. But I read the photographic image as a refusal to participate in the production of history. Archival photographs only appear to passively await the ascription of meaning, through the inscription of captions. In truth they are volatile agents that agitate against interpretation. In his book on the lives and loves of images, W. J. T. Mitchell poses the question "What Do Pictures Want?"[128] To answer, in my own terms: they want to undo stability, stasis, and comfortable positions; they want to pull out the carpet from underneath the contentment of scholarship.

The archival significance of the photographs I have been working with in central Siberia is doubly powerful because they occupy positions as both tangible and metaphorical archives. Not only do they reside in the archive, but they are also the substance of archive (of memory, of command and the power to state, but also of the State). Barthes wrote that the "[t]he Photograph belongs to that class of laminated objects whose two leaves cannot be separated without destroying them both: the windowpane and the landscape, and why not: Good and Evil, desire and its object: dualities we can conceive but not perceive."[129] As archival metaphors, photographs are contained and treated; they frame the world and in turn are framed by it. It is essential to recognize that these two aspects are inseparable.

Photographs of the everyday become significant through not only the event of the photographic performance but also their preservation and their circulation. This circulation works as a kind of double life, especially in the digital age of data proliferation as photographic images are presenting them-

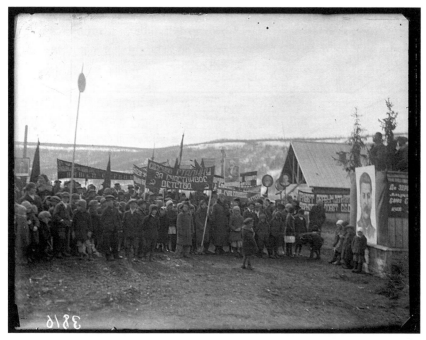

Figure 19. Parade in Tura. Central banner reads: "Thank you Stalin, for a happy childhood." Image courtesy Krasnoiarsk Krai Regional Museum.

selves more rapidly and more pervasively in new cultural contexts and media environments. What is interesting about this is that the sensuousness of the photographic image can transcend its second life, its interpretations and captions, and point back to the everydayness of life: the photographs have been unarchived and have travelled through time to the present: a picture of something that once was. It is almost as if the photo-image is constantly seeking to return to its referent; it is always indicating from which way it came, recalling Walter Benjamin's recollection of Paul Klee's painting *Angelus Novus*: The angel is swept up in progress but forever looking back over his shoulder:

> The angel would like to stay, awaken the dead, and make whole what has been smashed. But a storm is blowing from paradise; it has got

caught in his wings with such violence that the angel can no longer close them. This storm irresistibly propels him into the future to which his back is turned, while the pile of debris before him grows skyward. This storm is what we call progress.[130]

There is an inevitability to photographs, maybe a tragedy and longing or just a fecund nostalgia, but in their codification as history they remind us that history must fail. Their flat refusal to behave as stable signifiers echoes and intensifies the incredulity of everyday life in the face of theory and representation.

The photographs I have encountered in the archives are remnants of the everyday. They are not all readily identifiable as "events"; perhaps their "event-ness" has passed along with the identities of many of the subjects. Their dominant role now is to be part of an "era" of "the past" of sovietization in Siberia. But they won't let me do that, because as long as there is someone to look at them, there is the capacity to be struck by the ephemeral beauty of lingering campfire smoke and an Evenki family's tent in the faded background, and to wonder what has been left out.

Conclusion

Ethics of Presence and the (De)generative Image

Photography in the practice of history and cultural theory has consistently proven to confound interpretation as a generic category. It is apprehended along a spectrum of positions that see it alternately as a transparent reflection of the world and a fabricated cultural text. As I have shown in this book, whatever its ontological status, the photograph is implicated in historical discourses as a significant witness attesting to the everyday. As a resource in the production of historical narrative, it is much like any other document. A photograph, however, is an unstable element when reproduced as a component of historiography. I argue that photographs work along the same principle as archives and they undermine the rules of historical narrative by way of their bald disclosure of alternative historical readings, blind spots, and the seams of knowledge production itself. Image agitators are dangerous communications to the integrity of conventional historiography.

The idea of photographs as dangerous communications is borrowed from Odilon Redon, the French symbolist painter who was fascinated by obscurity, mysticism, and ambiguity. He once wrote that the photographer

> directly and shamefully uses photography in order to convey truth.
> [The photographer] believes . . . that this result is sufficient when it
> can merely provide him with a fortuitous accident of a crude phe-
> nomenon. The negative only conveys death. The emotion felt in
> the presence of nature itself will always supply him with an equally
> authentic amount of truth, the only truth, which he himself controls.
> The other is a dangerous communication.[1]

According to Redon, photographs that are used as reference for painters are "dangerous communications" because they support an illusion of presence

or witness and truth as a mask. In this case, the mediating role of the photograph is an invisible buffer between the world as it is experienced and the world as it is represented. The advent of photography ignited a burgeoning crisis in the art world. This was not only a crisis of representation but of the location of the author in the production of knowledge. The status of truth and the real is associated by Redon with the artist's "emotional" experience; it is a statement of positionality, an ethics of presence. Redon's "dangerous communication" is relevant here for noting the role of the photograph as a prosthesis for experience. The danger in this communication reveals consternation over practices of representation as well as the status of empirical knowledge, gained from direct experience. The photograph in this sense is a doppelganger of the real, of situated knowledge.[2] And not only does it double the real through a sensuously convincing copy, but it threatens to overwhelm and diminish it.

The role of agitating images and dangerous communications in this book is to highlight the (de)generative and unwieldy power of the image and to engage with the increasingly dislocated character of the archive. I mean to use these effects to develop my historiography of socialist colonialism as necessarily partial, contingent, and embodied. By this I mean it to work as an invitation to further research, query, and challenge. Various photographs and videos I have created are meant to function as interventions that simultaneously supplement and supplant the historical narratives I have established in the book. I take photography and archives as interchangeable concepts, similarly governed and similarly appropriated. They are also apprehended as communicative models: sources (though not necessarily originary) from which meaning issues forth. The emanations from these queer interventions have unpredictable consequences.

Working in the archive is the labor and proof behind the images you see here. Being in the archive and spending time there, doing time there, is presumably what many historians do. As a cultural theorist and ethnographer in the archive, I was never quite able to get out of a tense and sensuous encounter with state power. The archive overwhelmed what seemed to be my clear and direct questions about the visual histories of sovietization, with its own logics and institutionalized incredulities to my project. Where my ques-

tions at times brushed the archival grain in the wrong way, I was always put straight, set on the right track. The archivists were mostly polite, especially once I'd spent more than a week or two working through anonymous archival inventories [*opisi*], requesting archival files [*dela*], and more or less looking like a typical researcher [*issledovatel'*]. The Russian term for researcher translates literally as a tracker or one who looks for traces—an apt translation given the emphasis on the trace in archival theory and deconstruction. Besides the obvious absent presence that is the trace, the embodied haunting of documents whose histories have been frozen and who have become mute vessels beholden to the stuff of the past in the present, the trace reaches out of text and speech to mark both photography and the everyday life of indigenous Siberians.

If these last statements perhaps demonstrate my deviance in the post-Soviet archive, the policing function of archivists on my research was only a symptom of the larger technologies of rule and order implicit in the archive itself. Indeed, reconsidering my time in these institutions, the archives look more than ever like material incarnations of state power and order. They do not merely bear the history of the state, but they are among its earthly effects; the archives are not imaginary structures but ecologies of containment, like holy relics in their glass and wood.

Anachronistic Spaces, or Living on the Hundred-Year Mountain

In the life of the Turukhansk krai, since the moment of its conquest by Russians, there has not been seen such work and such construction as is currently being undertaken by Soviet power. . . . By granting full political rights of small nationalities of the North, Soviet power has fully raised the economic and cultural lives of the natives of the Turukhansk North.[3]

It was a journey into the distant past.[4]

The histories written by Evenki author V. N. Uvachan focus on the construction of socialism in the Turukhansk North. They frame the Soviet

past as a series of battles against backwardness and exploitation. According to Uvachan, the first journey of Soviet state representative and instructor E. S. Savel'ev to the inland territory north of the Nizhnaia Tunguska River "was a journey into the distant past."[5] Until the Culture Base was built, the Turukhansk North was understood as a wild and primitive land of darkness and privation where all kinds of uncivilized behaviors were left to thrive; it was an anachronistic space, a zone of permanent cultural anteriority. The instructor sent to report on the situation in the unknown landscape might have been a cosmonaut, but he was certainly not an envoy sent to negotiate with another sovereign state. The people of the taiga were stateless, which was seen not as a way of being in history but a way of being outside of history, of being stalled in time. According to historian Yuri Slezkine, Soviet administrators

> proceeded from the assumption that the circumpolar peoples—or the small peoples of the North . . . were at a stage of primitive communism. That is, there was no class stratification among them and whatever exploiters there were, were Russians.[6]

After a decade of weak Soviet interventions, the Committee of the North set about to build a lasting structure in the forests of central Siberia. The Culture Base was built as an outpost for the project of sovietization; it was a beacon of socialist enlightenment. It was meant to provide a space to foster the intermingling of cultures in a kind of temporal miscegenation. The past and the radicalized present would rub closely together to produce a future of plenty heretofore unseen in the Siberian North. It was an audacious promise full of hope and (some) honest belief in the ideals of the revolution. To the soviets, the forest was a site of capitalist exploitation, poverty, and privation; it was seen as a primordial landscape dominated by dark and primitive acts. Shamans' drums and Orthodox icons hung in skin tents and log cabins; power was diffuse but was largely patriarchal in character; marriages were arranged and paid for through dowry [kalym]. Furthermore, the hunters and herders believed in complex spirit worlds largely incomprehensible to the atheists (mostly former Jews and Orthodox Christians), who saw themselves

as bearers of light and reason and who sought to eradicate cultural elements perceived as abhorrent to socialist modernity.

While the Turukhansk North was seen as a potential font of natural wealth, it was simultaneously understood to be a land out of time, or at least a land of conflicting times; it was a territory mapped out by anachronisms and zones of modern socialist influence. The construction of the Culture Base was an incursion of industrial modernity plunged deep into the heart of the primeval. As Uvachan wrote, "The Tura Culture Base was the first beacon of socialist culture in the North."[7] The general sentiment was that in the years following the revolution and civil war, the indigenous peoples of the Far North had completely stalled in their social evolution. In 1924, the Peoples' Commissariat for the Affairs of the Nationalities (Narkomnats) made it clear that the people of the Siberian North existed outside of the Soviet decrees, that they had been left behind in the rush to consolidate power.[8] According to Soviet chronopolitical ideologies, the indigenous peoples were not the only living representatives of the past. The Siberian North was also inhabited by colonial exploiters—merchants and tungusniks who made their living off the backs of indigenous peoples. These exploiters were seen as offending survivals as well, but they represented the capitalist past, suppressed in Russia after the October Revolution. The moral topology of progress in early Soviet thought was also complicated by rapidly evolving political philosophies. The category of primitive Communist was perhaps one of the more challenging conceptual hurdles. It is difficult to discern the greater affront to early Soviet Communism: backwardness or capitalism. As the case of primitive Communism demonstrates, one could be backward and not capitalist, but capitalism was always backward in the living future of messianic Communism.

Russian Communists had a long history of colonial imaginaries to borrow from when they thought about the Siberian North.[9] "From the very beginning, Siberia was represented as both the frightening heart of darkness and a fabulous land of plenty."[10] The journey up the river toward the source mimicked the imagined journey back in time. This apocryphal journey is most famously known through Polish author Joseph Conrad's novella *Heart of Darkness*—a now classic fable of colonial horror that traces the journey from civilization to barbarism in a river expedition into Congo at the end

of the nineteenth century. The long river journey from the more frequently navigated waters of the Enisei River to the mouth of the Nizhnaia Tunguska River and beyond marked the frontier of civilization. The deeper into the taiga, the farther back in time the soviets imagined they were travelling. They saw "savages" less and less touched by modernity.

This peculiar geofantastical phenomenon has been characterized by Anne McClintock as an anachronistic space. The formulation draws attention to the mechanics of colonial ideology that naturalizes and actualizes cultural evolution. According to the logic of anachronistic space, those who are colonized "do not inhabit history proper but exist in a permanently anterior time within the geographic space of the modern empire as anachronistic humans, atavistic, irrational, bereft of human agency."[11] McClintock's formulation was developed in response to Western European colonialism, but it functions remarkably well in Siberia with one significant difference: the context of postrevolutionary Siberia needed temporally mobile subjects who could be participants in the multinational socialist state.

The Siberian natives could not be "permanently anterior" within the Soviet empire of nations. Spatial and temporal differences would be mediated through the technical apparatus of sovietization. Not only would the natives be transformed through sustained contact with the civilizing power of the Culture Base, but the land itself would become a modern rationalized industrial landscape. It was the techno-social machinery of sovietization that would make the people and lands of the central Siberian interior contemporaneous, but it was the logic of anachronistic spaces that motivated them. In the rhetoric of early Soviet Communism, backwardness (next to the accumulation of private wealth) was one of the most offensive states of being.

The Culture Base as a primary technology of sovietization in the Turukhansk North is a story of performing modernity. The Culture Base was an elaborate display of the future in the present. This approach to thinking modernity follows Louisa Schein's argument that "the modern is usefully thought of not only as a context in which people make their lives, nor only as a discursive regime that shapes subjectivity, but also as powerfully constituted and negotiated through performance."[12] Where overt culture change was seen as both laudable and inevitable, the demonstration of modernity through

carefully choreographed encounters was also necessary to sovietization. One of the more spectacular examples of such performative modernities was the terrifying "aerial baptism" [*vozdushnye kreshcheniia*] described by Scott W. Palmer: "In an effort to eradicate peasant 'superstition,' pilots [from Soviet agitational squadrons] took rural believers into the air in order to prove that the heavens held no God, no angels, and no other celestial spirits."[13] Soviet performative modernity functioned alternately as an incentive and a threat, and often both. In the emerging socialist gift economy, it was an irrefutable endowment that was paid back with complicity and subordination.

While the modern state cannot be seen as a unified political practice, Benedict Anderson's work on "imagined communities" offers a powerfully resonant case for examining the remarkably formulaic character of modern states. The press and the archives, national anthems, military marches, surveys, maps, and census are all regalia of the modern colonial state. These colonial technologies offered a "peculiar imagining of history and power," forming a grammar which made possible the colonial state.

> For the colonial state did not merely aspire to create, under its control, a human landscape of perfect visibility; the condition of this "visibility" was that everyone, everything, had (as it were) a serial number . . .[14]

Nicholas B. Dirks's notion of the "cultural technologies of rule,"[15] which emerged out of his study of the Indian colonial experience, can be used to extend this idea. At the time of Soviet ascendance, the clichés of modernity were in full swing. The template was Soviet man: national in form, socialist in content. So the peoples (especially the exotic ones) were encouraged in limited forms of cultural expression. This multiethnic state was presented as the brotherhood of nations. But the powerful rhetoric should not be seen as fully or necessarily duplicitous or cynical. Especially in the early years following the revolution, there was a real and affective sense of impending change. The cultural toilers who volunteered to work in the Turukhansk taiga were dedicated to the cause of revolution and societal change. They advocated and demanded cultural change from all levels of society. They subscribed to

a variant of what would later be critiqued as the European enlightenment project[16]—undertaken in the guise of socialism. The foreign culture workers were the acolytes of modernity who espoused a profound commitment to Marxist metanarratives that neatly compartmentalized righteous and deviant paths.

The idea that the natives of the Turukhansk tundra had not yet emerged from the primeval stage was a deeply held belief that is repeated in countless sources. This trope of a historically stalled native is a recurring theme that was crucial to the liberatory narrative that presented the ideas and effects of socialism as gratefully accepted gifts. This narrative is borne out in literature as well as visual culture and had become an important feature of Siberian-based propaganda. The narrative can be summarized like this: through great hardship and sacrifice, European Communists brought the fruits of civilization to the darkest corners of the former Russian empire. Crucially, though, it was not presented as a strictly paternalistic narrative but one of comradeship and brotherhood: they taught the natives how to pick and choose desirable elements from their culture all the while discarding those that were not. And most importantly they expected the natives to become fully capable of participating as equals in the Soviet project.

In *Empire of Nations*, Francine Hirsch describes the relationship between the indigenous minority groups of the Siberian North and the state as a form of "state-sponsored evolutionism." She goes on to note that "Imperial ethnographers shared with the Bolsheviks the view that humankind evolved through stages on an evolutionary timeline . . . Lewis Henry Morgan's ideas about periodizing 'progress in human history' were read with great interest by Marx . . ."[17] Criticized as social Darwinism, the evolutionism that emerged out of the theories of Marx and Engels envisioned a unilinear model of social evolution where all societies passed through a single evolutionary process from the most basic or primitive forms to the most sophisticated and evolved. This was based on Lewis Henry Morgan's theories of cultural evolution. Morgan thought that there was compelling evidence that human societies progressed "from savagery to civilization through the slow accumulation of experimental knowledge."[18] It is widely noted that Soviet ethnography was beholden to the evolutionist theories of Morgan, partly due, no doubt, to

the supportive references by Marx and Engels. The persistence and entrenchment of this theory had a significant effect on Soviet anthropology, which in the early years of the Soviet Union played a significant role in developing state policy around questions of ethnicity.

Near the end of the Soviet era, one could still write of a "continuing reliance, even in the 1980s, on Lewis Henry Morgan's obsolete formulations."[19] Despite this claim, Yuri Slezkine notes that in the 1920s cultural evolutionism was in decline: "Theories of universal development were out of fashion, and Morgan's, Tylor's, and Spencer's grand systems were being criticized as too abstract . . ."[20] In any event, Slezkine paints a complex picture of competing interests and ideas taking place within the precarious and sometimes deadly climate of early sovietization and class war.

> One way of being Marxist was to discover and analyze class differentiation and class conflict. This was a politicized requirement: collectivization was a given, and collectivization presupposed the existence of classes. On a loftier plane, all Marxist ethnographers agreed that their primary task was to define the place of a given society in the chain of sociopolitical formations and, having thus established their bearings, proceed to examine the interplay of base and superstructure and the operation of specific economic, social, and cultural phenomena.[21]

The Ilimpii taiga was not seen as an empty landscape. It was understood to be inhabited by Evenkis, Dolgans, and Yakuts (Sakha). The Soviet administrators understood that without reindeer they could have no command of the vast tundra lands that lay between navigable river ways. Future resource development would rely on reindeer for exploration, but in the present the reindeer were essential for the continued importance of furs, reindeer meat, and fish. The indigenous peoples, though, were seen as a potential resource, labor force, and (sometimes) partner. The logic of the Soviet Empire (as we learn from Hirsch) was such that nationalities would conform to Soviet rule and become docile to rule.

In terms of alternative uses of and possibilities for the Siberian taiga and

tundra, it was indeed seen as a virgin landscape, at least insofar as it had not been despoiled by heavy industry and thus held the promise of (primarily) mineral wealth. One of the functions of the Culture Base was to be a remote outpost for scientific exploration. The goal, of course, was for the land, just as for the people, to reach its full economic potential. In this logic the landscape itself was primitive (and virgin), having only experienced superficial exploitation. Surely greater and more intensive uses of it were possible! Through better organization and the industrial might of Communist science, the land could be exploited for the benefit of all.

> The colonial journey into the virgin interior reveals a contradiction, for the journey is figured as proceeding forward in geographical space but backward in historical time, to what is figured as a pre-historic zone of racial and gender difference. One witnesses here a recurrent feature of colonial discourse. Since indigenous peoples are not supposed to be spacially there—for the lands are "empty"—they are symbolically displaced onto what I call anachronistic space, a trope that gathered . . . full administrative authority as a technology of surveillance in late Victorian era. [22]

In conventional terms, the Siberian North was not colonized. There were no wagonloads of serfs bearing down over the soft hills of the Siberian plains. As with the Canadian North, Siberia was seen as a resource colony, suitable only for natives, ethnographers, arctic explorers, socialist missionaries, and hardy laborers. Nonetheless, the indigenous peoples posed a conceptual challenge for Soviet administrators. Their palpable otherness (or backwardness, in the language of the day) was an affront to socialist ideals. In the Soviet Union, the society of the future, there could be no primitive survivals; hence the rhetoric for cultural advancement and enlightenment.

Containment: Mastering Archival Emanations

I want an incessantly perspectival historiography, one that situates the author unapologetically. I want a scholarship that generates new forms of authority,

new contracts—a new groundwork for representing the world and for en-
couraging empowered, creative, and engaged discourse. We need better his-
tories. But the approach will fail if it replaces old histories with new histories
that make the same authoritative claims to finality and closure. We need his-
tories that are well researched and accurate; that are closer accounts of com-
plex happenings but that recognize truths are impossible to achieve; where
the authority of historical statements do not need to be cast in a language
of disciplinary power. They can be cast in other ways that tell the story, that
address blind spots, and that leave the way open for counter-narratives.

My project folds archival ethnography into cultural history and critical
theory. It is replete with disclosures and refusals as well as invitations to ex-
tend and participate. In other work, I have developed a video titled "Con-
tainment: Mastering Archival Emanations."[23] In the video, the emanation—
something that issues from a source—is a vignette of footage shot in and
around archives that I visited while conducting research in Siberia. The vi-
gnette operates on a number of levels but is primarily about the labor of re-
search. Time features as a prominent theme in this vignette; it suggests time
spent in the archives and time spent in the field. It is also meant to operate as a
mediation between the early Soviet photographs I use to counter my histori-
cal narratives and the time of my encounter with the archives.

Active Denial Systems

> History resembles photography in that it is, among other things, a
> means of alienation.[24]

The purpose of this work has been to answer a question that has haunted
me since I began my fieldwork and archival research: what is the role of pho-
tographs in the construction of history? The complex articulation of time
and space that is played out on the surface of a dusty print only hints at the
larger complexities that bind photography to contemporary historical under-
standing. History and photography are read through one another until they
become inseparable: the text is disseminated; the image is exhibited. In my
project, the interpenetrations of historical and photographic articulations are

aligned to focus upon the twentieth-century project of sovietization in north-central Siberia. The reemergence of the Russian imperial project as socialist colonialism and its first steps to the imposition of a modern landscape in Siberia is alternately constituted and dissolved through photographic documents.

My work demonstrates how history can be seen as being staged through various approaches to and motives for photography. The photographs that I refer to throughout my book document the first years of sovietization in central Siberia. They function as an articulation of the principle that the histories that photographs represent are always socially constructed and polysemic. This ongoing construction, in turn, forms an ever-receding horizon of deferred and negotiated meanings. However, it also presumes that there is a dominant reading, a grain, to which we have analytical recourse. Photography and history are embedded in articulations of power and knowledge. I explore the tension surrounding the perception of photographs as producing a discourse versus photographs as reproducing objective truths, and I propose that they are operating simultaneously as both.

In a social constructionist critique of photography, staging the photographic event is the first order of editorial selection that occurs in a long chain of choice and serendipity that will thoroughly undermine the putative objectivity of the photographic document. I see this critique as part of a much larger project concerned with submitting historical inquiry and interpretation to critical scrutiny. This critique, then, is a committed challenge to the naive idea that a photograph is merely a reflection of what is out there in the world; yet it can also become an overzealous polemic, overwriting the irrefutably sensuous reflections of the world produced by cameras.

An alternative approach to understanding photography and history is to consider the social practices of looking that in many ways predetermine both what is seen and how it is seen. Photographs participate in this by being records of how the world was seen and what in the world was seen (and can thereby be indicative of what is *not* seen in the world). Yet they also exceed what it is that was seen in them in the first place. They are both constructed and mimetic. Photographs resist or prevent the absorption of historical meaning. Their radical particularity agitates against generalizations. Photo-

graphs have the capacity to disrupt oppositions and associations produced in purely textual regimes of representation.

Traditional historiography not only makes a selective representation of history (which all historical writing must do), but it also simultaneously produces an effective denial of its own selectivity. I think of this effect as an *active denial system* (ADS) that neatly conceals and obscures the troubling or agitating details of everyday life of its own conditions of being and production. The active denial system generates its own agnotology[25] as a means of producing historical truths. In other words, it is a disciplinary apathy that engineers ignorance as a structural byproduct of its inquiry. The trick is not in the intensive generation of ignorance, though; it is an inverse operation, a magic that is "efficacious not despite the trick but on account of its exposure . . ."[26] Michael Taussig's exploration of the efficacies of public deception and collective belief through the idiom of "the skilled revelation of skilled concealment"[27] provides a compelling example. Building on Marcel Mauss's study of "corporeal techniques," Taussig proposes an intricate series of provocations to think through the faith and skepticism that offer a stage for both magic and ethnography.

I articulate my own sense of the intimacies of revelation and concealment through the active denial system, which is a term borrowed from the U.S. military. While my own active denial system is an effect of authority and representation, the U.S. military have a more acute awareness of its power to control (or rather, create) space. Developed by the military subcontractor Raytheon, the ADS is a nonlethal weapon that uses electromagnetic radiation waves to extend the military's sanction for righteous violence.

> Active Denial emits a focused beam of wave energy that travels at the speed of light and produces an intolerable heating sensation that causes targeted individuals to flee. The sensation immediately ceases when the targeted individual moves away from the beam.[28]

The curious name evinces a kind of Freudian slippage in language. The name for this device comes from a military term: "Area Denial Weapon." These are

weapons designed to prevent an adversary from occupying or traversing an area of land. The so-called "millimeter-wave" technology apparently causes only the sensation of pain but leaves no visible trace. While the name implies the strategic control of territory through nonlethal force, it doubles as a strategic control of language. The rhetoric surrounding the deployment of terms like "stress position" (torture) and "collateral damage" (allowable civilian death) suggest that military technologies today require their own euphemisms and sleights of hand, generating their own public secrets. The active denial system, which leaves no visible mark of damage on the subject, produces its own ignorance, its own system of denial against culpability. I transcode this term to highlight the implicit power relations that historians have in constructing the past. I argue that a more honest historiography builds its own limitations into its rhetoric.

The militaristic metaphors are resonant with Walter Benjamin's revolutionary take on history and his "state of emergency"—his conceptualization of history as something other than additive chronology. Taussig works with the emergency situation as well, noting that Benjamin's recognition that attention to the "tradition of the oppressed teaches us that the 'state of emergency' in which we live is not the exception but the rule." Taussig reads this as more than Benjamin's attempt to designate a reality . . . It was also designed to provoke a radically different way of seeing and reacting to history, because in a state of siege order is frozen, yet disorder boils beneath the surface.[29]

Surface and depth persist as metaphors in the examination of knowledge production. The seizure of order, or the caesura it produces, is an effect also explored by Roland Barthes. In a short article, Barthes describes the "uniformly assertive" and "affirmative" character of historical discourse: "The historical fact is linguistically associated with a privileged ontological status: we recount what has been, not what has not been, or what has been uncertain. To sum up: historical discourse is not acquainted with negation (or very rarely, in exceptional cases)."[30] Photographs, like historical discourses, seem to produce their own certainties. They tend to be apprehended within the active denial system and to generate powerful effects of realism. And like the discourses of history, though less forgivably, photographs are often implicated in the active denial of the visual sensuousness of the everyday. As I

have shown, photographs contain within them the capacity to undermine the denials and closures implicit in historical discourses. To publish a photograph may superficially illustrate the idea of the historical argument, but it also contains the seeds of destruction or marginalization of that argument. The excess of the everyday that constantly threatens to overwhelm or obviate interpretation agitates against representation. This is what makes it dangerous. History is an active denial system that obscures the messiness of the ordinary or everyday.

The evident challenge of working within the delimitations of epochs and eras reveals the fundamental dilemma of historiography: the application of boundaries. In many ways historians are judged, in part, by how well they have drawn the lines—whether the looming pasts have been neatly eviscerated or tidily contained. My contention is that photographs present ways of accepting and even highlighting loose ends—of undermining (or at least unnerving) history's own project or, at least, undermining a certain kind of authority upon which our historical projects rest. In Siegfried Kracauer's critique of historiography, he writes, "the mirage of unity can be authenticated only by chimerical evidence."[31] The image of illusion as a powerful agent in the writing of history forms a centerpiece to his essays. "The past is threaded with unaccountable changes and incoherent compounds of events which stubbornly resist the kind of streamlining required by general history."[32] It is this "streamlining required by general history" that is most challenged by the inclusion of photographs in my book. David Rodowick engages with Kracauer's critique of history through photography as well. He writes:

> By transposing and therefore unavoidably reducing the multiple experiences of daily life, photography and history are understood by Kracauer as complementary modalities because they are able to comprehend this reality by selectively giving it form and rendering it accessible and cognizable to a critical and self-reflective consciousness.[33]

Photography's privileged access to the everyday and the ordinary provides the ground of refusal for interpretation and its necessary reductions.

Photography's own genealogy provides a useful extension here. In *Camera*

Obscura of Ideology, Sarah Kofman notes that the camera obscura has been understood as a metaphor for forgetting: the transient but sensuously compelling image in the camera obscura flits across the surface only to disappear again.[34] The technique for fixing images, developed in the mid-nineteenth century, would appear to solve this and present a new metaphor, one of remembering. The privilege of forgetting, linked to the camera obscura, is agitated by the threat of remembering linked to photography. In the active denial system, the kind of remembrance made possible by photography, the inscription of light, points to an entirely situational and sensuously particular moment.

The potentially infinite numbers of inquiries that can trouble a history are typically written away. Writing a history is a lesson in writing away the awkward bits and the parts that do not fit in order to make order. This disciplining of the scholar has important ramifications for the history. While I may produce a perfectly good and passable history of sovietization in central Siberia, it is no less precarious for being acceptable. At some point we learn to not ask questions: "That part of my research is over!" or "I cannot know *that* before I publish *this*." So the detail can be duly noted or simply ignored. One example of this selective forgetting that haunts me comes from surveying the photographs in the archival collections I have studied. These photographs have been used in the construction of my own historical knowledge and discourse. Counterintuitively, their role has not been to illustrate this historical knowledge. Rather, I use them to agitate against it, to reveal its limits and its failures. These archival photographs offer unresolved (or irresolvable) questions that can only be dealt with through willful ignorance, marginalization (as a footnote), or theorization of their troublingly loose ends. To allow these historical nerves to hang out untidily from the history is to invite trouble, and that is precisely what I am interested in doing here. The trouble I wish to invite is not through textual opening but rather visual opening.

The active denial system of contemporary historiography has no place for these openings that are only pointed to in the disciplinary nervous system. Maybe the active denial system is part of the nervous system, Michael Taussig's response to the precariousness of the social sciences. The active denial system, whatever it is, must certainly be an artifact of modernity's fantasy of

progress and enlightenment. It is a public secret that refuses its own public. Taussig writes: "Might not the whole point of the [nervous system] be it's always being a jump ahead, tempting us through its very nervousness towards the tranquil pastures of its fictive harmony, the glories of its system, thereby all the more securely energizing its nervousness?"[35] The active denial system is perhaps less nervous, less unsettled (unless of course it is just a node in the nervous system!).

The active denial system produces its own fictions of stability and closure to veil its reliance on precarious and effuse systems of knowledge and ignorance. Through the mundane and systematic denial of fissures and incompatibilities, the active denial system removes culpability. It is a machine, after all.

Notes

The archival notation system I use in this book follows conventional Russian archival practices. The acronym refers to the archive itself. The first number refers to the "Fond." This is a standard archival term derived from the French language; it bears the connotation of origin, ground, and source. In archival terminology, it is a major unit of organization. The second number refers to the "inventory" [opis']. It is a medial unit of organization. The third number refers to the "file" [delo]. Following these numbers is usually a page or page range.

Below is a list of the archival acronyms used in this book.

AAEAO: Archive of the Administration of the Evenki Autonomous Okrug
EOKM: Evenki Okrug Regional Museum
GAKK: State Archives of the Krasnoiarsk Krai
GANO: State Archives of the Novosibirsk Oblast
KKKM: Krasnoiarsk Krai Regional Museum

Prologue

1. Debs 1890, 712. My emphasis.
2. Lenin 1902. In this quote from Lenin's famous article "What Is to Be Done?" he is engaged in a debate about revolutionary terminology.
3. See Gleason et al. 1985; Selishchev 1971.
4. Debs 1890, 712.
5. Benjamin 1969, 238. My emphasis.
6. Hansen 1999, 317.
7. Buck-Morss 1992, 17.
8. Benjamin et al. 2008, 45.
9. Hansen 1999, 348.
10. Butler 1999 [1990], xxix.
11. Rancière 2010.
12. Thesis VI from Walter Benjamin's "Theses on the Philosophy of History." Benjamin 1969, 255.
13. Ibid.
14. Bishop 2005, 167.

Introduction

1. The word is a contraction of culture and base *(kul'tbaza)*. In this book it will be referred to simply as Culture Base.

2. Czaplicka 1914, 1.

3. Uvachan 1975, 17.

4. Campbell 2003, 117.

5. Where studies have paid attention to visual culture, it has almost always been concerned with art and propaganda. The mundane visual ecologies of Russia and Siberia are largely absent from the field. A notable exception is Kivelson and Neuberger's 2008 edited volume, *Picturing Russia: Explorations in Visual Culture.* In most other work, photography plays a largely supportive role to textual exposition.

6. Quoted in Uvachan 1975, 84.

The Years Are Like Centuries

1. The geographical center of Russia is located within the boundaries of the Evenki Municipal District.

2. AAEAO_karta_eao_01.

3. KKKM_017–001. Titled, "Map of the Evenki National District, Krasnoiarsk Krai.

4. Benjamin 1999, 498.

5. Taussig 1992, 3.

6. Deleuze 1986, 95–96.

7. Bogue 2003, 79.

8. Deleuze 2005, 87.

9. The Mongolian Khanates are worth mentioning; they no doubt put pressures on the central Siberian North but there is no clear evidence that they were collecting tribute or taxes from the indigenous peoples there.

10. Vasilevich 1972, 160.

11. Shirokogoroff 1929.

12. The word *shaman* is derived from the Evenki term *khaman.*

13. Cf. Bloch 2004. In my own work on archival photographs, I have found one photograph, for instance, of two Evenki women with rifles and traps, demonstrating that hunting was not solely the domain of men.

14. Shirokogoroff 1935, 87.

15. Not to mention inter-species and inter-phenomenological. David Anderson (2000) has called this a "sentient ecology."

16. Burke 2001, 188.

17. Pesmen 2000, 6.

18. Emerson 1996, 117–18.

19. Several particularly important edited collections include Edwards' *Anthropology and Photography* (1992) and Pinney and Peterson's *Photography's Other Histories.*

20. Edwards 2001, 94.

21. Taussig 1999, 107.

22. Dobrova-Iadrintseva, 1925.

23. Ssorin-Chaikov 2003, 81.

24. Hall 1918, 8.

25. Cf. V. A. Tugolukov (1980) for a discussion of the collectivization of reindeer in Evenkiia.

26. It would be very interesting to explore the relationship between the Reindeer Saami and the Fishing Saami in comparison to the Reindeer Evenki and Reindeer-less Evenki. Cf. Hugh Beach's work for further exploration of the symbolic capital of reindeer in Saami society (2004).

27. Dolgikh 1960, 450.

28. Tugolukov 1960, 150, (translation mine). Poverty, as seen by lack of jewelry as well as poor cloth and canvas, is noticeable in Naumov's photographs (with the exception of the Chirinda Princelings).

29. Nansen 1914, 166.

30. Bassin 1991b, 766.

31. Slezkine 1994.

32. Raeff 1956.

33. China is a major exception that comes to mind.

34. Siniavskii 1990, 240; see also Bassin 1983.

35. Snow 1977, 31.

36. Bakhrushin 1929, 79 (translation mine).

37. Dolgikh 1960, 443.

38. Karlov 1982, 106.

39. Ibid., 107.

40. Cf. Hall 1918.

41. Shimkin 1990, 320.

42. Ssorin-Chaikov 2003.

43. Tammiksaar and Stone 2007, 208.

44. As a scientific discipline, ethnography was often seen as only a subset of geography and natural science; anthropology did not begin to comprehensively distinguish itself from other disciplines in Western Europe until the early twentieth century.

45. Cited in Tolz 2005, 137.

46. Turov 1990, 15. It is worth noting that Middendorf's Siberian expedition in 1845 took over a month to travel overland in the winter from Krasnoiarsk to Turukhansk. (Shimkin 1990).

47. An article published in *American Anthropologist* eloquently defends the salvage paradigm: "I believe the needs of salvage, in its stress on the imminent destruction of men and cultures, induced a profound humanism in those who were constantly charged with the preservation of the remnant. Prichard's concern, like that of Boas,

was not only that data are being lost, but that peoples are being lost as well." (Gruber 1970, 1297–8).

48. Shishkin 2000, 102.

49. Merzliakova and Karimov 2001.

50. The Krasnoiarsk terminus of the Trans-Siberian railway was completed in 1898.

51. Cf. Turov 1990 and Karlov 1982.

52. Uvachan 1959.

53. Nansen 1914; Hall 1918.

54. Dolgikh 1960, 120.

55. Czaplicka 1917, 290. its

56. Karlov 1982, 111.

57. Noted in *Developing Siberia (Osvoenie Sibiri)*. Novosibirsk State Oblast Scientific Library.

58. Ablazhei 2005, 138.

59. Anderson and Orekhova 2002, 89.

60. Ibid.

61. Raeff 1956.

62. Raeff 1956, 116.

63. Wong 2003, 336.

64. Grant 1995, 42.

65. cited in Uvachan 1975, 48. See also Pika 1999.

66. White 1990, 33; see also Badcock 2006.

67. Lenin 1917, quoted in Taylor 1971, 562.

68. White 1990, 34.

69. White 1990, 34.

70. Badcock 2006, 628.

71. Gérin 2003, 19.

72. Taylor 1971, 566.

73. Ibid.

74. Russell 1990, 232–33.

75. The Soviet archives contain many short *kharakteristiki* (personal biographies or character references), which were part of the new bureaucratic culture of the revolutionary government. One historian of Soviet social history, Ilya Zemtsov, writes that the *kharakteristika* was an official document "that describes the personality and activity of Soviet individuals and evaluates their standing in the eyes of the authorities. . . . Character references report the extent to which a given person conforms or does not conform to the prescribed modes of behavior in the USSR, that is, whether he or she is or is not politically 'reliable'" (Zemtsov 1991, 41–42). As attestations of an individual's class purity, these *kharakteristiki* populate the archives as coded biographies, weighted by the threats and promises of solicitous and anxious bureaucracies. See also Fitzpatrick 1993.

76. The use of the term ethnographic here should be read as synonymous with "ethnic" or "non-Russian" but possibly also as "folk."

77. I. M. Suslov. GANO f354–1–350.

78. Hirsch 2005, 65.

79. Slezkine 1994, 154.

80. Slezkine 1994.

81. Cf. Marcuse 1958.

82. Slezkine 1994.

83. Slezkine's 1994 book *Arctic Mirrors* was published at a time when scholarly research in English on the history of Siberia was particularly lacking. An emerging cadre of Western historians and anthropologists were descending on Siberia (notably David Anderson, Bruce Grant, Marjorie Balzer, and Gail Fondahl, among others; earlier scholars include Dennis and Alice Bartels, Caroline Humphrey, Ethel Dunn). For those studying indigenous peoples and the history of colonization in Siberia, it was a crucial and welcome history of the colonial experience.

84. Uvachan 1975, 69.

85. Karlov 1982, 112. Tugolukov also notes disease and sicknesses that killed many Evenki households in the 1910s and 1920s. (1980, 148–49).

86. Sergeev 1964, 490.

87. Scott 1999, 4.

88. Naumov 2006, 157.

89. *Soviet* translates literally as a "council." The organization of local representation through soviets is a legacy of the Communism in Russia. After the 1917 revolution, soviets became the organizing principle for representation and participation in society.

90. Naumov 2006, 159.

91. Naumov 2006, 160.

92. Dunn and Dunn 1962, 328.

93. Iurtaeva 1966, 21.

94. Iurtaeva 1966, 21–22.

95. Uvachan in AAEAO f.98–1–37, 5. My translation.

96. The potential wealth was balanced against the charge that the wealth was squandered. I believe for the most part they are thinking about agrarian and some mineral wealth at this time. Siberia, in most statements, only seems to incidentally include the Far North and other areas occupied by indigenous minorities. The trains transporting the all-important supplies of grains to European Russia were the primary focus in the first years after the revolution. Nonetheless, once this was secured, attention turned to other forms of wealth including forests and minerals, all of which were underdeveloped due to a limited transportation network: " Siberia's mineral wealth is literally boundless, and at best, even given significant progress, we cannot exploit even a hundredth part of it for many years." (http://www.marxists.org/archive/lenin/works/1920/8thcong/ch01.htm)

97. Lenin 1972, 238.

98. Hirsch 2005, 87.

99. Ibid., 90.

100. Pika 1999, xxii.

101. Grant 1995.

102. Slezkine 1994, 147.

103. Beissinger 2008, 1.

104. "Kharakteristika, Ilimpiiskogo raiona Evenkiiskogo Natsional'nogo okruga Krasnoiarskogo Kraia," signed by the head of the Executive Committee of the Raisovet: Kombagir. (AAEAO 1–1–242:10).

105. Iurtaeva 1966, 22.

106. April 26, 1919. signed V. Trofimenko from Podkamennaia Tunguska (KKKM 7886/193).

107. Ivanov 1966, 6.

108. The Red Cross Society in Russia predated the 1917 Revolution. According to Miterev (1965, 3), Lenin converted the Russian Red Cross Society into the Soviet Red Cross Society, renaming it and rewriting its aims. The Soviet Red Cross was recognized by the International Red Cross Committee in 1921 (ibid.).

109. GAKK 1845–1–143, 126.

110. Ssorin-Chaikov 2002, 16.

111. Christina Kiaer has written on eugenics in Soviet Russia, which "becomes a means to produce a specifically socialist Soviet subject" (2006, 184).

112. Kiaer 2006, 189.

113. AAEAO 27–20–2. The inspector along the Podkamennaia Tunguska was I. D. Potapov. F. E. Golovachev worked as inspector of the Taz Tundra. (Uvachan 1984, 84).

114. Uvachan 1984, 83.

115. Uvachan 1971, 157.

116. Kotkin 2002, 45.

117. Cf. Grant 1995 and Ssorin-Chaikov 2003.

118. Cf. Anderson 2011.

119. Ssorin-Chaikov 2003, 55.

120. Ibid.

121. AAEAO 1–1–22.

122. See, for example, Francine Hirsch's discussion (2005, 84) of the competition in vision between Gosplan and Narkomnats prior to 1924.

123. AAEAO 1–242, 10.

124. Ibid.

125. Ibid.

126. This photograph is part of the Polar Census photo album, KKKM 7930–1/10–03.

127. GAKK 1845–1–66, 44.

128. NEPmen [*nepmenshi*] was a derogatory term used to describe people who benefited from Lenin's New Economic Policy era.

129. AAEAO 24–1–6.

130. Ivanov 1966, 7.

131. Uvachan 1975, 37.

132. Anderson 1991, 18.

133. Iurtaeva 1966, 17.

134. McCannon 1998, 21–22.

135. Iurtaeva 1966, 19.

136. Ibid.

137. Sergeev 1955, 219.

138. GAKK 1845–1–63, 5. I. D. Potapov was the inspector for the Podkamenaia Tunguska (AAEAO_27–20).

139. Iurtaeva 1966, 19.

140. Tugolukov 1980, 148–49.

141. Uvachan 1975, 59.

142. Badcock 2006.

143. Slezkine 1994, 156.

144. Bloch 2004.

145. Hirsch 2005, 88.

146. Zemtsov 1991, 12.

147. Fitzpatrick 1999a, 15.

148. Peris 1998, 1.

149. Fitzpatrick 1999a, 15.

150. AAEAO 102–1–6. Cf. also Uvachan 1975.

151. Forsyth 1992, 245.

152. Shishkin 2000, 116.

153. Ivanov 1966, 5.

154. While *korenizatsiia* is a term I have not seen in the archival literature, it certainly describes the process of constructing an indigenous intelligentsia, which is a well-documented phenomenon. Cf. Blitstein 1999.

155. Smith 1962, 187.

156. Siegelbaum 1992, 125.

157. Slezkine 1994, 159.

158. GANO 354–1–86.

159. GAKK_1845–1–6.

160. Slezkine 1994, 173.

161. AAEAO 1–1–171.

162. Trotsky 1990, 123.

163. Slezkine 1994, 173.

164. Hirsch 2005, 91.

165. Slezkine 2000, 232.

166. Cornell 2001, 39.

167. Russian Soviet Federative Socialist Republic (Rossiyskaya Sovetskaya Federativnaya Sotsialisticheskaya Respublika, RSFSR).

168. Iurtaeva 1966, 17.

169. Slezkine 1994, 157.

170. Hirsch 2005, 253.

171. Figes 1997, 324.

172. Ibid.

173. Lenin 1966, 244.

174. Fitzpatrick 1999a, 11.

175. Figes 1997, 323.

176. Read 2003, 39.

177. Gurvich 1971, 82, quoted in Boulgakova 2003.

178. Marie Antoinette Czaplicka marked differences between "family shamans" and "professional shamans" in her 1914 book *Aboriginal Siberia: A study in Social Anthropology*.

179. Balzer 1990.

180. Boulgakova 2003, 145.

181. Fitzpatrick 1993, 749.

182. Ibid., 751.

183. The anthropologist Hugh Brody provides a counterintuitive example of mobilities in his work *The Other Side of Eden*. Brody writes, "It is agricultural societies that tend to be more on the move; hunting peoples are far more firmly settled" (Brody 2002, 7).

184. Cf. AAEAO 41–30.

185. Fitzpatrick 1999a, 11.

186. Ibid.

187. Slezkine 1994, 150.

188. Hirsch 2005, 309.

189. Bromlei 1981, 135–36.

190. Suslov 1931, 92.

191. P. G. Smidovich, head of the Committee of the North, quoted in Slezkine 1994, 179.

192. Stites 1989, 172.

193. Furthermore, they were subordinate to the Siberian Bureau (representatives of the Bolsheviks) in Krasnoiarsk.

194. The North Sea route was significant for shipping, whaling, and other mobile ocean industries but had no permanent colonial settlements of any note. Cf. Robert North (1972); for a discussion of industrial development in the Soviet North (1979).

195. Stalin was sent to Turukhansk in 1913; Lenin was exiled to Krasnoiarsk in 1897.

196. While I cannot explore this here, I. M. Suslov undertook the task of mapping

the Olenek River in the early 1930s. His atlas of the Olenek River helped to open the river to larger transportation networks, making it possible to build the Olenek Culture Base in Yakutiia.

197. Hirsch 2005, 84. Francine Hirsch has an excellent discussion of the role of Narkomnats and Gosplan in planning the future of the new Soviet Empire.

198. Ibid., 85. Hirsch is quoting a memo from the head of the Narkomnats.

199. Under the authority of the Presidium of the All-Russian Central Executive Committee (VtsIK).

200. P. G. Smidovich was head of the Committee of the North in 1924. Slezkine 1994, 158.

201. Slezkine 1994, 138.

202. Sergeyev 1964, 491.

203. *Ibid.*

204. The Enisei Provincial Committee of the North was created on March 17, 1925, but was likely subsumed into the Krasnoiarsk Committee a year later. AAEAO 27–20–01.

205. Sergeev 1964, 491.

206. Ibid.

207. Atwood and Kelly 1998, 256.

208. Anderson and Orekhova 2002.

209. Hall 1918.

210. Slezkine 1994, 155–56.

211. Slezkine 1994, 156.

212. AAEAO 27–1.

213. Suslov, GAKK 1845–1–143, 126.

214. Uvachan 1984, 100–101.

215. Quoted in Slezkine 1994, 192.

216. Weiner 1999, 1114.

217. Peter Holquist warns that a failure to consider institutionalization and internalization of violence as a technique fails to grasp a central feature of Soviet life: "actual instances of applied violence [should not be] treated as a rupture or deviation from a supposedly more normal Soviet policy" (2003, 19).

218. Weiner 1999, 1114.

219. Gurvich 1971, 23.

220. Hirsch 2005, 146n1.

221. Dirks 1996, xi.

222. Grant 1995, 72.

223. Anderson 2011, 268.

224. Anderson 2010, 24.

225. GANO 354–1–246, 108–9.

226. Kuzmenkina 2007.

227. Roberts 1999, 1.

228. Fitzpatrick 1999a, 225.

229. There is no evidence that all of these supplies were ever purchased. I have seen no records of film being shot at the Culture Base nor of audio recordings having been made. This is not to say that they don't exist, simply that they are not located or indexed through conventional means.

230. The Committee of the North gave careful and extensive instructions in their plan for the surveying and construction of Culture Bases in the Far North. (GANO 354–1–297, 26).

231. Slezkine 1994, 29.

232. In the context of a modern city, Zygmunt Bauman writes that "[f]rom the point of view of spatial administration, modernization means monopolization of cartographic rights." (Bauman 1998, 40).

233. Turyzh clan meeting, January 13, 1926. (GAKK 1845–1–20, 198).

234. Sergeev 1955, 262.

235. GAKK 1845–1–20, 198. The moniker "City of the Tungus" is also noted in Anderson and Orekhova (2002).

236. Terry Martin notes how Lenin saw nationalism as a trick of the bourgeoisie but that he also recognized it was necessary: "By granting the forms of nationhood, the Soviet state could split the above-class national alliance for statehood. Class divisions, then, would naturally emerge, which would allow the Soviet government to recruit proletarian and peasant support for their socialist agenda." (2001, 69).

237. Slezkine 1994, 154.

238. Suny 1994, 212.

239. GANO 354-1-246, 108-9.

240. Massey 1994, 120.

241. Cf. Anderson 2000 and Ssorin-Chaikov 2003.

242. GANO 354–1–297, 8–9.

243. Martin 2001, 73.

244. Mikhailov in Lamont 1946, 136.

245. Ssorin-Chaikov 2003, 15–16.

246. This quote raises several important questions. Chief among them is the degree to which the Evenkis understood what the Culture Base was to become. Could they know what a city was? Furthermore, as with most Soviet documents of this nature, the author of the statement needs to be examined for veracity.

247. GAKK 1845–1–20, 198.

248. GAKK 1845–1–125.

249. GAKK 1845–1–20, 30.

250. Sergeev 1955, 263.

251. In early documents, I have noted reference to Tura as the local name for the Kochechum River. Sometimes there is reference to the Culture Base being constructed at the confluence of the Nizhnaia Tunguska and Tura Rivers.

252. GANO 354–1–25a, 34.

253. AAEAO 27–20–02.

254. GANO 354–1–297, 8–9.

255. GANO 354–1–297.

256. GANO 354–1–25a.

257. GANO 354–1–25a.

258. Babkin's slippage, using the tsarist-era term for non-Russians, suggests not only residual lexica but also attitudes toward the indigenous peoples.

259. GAKK 1845–1–20, 124.

260. GAKK 1845–1–20, 162–63.

261. EOKM 2341_no.47.

262. I. M. Suslov quoted by Boulgakova 2003, 148.

263. Bogoraz, along with Lev Shternberg and Vladimir Jochelson, organized the Institute of the Peoples of the North and were active with the Committee of the North.

264. Vladimir Bogoraz in Slezkine 1994, 159–60.

265. GAKK 1845–1–181, 500.

266. KKKM 8471-416-52.

267. GANO 354–1–295, 5.

268. EOKM 2002.

269. GAKK 1845–1–143, 1–39.

270. GAKK 1845–1–143, 130.

271. Shimkin 1990, 323.

272. GAKK 1845–1–125.

273. Fitzpatrick 1999a, 205–6.

274. Dunn and Dunn 1962.

275. GANO 354–1–297, 2–3. See also Parkhamenko 1930, 125.

276. Bloch 2004, xv.

277. GAKK 1845–1–143, 131.

278. GAKK 1845–1–143, 1–39.

279. Ibid.

280. This point is actually more complicated because Babkin complains that the Evenkis seemed to expect gifts every time they came to the Culture Base. GAKK 1845–1–143, 1–39.

281. I. M. Suslov's father (M. I. Suslov) was apparently involved in choosing the location of the Tungus Culture Base. According to Anderson and Orekhova, Mikhail Ivanovich Suslov "is credited with founding and directing the first Soviet outpost at the mouth of the Kochechum river in 1925" (2002, 92).

282. GANO 354–1–316.

283. Pechenkin 1988, 79.

284. Krypton 1954, 343.

285. Sergeev 1955, 260.

286. GANO 354–1–297, 8–9.

287. Taylor 2008, 52.

288. Olson 1994, 227–28.

289. Krypton 1954, 354.

290. Krypton 1954, 356; citing Budarin 1949.

291. Trofimov 1964, 142.

292. GAKK 1845–1–143.

293. Bloch 2005, 241.

294. Taylor 1971, 566.

295. Aside from those already mentioned or quoted see Leonov 1928, 103; Dunn and Dunn 1962, 330.

296. Uvachan 1971, 4.

297. Grant 1995, 6.

298. Agata, Bachinskaia, and Turizh Evenkis quoted in Uvachan 1975, 102.

299. Uvachan 1975, 12.

300. Cf. Gurvich's book *Culture of the Northern Yakut-Reindeer Herders* (1977), which deals with questions of ethnicity and economy.

301. Sergeev 1955, 264.

302. Sahlins 1972.

303. Dunn and Dunn 1962, 331–32.

304. Zibarev 1968 and Uvachan 1977 are both good examples of this kind of dogmatism.

305. Shnirelman 1994, 203.

306. Kenez 2006, 90.

307. Fitzpatrick 1999b, 208.

308. Slezkine 1994; Hirsch 2005.

309. Slezkine 2000, 231.

310. Fitzpatrick 1999a, 207.

311. Evans 1993, 41.

312. Fitzpatrick 1999a, 208.

313. J. V. Stalin quoted in Welch 1999, 164.

314. Grenoble 2003, 44.

315. Meisner 1985, 290.

316. Bova 2003, 133.

317. McCannon 2003, 241.

318. The Evenki name for the paper was *Evedy omakta in*.

319. GANO 354–1–316.

320. Slezkine 1994, 156.

321. GANO 354–1–316.

322. Lamont 1946, 136.

323. Kolarz 1952, 63.

324. Michael David-Fox examines Soviet cultural revolution as a "contested and re-

markably wide-ranging rubric, one that bridges myriad projects of internal and external transformation and illuminates the dynamics between them in the turn from the 1920s to the 1930s." (David-Fox 1999, 182).

325. Cf. Bonnell 1997; Stites 1989.

326. GANO 354–1–316.

Dangerous Communications

1. Cf. Pika and Grant eds. 1999, among others.

2. O. Y. Artemova writes that Morgan's influence on Marx and Engels was so significant that "Soviet 'ethnological Marxism' formed a kind of symbiosis with classic unilineal evolutionism" (Artemova 2004, 81). The term "state-sponsored evolutionism" was coined by the historian Francine Hirsch. In her book *Empire of Nations*, she makes a strong case for understanding sovietization as "an interactive and participatory process" (Hirsch 2005, 5).

3. Aspaturian 1968, 159.

4. Gleason et al. 1985, 74.

5. Terry Martin developed the label "affirmative action empire" to describe the particular form of Soviet imperialism (Martin 2001).

6. The word is a contraction of culture and base (kul'tbaza) that I will refer to simply as Culture Base.

7. Unless otherwise noted, historical details concerning the Kul'tbazy are from my PhD research on the history of the Tura Culture Base and are referenced by archival sources. An edited volume by Donahoe and Habeck was published in 2011, titled *Reconstructing the House of Culture*, but the chapters make little connection to this early antecedent.

8. Sergeev 1964, 491.

9. Parkhamenko 1930, 125.

10. Cf. Slezkine 1994, Grant 1995, Anderson 2000, Ssorin-Chaikov 2003, and Bloch 2004.

11. Stoler 2002, 87.

12. Glagoleva 1998, 29.

13. Kotkin 2002, 45.

14. From Grimsted 1982, 431.

15. Glagoleva 1998, 33.

16. Cf. Kotkin 2002.

17. Hirsch 2005, 89.

18. Raleigh 2002, 18.

19. Ibid., 20. Some exceptions to this tendency to overlook accommodation and integration under state Communism include Caroline Humphrey's *Karl Marx Collective* (1983) and later, Yuri Slezkine's *Arctic Mirrors* (1994). These works are significant

for the manner in which they have detailed the complexity of resistance—as well as accommodation—among indigenous peoples of Siberia. The head of the Committee of the North was quoted by Slezkine as stating that the participation of indigenous minorities "as equal (not just in principle but also de facto) and active partners in the socialist economy" (Skachko in Slezkine 1994, 270).

20. Officially, this collection is known as project number 016, *Digitising the photographic archive of Southern Siberian indigenous peoples*. The name, however, is misleading, as many of the photographs include indigenous peoples of the North and Far North as well.

21. Duchein 1983, 64.

22. Cf. Appadurai 2003, 15.

23. Edwards 2001, 107.

24. Ibid.

25. Steedman 2002, 2.

26. Stoler 2002, 97.

27. Tagg 1988; Edwards 1992.

28. Harris 2001. Emphasis mine.

29. Lutz and Collins 1991, 134.

30. Schwartz 2000, 34.

31. Ibid.

32. Ricoeur 1965, 23.

33. Mitchell 2002, 86.

34. Ibid.

35. Derrida 1996, 3.

36. Sontag 1977.

37. Morozov 1953.

38. Suslov 1934.

39. Throughout the revolutionary period, serious rifts in scholarly communities were cutting through the universities at all levels. In 1917, for example, Suslov was part of a revolutionary students' organization, one among many, that anticipated a substantial overhaul of academic knowledge production.

40. Slezkine 1994; Hirsh 2005.

41. Plotkin and Howe 1985, 257.

42. Their policy recommendations and projects have been explored by Yuri Slezkine (1991), Francine Hirsch (1998), and others.

43. Tolstoy 1952, 10.

44. Alan Barnard (1993) problematizes the idea of "primitive communism" through his examination of Peter Kropotkin's Anarchism.

45. Knight 2000, 372.

46. Frédéric Bertrand (2003) writes on the tricky position of searching for legitimacy in this period.

47. Barchatova 1989, 81.

48. quoted in Kendall et al. 1997, 24.

49. Artemova 2004, 84.

50. Sirina 2004, 89.

51. Artemova 2004, 84.

52. There also appears to be a general move away from the extensive use of screens and backdrops. In my work with thousands of ethnographic images from Siberia, I have found that there are very few examples of backdrop photography after the 1920s. I take this to parallel the academic shift away from the methods of turn-of-the-century four-field anthropology. It might also be that such images conjured up a colonialist sensibility that Soviet ethnographers were urged to reject.

53. Slezkine 1994, 160.

54. One might even conjecture that the photographic negative was a model for the current popularity of amateur archiving. It was one of the earliest archival practices in modern homes: paper envelopes with negatives wrapped in cellophane. While they were dutifully tucked away in boxes or drawers, they were also a material lesson in the anxiety haunting the potential loss of heritage.

55. Derrida 1996, 3.

56. Sontag 2004, 46.

57. Sekula 1986, 6.

58. Pinney 1992, 76.

59. Ibid.

60. Faris 1996, 14.

61. GANO 277-1.

62. Pinney 1992, 81.

63. Ibid.

64. A notable exception is Dina Jochelson-Brodskaya (wife of Russian anthropologist Waldemar Jochelson). Jochelson-Brodskaya shot most of the expeditionary photographs from Siberia in the famous Jesup North Pacific Expedition of 1897–1902. Cf. Kendall et al. 1997.

65. Cf. Sekula 1986; Tagg 1988; Hayes 2000.

66. Cf. Edwards 1992, Pinney 1992, among others.

67. Osborne 2010, 67.

68. This is a paraphrase from Marx's description of commodity fetishism.

69. Sontag 2004, 29.

70. In Kendall et al. 1997, 21.

71. Cf. Barthes 1977; Foucault 1984.

72. Morton 2005, 402.

73. Baudrillard 2001, 141.

74. Brink 2000, 141.

75. Sontag 1977, 71.

76. Faris 1996, 90–91.

77. Sontag 1977, 108.

78. Katherine Verdery explores this history through the concept of "socialist paternalism." She writes: "At the center of both the Party's official ideology and its efforts to secure popular support was 'socialist paternalism,' which justified Party rule with the claim that the Party would take care of everyone's needs by collecting the total social product and then making available whatever people needed—cheap food, jobs, medical care, affordable housing, education, and so on."(Verdery 1996, 25).

79. Fitzpatrick 1999a, 9.

80. A fairly common stance that emerged after the revolution was that the photographic image (in both photography and cinema) was the most powerful propaganda tool due to its precision in recording visual facts. Prunes notes that according to the Soviet constructivist artist Gustav Klutsis, "photography and the cinema caused a much stronger impression than painting on the (largely illiterate) viewer for being 'not the sketching of a visual fact but its precise record.'" (Prunes 2003, 255).

81. Taylor 1991, 56.

82. Cf. King and Lidchi 1998.

83. Wolf 2004, 108.

84. Busch 2000, 55.

85. Shlapentokh 1993, 93.

86. While Russia saw Siberia as a corporeal extension, some Siberians dreamed of secession, especially during the civil war. Clearly there are a great many Siberian imaginaries, from the ideas of Poles remembering exile (cf. Czaplicka 1914) to those of Russians in great European cities romantically inclined to think of Siberia as a storehouse of furs and wilderness. In Siberia itself, those living in Novonikolaevsk (Novosibirsk) or Krasnoiarsk had their own notions, as did those in the smallest villages or living alone in the tundra.

87. Schwartz 1996, 18.

88. Hayes 2000; Buckley 2005.

89. Tagg 1988; Faris 1996.

90. Wolf 1999a; Wolf 1999b.

91. Cf. Dunn and Dunn 1962; Mowat 1973.

92. In the 1950s, the first mass-produced Soviet cameras came off the line. The growth of photo amateurs (*fotoliubiteli*) is seen at this time as well (cf. Stigneev 2004).

93. My translation, *Sovetskoe Foto*, 1927 quoted in Abramov, nd.

94. Biriukov 1999.

95. Tilney 1930, 2.

96. Leah Dickerman (2006) shows how Rodchenko's journal *Novyi Lef* functioned as a kind of bulwark against bourgeois photographic interests.

97. Marien 2006, 177.

98. The artist Varvara Stepanova is famous for her collaborative work with Aleksandr Rodchenko on Constructivist design; cf. Zaletova 1989.

99. Barthes 1981, 91.

100. Hansen 1999, 309.

101. Shearer 2006, 207.

102. Volkov 2000, 210.

103. Žižek 2006a.

104. Žižek 2007, 134–5.

105. Buck-Morss 1992, 19.

106. Fitzpatrick 1999a, 106.

107. Wolf 2004, 104.

108. Wolf 1999b, 54.

109. Ibid, 74.

110. Hoberman 1998, 16.

111. GANO 354–1–246: 108–109.

112. Poole 1997, 112.

113. Hamilton 2002, 115.

114. Schwartz 2000, 34.

115. Derrida 1996, 11.

116. These are titles from real lectures developed by I. M. Suslov.

117. Nonetheless the relative rarity of photography at this time in history wouldn't make that project entirely unthinkable.

118. Barthes 1981.

119. Sontag 1977, 68.

120. Burroughs 1993, 61.

121. Steedman 2002, 68.

122. Ibid.

123. Gordon 2008, 7.

124. Puranen 1999, 2.

125. Taussig 2003, B12.

126. Schwartz 2000.

127. Jervis 1998, 283.

128. Mitchell 2005.

129. Barthes 1981, 5–6.

130. Benjamin 1969, 257–8.

Conclusion

1. Quoted and translated in Bajac 2002, 149.

2. Donna Haraway (1988) uses the idea of situated knowledge to describe how

human knowing is embedded in cultural histories and traditions, a knowledge that cannot be separated from its own conditions of production. I take it as a core assumption in my work that all knowledge is situated.

3. Work plan of the Turukhansk Culture Base. GAKK 1845–1-125.
4. Uvachan 1984, 83.
5. Ibid.
6. Slezkine 1992, 57.
7. Uvachan 1984, 100–101.
8. Ibid; AAEAO 98: 5.
9. Cf. Bassin 1991a.
10. Diment and Slezkine 1993, 2.
11. McClintock 1995, 30.
12. Schein 1999, 361.
13. Palmer 2000, 21.
14. Anderson 1991, 185.
15. Dirks 2001.
16. Cf. Harvey 1990.
17. Hirsch 2005, 44.
18. Morgan 1877, 4.
19. Shimkin 1990, 319.
20. Slezkine 1994, 249.
21. Ibid., 254.
22. McClintock 1995, 30.
23. All of my films and experimental videos can be viewed at www.metafactory.ca/agitimage.
24. Kracauer 1969, 5.
25. Cf. Proctor and Schiebinger 2008.
26. Taussig 2006, 123.
27. Ibid.
28. Quoted from the Raytheon company website (Raytheon.com/newsroom/feature/ads_03-08).
29. Taussig 1992, 10.
30. Barthes 1981, 14.
31. Kracauer 1969, 174.
32. Ibid., 175.
33. Rodowick 2001, 149.
34. Kofman 1998, 29–30.
35. Taussig 1992, 2.

Bibliography

Ablazhei, Anatoliy M. 2005. "The Religious Worldview of the Indigenous Population of the Northern Ob' as Understood by Christian Missionaries." *International Bulletin of Missionary Research* 29, no. 3:134–39.

Abramov, Georgii. No Date. "Etapy Razvitiia Covetskogo Fotoapparatostroeniia." *Etapy Razvitiia Otechestvennogo Fotoapparatostroeniia.* www.photohistory.ru/SFI-2.html.

Anderson, Benedict R. O'G. 1991. *Imagined Communities: Reflections on the Origin and Spread of Nationalism.* Rev. ed. London: Verso.

Anderson, David G. 2000. *Identity and Ecology in Arctic Siberia: The Number One Reindeer Brigade.* Oxford Studies in Social and Cultural Anthropology. Oxford: Oxford University Press.

———. 2011. *The 1926/27 Soviet Polar Census Expeditions.* New York: Berghahn Books.

Anderson, David G., and Craig Campbell. 2009. "Picturing Central Siberia: The Digitization and Analysis of Early Twentieth-Century Central Siberian Photographic Collections." *Sibirica* 8: 1–42.

Anderson, David G., and Nataliia A. Orekhova. 2002. "The Suslov Legacy: The Story of One Family's Struggle with Shamanism." *Sibirica: Journal of Siberian Studies* 2, no. 1: 88–112.

Appadurai, Arjun. 2003. "Archive and Aspiration." In *Information Is Alive,* edited by Joke Brouwer, Arjen Mulder, and Susan Charlton, 14–25. Rotterdam: NAI Publishers.

Artemova, O. Yu. 2004. "Hunter-Gatherer Studies in Russia and the Soviet Union." In *Hunter-Gatherers in History, Archaeology, and Anthropology,* edited by Alan Barnard, 57–66. Oxford: Berg.

Aspaturian, V. V. 1968. "Chapter VII." In *Prospects for Soviet Society,* edited by Allen Kassof, 143–203. New York: Praeger.

Attwood, Lynne, and Catriona Kelly. 1998. "Programmes for Identity: The 'New Man' and the 'New Woman.'" In *Constructing Russian Culture in the Age of Revolution, 1881–1940,* edited by Catriona Kelly and David Shepherd, 256–90. New York: Oxford University Press.

Badcock, Sarah. 2006. "Talking to the People and Shaping Revolution: The Drive for Enlightenment in Revolutionary Russia." *Russian Review* 65, no. 4: 617–36.

Bajac, Quentin. 2002. *The Invention of Photography: The First Fifty Years.* London: Thames & Hudson.

Bakhrushin, Sergei Vladimirovich. 1929. "Ocherki Po Istorii Kolonizatsii Sibiri v XVI-XVII Vv." *Severnaia Aziia. Kn* 1: 50–65.

Balzer, Marjorie Mandelstam, ed. 1990. *Shamanism: Soviet Studies of Traditional Religion in Siberia and Central Asia.* Armonk, N.Y.: M.E. Sharpe.

Barkhatova, Elena, ed. 1989. *A Portrait of Tsarist Russia: Unknown Photographs from the Soviet Archives.* 1st American ed. New York: Pantheon Books.

Barnard, Alan. 1993. "Primitive Communism and Mutual Aid: Kropotkin Visits the Bushmen." In *Socialism: Ideals, Ideologies, and Local Practice,* edited by C. M. Hann, 1–19. Abingdon, Oxon: Routledge.

Barthes, Roland. 1977. *Image, Music, Text.* London: Fontana.

———. 1981. *Camera Lucida: Reflections on Photography.* 1st American ed. New York: Hill and Wang.

Bassin, Mark. 1983. "The Russian Geographical Society, the 'Amur Epoch,' and the Great Siberian Expedition 1855–1863." *Annals of the Association of American Geographers* 73, no. 2: 240–56.

———. 1991a. "Russia between Europe and Asia: The Ideological Construction of Geographical Space." *Slavic Review* 50, no. 1: 1–17.

———. 1991b. "Inventing Siberia: Visions of the Russian East in the Early Nineteenth Century." *The American Historical Review* 96, no. 3: 763–94.

Baudrillard, Jean. 2001. *Impossible Exchange.* London: VERSO.

Bauman, Zygmunt. 1998. *Globalization: The Human Consequences.* European Perspectives. New York: Columbia University Press.

Beach, Hugh. 2004. "Political Ecology in Swedish Saamiland." In *Cultivating Arctic Landscapes: Knowing and Managing Animals in the Circumpolar North,* edited by David G. Anderson and Mark Nuttall, 110–23. New York: Berghahn Books.

Beissinger, Mark. 2008. "The Persistence of Empire in Eurasia." *NewsNet, News of the American Association for the Advancement of Slavic Studies* 48, no. 1: 1–8.

Benjamin, Walter. 1969. *Illuminations.* New York: Schocken Books.

———. 1999. *The Arcades Project.* Cambridge, Mass.: Harvard University Press.

Benjamin, Walter, Michael William Jennings, and Brigid Doherty. 2008. *The Work of Art in the Age of Its Technological Reproducibility, and Other Writings on Media.* Cambridge, Mass.: Harvard University Press.

Bertrand, Frédéric. 2003. "Une science sans objet? L'ethnographie soviétique des années 20–30 et les enjeux de la catégorisation ethnique." *Cahiers du Monde russe* 44, no. 1: 93–109.

Biriukov, E. M. 1999. *Fotograf V. L. Metenkov.* Ekaterinburg: SV-96.

Bishop, Edward. 2005. *Riding with Rilke: Reflections on Motorcycles and Books.* Toronto: Viking Canada.

Blitstein, Peter A. 1999. "Researching Nationality Policy in the Archives." *Cahiers Du Monde Russe* 40, nos. 1–2: 125–38.

Bloch, Alexia. 2004. *Red Ties and Residential Schools: Indigenous Siberians in a Post-Soviet State*. Philadelphia: University of Pennsylvania Press.

———. 2005. "Longing for the Kollektiv: Gender, Power, and Residential Schools in Central Siberia." *Cultural Anthropology* 20, no. 4: 534–69.

Bogue, Ronald. 2003. *Deleuze on Cinema*. New York: Routledge.

Bonnell, Victoria E. 1997. *Iconography of Power: Soviet Political Posters under Lenin and Stalin*. Berkeley: University of California Press.

Boulgakova, Tatyana. 2003. "Nanai Shamans under Double Oppression. Was the Persecution by Soviet Power Stronger Than the Power of Shamanistic Spirits?" In *Multiethnic Communities in the Past and Present*, edited by Pille Runnel, 131–57. Tartu: Estonian National Museum.

Bova, Russell. 2003. *Russia and Western Civilization: Cultural and Historical Encounters*. Armonk, N.Y.: M.E. Sharpe.

Brink, Cornelia. 2000. "Secular Icons." *History & Memory* 12, no. 1: 135.

Brody, Hugh. 2002. *The Other Side of Eden: Hunters, Farmers, and the Shaping of the World*. New York: North Point Press.

Bromlei, Iulian Vladimirovich. 1981. *Sovremennye Problemy Etnografii: Ocherki Teorii i Istorii*. Moscow: Institut etnografii Akademii nauk SSSR.

Buckley, L. 2005. "Objects of Love and Decay: Colonial Photographs in a Postcolonial Archive." *Cultural Anthropology* 20, no. 2: 249–70.

Buck-Morss, Susan. 1992. "Aesthetics and Anaesthetics: Walter Benjamin's Artwork Essay Reconsidered." *October* 62: 3–41.

Budarin, M. 1949. "Kul'tbazy Obskogo Severa." *Izvestiia*, 284.

Burke, Peter. 2001. *Eyewitnessing*. Ithaca, N.Y.: Cornell University Press.

Burroughs, William S. 1993. *The Adding Machine: Selected Essays*. New York: Arcade Pub.

Busch, Lawrence. 2000. *The Eclipse of Morality: Science, State, and Market*. New York: Aldine de Gruyter.

Butler, Judith. 1999 [1990]. *Gender Trouble: Feminism and the Subversion of Identity*. 10th anniversary ed. New York: Routledge.

Campbell, Craig. 2003. "Contrails of Globalization and the View from the Ground: An Essay on Isolation in East-Central Siberia." *Polar Geography* 27, no. 2: 97–120.

Collins, David, and James Urry. 1997. "'A Flame Too Intense for Mortal Body to Support.'" *Anthropology Today* 13, no. 6: 18–20.

Cornell, Svante E. 2001. *Small Nations and Great Powers: A Study of Ethnopolitical Conflict in the Caucasus*. London: Routledge.

Czaplicka, Marie Antoinette. 1914. *Aboriginal Siberia: A Study in Social Anthropology*. Oxford: Clarendon Press.

———. 1917. "On the Track of the Tungus." *Scottish Geographical Magazine* 33: 289–303.

David-Fox, Michael. 1999. "What Is Cultural Revolution?" *The Russian Review* 58, no. 2: 181–201.

Debs, Eugene. 1890. "Agitation and Agitators." *Locomotive Firemen's Magazine* 14, no. 8: 712–13.

Deleuze, Gilles. 1986. *Cinema 1: The Movement Image*. Minneapolis: University of Minnesota Press.

———. 2005. *The Movement-Image*. London: Continuum.

Derrida, Jacques. 1996. *Archive Fever: A Freudian Impression*. Religion and Postmodernism. Chicago: University of Chicago Press.

Dickerman, Leah. 2006. "The Fact and the Photograph." *October* 118: 132–52.

Diment, Galya, and Yuri Slezkine, ed. 1993. *Between Heaven and Hell: The Myth of Siberia in Russian Culture*. New York: St. Martin's Press.

Dirks, Nicholas B. 1996. "Forward." In *Colonialism and Its Forms of Knowledge: The British in India*. Princeton Studies in Culture / Power / History. Princeton, N.J.: Princeton University Press.

———. 2001. *Castes of Mind: Colonialism and the Making of Modern India*. Princeton, N.J.: Princeton University Press.

Dobrova-Iadrintseva, L. N. 1925. *Tuzemtsy Turukhanskogo Kraia: Opyt Issledovaniia Ekonomicheskogo Polozheniia*. Novonikolaevsk: Sibrevcom.

Dolgikh, Boris Osipovich. 1960. *Sovremennoe Khoziaistvo, Kul'tura i Byt Malykh Narodov Severa*. Moscow: Izd-vo Akademii nauk SSSR.

Donahoe, Brian, and Joachim Otto Habeck, ed. 2011. *Reconstructing the House of Culture: Community, Self, and the Makings of Culture in Russia and Beyond*. New York: Berghahn Books.

Duchein, Michel. 1983. "Theoretical Principles and Practical Problems of Respect des Fonds in Archival Science." *Archivaria* 1, no. 16: 64–82.

Dunn, Stephen P., and Ethel Dunn. 1962. "Directed Culture Change in the Soviet Union: Some Soviet Studies." *American Anthropologist* 64, no. 2: 328–39.

Edwards, Elizabeth. 1992. *Anthropology and Photography, 1860–1920*. New Haven: Yale University Press in association with the Royal Anthropological Institute, London.

———. 2001. *Raw Histories: Photographs, Anthropology and Museums*. New York: Berg.

Emerson, Caryl. 1996. "Keeping the Self Intact During the Culture Wars: A Centennial Essay for Mikhail Bakhtin." *New Literary History* 27, no. 1: 107–26.

Evans, Alfred B. 1993. *Soviet Marxism-Leninism: The Decline of an Ideology*. London: Praeger.

Faris, James. 1996. *Navajo and Photography: A Critical History of the Representation of an American People*. Albuquerque: University of New Mexico Press.

Figes, Orlando. 1997. "The Russian Revolution of 1917 and Its Language in the Village." *Russian Review* 56, no. 3: 323.

Fitzpatrick, Sheila. 1993. "Ascribing Class: The Construction of Social Identity in Soviet Russia." *Journal of Modern History* 65, no. 4: 745–70.

———. 1999a. *Everyday Stalinism: Ordinary Life in Extraordinary Times: Soviet Russia in the 1930s.* New York: Oxford University Press.

———. 1999b. "Cultural Revolution Revisited." *Russian Review* 58, no. 2: 202–9.

Forsyth, James. 1992. *A History of the Peoples of Siberia: Russia's North Asian Colony, 1581–1990.* Cambridge, England: Cambridge University Press.

Foucault, Michel. 1984. *The Foucault Reader.* New York: Pantheon Books.

Gérin, Annie. 2003. *Godless at the Workbench: Soviet Illustrated Humoristic Antireligious Propaganda.* Regina: Dunlop Art Gallery.

Glagoleva, O. E. 1998. *Working with Russian Archival Documents: A Guide to Modern Handwriting, Document Forms, Language Patterns, and Other Related Topics.* Toronto: Centre for Russian and East European Studies, University of Toronto.

Gleason, Abbott, Peter Kenez, and Richard Stites. 1985. *Bolshevik Culture: Experiment and Order in the Russian Revolution.* Bloomington: Indiana University Press.

Gordon, Avery F. 2008. *Ghostly Matters: Haunting and the Sociological Imagination.* Minneapolis: University of Minnesota Press.

Grant, Bruce. 1995. *In the Soviet House of Culture: A Century of Perestroikas.* Princeton: Princeton University Press.

Grenoble, Lenore A. 2003. *Language Policy in the Soviet Union.* Dordrecht: Kluwer Academic Publishers.

Grimsted, Patricia Kennedy. 1982. "Lenin's Archival Decree of 1918: The Bolshevik Legacy for Soviet Archival Theory and Practice." *The American Archivist* 45, no. 4: 429–43.

Gruber, C. 2009. "Between Logos (Kalima) and Light (Nur): Representations of the Prophet Muhammad in Islamic Painting." *Muqarnas = Muqarnas.* 26: 229–62.

Gruber, Jacob W. 1970. "Ethnographic Salvage and the Shaping of Anthropology1." *American Anthropologist* 72, no. 6: 1289–99.

Gurvich, I. S. 1971. "Printsipy leninskoi natsiona'noi politiki i primenenie ikh na krainem Severe." In *Osushchestvlenie leninskoi natsional'noi politiki u narodov Krainego Severa,* edited by I. S. Gurvich, 9–49. Moscow: Izd-vo "Nauka."

———. 1977. *Kul'tura Severnykh Iakutov-Olenevodov: K Voprosu O Pozdnikh Etapakh Formirovaniia Iakut Naroda.* Moscow: Nauka.

Hall, H. U. 1918. "A Siberian Wilderness: Native Life on the Lower Yenisei." *Geographical Review* 5, no. 1: 1–21.

Hamilton, Carolyn., ed. 2002. *Refiguring the Archive.* Dordrecht, Netherlands: Kluwer Academic Publishers.

Hansen, Miriam Bratu. 1999. "Benjamin and Cinema: Not a One-Way Street." *Critical Inquiry* 25, no. 2: 306–43.

Haraway, Donna. 1988. "Situated Knowledges: The Science Question in Feminism and the Privilege of Partial Perspective." *Feminist Studies* 14, no. 3: 575–99.

Harris, Verne. 2001. "On the Back of a Tiger: Deconstructive Possibilities in 'Evidence of Me.'" *Archives and Manuscripts* 29, 8–22.

Harvey, David. 1990. *The Condition of Postmodernity: An Enquiry into the Origins of Cultural Change.* Oxford: Blackwell.

Hayes, Patricia. 2000. "Camera Africa: Indirect Rule and Landscape Photographs of Kaoko, 1943." In *New Notes on Kaoko: The Northern Kunene Region (Namibia) in Texts and Photographs.* Cape Town: Basler Afrika Bibliographien, 48–73.

Hirsch, Francine. 1998. "Empire of Nations: Colonial Technologies and the Making of the Soviet Union, 1917–1939."

———. 2005. *Empire of Nations: Ethnographic Knowledge and the Making of the Soviet Union.* Ithaca: Cornell University Press.

Hoberman, J. 1998. *The Red Atlantis: Communist Culture in the Absence of Communism.* Philadelphia: Temple University Press.

Holquist, Peter. 2003. "State Violence as Technique: The Logic of Violence in Soviet Totalitarianism." In *Stalinism: The Essential Readings,* edited by David Hoffmann, 127–56. Malden, Mass.: Blackwell.

Humphrey, Caroline. 1983. *Karl Marx Collective: Economy, Society and Religion in a Siberian Collective Farm.* Cambridge, England: Cambridge University Press.

Iurtaeva, V. I. 1966. "Sovetizatsiia Malykh Narodnostei Eniseiskogo Severa (1920–1923 Gg.)." In *Sibir' v Period Stroitel'stvo Sotsializma,* 6:16–23. Novosibirsk: Izd-vo "Nauka."

Ivanov, P. N. 1966. "Pervye Meropriiatiia Partiinykh i Sovetskikh Organizatsii Sibiri Po Likvidatsii Ekonomicheskoi Otstalosti Nerusskikh Narodov (1920–1925 Gg.)." In *Sibir' v Period Stroitel'stvo Sotsializma,* 6:5–15. Novosibirsk: Izd-vo "Nauka."

Jervis, John. 1998. *Exploring the Modern: Patterns of Western Culture and Civilisation.* Malden, Mass.: Blackwell Publishers.

Karlov, V. 1982. *Evenki Srednei Sibiri: Khoziaistvo I Obshchestvo XVII-Nachala XX Vekov.* Moscow: Izd-vo Moskovskogo un-ta.

Kendall, Laurel, Thomas Ross Miller, and Barbara Mathé. 1997. *Drawing Shadows to Stone: The Photography of the Jesup North Pacific Expedition, 1871–1902.* New York: American Museum of Natural History in association with Douglas & McIntyre.

Kenez, Peter. 2006. *A History of the Soviet Union from the Beginning to the End.* 2nd ed. Cambridge, England: Cambridge University Press.

Kiaer, Christina, and Eric Naiman, ed. 2006. *Everyday Life in Early Soviet Russia: Taking the Revolution Inside.* Bloomington: Indiana University Press.

King, J. C. H., and Henrietta Lidchi, ed. 1998. *Imaging the Arctic.* Seattle: University of Washington Press.

Kivelson, Valerie A., and Joan Neuberger. 2008. *Picturing Russia: Explorations in Visual Culture.* New Haven, Conn.: Yale University Press.

Knight, Nathaniel. 2000. "'Salvage Biography' and Useable Pasts: Russian Ethnogra-

phers Confront the Legacy of Terror." *Kritika: Explorations in Russian and Eurasian History* 1, no. 2: 365–75.

Kofman, Sarah. 1998. *Camera Obscura: Of Ideology*. London: Athlone Press.

Kolarz, Walter. 1952. *Russia and Her Colonies*. New York: F. A. Praeger.

Kotkin, Stephen. 2002. "The State—Is It Us? Memoirs, Archives, and Kremlinologists." *Russian Review* 61, no. 1: 35–51.

Kracauer, Siegfried. 1969. *History: The Last Things Before the Last*. New York: Oxford University Press.

Krypton, Constantine. 1954. "Soviet Policy in the Northern National Regions after World War II." *American Slavic and East European Review* 13, no. 3: 338–55.

Kuzmenkina, Liudmila. 2007. "Vzlet i Padenie 'Kinosibiri'." *Vechernii Novosibirsk*, 11.01.2007. http://vn.ru/index.php?id=83274.

Lamont, Corliss. 1946. *The Peoples of the Soviet Union*. New York: Harcourt Brace.

Lenin, V. I. 1902. "What Is to Be Done? BURNING QUESTIONS of our MOVEMENT," http://www.marxists.org/archive/lenin/works/1901/witbd/iii.htm, accessed February 14, 2014.

———. 1966. *V. I. Lenin Collected Works*. Volume 31. Moscow: Progress Publishers.

———. 1972. *Collected Works*. Moscow, Progress Publishers.

Leonov, N. 1928. "Sovetskoe Stroitel'stvo: Na Fronte Krainego Severa." *Severnaia Aziia* 3: 92–103.

Lutz, Catherine, and Jane Collins. 1991. "The Photograph as an Intersection of Gazes: The Example of National Geographic." *Visual Anthropology Review* 7, no. 1: 134–49.

Marcuse, Herbert. 1958. *Soviet Marxism: A Critical Analysis*. New York: Columbia University Press.

Marien, Mary Warner. 2006. *Photography: A Cultural History*. 2nd ed. Upper Saddle River, N.J.: Prentice Hall.

Martin, Terry. 2001. *The Affirmative Action Empire: Nations and Nationalism in the Soviet Union, 1923–1939*. Ithaca: Cornell University Press.

Massey, Doreen B. 1994. *Space, Place, and Gender*. Minneapolis: University of Minnesota Press.

McCannon, John. 1998. *Red Arctic: Polar Exploration and the Myth of the North in the Soviet Union, 1932–1939*. New York: Oxford University Press.

———. 2003. "Tabula Rasa in the North: The Soviet Arctic and Mythic Landscapes in Stalinist Popular Culture." In *The Landscape of Stalinism: The Art and Ideology of Soviet Space*, edited by E. A Dobrenko and Eric Naiman. Seattle: University of Washington Press.

McClintock, Anne. 1995. *Imperial Leather: Race, Gender and Sexuality in the Colonial Contest*. New York: Routledge.

Meisner, Maurice. 1985. "Chapter Sixteen: Iconoclasm and Cultural Revolution in China

and Russia." In *Bolshevik Culture: Experiment and Order in the Russian Revolution*, edited by Abbott Gleason, Peter Kenez, and Richard Stites, 279–94. Bloomington: Indiana University Press.

Merzliakova, Irina, and Alexei Karimov. 2001. "A History of Russian Administrative Boundaries (XVIII—XX Centuries)." www.ihst.ru/personal/imerz/bound/russia_report1.htm.

Miterev, Georgii Andreevich. 1965. *The Soviet Red Cross*. Moscow: Novosti Press Agency Publishing House.

Mitchell, W. J. T. 2002. "Showing Seeing: A Critique of Visual Culture." *Visual Culture Reader*. Second edition. London: Routledge. 86–101.

———. 2005. *What Do Pictures Want?: The Lives and Loves of Images*. Chicago: University of Chicago Press.

Morgan, Lewis Henry. 1877. *Ancient Society: Or, Researches in the Line of Human Progress from Savagery through Barbarism to Civilization*. Chicago: C.H. Kerr.

Morozov, Sergei Aleksandrovich. *Russkie Puteshestvenniki-fotografi*. Moskva: Gos. izd-vo geogr. lit-ry, 1953.

Morton, Christopher. 2005. "The Anthropologist as Photographer: Reading the Monograph and Reading the Archive." *Visual Anthropology* 18, no. 4: 389–405.

Mowat, Farley. 1973. *Sibir: My Discovery of Siberia*. Toronto: McClelland and Stewart.

Nansen, Fridtjof. 1914. *Through Siberia: The Land of the Future*. New York: Frederick A. Stokes.

Naumov, I. V. 2006. *The History of Siberia*. New York: Routledge.

North, Robert N. 1972. "Soviet Northern Development: The Case of NW Siberia." *Soviet Studies* 24, no. 2: 171–99.

———. 1979. *Transport in Western Siberia: Tsarist and Soviet Development*. Vancouver: University of British Columbia Press: Centre for Transportation Studies.

Olson, James Stuart. 1994. *An Ethnohistorical Dictionary of the Russian and Soviet Empires*. Westport, Conn.: Greenwood Press.

Osborne, Peter. 2010. "Infinite Exchange: The Social Ontology of the Photographic Image." *Philosophy of Photography* 1, no. 1: 59–68.

Palmer, Scott W. 2000. "Peasants into Pilots: Soviet Air-Mindedness as an Ideology of Dominance." *Technology and Culture* 41, no. 1: 1–26.

Parkhamenko, S. G. 1930. "Kraevedcheskaia Rabota v Kul'tbazakh." *Sovetskii Sever*, no. 1: 125–29.

Pechenkin, M. D. (Mikhail Dmitrievich). 1988. *Sibir' v Leninskom Plane Postroeniia Sotsializma, 1917–1924*. Novosibirsk: Nauka.

Peris, Daniel. 1998. *Storming the Heavens: The Soviet League of the Militant Godless*. Ithaca, New York: Cornell University Press.

Pesmen, Dale. 2000. *Russia and Soul: An Exploration*. Ithaca, New York: Cornell University Press.

Pika, Alexander, and Bruce Grant, eds. 1999. *Neotraditionalism in the Russian North: Indigenous Peoples and the Legacy of Perestroika.* Edmonton: Canadian Circumpolar Institute.

Pinney, Christopher. 1992. "The Parallel Histories of Anthropology and Photography." In Elizabeth Edwards, *Anthropology and Photography, 1860–1920.* New Haven: Yale University Press. 74–95.

Pinney, Christopher, and Nicolas Peterson, eds. 2003. *Photography's Other Histories.* Durham: Duke University Press.

Plotkin, Vladimir, and Jovan Howe. 1985. "The Unknown Tradition: Continuity and Innovation in Soviet Ethnography." *Dialectical Anthropology* 9, no. 1: 257–312.

Poole, Deborah. 1997. *Vision, Race, and Modernity: A Visual Economy of the Andean Image World.* Princeton, N.J.: Princeton University Press.

Proctor, Robert, and Londa L. Schiebinger, ed. 2008. *Agnotology: The Making and Unmaking of Ignorance.* Stanford, Calif.: Stanford University Press.

Prunes, Mariano. 2003. "Dziga Vertov's Three Songs about Lenin (1934): A Visual Tour through the History of the Soviet Avant-Garde in the Interwar Years." *Criticism* 45, no. 2: 251–78.

Puranen, Jorma. 1999. *Imaginary Homecoming.* Oulu, Finland: Pohjoinen Publications.

Raeff, Marc. 1956. *Siberia and the Reforms of 1822.* Seattle: University of Washington Press.

Raleigh, Donald J. 2002. "Doing Soviet History: The Impact of the Archival Revolution." *Russian Review* 61 (January): 16–24.

Rancière, Jacques. 2010. *Dissensus: On Politics and Aesthetics.* London: Continuum International Publishing Group.

Read, Christopher. 2003. *The Stalin Years: A Reader.* New York: Palgrave Macmillan.

Ricoeur, Paul. 1965. *History and Truth.* Evanston, Ill.: Northwestern University Press.

Roberts, Graham. 1999. *Forward Soviet! History and Non-Fiction Film in the USSR.* KINO, the Russian Cinema Series. London: I.B. Tauris.

Rodowick, David Norman. 2001. *Reading the Figural: Or, Philosophy after the New Media.* Durham: Duke University Press.

Russell, Robert. 1990. "The Arts and the Russian Civil War." *Journal of European Studies* 20, no. 3: 219–40.

Sahlins, Marshall. 1972. *Stone Age Economics.* Chicago: Aldine-Atherton.

Schein, Louisa. 1999. "Performing Modernity." *Cultural Anthropology* 14, no. 3: 361–95.

Schwartz, J. M. 1996. "The Geography Lesson: Photographs and the Construction of Imaginative Geographies." *Journal of Historical Geography* 22, no. 1: 16–45.

Schwartz, Joan M. 2000. "'Records of Simple Truth and Precision': Photography, Archives, and the Illusion of Control." *Archivaria* 50 (Fall): 1–40.

Scott, James C. 1999. *Seeing Like a State: How Certain Schemes to Improve the Human Condition Have Failed.* New Haven: Yale University Press.

Sekula, Allan. 1986. "The Body and the Archive." *October* 39: 3–64.

Selishchev, Afanasii Matveevich. 1971. *Iazyk revoliutsionnoi epokhi: iz nabliudenii nad russkim iazykom poslednikh let (1917–1926)*. Letchworth: Prideaux Press.

Sergeev, Mikhail Alekseevich. 1955. *Nekapitalisticheskii Put' Razvitiia Malykh Narodov Severa*. Moscow: Izd-vo Akademii Nauk SSSR.

———. 1964. "The Building of Socialism among the Peoples of Northern Siberia and the Soviet Far East." In *The Peoples of Siberia*, edited by L. P. Potapov and M. G. Levin, 487–510. Chicago: University of Chicago Press.

Shaffer, E. S. 1981. *Comparative Criticism: A Yearbook: Volume 3*. Cambridge, England: Cambridge University Press.

Shearer, David R. 2006. "Stalinism, 1928–1940." In *Cambridge History of Russia: Volume 3, the Twentieth Century*. Cambridge, England: Cambridge University Press, 192–216.

Shimkin, Demitri B. 1990. "Siberian Ethnography: A Current Assessment." *Cahiers du Monde Russe* 2–3: 317–26.

Shirokogoroff, S. M. 1929. *Social Organization of the Northern Tungus*. Shanghai: The Commercial Press Limited.

———. 1935. *Psychomental Complex of the Tungus*. London: K. Paul, Trench, Trubner.

Shishkin, Vladimir. 2000. "State Administration of Siberia: From the End of the Nineteenth through the First Third of the Twentieth Centuries. Chapter 4." In *Regions: A Prism to View the Slavic-Eurasian World: Towards a Discipline of "Regionology"*, edited by Kimitaka Matsuzato, 100–121. Sapporo, Japan: Slavic Research Center, Hokkaido University.

Shlapentokh, Dmitry. 1993. *Soviet Cinematography, 1918–1991: Ideological Conflict and Social Reality*. New York: A. de Gruyter.

Shnirelman, Victor A. 1994. "Hostages of an Authoritarian Regime: The Fate of the 'Numerically-Small Peoples' of the Russian North under Soviet Rule." *Etudes/Inuit/Studies* 18, nos. 1–2: 201–23.

Siegelbaum, Lewis H. 1992. *Soviet State and Society between Revolutions, 1918–1929*. Cambridge, England: Cambridge University Press.

Siniavskii, A. 1990. *Soviet Civilization: A Cultural History*. New York: Arcade Pub.

Sirina, Anna A. 2004. "Soviet Traditions in the Study of Siberian Hunter-Gatherer Society." In *Hunter-Gatherers in History, Archaeology, and Anthropology*, 89–101. Oxford: Berg.

Slezkine, Yuri. 1991. "The Fall of Soviet Ethnography, 1928–38." *Current Anthropology* 32, no. 4: 476–84.

———. 1992. "From Savages to Citizens: The Cultural Revolution in the Soviet Far North, 1928–1938." *Slavic Review* 51, no. 1: 52–76.

———. 1994. *Arctic Mirrors: Russia and the Small Peoples of the North*. Ithaca: Cornell University Press.

———. 2000. "Imperialism As the Highest Stage of Socialism." *The Russian Review* 59, no. 2: 227–34.

Smith, R. E. F. 1962. *A Russian-English Dictionary of Social Science Terms*. London: Butterworths.

Snow, Russell E. 1977. *The Bolsheviks in Siberia, 1917–1918*. Rutherford: Fairleigh Dickinson University Press.

Sontag, Susan. 1977. *On Photography*. New York: Farrar, Straus and Giroux.

———. 2004. *Regarding the Pain of Others*. 1st Picador ed. New York: Picador.}

Ssorin-Chaikov, Nikolai V. 2002. "Mothering Tradition: Gender and Governance among Siberian Evenki." Working Paper No. 45. Max Planck Institute for Social Anthropology Working Papers. Halle / Saale: Max Planck Institute for Social Anthropology.

———. 2003. *The Social Life of the State in Subarctic Siberia*. Stanford: Stanford University Press.

Steedman, Carolyn. 2001. "Something She Called a Fever: Michelet, Derrida, and Dust." *American Historical Review* 106, no. 4: 1159–80.

———. 2002. *Dust: The Archive and Cultural History*. New Brunswick, N.J.: Rutgers University Press.

Stigneev, Valery. 2004. "The Force of the Medium: The Soviet Amateur Photography Movement." In *Beyond Memory: Soviet Nonconformist Photography and Photo-related Works of Art*, edited by Diane Neumaier, 67–74. Rutgers: Rutgers University Press.

Stites, Richard. 1989. *Revolutionary Dreams: Utopian Vision and Experimental Life in the Russian Revolution*. New York: Oxford University Press.

Stoler, Ann Laura. 2002. "Colonial Archives and the Arts of Governance." *Archival Science* 2: 87–109.

Suny, Ronald Grigor. 1994. *The Making of the Georgian Nation*. 2nd ed. Bloomington: Indiana University Press.

Suslov, I. M. 1931. "Shamanstvo i bor'ba s nim." *Sovetskii Sever* 3–4: 89–152.

———. 1934. "Piatnadtsat' Severnykh Kul'tbaz." *Sovetskii Sever* 1: 28–37.

Tagg, John. 1988. *The Burden of Representation: Essays on Photographies and Histories*. Amherst: University of Massachusetts Press.

Tammiksaar, Erki, and Ian R. Stone. 2007. "Alexander Von Middendorff and His Expedition to Siberia (1842–1845)." *Polar Record* 43, no. 3: 193–216.

Taussig, Michael. 1992. *The Nervous System*. New York: Routledge.

———. 1999. *Defacement: Public Secrecy and the Labor of the Negative*. Stanford, Calif: Stanford University Press.

———. 2003. "The Diary as Witness: An Anthropologist Writes What He Must." *The Chronicle Review*. December 19, 2003: B12.

———. 2006. *Walter Benjamin's Grave*. Chicago: University of Chicago Press.

Taylor, Richard. 1971. "A Medium for the Masses: Agitation in the Soviet Civil War." *Soviet Studies* 22, no. 4: 562–74.

———. 1991. *Inside the Film Factory: New Approaches to Russian and Soviet Cinema*. London: Routledge.

———. 2008. *The Politics of the Soviet Cinema, 1917–1929.* Cambridge: Cambridge University Press.

Tilney, F. C. 1930. *The Principles of Photographic Pictorialism.* Boston: American Photographic Pub. Co.

Tolstoy, P. 1952. "Morgan and Soviet Anthropological Thought." *American Anthropologist* 54, no. 1: 8–17.

Tolz, Vera. 2005. "Orientalism, Nationalism, and Ethnic Diversity in Late Imperial Russia." *The Historical Journal* 48, no. 1: 127–50.

Trofimov, P. L. 1964. "K Istorii Narodnogo Obrazovaniia v Siviri Vo Vtoroi Piatiletke (1933–1937)." In *Kul'turnoe Stroitel'stvo v Sibiri.* vol. 2. Novosibirsk: Izd. SO AN SSSR.

Trotsky, Leon. 1990. *The Revolution Betrayed: What Is the Soviet Union and Where Is It Going?* Detroit: Labor Publications.

Tugolukov, Vladillen Aleksandrovich. 1960. "Ekondskie Evenki." In *Sovremennoe Khoziaistvo, Kul'tura i Byt Malykh Narodov Severa,* edited by Boris Osipovich Dolgikh. Moskva: Izd-vo Akademii nauk SSSR.

———. 1980. *Idushchie Poperek Khrebtov.* Krasnoiarsk: Krasnoiarskoe knizhnoe izd-vo.

Turov, M. G. 1990. *Khoziaistvo Evenkov Taezhnoi Zony Srednei Sibiri v Kontse XIX-nachale XX Veka: Printsypy Osvoenii Ugodii.* Irkutsk: Izd-vo Irkutskogo Universiteta.

Uvachan, V. N. 1959. *Eniseiskii Sever: Bibliograficheskii Ukazatel'.* Krasnoiarsk: Krasnoiarskaia kraevaia biblioteka.

———. 1971. *Put Narodov Severa K Sotsializmu.* Moscow: Mysl'.

———. 1975. *The Peoples of the North and Their Road to Socialism.* Moscow: Progress Publishers.

———. 1977. *Narody Severa v Usloviiakh Razvitogo Sotsializma.* Krasnoiarsk: Krasnoisrskoe kn. izd-vo.

———. 1984. *Gody, Ravnye Vekam: Stroitel'stvo Sotsializma Na Sovetskom Severe.* Moscow: Mysl'.

Vasilevich, G. M. 1972. "Nekotorye Voprosy Plemeni i Roda u Evenkov." In *Okhotniki, Sobirateli, Rybolovy,* 160–72. Moscow: Nauka.

Verdery, Katherine. 1996. *What Was Socialism, and What Comes Next?* Princeton: Princeton University Press.

Volkov, Vadim. 2000. "The Concept of Kul'turnost': Notes on the Stalinist mid-1930s." In *Stalinism: New Directions,* edited by Sheila Fitzpatrick, 210–30. London: Routledge.

Weiner, Amir. 1999. "Nature, Nurture, and Memory in a Socialist Utopia: Delineating the Soviet Socio-Ethnic Body in the Age of Socialism." *The American Historical Review* 104, no. 4: 1114–55.

Welch, David. 1999. *Modern European History, 1871–2000: A Documentary Reader.* 2nd ed. London: Routledge.

White, Anne. 1990. *De-Stalinization and the House of Culture: Declining State Control over Leisure in the USSR, Poland, and Hungary, 1953–89.* London: Routledge.

Wolf, Erika. 1999a. "'USSR in Construction': From Avant-garde to Socialist Realist Practice." PhD diss., University of Michigan.

———. 1999b. "When Photographs Speak, to Whom Do They Talk? The Origins and Audience of SSSR Na Stroike (USSR in Construction)." *Left History* 6, no. 2: 53–82.

———. 2004. "The Context of Soviet Photojournalism." *Zimmerli Journal* 2: 106–17.

Wong, Yoke-Sum. 2003. *The Chaos of Dainties: Singapore and the Confections of Empire, 1819–1930*. Thesis (PhD), University of Alberta, 2003.

Zaletova, Lidya. 1989. *Revolutionary Costume: Soviet Clothing and Textiles of the 1920s*. New York: Rizzoli.

Zemtsov, Ilya. 1991. *Encyclopedia of Soviet Life*. New Brunswick, N.J.: Transaction Publishers.

Zibarev, V. A. 1968. *Sovetskoe stroitel'stvo s malykh narodnostei Severa (1917–1932)*. Tomsk: TGU.

Žižek, Slavoj. 2006a. *The Pervert's Guide to Cinema*. Directed by Sophie Fiennes. P Guide, London. DVD.

———. 2006b. *The Parallax View*. Cambridge, Mass.: MIT Press.

———. 2007. *The Universal Exception*. Paperback ed. London: Continuum.

Index

Ablazhei, Anatolii, 37
Aboriginal Siberia (Czaplicka), 236n178
active denial system (ADS), 223–24,
 226–27
Agata, 36, 123, 137
agitation trains, 46–47
agitators, xi–xiii
Along the Kochechum (Campbell), 10, 14
Anderson, David, 69, 104, 164, 230n15,
 233n83
Anthropology and Photography (Edwards),
 230n19
Antireligious-ist (Anti-religioznik), 91
Apollov, A., 132
Archive Fever (Derrida), 168
archives, xvi–xix, 154, 158–73, 201–10,
 212–13, 232n75. *See also* photography
Arctic Mirrors (Slezkine), 58–59, 233n83,
 241–42n19
Arkad'in, N. E., 70
Arkhincheev, I., 132
Artemova, O. Y., 181, 241n2
Attwood, Lynne, 98

Babkin, Filipp Iakovlevich, 120–21, 122–23,
 124, 125, 239n258, 239n280; Tungus
 Culture Base, 126–28, 130, 239n257,
 239n280
Badcock, Sarah, 45
Bakhrushin, Sergei Vladimirovich, 29
Bakhtin, Mikhail, 20
Baluev, I. I., 110, 176–77, 196–97, 199, 200
Balzer, Marjorie, 87, 233n83

Barnard, Alan, 242n44
Bartels, Alice, 233n83
Bartels, Dennis, 233n83
Barthes, Roland, 13, 197, 205, 208, 224
Bassin, Mark, 27–28
Baudrillard, Jean, 188, 190
Bauman, Zygmunt, 233n232
Benjamin, Walter, xiv–xv, xvi, 11, 197,
 209–10, 224
Bertrand, Frédéric, 242n46
Bezbozhnik, 192
Bilibin, N., 132
Bishop, Ted, xvii
Bloch, Alexia, 72–73, 129
Bloch, Marc, 170
Bogoraz, Vladimir, 58, 80, 88, 123,
 239n263
Bolshevik Party, 29, 34, 47, 53, 64–65, 73–74,
 88–89, 122–23, 154
Boulgakova, Tatyana, 87–88
Brink, Cornelia, 189
British Library, 3, 164
Brody, Hugh, 236n183
Bromlei, Iulian, 90
Buck-Morss, Susan, xv–xvi, 200
Buriat, 49, 57
Burke, Peter, 20
Burroughs, William, 205–6
Bushmarin, S. N., 124
Butler, Judith, xv–xvi

Camera Obscura of Ideology (Kofman),
 225–26

Central Executive Committee of Russia (VtsIK), 157
Central Siberia, x, xiii, 9–14, 104, 148, 217
Chapogir (Miroshkol), 62, 77, 78
Chechens, 49
Chekanovski, A., 37
Chirinda, 38, 62, 71, 78, 123, 139, 149
Chukchi, 23
Chune River, 75
Collins, Jane, 169
Committee for the Assistance to the Peoples of the Northern Borderlands, 83, 141, 156. See also Committee of the North
Committee of the North, 83, 92–110, 111, 119–20, 131, 132–33, 142; liquidation of, 157; use of film, 105–9
Communist Party, 45, 48–49, 53, 56–57, 66, 75, 86; and nationality policies, 81–82, 114–15
"Containment: Mastering Archival Emanations" (Campbell), 221
Culture Base, xix–xx, 2–5, 45, 66, 111–117, 119–21, 126–52, 156–58, 214–17, 230n1. See also Tungus Culture Base; Tura Culture Base
Czaplicka, Marie Antoinette, 3, 35, 42, 236n178

David-Fox, Michael, 240–41n324
Debs, Eugene, xi–xii, xiii
Deleuze, Gilles, 14–15
Derrida, Jacques, 168, 182
Dickerman, Leah, 244n96
Dirks, Nicholas, 103, 217
Dobrova-Iadrintsev, Lydia, 22–23
Dolgan, 16, 219
Dolgikh, B. O., 25, 29
Drawing Shadows to Stone (Kendall, Miller, and Mathé), 186–87

Duchein, Michel, 164–65
Dunn, Ethel, 54, 129, 140–41, 233n83
Dunn, Stephen P., 54, 129, 140–41
Dust (Steedman), 206

Edwards, Elizabeth, 167, 168, 230n19
Ekaterinburg, 3, 93, 156. See also Sverdlovsk
Eldogir, 22
Emerson, Caryl, 20
Emidak, 22
Empire of Nations (Hirsch), 218, 241n2
Encyclopedia of Soviet Life (Zemtsov), 73
Endangered Archives Programme (EAP), xvi, 3, 163–64
Engels, Friedrich, 58, 218, 241n2
Enisei Gubernia, 32–33
Enisei Provincial Committee of the North, 237n204
Enisei River, 10, 23, 27, 30, 33–35, 38, 117, 123, 156
Eniseisk, 34, 54, 93
Essei, 38, 123, 139
ethnographers, 31–32, 35–36, 47–48, 58–59, 60, 61, 231n44; and photography, 181–90, 243n52; state, 94–96, 119–21, 132, 177–81
Ethnohistorical Dictionary of the Russian and Soviet Empires, An (Olson), 133
Evenki: description of, 16–27; nationality policies, 81–85; and reindeer, 17–18, 23–25; under Soviet rule, 41–100; under Tsarist rule, 27–41
Evenki Autonomous District, 2, 75, 146, 157, 164
Evenkiia, 1–2, 5–6, 9–14, 16, 29, 148, 155–56, 231n25
Evenki National District, 144, 145, 148–49
Evenki New Life, 71, 149

Evenki Region's Museum of Local History, 164
Evens, 17
Everyday Stalinism (Fitzpatrick), 190, 200

Faris, James, 183, 189–90
Figes, Orlando, 83
film, 105–9, 190–91, 198–99, 200–201, 238n229
Fitzpatrick, Sheila, 74, 86, 89, 109, 128, 143, 190, 200
Fondahl, Gail, 233n83
Fort Mangazeia, 27
fur farming, 125–26

Gender Trouble (Butler), xv–xvi
Gérin, Annie, 46
Glagoleva, Olga, 160
Golovachev, F. E., 234n113
Gosplan, 234n122, 237n197
Grant, Bruce, 1, 2, 103–4, 137, 233n83
Gurgugir, 22

Hamilton, Carolyn, 201–2
Hansen, Miriam Bratu, xv
Haraway, Donna, 245–46n2
Harris, Verne, 168
Hirsch, Francine, 48, 57, 103, 236n197, 241n2; on Narkomnats, 94; on sovietization, 83, 161, 218
historical materialism, 50–51, 82
Hoberman, J., 200
Holquist, Peter, 237n217
Humphrey, Caroline, 232n83, 241–42n19

Ialogir, 22
iasak (tribute payments), 28, 29, 30, 34, 74
Ilimpii taiga, 3, 60, 219
Ilimpii Tundra, 30–31, 36, 60–62, 70, 71, 77–78, 99, 219

In the Soviet House of Culture (Grant), 1
Irkutsk, 3, 93, 146, 156
Iurtaeva, V. I., 69, 82
Ivanov, P. N., 61

Jervis, John, 207
Jochelson, Waldemar, 179, 239n263
Jochelson-Brodskaya, Dina, 243n64

Karl Marx Collective (Humphrey), 241–42
Karlov, V. V., 30
Kelly, Catriona, 98
Kendall, Laurel, 186–87
Ket, 16
Khanti, 135
Khanty, 23
kharakteristika (autobiographical sketch), 47, 232n75
Khatangskaia, 132
Khirogir, 22
Khukochar, 22
Khutokogir, 22
Kiaer, Christina, 61–62, 234n111
Klutsis, Gustav, 244n80
Kochechum River, 10, 14, 100, 113, 118, 156, 158, 238n251
Kofman, Sarah, 226
Kolarz, Walter, 150
kolonizatsiia (Soviet colonization), 56–57
Kombagir, 22
korenizatsiia (nativization), 76–77, 146, 235n154
Kotkin, Stephen, 160
Kracauer, Siegfried, 225
Krasnoiarsk, 32, 34, 51, 53, 54, 93, 100, 123, 236n195
Krasnoiarsk Committee of the North, 151
Krasnoiarsk Krai, 33
Krasnoiarsk Krai Museum, 154

Krasnoiarsk Krai Regional Museum, xvi
Krasnoiarsk Territory Regional History
 Museum, 171
Krypton, Constantine, 132, 134
Kul'tbaza, xix, 230n1, 241n6, 241n7. See also
 Culture Base
Kurilovich, A. P., 135
Kytmanov, D. A., 124

Lake Chirinda, 36, 78
Lake Essei, 29–30, 36, 138
Lake Murukta, 71, 78
Lake Vivi, 78
Land of the Soviets (Mikhailov), 115
Lena River, x, 30, 37, 117, 156
Lenin, V. I., xii, 56, 144, 147, 234n108;
 "archival decree," 160; on colonialism,
 83–84; "Directive on Cinema Affairs,"
 190–91; exile, 236n195; on national-
 ism, 238n236; New Economic Policy,
 67–68, 235n128
Lipp, Jan Stepanovich, 148
Lobovikov, Sergei, 196
Lower Tunguska River, 29, 35, 68, 99, 113
Lunacharski, Anatolii, 61–62, 98
Lutz, Catherine, 169

Mangazeia, 31, 35
Masi, 135
Martin, Terry, 238n236, 241n5
Marx, Karl, xi, 185; interest in Morgan,
 58, 218–19, 241n2
Massey, Doreen, 113
Mathé, Barbara, 186–87
McClintock, Anne, 216
Meisner, Maurice, 147
Middendorf, A. F., 31–32, 231n46
Mikhailov, Nikolai Nikolaevich, 115
Miller, Thomas Ross, 186–87
Mitchell, W. J. T., 170, 208

Morgan, L. H., 58, 218–19, 240–41n2
Morozov, S. A., 174
Morton, Chris, 188
Moscow, 6, 42, 59, 80, 95, 97, 120
Moscow State Literary Archive, 171
Moscow University, 178
Municipal Archive of Evenkiia, 171
Murukta, 123

Nanai, 17
Nansen, Fridtjof, 26
Narkomnats, 48, 82, 94–96, 215, 237n197.
 See also Peoples' Commissariat for the
 Affairs of the Nationalities
Narkompros (Peoples' Commissariat of
 Enlightenment), 46
National Geographic, 169
Naumov, I. V., 53, 132, 231n28
Navajo and Photography (Faris), 183, 189–90
Nentsi, 135
Neotraditionalism in the Russian North, 57
Nikul'shin, N., 132
1917 October Revolution, xiii, 40–44,
 48–49, 51–53, 68, 141–42, 215
Nivkhi, 1, 58
Nizhnaia Tunguska River, 23, 36, 37, 38,
 62, 112, 130, 156, 214
Non-capitalist Way of Developing the Native
 Minorities (Sergeev), 204
Nosilov, Konstantin Dmitrievich, 194
Novonikolaevsk, 156, 244n86
Novosibirsk, 3, 244n86
Novyi Lef, 244n96

Oegir, 22
Okladnikov, A. P., 137
Olenek River, 25, 94, 156, 236–37n196
Olenek Tungus, 25, 29
Oleneok, village of, 1
Olson, James Stuart, 133

Omsk, 47, 48
Orochis, 17
Orthodox Christianity, 33, 35–38, 72–73, 87, 139, 214–15
Osborne, Peter, 185
Ostiak, 32
Other Side of Eden, The (Brody), 236n183

Palmer, Scott W., 217
Pal'min, V. I., 124
Pankagir (Liutokil), 62, 77, 78
Parallax View, The (Žižek), 198
Penin, M. I., 120
Peoples' Commissariat for the Affairs of the Nationalities (Narkomnats), 48, 82, 94–96, 215
Peris, Daniel, 74
Pervert's Guide to Cinema, The (Žižek), 198
Pesmen, Dale, 20
Petelin, Ioann, 26
Petri, Bernard Eduardovich, 41
photography, ix–x, xvii, 94, 153, 211–13, 221–27, 230n5; archival, 163–73, 201–10; ethnographic, 181–90; pictorialism, 195–97, 201; propaganda, 92, 190–96; Siberia collection, 163–64, 175, 196; socialist realism, 190–201; Soviet era, 77, 104–5, 173–81, 244n80; Suslov collection, 163–64, 185; tsarist era, 77
Photography's Other Histories (Pinney and Peterson), 230n19
Piasinskaia, 132
Picturing Russia (Kivelson and Neuberger), 230n5
Pika, Alexander, 57
Pinney, Christopher, 182–83
Podkamennaia River, 65, 124
Podkamennaia Tunguska River, 23, 124, 156
Polar Census of 1926–1927, 65, 67, 104, 134–35, 234n126

Polar Department, 83
politdoma (political houses), 46–47
Poole, Deborah, 201
Potapov, I. D., 234n113
Prokudin-Gorskii, Sergei Mikhailovitch, 191
Prunes, Mariano, 244n80
Puranen, Jorma, 206–7

Rancière, Jacques, xvi
Raytheon, 224
Red Atlantis, The (Hoberman), 200
Redon, Odilon, 211–12
Red Ties and Residential Schools (Bloch), 129
reindeer, 17–19, 23–26, 71, 115, 119; caravans, 99; collectivization, 131; and epizootics, 52, 64, 107, 123–24, 125; industry, 40, 51, 52, 107, 120, 121, 125; residential schools, 2, 73, 129–30, 136
Revolution Betrayed, The (Trotsky), 79
Ricoeur, Paul, 170–71
Riding with Rilke (Bishop), xvii
Road of the Northern Peoples to Socialism, The (Uvachan), 137
Rodchenko, Aleksandr, 173–74, 208, 244n96, 245n98
Rodowick, David, 225
Russian Committee for the Study of Central and East Asia, 32
Russian Soviet Federative Socialist Republic, 29, 93
Russian State Documentary Film and Photo Archive, 171

Sakha (Yakut), 16, 22, 58
Sakhalin Island, 42, 58
Savel'ev, Elizar Sergeevich, 62, 63–64, 70–71, 114, 214
Schwartz, Joan, 169–70, 203
Scott, James C., 52–53

Seeing Like a State (Scott), 52–53
Sekula, Allan, 182
Sergeev, M. A., 132, 157, 204
shamanism, xiii, 65–66, 67, 86–88, 91, 230n12, 236n178
Shamanism and the Struggle with It (Suslov), 87, 91
Shimkin, Demitri, 30–31
Shirokogoroff, Sergei Mikhailovich, 18–19, 41
Shklovsky, Viktor, 208
Shnirelman, Victor A., 141–42
Shternberg, Lev, 41, 43, 58, 239n263
Siberia, 3–4, 27–30. *See also* Central Siberia
Siberian Governorship, 28–29, 38
Siberian Regional Executive Committee, 75
Siberian Revolutionary Committee, 68, 70, 75
Siegelbaum, Lewis H., 76–77
Simonov, L. A., 124
Siniavskii, Andrei, 29
Slezkine, Yuri, 50–51, 58–59, 63–64, 144, 149, 214, 219, 241–42n19; on agitators, 72; on clan Soviets, 78–79, 80; on nationality policies, 81
smallpox, 17, 26, 93
Smidovich, Petr, 101, 237n200
Social Life of the State in Subarctic Siberia, The (Ssorin-Chaikov), 65
Sontag, Susan, 173, 182, 186, 189, 205
Sovetskoe Foto, 194
Soviet, 53, 75–76, 77–79, 157–58, 161, 233n89; clan, 54–55, 77–80
Soviet high modernism, 4, 155, 177
sovietization, 4–5, 40, 41, 49, 53–56, 66–67, 73–85, 135–37, 141, 147–49, 155, 216–17; counter-narratives, 158–59

Soviet Nationalities Policy, 255
Soviet North (Sovetskii Sever), 91, 133, 144–45
Soviet Union, 29, 36, 74, 111, 133, 142, 145, 160–62
Speransky, Count Mikhail, 32, 39–40, 88
Ssorin-Chaikov, Nikolai, 22, 65, 116
Stalin, Joseph, 141, 143–44; exile, 236n195; film, 198–99, 238n229; Five-Year Plan, 68, 85–86, 131, 133, 134–35, 142, 143
State Archive of Novosibirsk Oblast, 157
State Colonization Research Institute (Goskolonit), 161
Steedman, Carolyn, 167, 206
Stepanova, Varvara, 245n98
Stites, Richard, 91–92
Stoler, Ann, 159, 160–61, 163, 167
St. Petersburg, 3
Sushilin, N. V., 67
Suslov, Innokentii Mikhailovich, xiii, xiv, 38, 41–44, 46, 47–48, 61, 78, 156, 177, 236–37n196, 239n281, 242n39; and Committee of the North, 100, 108–9, 110, 112, 122–24, 151; creation of the first clan Soviet, 75; as ethnographer, 89–90, 95–96, 97; and photography, 163–64, 196–97, 200–201; and shamanism, 87, 91, 121
Suslov, M. I., 35, 37, 38, 239n281
Sverdlovsk (Ekaterinburg), 5, 70, 93

Tagg, John, 168
Taussig, Michael, 12–13, 21, 207, 223, 224, 226–27
Taylor, Richard, 46–47, 133, 136
Tazovskaia, 132
Trans-Siberian Railway, 156, 232n50
Travels in the North and East of Siberia (Middendorf), 32
Trofimov, P. L., 134–35

Trotsky, Leon, 79
Tsar Peter I, 28, 38–39
tuberculosis, 125
Tugolukov, V. A., 26, 71, 233n85
Tungus: usage of term, 17, 85
Tungus Culture Base, xix–xx, 9, 70, 85, 100, 110, 111, 114, 117–118, 126–28; construction of, 121–26, 157, 239n281; film and photography, 109
Tura, xx, 3, 4, 10, 78, 157
Tura Archives, 154
Tura Culture Base, 12, 85, 101–10, 112, 134, 144, 145, 157, 158; and photographs, 196–97
Turin, Victor, 192–93
Turinskaia, 132, 157
Turksib (Turin), 192–93
Turov, M. G., 32
Turukhansk, 33–35, 42, 54, 93, 236n195
Turukhansk Department of Native Affairs, 70
Turukhansk District, 33, 132–33
Turukhansk Executive Committee, 114, 120
Turukhansk Krai, 33, 60, 70, 117, 213
Turukhansk North, 2, 3, 51–92, 156. *See also* Evenkiia
Turukhansk Regional Executive Committee, 70

Turukhansk Revolutionary Committee, 59–60, 93
Tuvan, 49, 57

Udege, 17
Udygir, 22
Universal Exception, The (Žižek), 199
Usher, Henry, 23–24
USSR in Construction, 200
Uvachan, V. N., 3, 9, 55, 62, 64, 71–72, 137, 146, 150, 213–14, 215

Vasilevich, Glafira M., 16
Verdery, Katherine, 244n78
Vertov, Dziga, 208
Viliui River, 25, 26
Volkov, Vadim, 197–98

Weiner, Amir, 101
Wolf, Erika, 200
Wong, Yoke Sum, 39

Yakutiia, 1, 26, 156, 236–37n196
Yakuts, 22, 92, 137–38, 219
Youngblood, Denise, 109
Yukhagir, 16

Zemtsov, Ilya, 73, 232n75
Žižek, Slavoj, 198–99

Craig Campbell is assistant professor of anthropology and cultural forms at the University of Texas at Austin. He is a founding member of the Ethnographic Terminalia curatorial collective and coauthor of *Mihkwâkamiwi sîpîsis: Stories and Pictures from Metis Elders in Fort McKay.*